WOMEN IN EARLY AMERICA

Women in Early America

Edited by Thomas A. Foster

Foreword by Carol Berkin

Afterword by Jennifer L. Morgan

NEW YORK UNIVERSITY PRESS
New York and London

NEW YORK UNIVERSITY PRESS
New York and London
www.nyupress.org

References to Internet websites (URLs) were accurate at the time of writing.
Neither the author nor New York University Press is responsible for URLs that
may have expired or changed since the manuscript was prepared.

Library of Congress Cataloging-in-Publication Data
Women in early America / edited by Thomas A. Foster ; foreword by
Carol Berkin ; afterword by Jennifer L. Morgan.
pages cm Includes bibliographical references and index.
ISBN 978-1-4798-7454-5 (cl : alk. paper) — ISBN 978-1-4798-9047-7 (pb : alk. paper)
1. Women—United States—History—17th century. 2. Women—United States—History—
18th century. 3. Women—United States—Social conditions. 4. United States—History—
Colonial period, ca. 1600-1775. 5. United States—Social conditions—To 1865. I. Foster,
Thomas A., editor.
HQ1416.W656 2015
305.4097309'032—dc23 2014040537

New York University Press books are printed on acid-free paper,
and their binding materials are chosen for strength and durability.
We strive to use environmentally responsible suppliers and materials
to the greatest extent possible in publishing our books.

Manufactured in the United States of America

10 9 8 7 6 5 4 3 2 1

Also available as an ebook

For Marlon

CONTENTS

Meeting the Challenges of Early American Women's History

CAROL BERKIN

In the 1970s, the scholarly study of American women's history was in its infancy and its focus was largely on the nineteenth century. Toward the end of the decade, however, a group of intrepid—or, as others saw us, foolhardy—scholars began to commit themselves to the study of colonial and Revolutionary era women. Friends and advisors warned against it: best, they said, to continue to tread the paths that had led to publications and, in several cases, tenure at respectable universities. It was not that these colleagues necessarily lacked sympathy for the topic; they simply doubted it could be tackled. Everyone knew there were simply no sources to mine, no archives sheltering untapped treasures, and no big questions around which to shape an argument.

Despite all the good advice, the women of my generation persisted. Dogged research—and sometimes stubborn challenges to archivists—turned up diaries and letters, buried under inventory labels like "miscellanea" and "family records." Women's voices, it appeared, were not forever lost; they could be recovered. And women's experiences could be reconstructed. Articles and books began to appear, a mélange of contribution history, victim narratives, and accounts of resistance to established gender ideology. Our primary focus was recovery and restoration, and our goal was to repopulate the canvas of the colonial and Revolutionary eras with women as participants in shaping that world.

Much of the work we did, like pioneer work in any field, will not stand the test of time. For example, the voices we discovered were, with few exceptions, those of white elite women, and thus they emerged as the central actors in our earliest efforts. Too often we universalized their experiences, assuming that they were *the* American woman. And, much

of our work was aimed at proving women were relevant to the study of events traditionally defined as important or at challenging the prevailing "golden age myth" that claimed a rough equality existed between the sexes in colonial society until the capitalist serpent entered the garden in the nineteenth century.

In the decades that have followed, the field of early American women's history has grown far more sophisticated in its methodologies and far more inclusive in its subject matter. New voices have been added to those of the elite, and essentialism has given way as race, class, region, and a host of other factors have been shown to intersect gender. The recent focus on a transatlantic perspective has created a new and broader context in which to examine early American women's experiences. Finally, the application of feminist theory and of gendered analysis has opened up new avenues for exploration and allowed us to revisit and refine our older narratives. The study of the construction of gender and sexuality and of the embedded power relationships these constructions allow has become the newest frontier in our field.

Women in Early America admirably reflects where our field stands today. The range and reach of the essays are especially impressive, for they cross geographic and ethnic borders, examine choices women made during revolution and crisis, give voice to once silenced individuals, explore socially defined transgressive female behavior, and demonstrate the shared goals and values of women of different races. Taken together, they illustrate the vitality of the field, the sophistication of its practitioners, and the importance of the questions being raised—and answered—to a richer understanding of the lives of both women and men in seventeenth- and eighteenth-century America.

Perhaps most important of all, these essays constitute the boldest challenge yet to the notion, as Thomas A. Foster puts it, that it is still "acceptable for men to be portrayed as the universal historical subject." *Women in Early America* holds out the promise that this untenable and thus far intractable belief can at last be abandoned.

ACKNOWLEDGMENTS

This project was enormously gratifying to work on, in large part because of the input from so many excellent scholars along the way. I would especially like to thank the organizers and participants of the May 2011 workshop on women in early America, sponsored jointly by the Omohundro Institute of Early American History and Culture, the *William and Mary Quarterly*, and the University of Southern California–Huntington Early Modern Studies Institute. Attending that workshop was formative and provided the necessary encouragement and focus that I required for this project. As always, I owe a debt of gratitude to Mary Beth Norton. For input on some of the proposed essays, I would like to thank Carolyn Eastman and Leslie Harris. Carolyn Eastman, Rebecca J. Plant, Elizabeth Reis, and Lisa Z. Sigel all assisted greatly with the introduction. This project was initially accepted under the helpful editorial guidance of Deborah Gershenowitz. I would like to thank the readers of the proposal and the full manuscript for their helpful feedback. Ann M. Little (Historiann.org) also provided helpful support. Ramiro Hernandez assisted with formatting some of the manuscript. I am grateful to all those at New York University Press who worked on the book and to the University Research Council at DePaul University for funding to assist with production costs. Finally, I would like to thank all those who proposed essays and, most important, the contributors for their engagement with the project and for sharing their work to make this book possible.

Introduction

Women in Early America: Crossing Boundaries, Rewriting Histories

THOMAS A. FOSTER

Women first arrived in North America at least some fifteen thousand years ago. The traditional view of these migrants who crossed the Bering Strait is of men hunting for prey or explorers braving a new frontier. But we know that women also settled North America. By ten thousand years ago settlements stretched from coast to coast. For thousands of years, millions of women worked the land to provide agricultural sources of nourishment for their communities. Women played key roles in the great ancient societies of North America—the Anasazi, Hohokam, and Mound Builders.

By the time of Spanish settlement in Saint Augustine, Florida, in 1565, English settlement at Jamestown in 1607, and French settlement in Quebec in 1608, women had long established their roles as community builders. Most women who would come to the New World in the seventeenth and eighteenth centuries, however, like their male counterparts, came against their will—in chains. *Women in Early America* tells the stories of the myriad groups of women who shaped the early modern North American world.

The essays in *Women in Early America* interpret historical sources with a variety of lenses, including feminist theory, gender theory, critical race studies, environmental history, cultural history, and literary criticism. Thus, the book features new approaches to an older project of recovering women's lives and experiences from a historical record that has until relatively recently focused on men. Many of the essays locate their subjects in spaces that confound traditional boundaries—of gender, status, and ethnicity, for example. Some of the essays employ

1

a transnational lens. Collectively, the essays offer new ways of viewing early America and, in so doing, highlight the significance of examining women in history.

* * *

One of the earliest goals of the field of women's history was to write histories of women's lives and experiences. For generations, history had focused on men and there was even skepticism within the profession that evidence of women's lives could be located within archives. After all, the argument went, women did not produce extensive written documents or lead troops into battle. Nor did they have roles in government or politics or commerce. Women's work within the home was understood, wasn't it? What more could be studied and how? A generation of women's historians in the 1960s began to search, and, well, the rest is history. Works in the 1970s and 1980s ignited a field and helped to establish the history of early American women as integral to the history of the nation's founding.[2] From this generation of scholars we learned much about primarily middling and elite white women's involvement in a host of arenas—the family, to be sure, but also the church, politics, and the economies of early America.

In the 1990s, the turn to gendered analysis enriched and complicated the study of women's history in significant ways. Scholars began to shift their focus to social and cultural ideals of womanhood and to interrogating the very category of *woman* to take into account the multiple intersections and divisions among women such as race, class, region, and religion. Works such as Mary Beth Norton's *Founding Mothers and Fathers: Gendered Power and the Forming of American Society* (1996) and Kathleen M. Brown's *Good Wives, Nasty Wenches, and Anxious Patriarchs* (1996) deepened our understanding of gendered power in early America and sparked new avenues for more work. The fields have developed so closely together that many now consider women's history and gender history as a single unified field.[3] Indeed it may not be entirely productive to disentangle the subfields associated with women's history. Still, the quantity of scholarship with an explicit focus on women's history lags behind that of newer work on gender and sexuality and by the profession as a whole.

What would gender parity within historical scholarship look like? There's certainly an abundance of scholarship published on early Ameri-

can women. And the historical profession recognizes exemplary work in the field.[4] But the volume of publications still pales in the face of works published about men. And the most popular topics in early American history, which cross over from the academy to lay readers, remain focused on traditional narratives of war and politics—and great men. It is true that the amount of scholarship on women's history has increased in recent decades—enough to garner the attention of critics who decry a loss of attention on traditional subjects of state formation and military movements. But consider the following: of articles published in 1985, only about 4 percent covered women's history. By 2000, this figure had risen to a less-than-whopping 8 percent.[5] The original goal of the field— examining women's lives and experiences—remains as relevant as ever.

Moreover, one of the oldest feminist critiques of the field of history, one that drove the early women's history movement, remains remarkably relevant: It is still largely acceptable for men to be portrayed as the universal historical subject. Authors still present their works as complete histories while focusing almost exclusively on the experiences and writings of male subjects. Monographs and textbooks alike that focus largely on women still must declare as much in their titles, while histories primarily about men are still identified in titles by their subject matter alone. And while more and more work recognizing men as gendered subjects is being produced, as Toby L. Ditz has warned, much of that scholarship still pays only lip service to gendered power and to the experiences of women, and the "new men's history" threatens merely to recenter men in the traditional historical narrative.[6]

In addition, among those scholarly histories of women, coverage of the modern period far outstrips work on pre-1800 America. Scholarship on women's history mirrors the larger historical profession in its disproportionate coverage of the twentieth century. Indeed, histories of early American women accounted for roughly only a tenth of articles published between 1985 and 2000.[7]

Women in Early America, thus, addresses the need for scholarship on women's lives and experiences as well as the imbalance in the existing literature that privileges modernity over the more distant past. Only by examining early American women's history can one understand the developments of the modern era—both the advances and the setbacks. Too often, women's history is thought of by the public as a history marked

by progress. It is true that legal and cultural changes have advanced the opportunities that women today have in education, employment, and the law. But the modern feminist movement is still regularly positioned against an anachronistic and static early American setting. To properly situate contemporary women's history, one must understand gains and losses in a broad context that illuminates the shifting social, cultural, and economic trends that impacted women over the course of four centuries.

* * *

Americans have long been enamored of stories about a small handful of early American women. Generations of schoolchildren have learned about Pocahontas, whose image graces this book's cover, as the woman who saved Captain John Smith's life. But scholars have long argued that the focus on her romantic relationship with Smith (which almost certainly did not happen) obscures the role that she played in securing diplomatic peace between the Powhatan and the English at a key moment of settlement for the Jamestown community. Overlooked in the mythology that has grown up around Pocahontas is the role that countless women played in similar positions as cultural go-betweens, facilitating trade, communication, and diplomatic and economic connections between the Europeans and Native Americans. Pocahontas is, of course, not the only well-known early American woman. Others include Abigail Adams, Betsy Ross, Deborah Sampson, and Phillis Wheatley, to name a few. Some of the women in this book will be familiar to readers. But *Women in Early America* largely examines lesser-known women—both ordinary and elite and not only those who hailed from British mainland America, but also women in New Spain, New France, New Netherlands, and the West Indies.

The eleven chapters cover a wide range of women's experiences from the colonial era through the early republic. In these essays we learn about the conditions that women faced during the Salem witchcraft panic and the Spanish Inquisition in New Mexico, as indentured servants in early Virginia and Maryland, while caught up between warring British and Native Americans, as traders in New Netherlands and Detroit, as slave owners in Jamaica, as loyalist women during the American Revolution, while enslaved in the president's house, and as students and educators inspired by the air of equality in the young nation.

The subtitle of this introduction, "Crossing Boundaries, Rewriting Histories," is a double entendre: it applies to both the essays and the women who are their subjects. Collectively the book heeds the early call of feminist scholars and historians not to merely "add women and stir" (incorporate women into existing male-centered historical narratives) but to rethink traditional narratives themselves so that we may better understand how women and men created and developed our history. The women in these articles were also themselves agents of change. They crossed boundaries. They rewrote histories by consciously challenging social conventions and norms—and sometimes just by living their lives.

NOTES

1. Alan Taylor points out that two-thirds of the twelve million who came to the New World before 1820 were enslaved Africans. Alan Taylor, *American Colonies: The Settling of North America* (New York: Penguin, 2001), 44. See also Jennifer L. Morgan, *Laboring Women: Reproduction and Gender in New World Slavery* (Philadelphia: University of Pennsylvania Press, 2004), chap. 2.

2. Joy and Richard Buel, *The Way of Duty: A Woman and Her Family in Revolutionary America* (New York: Norton, 1984); Lois Green Carr and Lorena Walsh, "The Planter's Wife: The Experience of White Women in Seventeenth-Century Maryland," *William and Mary Quarterly*, 3rd series 34, no. 4 (1977): 542–71; Nancy F. Cott, *The Bonds of Womanhood: "Woman's Sphere" in New England, 1780–1835* (New Haven: Yale University Press, 1977); Carol F. Karlsen, *The Devil in the Shape of a Woman: Witchcraft in Colonial New England* (New York: Norton, 1987); Linda K. Kerber, *Women of the Republic: Intellect and Ideology in Revolutionary America* (Chapel Hill: University of North Carolina Press, 1980); Mary Beth Norton, *Liberty's Daughters: The Revolutionary Experience of American Women, 1750–1800* (Boston: Little, Brown, 1980); Marylynn Salmon, *Women and the Law of Property in Early America* (Chapel Hill: University of North Carolina Press, 1986); Laurel Thatcher Ulrich, *Good Wives: Image and Reality in the Lives of Women in Northern New England, 1650–1750* (New York: Knopf, 1982); Deborah Gray White, *Ar'n't I a Woman? Female Slaves in the Plantation South* (New York: Norton, 1985).

3. For an example of a treatment that approaches women's and gender history as one field, see Cornelia H. Dayton and Lisa Levenstein, "The Big Tent of U.S. Women's and Gender History: A State of the Field," *Journal of American History* 99, no. 3 (December 2012): 793–817.

4. The American Historical Association has administered the Joan Kelly Memorial Prize in women's history annually since it was established by the Coordinating Committee on Women in the Historical Profession and the Conference Group on Women's History in 1983. The Organization of American Historians has

administered the Darlene Clark Hine Award, given in recognition of the best book in African American women's and gender history, annually since 2010 and the Lerner-Scott Prize, honoring the best doctoral dissertation in U.S. women's history, annually since 1992.

Recent books on early American women's history that have won awards not specifically intended for women's history include Juliana Barr, *Peace Came in the Form of a Woman: Indians and Spaniards in the Texas Borderlands* (Chapel Hill: University of North Carolina Press, 2007); Emily Clark, *Masterless Mistresses: The New Orleans Ursulines and the Development of a New World Society, 1727–1834* (Chapel Hill: University of North Carolina Press, 2007); Carolyn Eastman, *A Nation of Speechifiers: Making An American Public after the Revolution* (Chicago: University of Chicago Press, 2009); Susan J. Klepp, *Revolutionary Conceptions: Women, Fertility, and Family Limitation in America, 1760–1820* (Chapel Hill: University of North Carolina Press, 2009); Clare A. Lyons, *Sex among the Rabble: An Intimate History of Gender and Power in the Age of Revolution, Philadelphia, 1730–1830* (Chapel Hill: University of North Carolina Press, 2006); Lisa Norling, *Captain Ahab Had a Wife: New England Women and the Whalefishery, 1720–1870* (Chapel Hill: University of North Carolina Press, 2001).

5. Sharon Block and David Newman, "What, Where, When, and Sometimes Why: Data Mining Two Decades of Women's History Abstracts," *Journal of Women's History* 23, no. 1 (Spring 2011): 84. See also Terri L. Snyder, "Refiguring Women in Early American History," *William and Mary Quarterly* 69 (July 2012): 421–50.

6. Toby L. Ditz, "The New Men's History and the Peculiar Absence of Gendered Power: Some Remedies from Early American Gender History," *Gender & History* 16 (April 2004): 1–35.

7. Block and Newman, "What, Where, When, and Sometimes Why," 89–90.

1

Doña Teresa de Aguilera y Roche before the Inquisition

The Travails of a Seventeenth-Century Aristocratic Woman in New Mexico

RAMÓN A. GUTIÉRREZ

April 11, 1663. Doña Teresa de Aguilera y Roche, the wife of New Mexico's governor, Don Bernardo López de Mendizábal, found herself in a dank and dingy cell, a prisoner in the secret jail of the Holy Office of the Inquisition, close to Mexico City's center. There she sat, hour after hour, day after day, until all the seasons had come and gone and nearly two years had passed. On December 19, 1664, her case was suspended for insufficient evidence. But for twenty-one months she had been stripped of her possessions, of all trappings of her aristocratic rank, cut off from communication with family and friends, and sustained on meager rations. The jail's warden, Bartolomé de Galdiano, reported that Doña Teresa often sank into weeks of deep depression followed by hysterical bouts: "She is disconsolate . . . is very sorrowful and distraught and has been on the verge of committing an irrational act imperiling her life." Indeed, her only pleasure seemed to be the two cups of hot chocolate she was allotted daily. Her days and nights were often filled with tears, with a cacophony of fractured memories that prison time only intensified, of muddled conversations, of insults and slights now more remote and difficult to reconstruct, and a yearning to be with her beloved Don Bernardo, her long-philandering husband who was now quite ill.[1]

Constantly she asked her jailers about his fate. Was he being held nearby? He was. Had his health deteriorated further? It had. To what extent? Long a sickly man, Don Bernardo's condition had been made worst by the seven-month journey from Santa Fe to Mexico City shackled in a caged cart. The rigors of jail were all the more taxing. He petitioned his inquisitor to be transferred to Doña Teresa's cell and into

her care. Denied. Given his rapidly declining condition, certified by the jail's physician, he asked to be moved to a cell with more light and better ventilation because he often gasped for air. No. As his health worsened, his inquisitor did agree to leave his cell door open during the day. There, in the secret prison of the Inquisition, Don Bernardo died. His interment record, dated September 16, 1664, noted that he had been buried in unconsecrated ground, in the jail's own corral amid the odor of horses, rats, and mules. On April 30, 1671, the Holy Office exonerated Don Bernardo of all the charges that had been brought against him. Doña Teresa had his bones exhumed and placed in Mexico City's Cathedral of Santo Domingo on May 12.

How Doña Teresa, wife of the governor of the Kingdom of New Mexico from 1658 to 1661, became entangled in the web of the Holy Office of the Inquisition is the complicated story here. The events are known through two very large *procesos*, or Inquisition court dockets, still extant in Mexico's National Archive. The case against Doña Teresa consisted of forty-one counts of heresy, Judaism (*judaizante*), and sorcery, which all stemmed from her years in Santa Fe as the governor's wife. Don Bernardo had 257 counts of heresy, Judaism, blasphemy, propositions contrary to the cult of the Church, and destruction of the Church's authority, all of which likewise originated from his term as New Mexico's governor. As they were husband and wife, some of the counts intersected, involving domestic marital behavior. Here we focus mainly on Doña Teresa's case and her point of view, turning to the accusations against Don Bernardo at the essay's end to understand the larger social milieu in which these cases emerged.[2]

Very few documents from seventeenth-century New Mexico still exist. The bulk were destroyed during the 1680 Pueblo Revolt, when the kingdom's Indians rebelled against their Spanish overlords, killing the majority of the colonists and driving those who survived from the province until 1693. The only records that escaped destruction were those already housed in Spain, in Mexico City's viceregal archives, or in the ecclesiastical repositories of the Holy Office of the Inquisition, the Office of the Holy Crusade, and Episcopal Sees, which were the regnant ecclesiastical courts of New Spain.

Unraveling the knowledge/power politics embedded in Inquisition cases is not an easy task. Beginning with the institution's formal estab-

lishment in Mexico in 1571, its court and lawyers were used to curb the wealth and authority of the conquering citizen-soldier class whenever the Church felt its prerogatives and the primacy of its evangelization project slowed or affronted in any way. Then there were the carceral facts of confinement and torture by which testimony often emerged. One can only imagine how terrifying it must have been to be called before the Inquisition, particularly as one contemplated the punishments it was known to mete out. Its milder forms were exile and public humiliation in *autos de fé*. Being water-boarded, garroted, and then burned at the stake, though admittedly more rare, still occurred often enough to be emblazoned vividly in the social imagination. Historian Solange Alberro concludes that between 1571 and 1700, thirty-four to thirty-seven persons were consumed by such flames in New Spain.[3]

The Inquisition case against Doña Teresa de Aguilera y Roche is singular because it gives us a glimpse into the complex public and private life of a worldly, educated, aristocratic woman living in seventeenth-century Santa Fe, which by all assessments was a remote frontier place populated by rude and crude folk and surrounded by hostile indigenous groups. Provisioned by caravan three times yearly, Santa Fe in 1660 had a population that reached around eight hundred, of whom some two hundred called themselves "Spaniards." Only thirty-five of them were capable of bearing arms. The entire Kingdom of New Mexico, which in the colonial period encompassed much of what are now the states of New Mexico and Arizona, counted only a total of 170 armed men and roughly two thousand persons residing in households headed by so-called Spaniards. Beyond Santa Fe, the majority of these residents were much more dispersed, living with their families, servants, and slaves close to the indigenous villages they had been entrusted to protect and Christianize, and from which they expected tribute in the form of food, work, and goods as part of their *encomiendas*, those grants of entrustment Spanish soldiers won for their labors of conquest. The Inquisition case against Doña Teresa is one of the few windows we have into the fractiousness of Santa Fe's Hispanicized community on the eve of the 1680 Revolt of the Pueblo Indians from an aristocratic woman's perspective.[4]

In the early seventeenth century the Inquisition brought charges against a number of visionary mystic women, known as *iluminadas*

and *beatas* in Spain and the Americas, mostly for usurping the clergy's jealously protected monopoly on the expression and interpretation of religious experience. There were cases too against indigenous and African slave women for practicing sorcery and love magic.[5] But rarely were these women literate, and even more singular were the women who had the wherewithal to mount spirited defenses against their accusers before the Inquisition.[6] Doña Teresa was such a woman. She was literate and learned, speaking Italian, French, and Spanish and reading broadly, even in Latin. She was pugnacious and testy, of course, made all the more so in her written declarations by her imprisonment, determined not to let the words of her accusers stand. Many times during her confinement she requested ink and paper to pen her own account of events, impeaching her unknown but suspected accusers, declaring that they had borne false witness against her, outlining the pettiness of her husband's employees and her household staff, their malice and their envy, their intrigues and their sexual peccadillos, in which even the Franciscan friars were participants. No other woman in colonial New Mexico left such a record. Few were the women who penned accounts of their lives in colonial New Spain. Indeed, if one looks for similarly literate women in Mexico and Spain, only Doña Teresa's younger contemporaries, Sor Juana Inés de la Cruz and Sor María de Agreda (also known as María Fernández Coronel y Arana), come to mind. The former is well known; the latter was a Spanish Franciscan nun, the abbess of the convent in Agreda, Spain, who wrote extensively about her mystical flights to New Mexico and West Texas in the 1620s, putatively to assist the Franciscan friars Christianizing there.[7]

In the histories of colonial New Mexico, Doña Teresa de Aguilera y Roche is a marginal figure, often depicted as a bit player ensnared in her husband's reckless machinations, brazenly appropriating most of the kingdom's economic resources for himself, thereby sparking bitter struggles with the Franciscan friars and the local Spanish settlers, eventually landing him (and her) in the Inquisition's jail.[8] Other than this essay, no research has yet carefully studied Doña Teresa's Inquisition case as a whole. María Magdalena Coll More's superb but as of yet unpublished dissertation is an in-depth linguistic analysis of the seven-page self-defense document Doña Teresa wrote for the Inquisition.[9] The rest of the published literature on Doña Teresa consists of either Span-

ish transcriptions of portions of her *proceso* or English translations of these.[10] The entire case offers us a complex portrait of social and cultural relations in Santa Fe from the perspective of an elite woman, giving us entrée into the most intimate details of her private and public life. We learn how romances and illicit affairs reverberated locally, how they could rapidly provoke shifting political alliances, and the nature of licentiousness and its communal control by church and state. Most important perhaps is the window the case opens to how patriarchy operated in seventeenth-century New Spain. Though aristocratic women enjoyed considerably more autonomy over their persons in regard to movement and education, they nevertheless remained appendages of their fathers and husbands. Their fortunes rose and sank because of them. In the case of Doña Teresa de Aguilera y Roche, who spent almost three years in an Inquisition jail, her fate was dictated by the men who wanted to humiliate and punish her husband, not her.

* * *

Doña Teresa de Aguilar's troubles with the Inquisition began at midnight on August 27, 1662, when Juan Manso, the recently appointed New Mexican commissary of the Holy Office arrived at her home with an arrest warrant that had been issued on March 22. Two hours earlier, at about ten o'clock, her husband, Governor Bernardo López de Mendizábal, who had been held prisoner since December 1661 awaiting the administrative review (*residencia*) of his governorship, was transferred into Manso's custody, as the Inquisition's warrant ordered. In the hours that followed they were each separately transported and jailed in the Franciscan convent at Santo Domingo Pueblo, some twenty miles south of Santa Fe. Throughout the rest of the summer Doña Teresa and Don Bernardo were confined there and "saw neither sun nor moon."

Dr. Don Pedro Medina Rico (hereafter Dr. Medina) was appointed the inquisitor in Doña Teresa's case. His arrest warrant ordered that she should be held in detention and her property immediately sequestered.[11] Accordingly, one of the first documents in her docket is a property inventory, enumerating what were clearly the possessions of a woman of means. She owned "some gold earrings; a necklace and bracelets of glass beads, coral, and pearls." In her pocket was found a "rosary made of black palm seeds . . . a small caplet, and a small cross, and a bronze

[religious] medal that she said she needed for her use." When arrested she wore "a bodice of satin plush with a flower pattern in brown, black, and white, lined with purple taffeta and with buttons of silver thread, a mantelet of scarlet wool, adorned with silver-tipped ribbons and lined in blue taffeta, with buttons of silver thread." Among her many things, listed in 118 different categories, were "a quadroon girl called Clara, her slave . . . a mulatto boy called Diego, who is also a slave; four Indian women . . . one of the Quiviras is called María and the other Micaela; and one of the Apaches is called Isabel and the other Inés; [plus] another Indian of Mexican nationality, called Cristina." There were several bags containing debt notes owed to her husband. She had all the things a wealthy woman needed for daily life: dresses and petticoats, shawls and handkerchiefs, shoes, stockings, slippers, hats, and gloves, along with bolts of cloth and all the tools necessary to fashion clothes: ribbons, needles, thread, thimbles, scissors, pincushions. Her kitchen was well appointed with pots and pans, towels and napkins, flints, candles and candlesticks, cups, knives and spoons, with pepper and "about three pounds of chocolate." There were beds and bedding, furniture cases, a copy of the "bull of the Holy Crusade . . . a small book bound in boards titled *El perfecto Cristiano*, printed in Seville in 1642 . . . [and] a book bound in boards, titled *Officium Beatae Mariae Virginis*, printed in Antwerp in 1652."[12]

The triennial Franciscan mission supply caravan between Santa Fe and Mexico City finally was ready to return south on October 6, 1662. With it traveled Doña Teresa, restrained in one of her husband's carriages, while Don Bernardo was loaded onto a caged cart, with heavy shackles on his feet.[13] The slow-moving convoy reached the Inquisition's prison in Mexico City, roughly six months later, on April 10, 1663. The following morning the jail's warden placed Doña Teresa in cell 17, in which she was allowed to keep Clara, her mulatto slave, "for now." In successive weeks the jail's warden and her inquisitor, Dr. Medina, exchanged letters over how much clothing, bedding, and personal effects she would keep in her cell, what the cost of her daily food ration would be, how much chocolate, wine, and sugar she would be allotted monthly, particularly during Lent, and what to do with the six other servants and slaves she still owned. Around April 20 Doña Teresa requested that she be moved to a nicer cell, one that was "comfortable and dry," given that

she had "come from so distant a place and [already] been a prisoner for so long a time." Dr. Medina agreed because she was "a women raised amidst much pomp and luxury."[14]

* * *

A few pages into Doña Teresa's court record sit twenty-six affidavits Juan Manso collected in New Mexico in late 1661 and early 1662 as the Inquisition's commissary. In these declarations several friars, citizens, and Doña Teresa's household servants and retainers residing in the governor's palace swore before God that they had heard her utter words and seen her perform deeds that led them to believe that she was a heretic, a Jew, and an active participant in the black arts.

On the morning of May 2, 1663, finally Doña Teresa stood face-to-face with Dr. Medina and his scribe. She was placed under oath and asked her name, age, occupation, residence, and nativity, how long she had been a prisoner, and the names of her parents and grandparents. Doña Teresa de Aguilera y Roche was forty years old, a native of Alexsandria (Italy), the wife of Don Bernardo López de Mendizábal, with no occupation. She had been arrested in Santa Fe, New Mexico, on August 27, 1662, and jailed in Mexico City on April 10, 1663. Her father, Don Melchor de Aguilera, was a Spanish soldier of considerable fame. He had served as governor of Alexsandria and of Monferrato and had become the infantry's captain in Milan, then the admiral of Castile's chief aid. Next he became the governor of Cartagena de Indias, and finally governor of Toledo. It was there that he died. Her mother was Doña María de Roche, who was Irish by birth. Doña María's father had dispatched his children to Madrid to live in the care of Don Juan de Marqués de Santa Cruz while they were still young, fearing that if he were captured by English Protestants, they might "seize [his children] and raise them in their wicked sect." Don Marqués de Santa Cruz "contracted a marriage by proxy in Madrid" for Doña María and Don Melchor. They wed in Genoa. Her widowed mother now resided in Madrid.[15]

Doña Teresa met and married her husband Don Bernardo López de Mendizábal in Cartagena de Indias while her father was governor there. Don Bernardo was about forty-five years old, the son of Cristóbal López de Mendizábal and Leonor de Pastrana and born in the Mexican municipality of Chietla. The family moved to Puebla while Don Bernardo

was still a child. There his family became quite affluent, sporting a life of leisure on their estate, eating well and donning fine clothes, hosting elegant parties, served by a coterie of Indian servants, African slaves, and Mexican *peones*. But the sugar plantation and mill that first generated all this wealth fell into disrepair. By the time Don Bernardo was a young man the land was fallow and the mill's machinery still. So he went to the Royal and Pontifical University of Mexico to study the arts and canon law, initially contemplating the priesthood but turning to military service instead. His first assignment was on the Spanish treasury fleet, ferrying silver bullion and manufactured products between Cadiz and Havana, and from Havana to Veracruz and Cartagena. Bernardo settled for a while in Cartagena, where his cousin, Don Fray Cristóbal de la Zárraga, was bishop. There he met and married Doña Teresa de Aguilera y Roche.[16] Shortly after they returned to Mexico to take up a series of government posts that became more lucrative with every move. First he was the chief constable (*alcalde mayor*) of San Juan de los Llanos in Guanajuato, then the chief magistrate (*corregidor*) of Huayacocotla in Veracruz. In 1658 the viceroy of New Spain appointed him governor of the Kingdom of New Mexico. Powerful connections were absolutely necessary to land such posts, which Doña Teresa's distinguished military family had. Of course, such nominations were always helped along by gifts and bribes, and frequently even a handsomely disguised purchase price.[17]

Doña Teresa next was asked the race and lineage of her parents and relatives and whether any of them had ever been "arrested, reconciled, or subjected to public penance or punishment by the Holy Office of the Inquisition." She, her parents, her grandparents, and all of her relatives were Catholic Christians "free of any bad blood." None had ever had any dealings with the Holy Office. When interrogated about her sacramental life as a Catholic, she recounted the dates and places of her baptism, confirmation, and marriage. Yearly she confessed and communed as the Church commanded. She even had a copy of the bull of the Holy Crusade in her cell. On command she recited the Our Father, Ave Maria, Credo, and Salve Regina, the Ten Commandments, and the laws of the Church, which, noted Dr. Medina, she did "all very well." She could read and write and had been home schooled by teachers her parents had employed.[18]

So ended the routine preliminaries of every Inquisition case. Next, on three different occasions, the accused would be admonished to confess their sins without yet knowing what exactly they were accused of. If they willingly self-incriminated they were promised leniency. Doña Teresa accordingly was asked "whether she knows or surmises or suspects the reason for their being arrested in New Mexico and brought to the prison of this Holy Office." She declared that she was a Catholic Christian, was prepared to die in defense of her faith, but did not know why she had been arrested "unless this be due to enemies who have given false testimony." It is "not the custom of this Holy Office to arrest anyone without sufficient evidence of having done, said, or committed . . . something that might be or appear to be contrary to our holy Catholic faith, and the law of the Gospel," Dr. Medina thundered. Evidence existed. "Search your memory and declare and confess the whole truth . . . clear your conscience . . . and save your soul." "I am a devout Catholic Christian and very proud of it," Doña Teresa replied, claiming that she was being held prisoner by "false testimony." "You are in error," Dr. Medina retorted. Doña Teresa's testimony was read back to her. She signed the transcript, certifying to its accuracy, and was returned to her cell.

On May 9, and again on May 12, Doña Teresa was similarly admonished to search her memory and unburden her conscience. Again she insisted that she had nothing to confess. "I am a Catholic Christian and if I suffer it is due to persecution by my enemies." In the months that followed she complained that she did not have the proper clothing to attend her hearings. She wanted her black dress of camlet and her heaviest black cloak. She got the dress but not the cloak. She protested that her property was being kept in a damp room and would surely be ruined. It was moved. Again she requested her black cloak and her book of prayers to the Virgin Mary. She got the book but not the cloak. And she demanded a speedy trial because after so much time in jail she was "lacking strength and patience to bear her confinement." Still the trial moved along at glacial pace.[19] On September 27, 1663, she once more asked that her case progress, yet little happened.[20]

* * *

On October 26, 1663, some fourteen months after her arrest in Santa Fe and more than six months into her imprisonment in Mexico City,

Doña Teresa listened as the Inquisition's prosecutor, Dr. Rodrigo Ruíz de Cepeda Martínez y Portillo (hereafter Dr. Ruíz), read the forty-one charges against her. Dr. Ruíz vaunted that "she has apostasized from our holy Catholic faith and the law of the Gospel, wickedly and perfidiously contravening the declaration she made at her holy baptism and turning to the observance of the defunct and obsolete law of Moses, observing the rites and ceremonies of Judaism and believing that she would be saved thereby, and committing other offenses indicative of her imprudence and apostasy."[21] Doña Teresa and Don Bernardo had practiced the "special Judaic ceremony of washing on Friday evenings," cleaning their hair, having their servants cut their toenails, and placing freshly washed linens on their marital bed. After washing her hair, Doña Teresa would shut herself up in a room for three hours "pretending . . . to clean her private parts," not allowing anyone to enter her room "because of the stigma that falls on her because of that Judaic ceremony." Every Saturday Doña Teresa would "adorn and groom herself," celebrating that day as prescribed by "the defunct law of Moses."[22]

On Good Friday 1661, at about three o'clock in the afternoon, just as the procession that "commemorates the Passion of Christ Our Lord and the death He suffered at the hands of the perfidious Jews" approached Santa Fe's governor's palace, Doña Teresa gave Don Bernardo a smock and a clean bonnet. "Put this one on, Sir Lazybones," witnesses heard her say. As soon as the procession passed the hat and smock came off. With such actions Doña Teresa most certainly was mocking the procession. And if that were not enough, she owned a book "in a foreign and unintelligible language from which she would always read." All of these behaviors provided "a strong indication that they were observant Jews."[23]

In addition to these overt rituals, it was evident that Doña Teresa did not obey the laws of the Church, which required all Catholics to fast during Lent, to avoid eating meat on Fridays, to confess their sins yearly, and to receive Holy Communion during Easter. Of all of this she had been remiss. During Holy Week 1659, as Don Bernardo's inaugural convoy advanced toward New Mexico, she failed to confess or to receive the Eucharist, though she could have easily done so in Parral, where they stopped. As the caravan proceeded northward Doña Teresa rarely attended mass, and when she did, she would have her carriage parked close to where mass was being said. She would attend lying inside the

carriage with its curtains closed. Once she arrived in Santa Fe her apostasy persisted, irregularly attending mass, always feigning illness, rarely observing the Lenten fast. Instead she would drink chocolate twice a day accompanied by two big slices of toasted bread, even eating meat during Holy Week, never confessing her sins, and rarely receiving communion. These were surely signs of Doña Teresa's paganism and heretical contempt for the Church.[24]

During this journey, she had expressed "mockery and derision . . . for the monastic habit and estate." Several witnesses heard Don Bernardo constantly repeat Juan Gonzáles Lubón's foul-sounding words, insisting that he, Juan, preferred to "be buried in Lucifer's hide than in the habit of Saint Francis." This seemed like music to Doña Teresa's ears. It brought her "great amusement, applauding her husband with uproarious laughter." Doña Teresa had spoken ill of a priest, saying that he "had died with eleven or twelve children and his mistress at his bedside." Her contemptuousness of the sacraments and the clergy were apparent in her refusal to confess regularly, claiming that she did not do so because the friars were gossips.[25]

Once Doña Teresa established her stewardship over the governor's palace in Santa Fe in 1659, she "repudiated the efficacy and necessity of the holy sacraments," failing to ensure that her servants attended mass, received confession and communion, and obeyed the laws of the Church. When Doña Teresa's black slave named Clara fasted and went to church on Wednesdays because of her devotion to Our Lady of Carmel, she called her "a deceitful bitch," ordered her to remove the scapular she wore around her neck, and had her whipped. On this and many other occasions Doña Teresa had shown a lack of respect for holy objects, once describing a statute of Saint Anthony as "looking like a stump" and discarding "images of saints in a pantry among the rubbish." Daily good Christians were enjoined to praise the Blessed Sacrament when they awoke, ate, and retired. Rarely was "Praise Be to the Blessed Sacrament" or "Blessed Be His Holy Mother" ever heard in Doña Teresa's home, much less the requisite ejaculatory response, "Forever."

Undoubtedly motivated by superstition or witchcraft, Doña Teresa collected "her menstrual blood and kept it in a silver cup." Daily she would put onion peels on her feet, explaining to her servants that it was to relieve the pain of her corns. Dr. Ruíz demurred. "This reason

must be deemed insincere . . . [and undoubtedly] a superstitious one." In October 1660 or 1661 she had also obtained "some powders that would make her husband Don Bernardo love her." This must have been why Doña Teresa prohibited her servants from entering her dormitory when she and Don Bernardo were in bed. "Although this action is morally neutral and insufficient in itself to arouse suspicion," Ruíz conceded, it must have been "a stratagem to avoid being observed in the evil deeds that they might engage in when alone."[26]

The last eight counts against Doña Teresa stemmed from the events that surrounded her arrest and incarceration. Eager to learn the fate of her husband, she dispatched one of her servants to see if Don Bernardo also had been arrested by the Inquisition. One of the friars caught the girl and had her whipped for ferrying messages. "Father, stop. It is not the girl's fault," Doña Teresa begged. "I am to blame because I sent her." "Shut your mouth, madam," the friar rebuked. Her retort: "May God's justice strike them all, because such scoundrelly behavior is intolerable. God grant they get their whipping in Hell, because no woman in the world has been treated with greater cruelty than I." The Franciscan then sternly lectured Doña Teresa, reminding her that she was under arrest and had been allowed to travel to Mexico City in the relative comfort of her carriage only because "she was a woman and frail." If she persisted sending messages, he would transport her shackled in a caged cart too, just like her husband. Throughout the trip to Mexico City, Doña Teresa had repeatedly "impugned the equitable operation of this Holy Tribunal." Dr. Ruíz thus ended his reading of the charges urging Dr. Medina to "torture Doña Teresa . . . continually and repeatedly . . . until she fully declares and confesses the truth."[27]

* * *

Still unaware of the exact identities of her accusers, but suspecting who they were, between October 27 and November 26, 1663, Doña Teresa contested the charges. She began her rebuttal explaining that she was a sickly woman who had long suffered from arthritic hands, a condition that had been exacerbated by Santa Fe's cold climate. Sometime her hands hurt so much that she "could not move them and sought relief by washing my hair." The warm water loosened her joints and the activity chastened her pain. Sometimes she may have washed her hair on

Fridays. It happened on other days of the week as well, whenever the pain in her joints flared up. Sometime this occurred in her bedroom, other times in the parlor. Doña Catalina de Zamora, her close friend, was often present on such occasions dispensing hairdo advice. If the Inquisition wanted testimony on when and where Doña Teresa washed her hair, she should be interrogated.[28]

"About every month or month and a half," she would indeed lock herself in her bedroom to clean her private parts, as her accusers attested. This never occurred weekly. It never happened on a particular day of the week. It was done for purposes of cleanliness and not "in observance of . . . the law of Moses or any other." On Saturdays Doña Teresa would adorn herself in anticipation of mass on Sunday, "just as all women [in Santa Fe] usually do."[29]

The servants in Doña Teresa's household regularly washed clothes three times weekly and as part of their routine changed the tablecloths, bed linens, and Don Bernardo's clothes. She never noted the day of the week it was done because doing laundry was a task that rarely gained her attention. That was the responsibility of the servants.[30] Way too much had been made of the fact that neither she nor Don Bernardo had attended Good Friday services in Santa Fe in 1661. They were both ill and had remained in bed most of the day. But because they had invited the town's citizens to the governor's palace for hot chocolate after services, they got out of bed and put on clean clothes when the servants informed them that the procession was approaching. That they had changed into smocks was simply not true. Don Bernardo owned one smock, not two, which he donned only when he shaved, and most certainly never when he welcomed the town's citizens into their home.[31]

As for the suspicious book her accusers claimed marked her as an observant Jew, if the Inquisition sought the truth, they should examine her sequestered goods. It was written neither in Hebrew nor in Ladino, but "in the Tuscan language . . . entitled *Aristo*, which contains the story of *Orlando furioso*." She occasionally read it "not to forget my Tuscan." It was a book of chivalric romance full of "enchantments and wars and sometimes I had to laugh reading those things." Nothing therein was contrary to the faith, nor was it a title on the Inquisition's prohibited book list.[32]

She had always been punctilious in going to confession and communion, especially during Holy Week, as the Church commanded, Doña

Teresa explained, but her poor health and Santa Fe's extreme cold had increasingly limited her mobility and exacerbated her frailty. It was true that during Holy Week of 1659 she had not fulfilled this obligation because just as their convoy reached Parral, "I had a miscarriage, and was crying out day and night throughout Holy Week." Months later, on reaching the Manso Indian villages of southern New Mexico, "I did confess and receive communion from Fray García de San Francisco on Corpus Christi Day." This fact the friar would surely corroborate.[33]

While Doña Teresa and her husband were guests in the house of Parral's governor, Don Enrique de Avila, they were served meat at their first dinner together. The following morning Don Bernardo asked Fray Diego Rodríguez, who was traveling with their convoy, whether they should eat the meat. He advised, "In someone else's house you should eat what you are given." Doña Teresa's doctor also ordered her to eat meat because of her miscarriage and did so "because of sickness and not in order to disregard my obligations as a Christian."[34]

"To protect myself from the sun and wind, as a delicate woman distressed by everything, especially with such a long and slow voyage, always exposed to the inclemency of the weather and extremes of temperature" Doña Teresa did sometimes attend "mass lying in bed [in my carriage]; and out of modesty and concern for what is proper I closed the curtain of the carriage." Attending mass so occurred only in the months after she miscarried.[35]

It was widely known in Santa Fe that Doña Teresa did not attend mass regularly. This was not some occulted fact. Her arthritic limbs so pained her that some days she could not get out of bed much less walk more than a few steps.[36] Cold and snow exacerbated her condition so she only went to mass on "bright sunny days."[37] After Don Bernardo's governorship ended and Governor Peñalosa took charge, Peñalosa placed Doña Teresa's chair in the chapel of Christ "where the wives of former governors sat [next to] a light mulatto girl with whom the said governor was maintaining an illicit relationship." For this reason she also stopped going to church.[38]

Doña Teresa stated categorically that during Lent she, her husband, and all their household servants "fasted like Catholic Christians." On those days they drank "chocolate made only with water, not with *atole*, which the Church allows."[39] We would each eat "a small slice of toasted

bread, which was shared with Don Bernardo's little dogs and with the little servant boys of the house." The slices of bread looked enormous because the dough contained lard, which made the loaves rise more than usual, giving them the appearance of being more substantive than they really were.[40]

"That I have expressed mockery and derision for the monastic habit and estate" was not true. Everyone in Santa Fe knew that Juan González Lobón was "half crazy." He often said some of the silliest things, like that "he would sooner be buried in Lucifer's hide than in the habit of St. Francis." This was just his "nonsense," which provoked laughter among everyone.[41] Doña Teresa had no memory of saying that a particular priest died with his mistress and twelve children by his side. Doña Teresa had always held priests "in the greatest veneration," could not imagine speaking ill of them, and would "gladly kiss the ground trod by the meanest priest" no matter what his faults.[42]

Doña Teresa had never prohibited her servants from fasting, abstaining from eating meat during Lent, going to mass, or receiving the requisite sacraments at Easter time. She constantly reminded them of these obligations. Indeed, "the two servants I brought from Cartagena, the mestizas named Juana and María" would testify to this. The reality was that she had many servants in the governor's palace and the edifice itself was so large and rambling that it was unimaginable that she would know exactly who had and had not fulfilled their Lenten obligations.[43]

Doña Teresa took offense to the accusation that she had whipped her black slave Clara and called her a "deceitful bitch." The charge was factually wrong on several counts. Clara was the name of her faithful slave, the girl now serving her in jail. She had long been considered a trusted member of the family. Ana was her particularly troublesome black slave, whom she had purchased earlier in Mexico City. Black slaves typically hated their masters in Mexico, and this was particularly true of Ana. Ana despised Doña Teresa and was constantly wrecking havoc in her household. "I punished her frequently for her insolence and idle chatter, carelessness and negligence and also gluttony." In 1659 Ana claimed that she had been "undone in New Mexico [i.e., lost her virginity] and became pregnant." It was all a lie. She was "wrapping herself in rags to create a belly, and she would pretend to faint, affecting to fall and sometimes holding onto the walls." Doña Teresa asked Josefa, her chief maid,

what was wrong with Ana. She was pregnant and fasting, thus the faint-
ing spells, Josefa explained. When Doña Teresa discovered this was all
a ruse, she had Ana whipped numerous times. Still she was quite incor-
rigible. The pack of lies Doña Teresa's accusers fabricated concerning
Ana's scapular and devotion to Our Lady of Carmel bore little relation-
ship to the truth. Ana lost her scapular the night she started a fire in
her room out of pure malice. She was whipped for starting the fire and
destroying property, not for fasting or taking the sacraments.[44]

"I have religious images in my house, on my altar and at the head of
my bed," Doña Teresa declared. They were all treated with the utmost
reverence and respect. If some had been discarded in the pantry of the
governor's palace, as the prosecutor alleged, "I never even noticed that
there was a pantry" in the house.[45] The charge that Doña Teresa and her
husband never routinely praised the Blessed Sacrament and the Virgin
Mary or prayed before meals was also patently false. Before meals "both
of us said grace, although very quietly." Whenever Josefa would come
into their bedroom early in the morning to rouse them, she would say,
"Praise be the Lord." Don Bernardo always replied, "Forever," though
admittedly in a low sleepy voice.[46]

Placing onion peels on her feet, Doña Teresa explained, had nothing
to do with superstition or belief in the black arts and everything to do
with her painful feet. "Your honor, I say that I laid on a bit of onion peel
only when my corns bothered me . . . there was no other appropriate
remedy available there."[47]

The charge that she would not allow the maids to sleep in her bedroom
Doña Teresa found particularly bizarre. "Why should the other maids
sleep in my bedroom?" The only time she allowed anyone other than her
trusted slave Clara in her bed chamber at night was when the governor
was out of town. The unmarried female servants slept in Doña Teresa's
dressing room, an area accessed only through her bedroom. There they
were also isolated from the male servants for their own protection as most
of them were maidens. But they were never locked in. Had they been, it
would it have been impossible for her two Apache slaves—"Isabelilla, ten
years old, and Francisca, nine"—to have run away, as they did. They were
caught two days later in the Indian pueblo of Cochiti.[48]

Adamantly asserting her innocence throughout her first round of
rebuttals, which ended on November 5, 1663, Doña Teresa solicitously

stated that she was certain the Holy Office "will render justice to me."[49] For the next phase of the trial she was assigned a defense lawyer. She quickly objected to Licenciado Don José de Cabrera because he was close to a number of her husband's enemies and thus was unlikely to be fair or to mount a vigorous defense. She requested Licenciado Don Alonso de Alavés. He was approved.[50]

* * *

On January 9, 1664, Doña Teresa undertook an unusual tactic. She requested an audience with her inquisitor, Dr. Medina. It was granted. There she presented him with a document "of seven folds" written in her own hand and read into the court transcript, with the original still appended therein. Whether submitting this declaration was her defense lawyer's idea or someone else's, we do not know. Her audience began with a harangue against all the persons she suspected as her accusers, why each wanted her publicly humiliated, and thus why they had reasons to lie or distort the facts. The declaration was hard-hitting and raw. Clearly she was frustrated by what she deemed extremely frivolous charges, which all could easily be explained, and by a court that had no interest in seeing justice served, much less in a timely manner. Her husband was also languishing in the Inquisition's prison. Now he was at the point of death without his innocence yet proclaimed or his property restored.

The jeremiad Doña Teresa read to the Inquisition began with a list of her enemies: "Don Juan Manso is our enemy . . . Catalina Bernal is an enemy . . . Francisco de Javier is our enemy." She continued until she had named some thirty. Each had grudges of varying intensity against her and her husband, which explained why they would falsely accuse her of heresy, Judaism, and sorcery. Indeed, Doña Teresa was amazingly accurate in identifying her accusers.

First on the enemy list was Don Juan Manso de Contreras, the man who preceded Don Bernardo as New Mexico's governor and was now commissary of the Inquisition. He was the person responsible for the accusation of Judaism. When Manso returned to Santa Fe in 1661, having traveled north in Governor Peñalosa's convoy, he immediately began gathering declarations from several Franciscans attesting to Doña Teresa's infrequent and seemingly grudging fulfillment of her religious

obligations, which he presented as proof perfect that she was a secret Jew. Manso then turned to Doña Teresa's household servants, promising blandishments so that they would provide him with additional evidence to expand and deepen the charges. None of the affidavits Manso submitted to the Holy Office were certified. They had not been conducted before a judicial panel, nor had the witnesses been cross-examined to verify the identity, veracity, and vested interests of the declarants. Instead, the declarations read as coached and rehearsed. All the household employees recounted Doña Teresa's questionable words and deeds in stunningly identical fashion. They were nevertheless sufficient for the Inquisition arrest warrant that would allow Manso to embargo Doña Teresa's property. If mysteriously most of that property disappeared, as was all too common, who would publicly protest a heretic's plight? This was precisely Manso's goal. We will return to the complex economic motives behind all of this, but for the moment suffice it to say that by the time arrest warrants for Doña Teresa and her husband reached Manso in Santa Fe on August 18, 1662, Governor Peñalosa had already clandestinely absconded with much of ex-Governor López's property. Manso knew none of this. He had expected to seize both Don Bernardo and Doña Teresa's assets. With Don Bernardo's already in Peñalosa's pocket, only one target remained within Manos's reach: Doña Teresa's belongings. We will return to the origins of the enmity between Juan Manso and Bernardo López. It was deep and personal, involving romantic affairs and humiliated kin. Manso wanted revenge. With Doña Teresa and Don Bernardo both in the Inquisition's jail, he now had it.[51]

The charges against Doña Teresa were so intricately tied to those against her husband that they were quite impossible to disentangle. She was, after all, Don Bernardo's wife, his companion, and the governess of his household. In her mind their troubles in New Mexico began when Don Bernardo took into his confidence and into his wealthy household a number of grifters, whose loyalties were fickle and who ultimately became sworn enemies of the governor and his wife. Francisco de Javier was such a man. He met Don Bernardo shortly after his governorship was announced. Though at the time Francisco worked for Governor Manso, he "immediately . . . sent people to plead with us to receive him into our household." Governor López hired him to manage the convoy to New Mexico, but soon discovered what a scoundrel he was, swin-

dling the governor's family of so many things that they were "ready to kill him."[52]

Then there was Juan Griego. He was first hired as Don Bernardo's interpreter near Mexico City in 1658. But their relationship soon soured too when Griego came up short on the sale of Governor López's goods. He was fired and dispatched on expeditions against the wild Indians, "which he [Griego] resented very much." Catalina Bernal, Juan Griego's sister, only added tinder to these flames of resentment. She and her daughters were notorious "for their loose living" and for having "sold one of her daughters to Don Juan Manso." For all of this Governor López banished Catalina Bernal from the province.[53]

Anytime one had rancorous dealings with the Griego or Bernal families in Santa Fe, one immediately had conflicts with their entire extended clans, explained Doña Teresa. The ill will between her and Catalina Bernal so originated. Catalina first gained Doña Teresa's trust and eventually employment by telling her that she knew how "to prepare some remedies" for her arthritic limbs. But before long Catalina was stealing her blind. She would often come to the governor's palace "with some empty space under the petticoat or hoopskirt . . . with a sack for when chocolate was being ground, and she would pretend to be adjusting her dress and would slip in the tablets." Catalina had shared intimacies with Don Bernardo and also "pimped one of her daughters to my husband." Doña Teresa caught Catalina one night "when she came in disguise through the garden gate to look for him, and found me." Doña Teresa asked what she wanted. Catalina acted as if she had come begging for "sweets and bread," which were given, and was immediately ordered to depart. From that moment on Catalina Bernal was contemptuous of Doña Teresa, compounded by the fact that Governor López had publicly punished several in her clan. He had arrested her son-in-law, Juan Polanco, for philandering; had fired her nephew, Francisco Gabriel, for stealing; had demanded an accounting of the products on consignment from her nephew, Francisco Gabriel; had fired her brother, Juan, as interpreter; had sent a number of her relatives on dangerous expeditions; and finally had banished Catalina from Santa Fe. These were the reasons why Catalina had falsely and maliciously accused Doña Teresa of heresy and sorcery.[54]

Governor López and Doña Teresa also met Miguel de Noriega on their way to Santa Fe. Don Bernardo hired him and rapidly promoted

him to ensign and then provincial secretary. But Noriega's allegiance to Don Bernardo quickly shifted the moment Governor Peñalosa arrived in Santa Fe. He began "telling great lies about me to further his career," explained Doña Teresa. Almost simultaneously Noriega befriended ex-Governor Manso and soon accused Doña Teresa and her husband of being secret Jews.[55]

Three other strays who joined Governor López's convoy proved particularly toxic: Pedro de Arteaga, his wife Josefa de Sandoval, and Diego Melgarejo. When they arrived in Santa Fe they were homeless and unemployed. Don Bernardo generously gave them hospice in the governor's palace, which they repaid by constantly stealing. First they took food, which they sent "to the households they were supporting on the outside." "No granary or pantry was safe from them," recalled Doña Teresa. Next they "threw sheep, tied with ropes, over the wall at night, not satisfied with the four that they killed every week and the seven cows, all of which they consumed." Finally, on the day a man brought the governor a large number of blankets, Don Bernardo noted that Diego Melgarejo and Pedro de Arteaga were acting strangely. He was right. The two "had thrown the blankets from the storeroom into the external corral," clearly intending to steal them. He had them arrested and flogged, thus becoming sworn enemies of Doña Teresa and her husband.[56]

The vilest bile Doña Teresa spewed was against Josefa de Sandoval, Arteaga's wife. She was the palace's head maid and the person who most extensively described what went on in Doña Teresa's household for the Inquisition. She was "a leader in all the wickedness committed in my house by my servants and of the hostility they all felt toward us." Josefa, like her husband, haphazardly joined Governor López's convoy. But from the start she was difficult and unruly. "I was constantly having to correct her," declared Doña Teresa, because as their convoy inched northward Josefa was amorously cavorting with all of the single men. "We most severely rebuked her for it and also her husband because he permitted it."[57]

In the governor's palace Doña Teresa placed the management of the servants under Josefa's authority, but she justifiably never really trusted her. Little things constantly disappeared. Doña Teresa began locking her chest of drawers because Josefa would rummage through them taking this and that. She was a bad influence on the other servants. Josefa and

Ana, Doña Teresa's troublesome black slave, had an unusual bond, often kissing quite scandalously in public. At night Josefa would gather the female servants and sneak out of the house to sing, dance, and cavort. The result of these escapades was that "seven servants escaped." But what most ired Doña Teresa was that Josefa was pimping for Don Bernardo, sneaking women into the palace for his pleasure at all hours of the day and night. Because of this "I had one of the constant fights I had with my husband." A confidant of Doña Teresa advised her to bear her husband's infidelities quietly. "Be patient, lest something should happen to me that would bring on a convulsion and deprive me of my sanity or my life because of the threats that I would sometimes hear [that Josefa and her husband, Pedro de Arteaga] were making against me."[58] "After endless annoyances, I succeeded, almost by violence to have them expelled from our house . . . and even after their expulsion they always did whatever they could against me," explained Doña Teresa. Months later her slave Ana told Doña Teresa that Josefa and her husband Pedro were living like animals in the wilderness, poorly clothed, with no food, and quite remorseful about how they had behaved. Ana begged her mistress to meet with Josefa "because she was dying of hunger and would die without fail if she could not come to avail herself of my charity." Doña Teresa agreed. Josefa looked wretched and emaciated. She begged Doña Teresa's forgiveness. It was granted. In the weeks that followed she ate regularly at the governor's palace. But, again, her gratitude was very short-lived. As soon as Governor Peñalosa arrived in Santa Fe both Josefa and her husband Pedro befriended him and complained about all the "martyrdom and torment" they had suffered at Doña Teresa's hands. Josefa's malice did not end there. She then declared before the Inquisition that Doña Teresa frequently turned to sorcery in hopes of putting an end to Don Bernardo's constant sexual affairs. Josefa gave her "some powders to make her husband Don Bernardo love her again." She was to sprinkle the powder by Don Bernardo's feet and await his ardent love anew.[59] Whether she did or whether they had any effect, Doña Teresa never said.[60]

As the governor's wife and at his behest, Doña Teresa offered hospice to Petrona de Gamboa, whose parents, Juan de Gamboa and María Pacheco, had been arrested for "beating a girl to death." Because she "was a virgin" Doña Teresa acted as Petrona's guardian while the authorities

investigated the murder. She was assigned a bed in the room where the other maids slept. One morning Doña Teresa discovered that Petrona would "pry loose a board from one of the windows and go out . . . to sleep with whomever she wished."[61] Had Petrona's sexual liaisons remained outside of the governor's palace there might have been little reason for Doña Teresa to concern herself, except perhaps to ensure the good morals of her charge. Quite by chance Doña Teresa discovered that "while [Petrona] was in our house . . . she had had relations" with Don Bernardo. Their trysts in the governor's palace were frequent. Often she would arrive at the palace with preposterous pretexts, asking to see the governor. "When I asked my husband whether this was right, and other things that as his own wife I had to say, he was blinded by the deceit and felt it as they all do, and for this reason I came to have more quarrels with him than I can say." Doña Teresa warned Petrona that she "would skin her alive with whippings" if she continued to fornicate with Don Bernardo. The affair continued provoking "every day countless very tiresome and dangerous conflicts with my husband." Petrona too proved fickle in the end. The moment Governor Peñalosa arrived in Santa Fe, she entered his entourage presumably with equally evil intent.[62]

Doña Teresa offered no moral judgment of her husband's philandering with the household's staff but did explain why each of these women had reason to denounce her to the Inquisition. Juana, an Indian woman from Jémez Pueblo, one of their cooks, was fired when Doña Teresa learned that "she was having relations with my husband."[63] Ana, an Indian woman married to Juan Joaquín, also one of their cooks, had a long-standing affair with the governor, facilitated by Josefa, who regularly sneaked her into the palace. And so "I threw her out."[64]

So ended Doña Teresa's rant, correctly identifying her accusers, tartly noting which ones had filed claims against her property, depicting them as motivated by greed, envy, and festering resentment over their public humiliation. Doña Teresa's cutting declaration is clearly moving and must have moved Dr. Medina, her inquisitor. She so discredited her accusers that soon after she read her declaration into the record, the charges against her were dismissed.

The case Juan Manso built against Doña Teresa on charges of heresy, Judaism, and sorcery, while fulsome enough for indictment, did not warrant conviction. The evidence was circumstantial and flimsy, rarely

corroborated, all too often pure hearsay, or transparently motivated by personal and material vendettas. The accusatory declarations Manso gathered lacked formal certification, appeared coaxed and rehearsed, with various declarants repeating with exactly the same words what they said they had witnessed Doña Teresa say or do. The testimony clearly came from her disgruntled household servants, individuals she had punished for stealing, failing to perform their duties, leading disordered lives, and engaging in adulterous acts, particularly with Don Bernardo.

The descriptions of Doña Teresa's personal habits offered by her servants were those of a worldly, aristocratic woman living in Santa Fe in the mid-seventeenth century. Little suggested that she followed the law of Moses. These servants and strays, which included Apache slaves awaiting sale and Pueblo Indian women sentenced to work in the governor's household for their crimes, were poor and illiterate natives of New Spain's north, with limited social horizons and totally unfamiliar with the daily comportment of a cosmopolitan woman of Doña Teresa's rank. The Franciscan depositions were more credible but also more limited to Doña Teresa's failure to attend mass, to receive the sacraments, and to send her servants to church regularly. These were certainly infractions of the laws of the Church, but hardly unimpeachable evidence of her secret practice of Judaism. Doña Teresa defended herself by demonstrating for the court the ravages arthritis and gout had wrecked on her body. Her limited mobility was not feigned but well explained why she only ventured to mass when it was warm and sunny.

* * *

How does one explain the complex web into which Doña Teresa de Aguilera y Roche was snared? The politics of two issues illuminate the case. The first is found in the fractious wrangling that was typical at the end of every governor's administration when a review of his term, known as a residencia, took place. Second, the Kingdom of New Mexico was established in 1598 primarily at the behest of the Franciscan Order. Through much of the seventeenth century the order ruled the kingdom as a theocracy, brooked little secular interference in their Christianization of the Indians, and did everything in their power to rid themselves of civilian critics and challengers. They had one governor assassinated and mired several more in litigation in Mexico City, effectively removing from New

Mexico any irritant to their command. Let us turn to these two issues in more depth.

The Inquisition cases against Doña Teresa de Aguilera y Roche and Governor Bernardo López de Mendizábal originated in the politics and economics of residencias, those administrative reviews every major official in the Spanish Empire had to undergo at the end of their term. In mid-August of 1661, when Don Diego Dionisio de Peñalosa Briceño y Berdugo arrived in Santa Fe as the kingdom's new governor, his first official duty was to conduct the residencia of Governor López, his predecessor. These reviews were formal civil court proceedings. Anyone, rich or poor, slave or free, Spaniard or Indian, could denounce injustices they had suffered at the hands of the outgoing governor and seek amends. When Governor López arrived in Santa Fe in 1659 to begin his term, he conducted Governor Juan Manso de Contreras's review. And here was the origin of their feud. During his administration Manso had arbitrarily seized Francisco de Anaya's encomienda, that Indian tributary grant given the first conquerors of the kingdom; he had expropriated the homes of Anaya and his son-in-law, Alonso Rodríquez, and had caused them a host of other vexations including exile. Anaya and Rodríquez made their way to Mexico City, complained bitterly to the viceroy about Manso's behavior. The viceroy in turn asked López to resolve the issue. Thus, on beginning Manso's residencia, Governor López embargoed his property, seized many of Manso's goods for himself, and found Anaya and Rodríquez's claims justified, returning the encomienda and their homes. Manso was sent packing south to Mexico City, significantly poorer, particularly embittered, vowing revenge, and seeking a way to get it.

Governorships, won by connections, sealed by bribes and outright purchase, were opportunities for self-enrichment. Availing oneself of a predecessor's wealth was the quickest way to do it. While New Mexico's economic resources were meager in comparison to those of the densely populated, silver-producing areas of north-central Mexico, it nevertheless was surrounded by nomadic Apache Indians whose capture and sale into slavery brought a handsome price. The kingdom's sedentary Pueblo Indians, who numbered about twenty-five thousand in 1660, were all apportioned in encomiendas. To fulfill the tribute obligations they owed their *encomendero*, they wove blankets and gloves, gathered sacks of pine nuts and salt, and molded and baked those ceramic plates, bowls,

and jars for which they are still known, while tilling the land and working hides. By drawing on all of these resources, while simultaneously depriving the resident citizen-soldiers and clergy in the kingdom of these, a governor could profit handsomely. The secret to success for a newly arriving governor was to move slowly and carefully, gathering powerful allies, while exploiting the most vulnerable and honoring some semblance of a moral economy in this highly exploitative colonial regime.

Juan Manso did this well when he was the kingdom's governor between 1656 and 1569. Of course, he was aided by his older brother, Fray Tomás de Contreras, who was the custodian of the New Mexico's Franciscan missions and the commissary of the Holy Office of the Inquisition. Governor Manso thus had no major conflicts with the clergy, appears to have kept clashes with citizens to a minimum, and together with the Franciscans exploited the Indians without notorious complaints or rebellion.

When Governor Peñalosa arrived in Santa Fe in 1661, the tables were turned on Governor López. He quickly felt the sting. Returning to New Mexico with Peñalosa's entourage was ex-governor Juan Manso, now as a commissary of the Holy Office. He was quite eager to settle scores with Governor López for reasons that now went well beyond their pure property disputes. During his term Governor López had a dalliance with Ana Rodríguez, the wife of Pedro de Valdés, who was Manso's nephew. López not only cuckolded Valdés but then also had him jailed for his public debauchery "with the daughter of Juan Griego" and for other similar "scandals" with women in Santa Fe.[65]

Manso knew all this when he returned to Santa Fe in 1661 and rapidly went to work with Fray Alonso de Posada, the head of New Mexico's Franciscan missions, gathering complaints against Don Bernardo and Doña Teresa, soliciting the kinds of testimony that would produce Inquisition arrest warrants mandating the sequestration of their property. In the 1640s New Spain had just witnessed a flurry of Inquisition investigations and executions of secret Jews. Manso certainly understood what kind of a response this particular accusation would provoke in the tribunal of the Holy Office. His strategy unfolded as planned. With the arrest of Don Bernardo and Doña Teresa, their property was embargoed. Manso registered financial claims against them, hoping to recoup what he had lost during his own residencia.

In early December 1661, way before the Inquisition arrest warrants arrived on August 18, 1662, Governor Peñalosa began Governor López's residencia as prescribed by law, arresting Governor López and keeping him under house arrest until the review was done. Peñalosa later claimed that he had sequestered López's property, rummaging through his personal effects, even absconding with a pair of his worn slippers, to fund the cost of the review and to satisfy any justified claims against López that might emerge. Peñalosa's machinations during López's residencia are worthy of a novel. Here, suffice it to say that he dragged out the proceedings until he learned that Juan Manso had finally obtained Inquisition arrest warrants against López and his wife. Because the Inquisition would require that their property be embargoed and some of it sold to cover the costs of transport, jailing, and trial, Governor Peñalosa anticipated this and moved swiftly and clandestinely to ship López's property to Parral for sale, pocketing the proceeds. When Manso found himself outmaneuvered he spent several more years bureaucratically bickering with Peñalosa over López's property. For the moment all that was left for Manso was Doña Teresa's considerable estate. He intended to seize as much of it as he could. Mysteriously, (Surprise! Surprise!) when the Inquisition dismissed the charges against Doña Teresa in 1664, much of her property had disappeared. She too spent years trying to recover what she and her husband had lost as victims of the Inquisition.

* * *

The Kingdom of New Mexico was founded in 1598. From its bloody and violent start its future was far from certain. It lacked the natural resources to make it an appealing place to invest. The kingdom's sedentary Pueblo Indians and the surrounding nomadic Apaches, were not particularly hospitable hosts. Few settlers wanted to venture there, preferring more lucrative and densely settled locales. The kingdom tittered. It stood on the edge of abandonment several times, rocked by discord among the Spanish settlers and riddled by intense conflicts with the indigenes. Intensive lobbying by the Franciscans, claiming that thousands of Indian souls in New Mexico were yapping for the waters of baptism and yearning to hear the Gospel, stirred the king's conscience enough to fund a permanent colony there in 1608. The appointment of

a governor and fifty soldiers followed in 1609. And in 1610 Santa Fe was founded as the kingdom's capital.

The kingdom's raison d'être thus became Indian Christianization under Franciscan control. The history that followed from the 1620s to the 1680 Pueblo Revolt was one of intense squabbles between the friars and the governors, between ecclesiastical and secular authority, over the competing motives that propelled Spain's colonial project. Would New Mexico be devoted to expansive mercantilism or the religious assimilation of new subjects?

The union of these competing goals originated in papal concessions of 1501 and 1508, collectively known as the *patronato real*, granting Spain's monarchs governance over the Church in return for protecting Catholicism's primacy throughout the realm. In the central places of Spain's American empire, these twin imperative were articulated through distinct civil and ecclesiastical institutions, with clear jurisdictional lines. But in remote places like New Mexico, the Amazon, Chile, Paraguay, and southern Brazil, where personnel were limited and administrative institutions functioned only in elemental form, the missionary orders had extensive power to regulate morals and manners, without much restraint. The church/state conflicts that naturally followed, and which embroiled most of New Mexico's seventeenth-century governors, stemmed from the fact that the Franciscans controlled three ecclesiastical courts—the Holy Office of the Inquisition, the Office of the Holy Crusade, the Episcopal See (as prelates)—and wielded them to ensure their will would be done.[66]

Governor López stepped into the middle of this murky jurisdictional space when he arrived in New Mexico in 1659. He was a fierce soldier and a seasoned administrator and was well tutored in canon law. He was well known for his foul mouth and ruthlessness, be it with the men he subordinated to his will or the women who serviced his needs. In none of this was he unique. He was typical of the accomplished warriors known as hard-hitting, vulgar, and playing by few rules. The charges the Franciscans and ex-Governor Manso leveled against him in 1662 were again not unlike those that bedeviled many other provincial governors. Most of his peers were equally hell-bent on quickly seizing the spoils of office. Governor López arrived amid a severe famine, staging raids

into Apache territory to seize slaves, thus provoking endless retaliation, putting the Pueblo Indians to work almost exclusively in his workshop, weaving blankets, constructing carts, making shoes, and collecting salt and pine nuts, all for sale in Parral, thus depriving the friars and the settlers of their customary indigenous tribute. If *encomenderos* were to receive their quarterly tribute payments in food, labor, and goods, if luxurious Church furnishings and even the candles and wine necessary for daily mass were to be purchased, it all depended on this very same Indian labor López had singularly seized.

Governor López's sins, or so said his clerical accusers, were that he had radically reorganized the distribution of indigenous labor and granted the Indians much more freedom to practice their ancient religious rituals, thus undermining Franciscan goals and governance. López boasted with considerable bravado that as governor he was the king's legate in New Mexico. The friars were required to recognize him as their supreme authority, a claim the Franciscans rejected, using every tool they had to subvert him.[67] The governor had trampled on ecclesiastical privileges and immunities (*fueros*) by criticizing the Franciscans for failing to honor their vows of chastity, poverty, and obedience. Many friars in New Mexico were openly living with Indian women, many as more than figurative fathers. The missions by 1660 encompassed building compounds and large tracts of land, with well-stocked granaries and sizeable herds. Was such wealth really necessary to preach to the word of the poor man from Galilee or of *il poverello*, their founder Saint Francis of Assisi? By offering such stern and mocking rebukes, depriving the friars of Indian labor, his aim was the Franciscan vow of obedience. López contended that he was the "universal head" of the province by rights of the *patronato*, and as such he was both the kingdom's temporal and spiritual lord whom the Franciscan had to obey. The Franciscans orchestrated López and his wife's inquisitorial indictments precisely to show him and any successors of the pure folly of such secular interpretations of clerical authority in New Mexico. Several more governors certainly arrived after 1661, but the actions the Franciscans had taken against their predecessors terrorized them into much more timorous behavior. The 1680 Pueblo Revolt would soon chasten the friars too. Amid the ashes of their once glorious churches they beheld the corpses of their bludgeoned, beheaded, disemboweled, and sodomized brothers of Saint Francis.[68]

* * *

Two questions still remain. Was Doña Teresa a secret Jew? What does her case tell us about the lives of women in colonial New Mexico? On the first question, I think it safe to say that Doña Teresa was not a Jew. When the Inquisition reviewed her genealogy no ties were found to Jews or to Jewish converts in either the maternal or paternal lines six generations back. Doña Teresa moved from Cartagena (Colombia) to Puebla, Mexico, when she married Don Bernardo. That migration did not coincide with any known exodus or movement of Jews in Spanish America. Doña Teresa's Irish Catholic grandfather sent his children to Spain to escape Protestantism. When Doña Teresa was arrested in Santa Fe in 1662, she was carrying in her pocket a rosary, a small cross, and a religious medal normally worn around the neck. She had two prayer books she was frequently seen to use. Later she impressed her inquisitor with her Latin erudition and flawless recitation of the prayers, rituals, and law of God and of the Church. The declarations Doña Teresa's servants offered of her domestic behavior mentioned nail clipping, changing bed linens, and hair washing on Friday nights, but little else of any substance that would definitively mark her as a Jew. While there were certainly Jewish ritual meanings around these, the much more significant Jewish practices and rites around births, diet, bathing, menses, genital hygiene, prayer, oaths, and burial never surfaced, despite the prying eyes of Doña Teresa's servants.[69] Had the declarations of her household servants and retainers varied, had they appeared less rout, had they withstood cross-examination, the Inquisition might have found this testimony more credible.

The northern frontier of New Spain certainly was a place many Jews found safe haven. I suspect this is why the Inquisition initially found the charges against Doña Teresa credible. Here Jews maintained their beliefs and ritual practices quite openly and with minimal surveillance or apparent concern.[70] In the mining and marketing centers of northern New Spain, in places like Zacatecas, Parral, and Chihuahua, the bustling commercial culture that flourished here produced extensive social mixing and a colonial culture tolerant of difference. For after all, these were all places largely populated by religious neophytes, by African slaves, Indian captives, and illegitimate half-breeds, mixed in with New Chris-

tians of Jewish and Moorish ancestry, who were all quite new and flaccid in their faith. This is why today we can find a positive statistical association between Inquisition actions and economic cycles, explains historian Solange Alberro. Economic upturns bred rapid social mixing, much of it heterodox, much of it promiscuous, much of it too libertine and potentially corrosive of the orthodoxies the Inquisition was charged to uphold through a well-ordered society.[71] This is probably why the accusations against Doña Teresa grained enough traction for an indictment but not for a conviction.

Still, some scintilla of doubt must remain about the principal charge against Doña Teresa. In prison she was regularly visited by Juan de Cárdenas, an assistant jailer, who had been a close friend of her father's in Cartagena de Indias. The Inquisition later took action against Cárdenas for ferrying messages between Doña Teresa and her husband and for offering them advice. Who knows whether without Cárdenas's counsel Doña Teresa's trial might have ended differently.[72]

The life of Doña Teresa de Aguilera y Roche, as revealed through her Inquisition case, was not the typical lot of the majority of Hispanic women who lived and labored in the Americas during the seventeenth century. Doña Teresa was of aristocratic ancestry, of refined manners and extensive education. She had traveled throughout the Spanish Empire and thus had a capacious worldview, even reading novels of chivalric romance. As the daughter and then wife of men who had made their marks as warriors, she enjoyed all the blandishments of their rank. She naturally expected transport to jail in the luxury of her carriage, served by her slave while there, worthy of being allowed to dress in her fancy black cloak whenever she appeared before her inquisitor, and, of course, never deprived of her hot chocolate. Women of the popular classes received no such privileges when they stood indicted by the Inquisition. They had no family friends whispering advice or bringing them extra rations. Mostly the terror of isolation and torture filled their jail lives.

This case also offers us a detailed window into the nature of religious life in the Kingdom of New Mexico. Here the Franciscans often fantasized that their converts would joyfully sing and pray, march in processions to the Blessed Sacrament, shouting hosannas galore and leading model Christian lives with the sole purpose of saving their souls and enjoying eternal bliss. As we saw, the friars expected the Spanish soldier-

settlers to act as model Christians for their subordinates and Native subjects, to ensure that they obeyed the laws of God and of the Church, fasting and feasting, confessing and communing, honoring the clerical estate, and never questioning its imperatives or mandates.

That was the ideal. The reality was more complex. Right from the kingdom's 1598 conquest the colonists marveled at the sexual licentiousness of Pueblo Indian culture and reported with quizzical delight their mistaken perception that Native women had no "vices other than lust" and that their husbands did not care if they had relations with other men.[73] This fantasy, when conjoined with the paucity of single Spanish women and the abundance of young, unmarried Spanish men, created a culture of sexual violence that produced extensive biological mixing, most of it by force, some undoubtedly enveloped in desire, which was mostly rationalized as seduction and love. There is ample evidence to establish that what the colonists found in New Mexico among the Pueblo Indians was a sex-positive culture that only intensified the sexual license commonly taken by victors in theaters of war.

Such was the case in Governor López's household where he was regularly having sex with his servants, the wives of Santa Fe's nobility, and apparently any woman who caught the corner of his eye or sought his favor. We read about the despair and anger it caused Doña Teresa, her frequent arguments with the husband, but as a sickly and largely isolated wife, with few allies to whom she could turn, she suffered her humiliations silently, fearful even of turning to the Church. If Doña Teresa's declarations about the sexual lives of her servants, slaves, and strays are accurate, the entire social structure created by the conquest was one of considerable personal license around sexual matters.

Though the Church condemned such behavior and railed against promiscuity, it was more hesitant to sanction marriages between Spaniards and Indians, which they saw as repugnantly unequal. More troublesome was the fact that many friars were themselves participants in this sexual culture of the conquest. Several Franciscans were living with Indian women and were rearing the children begotten of these intimacies in their convents. The Inquisition case against Governor López documents the many times he had to intervene to mediate explosive conflicts between indigenous communities and their sex-crazed friars. Instead of discreetly and quietly settling such confrontations, López

openly announced these clerical lapses. The Franciscans bitterly complained to their superiors that Governor López's sole purpose for doing this was to undermine their ecclesiastical authority in the kingdom. He mocked the friars' hypocrisy and questioned their vow of chastity and order of celibacy. Stains of honor are only cleansed by blood, the ancient Spanish motto holds. The Franciscans were determined to avenge these stains. While they did not exactly get the blood they sought, they got Governor López charged and jailed by the Inquisition. He died in its prison and never earned exoneration.

Doña Teresa's case tells us two things about women in colonial Spanish America. First, most Hispanicized women, whatever their rank, were under the authority and governance of men. The soldiers who gained their nobility by venturing into the frontier to conquer and subjugate indigenes constantly announced the grandness of their honor and the luster of their prestige. Honor in colonial New Mexico had two interlocking definitions, the first premised on protection and defense, the second on attack and subordination. The honor virtue of the area's Spaniards required fathers, husbands, and brothers to protect the virginity and sexual fidelity of their womenfolk. But men gained their honor as social status by seducing and assaulting other men's women as a sign of one's virility and strength, one's capacity to humiliate and force others into submission, without the capacity or strength to foil such attacks.[74]

It was in this honor culture of war and of humiliation that Doña Teresa became trapped as a pawn in the struggles between two powerful men. Governor López not only had stolen Governor Manso's property but also had bedded the wife of Pedro de Valdés, Manso's nephew, and then proceeded to further humiliate the family by having Valdés publicly excoriated for fornicating with several of Santa Fe's women, something Governor López frequently did himself with considerable bravado.[75] What could Juan Manso do to avenge these humiliations? He had Doña Teresa arrested on false charges. He pilfered through her possessions. What could Governor López do to protect his devoted wife, shackled and jailed as he was? The person who most paid the price was Doña Teresa in an age when women were largely seen as appendages of men, to be used and controlled by them as they wished with very few exceptions.

What the case of Doña Teresa tells us also about women is that class mattered. The Inquisition testimony against her offered by her house-

hold staff paints a picture not of a woman to be pitied by us but of one who was brutal to her servants and slaves. She tried to regulate their sexual comportment precisely because she could not control her own husband's. Her servants and slave constantly complained about being hungry and stealing food from the household, something she too well acknowledged. Her solution to the problem was to have Ana, her "bad" slave, repeatedly whipped for her gluttony. Even in the darkest moments of Doña Teresa's incarceration, she always had ample food rations. She had her hot chocolate, sugar, and wine, even during Lent. None of her servants ever had such luxuries and apparently lived at the margins of material existence.

NOTES

1. *Proceso contra Doña Teresa de Aguilera y Roche, mugger de Don Bernardo López de Mendizabal, por sospechosa de delitos de Judaísmo*, Ramo de Inquisición, vol. 596, expeditente 1, folio 71v, Archivo General de la Nación, Mexico City, Mexico (hereafter cited as AGN-INQ, followed by the volume and folio numbers from which quotations were drawn).

2. Several parts of Doña Teresa de Aguilera y Roche's Inquisition case have appeared in print. See María Magdalena Coll More, "'Fio me a de librar Dios Nuestro Señor . . . de mis falsos acusadores': doña Teresa de Aguilera y Roche al Tribunal de la Inquisición," *Romance Philology* 52 (Spring 2000): 289–362, and Coll More, "Un studio linguístico-histórico del español en Nuevo México en la época de la colonia: análisis de la carta de Doña Teresa de Aguilera y Roche al Tribunal de la Inquisición en 1664" (doctoral diss., University of California, Berkeley, 1999).

3. Solange Alberro, *Inquisición y sociedad en México 1571–1700* (Mexico City: Fondo de Cultura Económica, 1988), 172.

4. Ramón A. Gutiérrez, *When Jesus Came, the Corn Mothers Went Away: Marriage, Sexuality, and Power in New Mexico, 1500–1846* (Stanford, Calif.: Stanford University Press, 1991), 92.

5. Noemí Quezada, *Amor y magia amorosa entre los aztecas: supervivencia en el México colonial* (Mexico City: Universidad Nacional Autónoma de México, 1975).

6. See, for example, Mary E. Giles, ed., *Women in the Inquisition: Spain and the New World* (Baltimore: Johns Hopkins University Press, 1999); Mary Elizabeth Perry and Anne J. Cruz, eds., *Cultural Encounters: The Impact of the Inquisition in Spain and the New World* (Berkeley: University of California Press, 1991).

7. On María de Agreda, see Marilyn H. Fedewa, *María de Agreda: Mystical Lady in Blue* (Albuquerque: University of New Mexico Press, 2009); Clark Colahan, *Writing Knowledge and Power: The Visions of Sor María de Agreda* (Tucson: University of Arizona Press, 1994); Joaquín Pérez Villanueva, "Algo más sobre la Inquisición y Sor María de Agreda: La prodigiosa evangelización americana,"

Hispania Sacra 37 (1985): 597–602; John L. Kessell, "Miracles or Mystery: María de Agreda's Ministry to the Jumano Indians of the Southwest in the 1620s," in *Great Mysteries of the West*, ed. Ferenc Morton Szasz (Golden, Colo.: Fulcrum, 1993), 124–27.

8. See France V. Scholes, *Troublous Times in New Mexico 1659–1670* (Albuquerque: University of New Mexico Press, 1942); Gerald T. E. González and Frances Levine, "In Her Own Voice, Doña Teresa Aguilera y Rocha and Intrigue in the Palace of the Governors, 1659–1662," in *All Trails Lead to Santa Fe: An Anthology Commemorating the 400th Anniversary of the Founding of Santa Fe, New Mexico in 1610* (Santa Fe: Sandstone Press, 2010), 179–208.

9. See Coll More, "'Fio me a de librar Dios Nuestro Señor.'"

10. A complete but unpublished Spanish transcript of Doña Teresa's Inquisition case can be found in the Library of Congress. See Frances V. Scholes (LCCN, record MM8, 1072132, boxes 4631–32). For an English translation of part 2 of the case, see "The Trial before the tribunal of the Holy Office in Mexico City of Doña Teresa de Aguilera y Roche, Wife of Governor of New Mexico, don Bernardo López de Mendizábal, on Suspicion of Practicing Jewish Rites (1664)," transcribed by Magdalena Coll, revised by Heather Bamford, Heather McMichael, and John H. R. Polt, translated into English by John H. R. Polt, http://www.escholarship.org/uc/item/3769j3mm (accessed April 11, 2013).

11. AGN-INQ, vol. 596, folios 45v–48r.

12. Ibid., folios 46v–48r.

13. Scholes, *Troublous Times*, 142–43.

14. Ibid., folios 52r–55r.

15. Ibid., folios 56r–59r.

16. Ibid., folios 56r–59r.

17. Ibid., folios 56r–59r.

18. Ibid., folios 56r–59r.

19. Ibid., folios 59r–86v.

20. Alberro, *Inquisición y sociedad*, 30–49.

21. AGN-INQ, vol. 596, folios 86r.

22. Ibid., folios 86r.

23. Ibid., folios 90v–94r.

24. Ibid., folios 90v–94r.

25. Ibid., folios 94r–96v.

26. Ibid., folios 86v–90v.

27. Ibid., folios 96v–99v.

28. Ibid., folios 100r–v, 118r, 104r.

29. Ibid., folios 100r–v, 118r, 104r.

30. Ibid., folios 103v, 104r.

31. Ibid., folios 103v, 104r.

32. Ibid., folios 120r, 100v.

33. Ibid., folio 102r.

34. Ibid., folio 107v.

35. Ibid., folios 118r–v, 102r.

36. This is a conjecture here on my part, surmised by the way she complained about her feet, and the way others described them.

37. Ibid., folio 100r.

38. Ibid., folio 107r.

39. *Atole* is a corn porridge most commonly consumed as a breakfast food in Mexico.

40. Ibid., folios 107r, 119v.

41. Ibid., folio 102v.

42. Ibid., folios 109r, 138v.

43. Ibid., folios 105r, 103v–r, 141v.

44. Ibid., folios 104v, 152v, 104v.

45. Ibid., folios 106r, 119r.

46. Ibid., folios 118v–119r, 106r.

47. Ibid., folios 121v, 111r.

48. Ibid., folios 119r, 103v, 119r.

49. Ibid., folio 121v.

50. Ibid., folios 114r–116r.

51. Ibid., folio 148r.

52. Ibid., folio 148r.

53. Ibid., folio 148r

54. Ibid., folio 148v.

55. Ibid., folios 149v–150r.

56. Ibid., folios 150r–v.

57. Ibid., folio 150v.

58. Ibid., folio 150v.

59. Ibid., folio 134v.

60. Ibid., folio 151v.

61. Ibid., folio 152v.

62. Ibid., folio 153r.

63. Ibid., folio 152r.

64. Ibid., folio 152r.

65. Ibid., folio 148r.

66. John L. Phelan, "Authority and Flexibility in the Spanish Imperial Bureaucracy," *Administrative Science Quarterly* 5 (1960): 47–65.

67. Gutiérrez, *When Jesus Came*, 119.

68. Scholes, *Troublous Times*, 128n12, 207–44; AGN-INQ, vol. 590, folio 513rv; AGN-INQ, vol. 600, folio 155rv.

69. See David M. Gitlitz, *Secrecy and Deceit: The Religion of Crypto-Jews* (Albuquerque: University of New Mexico Press, 1996).

70. Stanley M. Hordes, *To the End of the Earth: A History of the Crypto-Jews of New Mexico* (New York: Columbia University Press, 2005), 148.

71. Alberro, *Inquisición y sociedad*, 160–64.

72. Scholes, *Troublous Times*, 166–67.

73. Declaration of Ginés de Herrera Horta, 1601, in *Don Juan de Oñate: Colonizer of New Mexico, 1595–1628*, ed. and trans. George Hammond and Agapito Rey (Albuquerque: University of New Mexico Press, 1953), 2:647.

74. Gutiérrez, *When Jesus Came*, 176–226.

75. AGN-INQ, vol. 596, folio 148r.

2

"Women Are as Knowing Therein as the Men"

Dutch Women in Early America

KIM TODT

Visitors to the Dutch Republic in the seventeenth century often commented on the extraordinary independence of Dutch women. The repute of Dutch women's general education and commercial wisdom became widely known. Josiah Child, famed English merchant and economic theorist, recommended that England emulate the Dutch example of instructing all children, "as well Daughters as Sons," in "Arithmetick and Merchant Accompts." As a result of this custom, Child submitted, in the United Provinces the "women are as knowing therein as the Men." James Howell, the Anglo-Welsh historian and writer who also visited the Dutch Republic in the seventeenth century, commented on the intelligence, education, and business expertise of Dutch women: "In Holland the Wives are so well vers'd in Bargaining, Cyphering, and Writing, that in the absence of their Husbands in long Sea voyages they beat the Trade at home, and their Words will pass in equal Credit: These Women are wonderfully sober, tho' their Husbands make commonly their Bargains in drink."[1] Unknown to the visitors, the laws and culture of the Dutch Republic afforded Dutch women significant independence. And such factors, along with self-reliant Dutch women who immigrated to or were born in the colony, were integral to New Netherland.

This chapter examines the lives of women in New Netherland. Much of the historical evidence available about women in seventeenth-century New Netherland seems so inconsequential to historians' interpretations. Yet, wide-ranging aspects of the historical record—the recounting of daily activities in correspondence, the notation of commodities purchased or sold in account books, the lawsuits between neighbors, the quotidian incidents—reestablish the composition of Dutch women's

lives in New Netherland and the succeeding colony of New York. To understand the lives of women in New Netherland, I have drawn upon a variety of sources including correspondence, account books, enacted laws, court records, and notarial records.[2] By examining the various records, one can begin to piece together how women lived, and often persevered, in the colony. Examining this evidence allows us to reconstruct and clarify the experiences of Dutch women, too often relegated to the fringes of the historical metanarrative about the seventeenth century. Attuned to the rhythms of women's lives—their childhood, education, marriage, childbirth, economic participation, fiscal opportunities, widowhood, and death—the chapter highlights the events of women from the colony's founding in 1624 through the transformative events of the late seventeenth century.

While granting the brevity of the colony's life, thanks to the English seizure in 1664, the Dutch population did not disappear from early America—predominately present-day New York, New Jersey, and parts of Delaware and Connecticut. Instead, subsequent to the political handover of the colony, denizens of Dutch ancestry continued to serve in political and administrative offices, own property, and maintain and extend their substantial economic activities. In addition, women persisted in conducting themselves as they had done under Dutch authority.

Marriage and motherhood formed central experiences for women in New Netherland, as well as in the English colonies. Yet, studying women in New Netherland recognizes the diversity of women's experiences in early America. Historians have examined, and continue to consider, the lives of women who came to the colonies (free, indentured, or enslaved) and those who already resided in North America. However, relatively little has been published about women in New Netherland.[3]

The lived experiences of women in a Dutch colony shared characteristics with those of women from other European colonies in North America. Dutch women received an education and training to enable them to manage a household. They sought good partners for marriage. They bore children and endeavored to raise those children in a manner attuned with Dutch culture, yet in a strange new land. These same Dutch women participated in their local economy through trade or running small businesses. Often, their trade or businesses took them outside of the colony. As widows, they often managed multiple businesses and

administered their husband's estate. And yet, while it is dangerous to make cross-cultural comparisons, it can be asserted that Dutch women of seventeenth-century New Netherland experienced more economic, legal, and personal freedoms than their sisters in English colonies. But the situation did not remain static, and in the late seventeenth century and early eighteenth century something more closely approaching equality in legal restrictions existed throughout the colonies.[4]

The Settlement of New Netherland

Like many other North American colonies, New Netherland was an outlying settlement of the transatlantic political and economic order associated with early modern Europe. Subscribing to mercantilist theory, most European nations created colonies to augment the mother country and, hence, the individual country's power.[5] But the Dutch did not espouse mercantilism and, instead, championed free trade. Dutch political and economic policies exhorted the creation of trading posts and not permanent settlements.

Thus, on such basis was New Netherland founded and colonized by the Dutch. Henry Hudson's 1609 voyage on behalf of the Dutch East India Company (Vereenigde Oost-Indische Compagnie, or VOC) in search of a passage to Asia discovered a fertile land and Native peoples willing to trade. Encouraged, Dutch merchant-traders from Amsterdam and Antwerp financed further expeditions. After an unsettled period involving merchant cartels and the New Netherland Company, the formation of the Dutch West India Company (Geoctroyeerde Westindische Compagnie, or WIC) in 1621 ushered in new colonization efforts by the Dutch in the Americas.

Despite the construction of various forts across the region, the Dutch needed permanent settlement to maintain a territorial claim—particularly as the English to the east and south and the French farther north had begun to actively explore, trade, and lay claim to lands in North America. In 1624, the WIC encouraged settlement and thirty French-speaking Walloon families found refuge in New Netherland. These colonists formed the nucleus of the future Dutch presence in the area. Settlement of the colony clustered around the North River (later named the Hudson River), from Fort Orange and Beverwijck (present-

day Albany) to Fort Amsterdam and New Amsterdam (Manhattan). The next year, many more Dutch settlers followed the Walloon refugees.

Notwithstanding the steady flux of people populating the colony, the directors of the WIC had divergent opinions about how to sustain their colonial enterprise. Some directors contended that the WIC should abandon colonies in the New World as too expensive to establish and maintain and should concentrate instead on the lucrative fur trade with the Native peoples. Trading posts, they asserted, required fewer people than multiple settlements. Other directors argued in favor of continued colonization. They proposed giving land to "patroons," or patrons, wealthy Dutchmen who would invest their own money to attract settlers and develop the local economy. The patroon system, though, would not provide the salvation for populating the colony that some WIC directors had envisioned.[6]

However, with the abandonment of the WIC's trade monopoly, the colony began to attract a larger influx of immigration.[7] Single young men dominated the earlier migration to New Netherland—a migration similar to that experienced during the formative years in the Chesapeake. But with the disintegration of the WIC's trade monopoly, migration of nuclear families accelerated bringing wives, daughters, and sisters to the Dutch colony in greater numbers.[8]

A Childhood of Education and Training

In New Netherland, law and custom made a woman's life differently ordered from the lives of women in New England or the Chesapeake. This began with the Dutch approach to education. In 1693, the Englishman Josiah Child intimated that education, in part, aided in augmenting the wealth of the northern provinces of the Dutch Republic. He noted that "the education of their Children, as well Daughters as Sons; all which, be they of never so great quality or estate, they always take care to bring up to write perfect good hands, and to have the full knowledge and use of Arithmetick and Merchants-Accounts." Earlier in the seventeenth century, Roger Coke noted that "the Dutch generally breed their youth of both Sexes in the Studies of Geometry and numbers, especially more than the English do"—these subjects being one of the foundational tools, in his opinion, for success in trade. Dutch

children, Child observed, grew up to have "an ability for Commerce of all kinds."[9]

Contemporary Dutch philosophers avowed that an education, when combined with parental guidance, allowed children to make responsible moral choices and become conscientious participants in their community.[10] Education emanated in many forms within New Netherland, as it did in Europe and other North American colonies. Traditional instruction in a prescribed school setting was available. As well, vocational training at home or in a business and indentures for service to skilled craftsmen provided particular preparation for a trade or occupation. And all of this was offered to both boys and girls.

The colony followed the Dutch Republic's educational practices and admitted girls and boys to the elementary schools, generally at their parents' expense. The community, cognizant that economic factors should not preclude a basic education, also admitted those too poor to pay tuition.[11] Children could begin attending school as early as three years old. The standard curriculum included reading, writing, and ciphering. Early modern pedagogy followed a basic pattern of learning the alphabet, then spelling, reading, and grammar. Through attendance at the colony's elementary schools, a child could obtain basic literacy and numeracy skills.[12]

Segregation between boys and girls did exist within the classroom for younger children. Beyond the age nine or ten, boys and girls were taught in separate rooms. For girls, formal education concluded with elementary school. Following Dutch practice, which barred higher education for girls, girls could not seek admission to the Latin School.[13] The philosophy behind education of girls in the Dutch Republic was that girls were trained to be in a supporting role beside their husbands in a future business undertaking, while boys were trained to be the center of that business.

Beyond formal education, vocational training provided boys and girls with skills necessary for particular occupations. The extent of such training, either in the Dutch Republic or in New Netherland, is difficult to discover. Vocational training most likely occurred in informal settings. Boys and girls trained while working alongside their parents, relatives, or even neighbors.[14] However, vocational training most likely occurred when a need was present within a household or as arose within

businesses or trades of relatives or neighbors that could not be fulfilled within their own households.

In New Amsterdam, Maria van Cortlandt operated a brewery for her father, Olaf Stevensen van Cortlandt. He may have instructed his daughter in brewing methods, along with training she received from her mother. Maria's husband, Jeremias van Rensselaer, wrote his mother in April 1665, "I have taken up brewing, and this for the sake of my wife, as in her father's house she always had the management thereof, to wit, the disposal of the beer and helping to find customers for it."[15] While we are uncertain as to Maria's formal education, the account books she kept and letters she wrote on behalf of the patroonship demonstrate her literacy and numeracy skills. Moreover, her early practical (or vocational) training provided her with the acumen to undertake commercial enterprises including running a mill, leasing property, directing agricultural operations, and managing fur trading.[16]

Along with vocational training, parents could apprentice their daughter for training in a trade or craft. Traditionally, in the Dutch Republic, most apprentices were hired for a period of two to six years. Apprentices received board and lodging and occasionally received remuneration for their work. The majority of apprentices, however, paid for the occupational training, generally a specified sum of money annually. Parents contemplating this form of education for their daughters considered the substantial investment for an apprenticeship with what they hoped their daughter would acquire financially from it.[17]

New Netherland adopted the Dutch Republic's system of apprenticeship, or indenture for a term of years, as a platform for further education.[18] Parents or guardians could enter into an agreement of indenture or apprenticeship. As New Netherland developed as a society, such agreements needed to be legally drawn by a notary and registered with local authorities.[19] In 1644, Hans Jansen, for example, bound his daughter Marritjen for a term of three years to serve the tavern keeper Philip Gerritsen and his wife. Gerritsen assented to provide Marritjen with "board, lodging and the necessary clothes, and also have her taught sewing, in such a manner as a father should or might do with his child."[20]

Also in 1644, a different sort of father figure indentured a girl into service. Director Willem Kieft bound Maria, a "young Negro girl" who was owned by the West India Company, to an indenture as a servant of

Nicolaes Coorn, a resident of Rensselaerswijck. Her term of service was four years, without any special training given to her, after which time she was to be returned to Kieft "if she be living."[21] However, her biological father, Big Pieter, did not have the legal capacity to agree or object to his daughter's indenture presumably because he was a slave.

Apprenticeships often provided stability to children whose lives were disrupted by the death of a parent or economic collapse. An apprenticeship could ensure adequate food and clothing to a child, as well as some sort of training. In 1674, Barentie Stratsman bound out her eight-year-old daughter, Johanna Hans, to Richard and Elizabeth Pretty for a term of eight years.[22] The term was longer than normal, but would have allowed Johanna to enter the labor market (or marriage market) with certain marketable skills.

Despite a favorable climate, agricultural surpluses, and economic growth, a parent's death was a common reality in New Netherland. With the parent's death, not only were children deprived of the provision of a parent's love and guidance, but they could also be deprived of education or training. Civic officials in the Dutch Republic recognized that pauper, foundling, and orphaned children required special oversight and charity.[23] In New Netherland, the development of civic charitable institutions arose to step in and care for children.[24]

Often, parents in New Netherland made provisions before their passing for the economic, educational, and moral development of their children. Girls were not excluded from these provisions.[25] For instance, the West India Company allowed colonists to lease cows from the company. Leendert Aertsen and Joris Rapalje made provisions for their respective daughters by negotiating in their lease agreements that the first heifer calf produced by the leased herd would be kept for their daughters. The heifer could later provide offspring and milk for each daughter to establish an economic foundation.[26]

Colonial marriage contracts and wills emphasized education regardless of gender. The colony's laws required that prior to the remarriage of a widow or widower, who was the parent of minor children, the local Orphanmasters were required to appoint guardians for the children. The affiant parties were then required to appear before the Orphanmasters and enter into a formal agreement regarding the care of the child or children and of the property to them due. Numerous marriage contracts of

this nature were recorded.[27] Within many of them are specific references to the education of girls. For example, in 1632 a contract was executed in which both parties promised with regard to Resel (Racel) and Jan "both minor children," "to keep them at school, to teach them a trade."[28] A boy and a girl are here to be treated alike.[29]

Entering Adulthood: To Find Such a Good Partner

Marriage and motherhood were central to Dutch women in New Netherland, as such conventions were throughout the colonies. And the transition from girlhood to adulthood traditionally meant a young woman began to consider marriage. However, a young woman could begin to assert her legal and economic autonomy as Dutch law allowed single and widowed women the same economic rights as men. In other words, at the legal age of twenty, a woman could administer her own real and personal property, carry out legal transactions, enter into contracts, and appear before a court on her own.[30]

As historians, we must ask whether marriage offered any supplementary legal rights to women. Dutch law, in addition to acknowledging the social union between a man and a woman, viewed matrimony as the marriage of community goods when the assets held by both parties were joined. Since Dutch women could inherit property and confer their own estates through a testamentary document, such holdings were part of the community of goods, including debts brought into the marriage by either spouse and for which both partners, generally, became responsible.

Still, Dutch law offered a wife the option of foregoing placement of her property into the marital community of goods. Instead, a husband and wife could enter into an antenuptial agreement and reach a consensus about which assets or liabilities would become part of the community of goods. This type of agreement was more frequent with second marriages.[31]

Despite the seeming equality of Dutch marriage provisions in the seventeenth century, the law considered women *sub tutela*—minors—and their husbands their lawful guardian. Legally, wives could not independently institute a court action, defend themselves in court on their own, or trade without their husband's verbal consent. Dutch law recognized a husband as the administrator of his wife's estate, bestowing upon him

authority over her property. And while there were instances of abuse of authority, the Dutch view of marriage minimized exploitation.[32]

Seventeenth-century Dutch society viewed marriage as a partnership, and when a woman contemplated marriage she sought not just a husband, but also a partner—to participate in these distinctly Dutch perceptions of marriage of shared opportunities and responsibilities. When Jeremias van Rensselaer married Maria van Cortlandt in 1662, he wrote his brother Jan Baptist with the news: "I thank the good Lord for having granted me such a good partner and we shall beseech Him that He may let us live together long in peace and health."[33]

Along with traditional notions of domestic activities assigned to women as wives and mothers, colonial women took care of the house and household by cooking, preserving food, sewing, spinning, tending gardens, taking care of sick or injured family members or servants, and performing numerous other tasks. In this, Dutch and English women shared common domestic obligations. However, wives in Dutch culture had greater economic responsibilities.

Visitors to the Dutch Republic observed the role Dutch women played in their family's financial management. An English traveler remarked in the late sixteenth century, "One thing not used in any other Countrey, is here most common . . . the Weomen especially of Holland . . . manage most part of the businesse at home, and in neighbour Cities [and] in the shops they sell all, they take all Accompts."[34] Yet management of the domestic economy was important during the seventeenth century to reach, or keep, the family at a subsistence level. As an illustration, while Aafie Leender's husband, Jan Perier, was at sea, she appealed to New Amsterdam's Court of Burgomasters and Schepens for seven hundred florins owed to her husband from Captain Augustyn Beaulieu. A Captain Rooslyn had attached her husband's assets. Seven hundred florins was a significant sum in seventeenth-century New Amsterdam.[35] At Aafie's request, the court agreed that the money and the attached assets should be deposited with the court until her husband's return. In essence, Aafie used the court to protect her family's assets.[36] While her husband was at sea, Aafie most likely undertook some sort of work to supplement the family's income. Many women aided their husband's business or administered their own business, or both. Doing so indisputably ameliorated the family's economic stability.

Women in New Netherland held a variety of occupations while ful-
filling their responsibilities as wives and mothers. Women took in wash-
ing, cleaned houses, and sewed—occupations customarily attendant
with their domestic labor. In addition, they also oversaw small shops
or peddled goods—occupations that had low financial barriers to entry.
Their wares included linen napkins, pins, needles, thread, buttons, linen
caps, porcelain dishware, stockings, gloves, and children's toys.[37] As well
as trading with Europeans resident in New Netherland, women also
traded with Indians who offered furs in exchange for European goods.[38]
The fur trade, particularly in Beverwijck, allured women to engage in
trade with Indians. Even the acquisition of a few beavers during the fur-
trading season could augment a family's income.[39]

Women also managed businesses because of a husband's absence or
death. In their own right or on behalf of their husbands, they operated
taverns, breweries, bakeries, farms, and brickyards, speculated in real
estate, and, as landlords, leased properties or rooms.[40] Some women
became substantial intercolonial or transatlantic traders, rivaling even
their male counterparts. For instance, Margaret Hardenbroeck had
whole or partial interests in at least fifteen ships that undertook trans-
atlantic voyages from New Netherland to Amsterdam. And later, after
the English takeover in 1664, her ships sailed to England to comply with
the Navigation Acts, pay duties on enumerated articles, and trade in
the London market. With her second husband, Frederick Philipse, Mar-
garet's commercial pursuits escalated, ultimately incorporating trade in
slaves, rum, wine, tobacco, grain, and salted beef.[41]

Similar to Margaret and her husband, husbands and wives also coop-
eratively handled the family financial management in New Netherland.
However, women's financial roles in New Netherland, as derived from
Dutch conventions, demonstrated how Dutch culture shaped women's
autonomous economic participation. As well, the nondomestic endeav-
ors of sundry women, which included trade or managing commercial
concerns, were integral to their roles as wives and mothers.

In addition to prodigious economic responsibilities, what did the law
afford a married woman living in New Netherland? Take for instance
Baefje Pieters. She married Ulderick Klein, became a mother, and ran
a tavern in Beverwijck, a fur-trading community north of Fort Orange
on the Hudson River that was later to become Albany. In April 1657, she

appeared before the Court of Fort Orange and Beverwijck with her account book to sue three male patrons of her tavern who had "consumed wine and beer at her house," but failed to pay for the drink. As Baefje had summoned the men to court two previous times and they once again failed to appear, the court entered an admission of guilt under Dutch law. The court awarded her the debts owed by the men as well as her court costs.[42] Although a simple matter of debt collection, the lawsuit illustrates a number of essential aspects of how women engaged with the legal system in New Netherland. Baefje had awareness of legal procedures and her rights as a creditor under the law. In addition, Baefje appeared in court by herself. She was not represented by her husband or another man, a right afforded women by Dutch law.[43] In order to prove her case, Baefje provided the court with the tavern's account book evidencing monies expended and owed. As a business owner, Baefje would have received training in how to maintain an account book. For claims of debt, the court required Baefje to enter the account book as evidence.[44] Throughout the proceedings, Baefje demonstrated a high degree of legal competence that was characteristic of Dutch women.

Dutch Widows: Carrying On

As with widows in other areas of colonial America, Dutch women in New Netherland wrestled with the emotional concerns and practical quandaries associated with widowhood. Nonetheless, a Dutch widow had economic knowledge and proficiency accumulated during her education and marriage that assisted her transition into widowhood. As well, the colony's inheritance customs mirrored the joint ownership of the marital estate. Such customs directed on the intestate death of either spouse, the court divided the estate in half with one-half going to the surviving spouse and one-half to the heirs. And, while men and women could make separate wills under Dutch law to bequeath their estates, couples in New Netherland traditionally used a mutual will appointing the surviving spouse as the "sole and universal heir."[45]

The law required payment of outstanding debts to the husband's creditors prior to the wife receiving her husband's estate. Occasionally, a wife faced financial insolvency upon her husband's death. For instance, when Caitlin Berecx's husband, Dirck Bensing, died in 1660, Jeremias

van Rensselaer characterized Bensing's estate as in a "bad condition."[46] Real estate speculation and debts owed for wages and yacht payments had encumbered Bensing even prior to his passing, forcing him to accept manual labor to support his family. Catalijn decided to turn the estate over to the Orphanmasters to administer and informed her husband's creditors. The Orphanmasters granted consent for Catalijn to sell one house and a piece of property most likely to provide some income for her family and pay off some creditors.[47]

Catalijn, hindered by debts to her husband's estate, sought another marriage partner. Catalijn's new husband, master shoemaker Harmen Thomansz, provided financial relief "with the labor of his own hands has earned, cleared off, and paid the greater part of her debts and charges upon the estate."[48] In a colony with a gender imbalance that favored women, remarriage offered a respite from emotional and fiscal concerns.[49]

Did women choose not to remarry? There were legal advantages for women in New Netherland to remain unmarried. The experience of widowed Dutch women in New Netherland highlights distinctive features about this particular passage in a woman's life. As noted earlier, Dutch law consigned women to a minority status under their husband's control.[50] As a consequence, their abilities to own property and represent themselves and their children in court were potentially impeded. Widowhood allowed Dutch women the same Dutch cultural concurrence of heightened roles for wives implemented through daily practices of uncommon responsibilities without a husband's administration.

Because the Dutch were prodigious in the detailed memorializing of legal conflict, we have evidence of the frequent actions undertaken by widowed women. Women persevered to legally protect their interests and their children's interests. And although some of the most provocative and exciting cases involved widowed women of wealth and status, women of more common means defended their property and assets.[51] However, the success of any widowed woman's efforts often depended on the pragmatic legal and commercial acumen she acquired during her marriage.

Still, despite their education, cultural support, and legal standing, widowed women resident in New Netherland occasionally faced exposure from those who sought to prey upon their perceived weaknesses as

women without a marriage partner. Take, for instance, Maria van Cort-landt van Rensselaer.[52] Maria was raised in one of the colony's elite families and married into one. Her husband, Jeremias, died in 1674, leaving Maria with six young children. Since their children were minors and no other male representative of the Van Rensselaer family was in the colony, the burden of administering the vast Rensselaerswijck property—approximately twenty-four square miles—fell to Maria.

Maria encountered numerous obstacles in managing both the property and her husband's estate in her efforts to ensure her eldest son, Kiliaen, should inherit the title of "patroon." Others acknowledged her as a capable and astute businesswoman in her own right. A visiting Labadist missionary, Jasper Danckaerts, reported finding her, in 1680 "polite, quite well-informed, and of good life and disposition. . . . We went to look at several of her mills at work, which she had there on an ever-running stream, gristmills, sawmills, and others."[53]

As executrix of her husband's estate, Maria sought clear title to Rensselaerswijck after the English conquest of the colony in 1664, the Dutch reconquest in 1673, and the final English reconquest in 1674. "You well know yourself," Maria complained to her brother-in-law in the Dutch Republic in 1680, "how it went, first upon the arrival of the English, then upon the arrival of the Dutch, and then again upon the arrival of the English, and how, whenever any one of importance came from New York, he had to be entertained to keep up the dignity of the colony."[54] The Van Rensselaers repetitively sought a reaffirmation of their title from governing authorities and finally achieved it in November 1685 from the English.

A second notable testamentary dispute also involved the Van Rensselaers, although in this instance the death of a Van Rensselaer attracted the attention of someone who sought to take advantage of a widow's perceived vulnerability. The death of Nicolas van Rensselaer, Maria's brother-in-law, left his widow, Alida Schuyler van Rensselaer, susceptible to the charisma of Robert Livingston.[55] Alida remarried within eight months of Nicolas's death. Owing to the requirements of Dutch and English law, when Livingston married Alida, he assumed Nicolas's debts.[56] However, Livingston also pursued another strategy, which highlighted his relentless efforts to acquire Rensselaerswijck property through his marriage and profit from his union with Nicolas's widow.[57]

Livingston maintained a claim on Rensselaerswijck, which he argued derived from his responsibilities for Nicolas's debts.[58]

In a 1680 letter to his sister, Maria van Rensselaer, Stephanus van Cortlandt signaled that Livingston was, at the same time, attempting to negate Alida's inherited indebtedness. He cautioned Maria to "keep a sharp lookout."[59] Livingston continued to pursue Maria van Rensselaer and the Dutch Van Rensselaers about his claims on Rensselaerswijck until 1685, when the parties finally agreed upon a settlement.

Widows like Maria van Rensselaer were secure in their ability to independently manage affairs after their husbands' deaths. Elite status by birth that was maintained through endogamous marriages did give them some advantages unavailable to other widows. Elite Dutch women often did not need male benefactors for maintenance and frequently represented their own interests during widowhood. Therefore, remarriage was an option rather than an economic necessity for widows.

Conclusion

The legal status of women during the Dutch colonial period is a story not of change over time as they adapted to their new environment but of the continuation of a legal system that benefitted both men and women. Dutch women in early America received an education that allowed them to run a household and, if desired or required, a business. They entered into marriage with the expectation of a matrimonial union that Dutch society characterized as a partnership. These same Dutch women participated in their local economy. They managed households, sold surplus agricultural products, ran mills, tended taverns, and participated in myriad other economic endeavors. However, their pursuits often extended beyond their neighborhoods. Many traded as merchants to other colonies and a few even plied the Atlantic trade. While a gender-based division of labor did occur with respect to some occupations, Dutch women had more latitude in seeking economic opportunities than did women living in Anglo-American colonies during the seventeenth century. As widows, they managed their own and their husband's businesses and the family estates.

After the surrender of New Netherland to the English in 1664, women lost some of this freedom under the crush of English law. How much

effect it had on the general continuation of cultural behavior of Dutch women and men subsequent to 1664 is difficult to assess. Some aspects of English acculturation on the Dutch population were more recognizable than others.[60] Dutch merchants pledged their loyalty to an English king and embraced the new markets opened to them. New settlers in the colony of New York came from England rather than the European continent. English common law began to replace Dutch civil law.[61]

Less obvious facets of English acculturation—those that took a generation or more to impact local culture—included a redefinition of gender roles. A diminishing public role of women in the management of financial and legal affairs meant that women in late seventeenth-century New York had less public experience, knowledge, and talent than women of their mothers' or grandmothers' generations. As a consequence, women became more dependent on men who could advise on or conduct legal, commercial, or financial affairs on their behalf.[62]

As English acculturation moved Dutch women to the periphery of quotidian fiscal activities, families no longer had the model of wives and mothers in an active and public role as financial managers and public advocates. As a consequence, the cultural norms associated with widowhood for Dutch women altered. Quantifying widows' independence in the late seventeenth and eighteenth centuries in New York raises problematic issues for historians. As the influence of English culture increased in New York society, criminal and testamentary court appearances by women outnumbered their appearances in civil litigation suits—a subtle indication that women no longer stood on equal footing before the court on civil matters.[63] The progression occurred in measured phases. Increasingly, practices that shaped and guided women's roles became influenced by English values supplanting Dutch cultural practices.

Nevertheless, during the period of Dutch presence in colonial history, women conducted their lives in North America as they did in Holland. While the English conquest of the Dutch colonial government had immediate repercussions, Dutch cultural institutions and norms remained in place for decades. Gradually, change occurred. By examining the lives and social position of Dutch women in New Netherland, we can better appreciate the variety of women's experiences in early America, across time as well as region, and we can expand our understanding of early

American women's history, which is all too often dominated by histories of the English.

NOTES

1. Josiah Child, *A New Discourse of Trade: Wherein Is Recommended Several Weighty Points Relating to Companies of Merchants, etc.* (London: John Everingham, 1693), 4; James Howell, *Epistolae Ho-Elingae: The Familiar Letters of James Howell,* ed. Joseph Jacobs (London: David Nutt, 1890), vol. 1, sec. 2:128. As well, Sir William Montague complimented Dutch women's skill and intelligence by observing, "More women are found in the shops and business in general than men; they have the conduct of the purse and commerce, and manage it rarely well, they are careful and diligent, capable of affairs (besides domestik), having an education suitable, and a genius wholly adapted to it." See William Montague, *The Delights of Holland: or, a Three Months Travel about That and the Other Provinces* (London, 1696), 183. Of course, others were less complimentary about Dutch women. One English traveler wrote, "Nor would I be a Dutchman/To have my wife, my sovereign, to command me." A. T. van Deursen, *Plain Lives in a Golden Age: Popular Culture, Religion and Society in Seventeenth-century Holland* (Cambridge: Cambridge University Press, 1978), 83.

2. The New Netherland Project and earlier historians of the colony have made many of the original Dutch language documents accessible to today's historians through translation and publication. In addition to sourcing these materials for this chapter, I have also accessed Dutch-language documents in the New York State Archives, the New York State Library, the Nationaal Archief in The Hague, and the Stadsarchief Amsterdam. "The crucial role of the Dutch in the process of exploration and colonization has always been vastly underplayed," one historian has noted, "largely because so few scholars had the linguistic skill to open the archives to study." Karen Ordahl Kupperman, "Early American History with the Dutch Put In," *Reviews in American History* 21 (June 1993): 195–201.

3. Many past histories concerning women in early America provided nominal information about women from New Netherland and instead had an Anglo-centric focus. See, e.g., Marylynn Salmon, *Women and the Law of Property in Early America* (Chapel Hill: University of North Carolina Press, 1986). Other histories were exclusively attentive to elite women, including those in New Netherland. See, e.g., Carol Berkin, *First Generations: Women in Colonial America* (New York: Hill & Wang, 1996); Linda Biemer, *Women and Property in Colonial New York: The Transition from Dutch to English Law, 1643–1727* (Ann Arbor: UMI Research Press, 1983). Joyce Goodfriend has asserted, "Because Dutch culture has traditionally been evaluated by the standards of the Puritans, emphasis has too often fallen on its deficiencies." Rather, she contends, historians should examine "Dutch culture on its own terms." See Joyce D. Goodfriend, "The Historiography of the Dutch in Colonial America," in *Colonial Dutch Studies: An Interdisciplinary*

Approach, ed. Eric Nooter and Patricia U. Bonomi (New York: New York University Press, 1988), 19–20.

4. There is no doubt that the actual Dutch political presence in North America was brief, lasting little more than forty years, from 1621 to 1664. On the other hand, overwhelming evidence intimates that both a Dutch cultural presence and the republic's political and legal legacy lasted in the mid-Atlantic region well into the nineteenth century. See, e.g., David Narrett, *Inheritance and Family Life in Colonial New York* (Ithaca, N.Y.: Cornell University Press, 1992); Martha Dickinson Shattuck, "A Civil Society: Court and Community in Beverwijck, New Netherland, 1652–1664" (Ph.D. diss., Boston University, 1993); Adriana van Zwieten, "'On her woman's troth': Tolerance, Custom, and the Women of New Netherland," *de Halve Maen* 55 (Spring 1999): 3–14; Susan Elizabeth Shaw, "Building New Netherland: Gender and Family Ties in a Frontier Society" (Ph.D. diss., Cornell University, 2000); and Michael E. Gherke, "Dutch Women in New Netherland and New York in the Seventeenth Century" (Ph.D. diss., West Virginia University, 2001).

5. David Ormrod, *The Rise of Commercial Empires: England and the Netherlands in the Age of Mercantilism, 1650–1770* (Cambridge: Cambridge University Press, 2003).

6. For a general discussion about the patroon system in New Netherland, see, e.g., Oliver A. Rink, *Holland on the Hudson: An Economic and Social History of Dutch New York* (Ithaca, N.Y.: Cornell University Press, 1986), 94–116. The most successful patroonship was Rensselaerswijck. See, e.g., Janny Venema, *Beverwijck: A Dutch Village on the American Frontier, 1652–1664* (Albany: State University of New York Press, 2003); A. J. F. van Laer, trans. and ed., *Van Rensselaer Bowier Manuscripts* (Albany: University of the State of New York, 1908); Shattuck, "Civil Society."

7. For the discussion about eliminating nearly all of the monopolistic privileges of the WIC in New Netherland, see Edmund B. O'Callaghan and Berthold Fernow, eds. and trans., *Documents Relative to the Colonial History of the State of New York* (New York, 1856–87), 1:110–15.

8. The WIC encouraged single and widowed women to immigrate to New Netherland. Van Laer created a partial list of passengers arriving in New Netherland between 1654 and 1664. Of the 1,095 passengers he noted, 76 were single women. See A. J. F. van Laer, "Passengers to New Netherland," *Yearbook of the Holland Society of New York* (1902): 1–37. Given the gender imbalance within the colony, women arriving in New Netherland could easily acquire a husband.

9. Child, *New Discourse of Trade*, 4. See Roger Coke, *A Discourse of Trade* (London: H. Brome and R. Horne, 1670). See also Jan de Vries and Ad van der Woude, *The First Modern Economy: Success, Failure, and the Perseverance of the Dutch Economy, 1500–1815* (Cambridge: Cambridge University Press, 1997), 596–603.

10. See Van Deursen, *Plain Lives in a Golden Age*, 130.

11. On the general education of girls in New Netherland and the Dutch Republic, see William Heard Kilpatrick, *The Dutch Schools of New Netherland and Colonial New York* (Washington, D.C.: Government Printing Office, 1912), 30–31. See also Margaret Spufford, "Literacy, Trade and Religion in the Commercial Centres of Europe," in *A Miracle Mirrored: The Dutch Republic in European Perspective*, ed. Karel Davids and Jan Lucassen (Cambridge: Cambridge University Press, 1995), 259. On the charity proffered to the poor to enable them to attend school, see Berthold Fernow, trans. and ed., *The Minutes of the Orphanmasters of New Amsterdam, 1655 to 1663* (New York: Francis P. Harper, 1902–1907), 2:116.

12. See Kilpatrick, *Dutch Schools*, 227; Van Deursen, *Plain Lives in a Golden Age*, 122; Danielle van den Heuvel, *Women & Entrepreneurship: Female Traders in the Northern Netherlands, c. 1580–1815* (Amsterdam: Aksant, 2007), 48.

13. Kilpatrick, *Dutch Schools*, 30–31.

14. See, e.g., Ariadne Schmidt, *Overleven na de dood: Weduwen in Leiden in de Gouden Eeuw* (Amsterdam: Bert Bakker, 2001), 130–32.

15. A. J. F. van Laer, trans. and ed., *Correspondence of Jeremias van Rensselaer, 1651–1674* (Albany: University of the State of New York, 1932), 377–78.

16. Kim Todt and Martha Dickinson Shattuck, "Capable Entrepreneurs: The Women Merchants and Traders of New Netherland," in *Women in Port: Gendering Communities, Economies, and Social Networks in Atlantic Port Cities, 1500–1800*, ed. Douglas Catterall and Jodi Campbell (Leiden: Brill, 2012), 193.

17. See, e.g., J. G. van Dillen, *Bronnen tot de Geschiedenis van het bedrijfsleven en het gildewezen van Amsterdam*, I II III, RGP Grote Serie 69 (The Hague: M. Nijhoff, 1925).

18. See Ronald W. Howard, "Apprenticeship and Economic Education in New Netherland and Seventeenth-Century New York," in *A Beautiful and Fruitful Place: Selected Rensselaerswijck Seminar Papers*, ed. Nancy Anne McClure Zeller (Albany, N.Y.: New Netherland Publishing, 1991), 205–9. These were contracts in which a person binds another to service because of the legal relation one person has over another. See R. W. Lee, *An Introduction to Roman-Dutch Law* (Oxford: Clarendon, 1946), 245n3, referencing the Dutch jurist, Hugh Grotius, and his *Inleydinge tot de Hollantsche rechtsgeleertheit* (1631).

19. As in the Dutch Republic, notaries in New Netherland undertook a variety of functions. They were competent to draft and execute legal documents of all sorts.

20. A. J. F. van Laer, trans., *New York Historical Manuscripts: Dutch*, ed. Kenneth Scott and Kenn Stryker-Rodda (Baltimore: Genealogical Publishing, 1974), 2:222.

21. Ibid., 224.

22. Jonathan Pearson, trans., and A. J. F. van Laer, rev. and ed., *Early Records of the City and County of Albany, 1654–1678* (Albany: J. Munsell, 1916–19), 3:415. But it must be remembered that by contracting out her daughter for a term of years, Barentie was deprived of her daughter's labor at home. Mothers from lower social classes who could not afford to replace the lost labor of their daughters assumed greater responsibilities for domestic labor.

23. See Anne McCants, *Civic Charity in a Golden Age: Orphan Care in Early Modern Amsterdam* (Urbana: University of Illinois Press, 1997); B. S. Hempenius-van Dijk, *De weeksamer van de stad Groningen 1613–1811* (Groningen: Wolters-Noordhoff/ Egbert Forsten, 1991).

24. See, e.g., Susanah Shaw Romney, "Intimate Networks and Children's Survival in New Netherland in the Seventeenth Century," *Early American Studies* 7 (2009): 270–308; Adriana E. Van Zwieten, "The Orphan Chamber of New Amsterdam," *William and Mary Quarterly* 53 (1996): 319–40; Janny Venema, *Kinderen van weelde en armoede: Armoede en liefdadigheid in Beverwijck/Albany* (Hilversum: Verloren, 1993).

25. Unlike primogeniture customs under the English, the Dutch had more equitable inheritance procedures in which all children received an equal share from their parents' estate. This did not mean, however, that daughters necessarily received land. But it did mean, as well as receiving their *uitzet* (typically a chest used to collect items by unmarried young women in anticipation of their marriage), daughters received goods in equal value to land that was traditionally divided among the sons equally. Primogeniture favored the eldest son and forced younger sons to seek careers in the military or clergy. See David E. Narrett, "Dutch Customs of Inheritance, Women, and the Law in Colonial New York City," in *Authority and Resistance in Early New York*, eds. William Pencak and Conrad Edick Wright (New York: New-York Historical Society, 1988), 27–55.

26. Van Laer, *New York Historical Manuscripts*, 1:17–18, 20–21.

27. For instance, prior to the marriage of Aryaentie Cornelius, a widow with six children, to Albert Leendersen, both Aryaentie and Albert appeared before the Orphanmaster's Court and promised that they would "bring up the six children aforesaid, to feed them, to care for them, [and] to have them taught to read and write." Fernow, *Minutes of the Orphanmasters*, 1:25–26. Occasionally, provision for the care of stepchildren saw a stepparent unwilling or incapable of caring for the children after the death of the sole biological parent. Ibid., 1:87–88.

28. O'Callaghan and Fernow, *Documents Relative to the Colonial History of the State of New York*, 1:6. The same is true of the contract drawn by Dr. Everardus Bogardus and Annitje Jans. The children were Sarah, Tryntje, Lytje, Jan, and Annitje. The affiants here promised "to keep them at school and let them learn reading, writing, and a good trade." Ibid., 2:20. In another contract of the same year, the children were both girls, Catrina and Johanna, and the promise was to "let them learn to read and write and have them taught a trade." Ibid., 22.

29. In instances when parents died without wills, local Orphanmasters enlisted guardians and tutors for younger children, often to be paid from the sale of the deceased's property. For example, in November 1655, Pieter Cecer, alias Mallemock, and his wife died. A meeting of the Orphanmasters determined that they would appoint tutors and guardians for the couple's six small children and "they are hereby authorized to sell or employ the goods and property, left by deceased, for the benefit of the children, to hire out or bind out the children to

honest and suitable people and to do everything, what time and circumstances point out as proper." See Fernow, *Minutes of the Orphanmasters*, 1:4.

30. See Hugo Grotius, *The Jurisprudence of Holland*, trans. R. W. Lee (Oxford: Clarendon, 1926), 6–15.

31. For example, Maritgen Damen and her third husband, Cornelis van Nes, entered into an antenuptial agreement. Maritgen traded extensively as well as invested in real estate and Dutch public stock companies. The couple agreed to pool their assets, but acknowledged that debts incurred before their marriage were the individual's responsibility and not part of the marital community of goods. See Pearson and Van Laer, *Early Records of the City and County of Albany*, 3:273–74. For a general discussion about antenuptial agreements, see Lee, *Introduction to Roman-Dutch Law*, 73–79.

32. A wife could petition the court to exclude her husband as her administrator if she considered that he was mismanaging her estate. If a wife's petition was granted, the court effectively severed their economic partnership and extinguished the wife's liability for the husband's debts. Grotius, *Jurisprudence of Holland*, 30–32.

33. Van Laer, *Correspondence of Jeremias van Rensselaer*, 297.

34. Fynes Moryson, *An Itinerary Containing His Ten Yeeres Travell through the Twelve Dominions of Germany, Bohmerland, Sweitzerland Netherland, Denmarke, Poland, Italy, Turky, France, England, Scotland & Ireland* (Glasgow: James MacLehose, 1908), 4:58–59. Moryson spent much of the 1590s journeying through Europe and the eastern Mediterranean. He wrote about his travels in his multivolume *Itinerary*, a work regarded as a representation of the social conditions existing in the lands he visited.

35. For instance, in 1639 a maidservant in New Amsterdam earned 40 guilders (florins) per year and a couple received "the considerable sum of 200 guilders per year" for overseeing the farm of the director of New Netherland. Firth Haring Fabend, "Cosyn Gerritsen van Putten: New Amsterdam's Wheelwright," *de Halve Maen* 80 (Summer 2007): 2:23–30.

36. See Berthold Fernow, ed., *The Records of New Amsterdam from 1653 to 1674* (Baltimore: Genealogical Publishing, 1976), 3:18–20. Unfortunately, Aafie's husband never returned as his vessel was shipwrecked on the Island of Anticosti in Canada.

37. Peddling goods had its own perils. Jochem Becker beat Mariken ten Haer and had her merchandise thrown into the street while she tried to peddle her goods. Charles Gehring, trans. and ed., *Fort Orange Court Minutes, 1652–1660* (Syracuse: Syracuse University Press, 1990), 61.

38. Todt and Shattuck, "Capable Entrepreneurs," 198–99.

39. Ibid., 201–4; Venema, *Beverwijck*, 175–236; Pearson and Van Laer, *Early Records of the City and County of Albany*, 3:86–87 (Catarina Sanders acknowledged her indebtedness to Nicholaes de Meyer for 535 guilders worth of beaver). Women also illegally sold liquor to Indians in order to obtain beavers, which were used as currency throughout the colony. See Gehring, *Fort Orange Court Minutes*, 328.

40. See, e.g., Van Laer, *Correspondence of Jeremias van Rensselaer*, 377–78; Biemer, *Women and Property in Colonial New York*. Many wives received expansive powers of attorney from their husbands to conduct business on their husband's behalf, including appearing in court. See, e.g., Pearson and Van Laer, *Early Records of the City and County of Albany*, 1:279.

41. Todt and Shattuck, "Capable Entrepreneurs," 183, 207–8.

42. Gehring, *Fort Orange Court Minutes*, 289–90.

43. A wife needed to have only her husband's verbal consent, or power of attorney if his legal interests would be affected, to litigate a civil case. See Lee, *Introduction to Roman-Dutch Law*, 64; Grotius, *Jurisprudence of Holland*, 31.

44. See, e.g., Gherke, "Dutch Women in New Netherland," 146–49. Gherke analyzes debt litigation cases involving women and their provision of written proof. As well, Maria van Rensselaer maintained accounts for the patroonship of Rensselaerswyck. *Rensselaerswyck Manor Records, 1630–1899*, New York State Library, SC7079. In contrast, Ulrich has noted for northern New England that "although many such books survive, in the entire century between 1650 and 1750 there is not a single one known to have been kept by a woman." An account book was a noteworthy economic step even for a man, she asserted. See Laurel Thatcher Ulrich, *Good Wives: Image and Reality in the Lives of Women in Northern New England, 1650–1750* (New York: Knopf, 1982), 44.

45. For Dutch inheritance practices in intestacy, see Lee, *Introduction to Roman-Dutch Law*, 68. On the use of mutual wills in New Netherland, see Narrett, "Dutch Customs of Inheritance," 27–55. For instance, Tryntie Barentse and Cornelius Barentsen executed a joint will naming each other "co-testator" and bequeathing their mutual estate to "be inherited by the survivor" or to be divided equally among their surviving children in the case of both of their deaths. See Gustave Anjou, trans., *Ulster County, N.Y. Probate Records Vol. I & II* (Rhinebeck, N.Y.: Palatine Transcripts, 1980), 32.

46. Van Laer, *Correspondence of Jeremias van Rensselaer*, 203.

47. See Pearson and Van Laer, *Early Records of the City and County of Albany*, 1:278; 4:83; Gehring, *Fort Orange Court Minutes*, 79–80, 402, 475, 483–84.

48. Pearson and Van Laer, *Early Records of the City and County of Albany*, 3:216–18.

49. There were many compelling reasons why a woman might have chosen to remarry after the death of her husband. Companionship, legitimate and Church-sanctioned sexual activity, assistance in rearing children, and social pressure in a population with a skewed sex ratio are among them. However, one of the most important considerations in early America, particularly for widowed women, was financial. See Lois Green Carr and Lorena Walsh, "The Planter's Wife: The Experience of White Women in Seventeenth-Century Maryland," *William and Mary Quarterly*, 3rd series, 34, no. 4 (1977): 542–71; Terri Lynn Snyder, "'Rich Widows Are the Best Commodity This Country Affords': Gender Relations and Patriarchy in Virginia" (Ph.D. diss., University of Iowa, 1992). As noted earlier, partnerships between a man and a woman characterized Dutch marriages in New

Netherland and seventeenth-century New York. And while legal and cultural markers gave Dutch widows the ability of managing their affairs after the deaths of their husbands, many widowed women chose remarriage over continued widowhood. Narrett, "Dutch Customs of Inheritance," 29–33.

50. This is referred to as *sub tutela*. Grotius, *Jurisprudence of Holland*, 29–33.

51. For instance, Metje Wessels, widow of Wessel Wesselsz, was a New Amsterdam entrepreneur whose status and wealth were middling. Nevertheless, with resolution she personally defended her interests on many occasions during her marriage and during her widowhood. E. B. O'Callaghan, trans., Kenneth Scott and Kenn Stryker-Rodda, eds., *The Register of Salomon Lachaire, Notary Public of New Amsterdam, 1661–1662* (Baltimore: Genealogical Publishing, 1978), 7.

52. Dutch women typically retained their own patronymic. Calling her "the wife of X" did not subsume a woman's identity. On any formal legal documents, a wife or widow signed or marked with her patronymic.

53. Jasper Danckaerts, *Journal of Jasper Danckaerts*, ed. Bartlett Burleigh James and J. Franklin Jameson (New York: Scribner, 1913), 214. Danckaerts and his co-emissary, Peter Sluyter, were Friesland Pietists who had come to America in search of land for a Labadist settlement.

54. A. J. F. van Laer, trans. and ed., *Correspondence of Maria van Rensselaer, 1669–1689* (Albany: University of the State of New York, 1935), 37.

55. Although Livingston was born in Scotland, his father was exiled to Rotterdam in the Dutch Republic for religious reasons. Thus, Livingston grew up speaking Dutch. He immigrated to New York in 1673 and made a substantial fortune in the fur trade.

56. Lee, *Introduction to Roman-Dutch Law*, 79, 81; Van Laer, *Correspondence of Maria van Rensselaer*, 63.

57. Biemer, *Women and Property in Colonial New York*, 53–55.

58. Lawrence H. Leder, *Robert Livingston, 1654–1728, and the Politics of Colonial New York* (Chapel Hill: University of North Carolina Press, 1961), 24–32.

59. Van Laer, *Correspondence of Maria van Rensselaer*, 43.

60. Historians have contended that during the last decade of the seventeenth century, English acculturation affecting women was easily recognizable. Biemer, *Women and Property in Colonial New York*; Narrett, *Inheritance and Family Life*; Deborah A. Rosen, "Mitigating Inequality: Women and Justice in Colonial New York," in *Women and Freedom in Early America*, ed. Larry D. Eldridge (New York: New York University Press, 1997), 313–29; Salmon, *Women and the Law of Property in Early America*; Joan R. Gundersen and Gwen Victor Gampel, "Married Women's Legal Status in Eighteenth-Century New York and Virginia," *William and Mary Quarterly* 39 (1982): 114–34.

61. See Dennis Maika, "Commerce and Community: Manhattan Merchants in the Seventeenth Century" (Ph.D. diss., New York University, 1995).

62. David Narrett has revealed the declining role of widows in the social and economic life of late seventeenth- and eighteenth-century New York. See David E.

Narrett, "Men's Wills and Women's Property Rights in Colonial New York," in *Women in the Age of the American Revolution*, ed. Ronald Hoffman and Peter J. Albert (Chapel Hill: University of North Carolina Press, 1989), 91–133.

63. Biemer, *Women and Property in Colonial New York*, 7–9; "Criminal Law and Women in New Amsterdam and Early New York," in Zeller, *Beautiful and Fruitful Place*, 73–82; Joyce Goodfriend, *Before the Melting Pot: Society and Culture in Colonial New York City, 1664–1730* (Princeton: Princeton University Press, 1992). David William Voorhees ascribes "the angry and sometimes violent nature of women's actions" against men during Leisler's Rebellion (1689–91) as a result of the erosion (by men) of women's traditional economic and legal rights after the introduction of English law. See David William Voorhees, "'How Ther Poor Wives Do, and Are Delt With': Women in Leisler's Rebellion," *de Halve Maen* 70 (Summer 1997): 41–48.

3

Women as Witches, Witches as Women

Witchcraft and Patriarchy in Colonial North America

MATTHEW DENNIS AND ELIZABETH REIS

In early America, witchcraft was a serious matter. The Connecticut stat-
ute of 1642 conventionally designated it as a capital crime—defined in
part by the Bible, but proscribed and prosecuted as a secular, criminal
offense, punishable by death. Colonial Connecticut's law, like similar
codes in England, throughout Europe, and among various European
colonies, gives the impression of gender neutrality—it applied its stric-
tures to "any man or woman [who is found to] be a witch." But despite
the statute's gender inclusiveness, an accused "witch" was likely to be a
woman. The association has endured the test of time, but as this essay
demonstrates, a brief history of witch-hunting offers us a partial but
useful lens for surveying patriarchal power, how it was developed and
where it was absent or underdeveloped. The consideration of witchcraft
and its alleged practice helps us assess the status of women, their pre-
scribed roles, and their place within the new, shifting, cross-cultural
social worlds of early America.

Witches could appear at any moment in colonial America. Or at least
so believed virtually all of the inhabitants of North America, Native and
newcomer, throughout the seventeenth and eighteenth centuries, across
geographical regions and various colonial regimes, across class, race,
gender, and religion, and regardless of free or unfree status. Witches
haunted some places more than others, forms varied across cultures,
and major witchcraft outbreaks erupted irregularly. But few doubted the
presence of a powerful spirit world or the nefarious deeds of witches.[1]

This essay examines and complicates the proposition offered by the
historian Carol Karlsen, who famously declared, "The history of witch-
craft is the history of women." It suggests how the histories of women

and witch-hunting were imbedded in the history of power, especially patriarchy, a social order pervasive in the early American era that assigned women unique social and spiritual roles, which were often oppressive, but which cannot be reduced simply to misogyny—the hatred of women. Patriarchy and its alternatives, as well as misogyny, have varied over time, place, and circumstances. New World conditions sometimes made patriarchy hard to create, and colonial North America was a complex and variegated place shaped not merely by English Puritans, say, but by others professing different faiths or representing different national or ethnic groups, and by those native to the continent or who arrived involuntarily from continents other than Europe. In the social relations within communities and between them, power mattered, and that power was invariably gendered. When white colonists built their preferred social worlds in America, they often constructed, or aspired to construct, patriarchy—defined most simply as rule by fathers. Patriarchy was more than a set of benign customary arrangements; it was a system of power that fundamentally affected the lives of those who lived under it.[2]

Carol Karlsen's *The Devil in the Shape of a Woman* closely examined those accused in the major witch-hunting episodes in colonial New England and argued that, rather than merely powerless social misfits who might easily be scapegoated, these "witches" instead were often those who seemed threatening as formidable (or potentially powerful) women. Endowed with particular intelligence, facility in speech, and real or prospective independence and wealth, such women were unconventionally feminine and challenging within the context of the socially conservative, patriarchal communities in Massachusetts Bay or Connecticut. Karlsen's book struck a chord in a particular political moment, as it documented the persecution of strong women who might even be construed as proto-feminist. If feminist scholarship first emerged through the recovery of founding mothers, Karlsen helped supply a cast of admirable founding victims. And victims they were. Historians of witchcraft over the past three decades have built on Karlsen's contribution, and the historical association of women with witchcraft endures. But some have emphasized the role of female accusers as well as the experience of victimized "witches," the dynamics of religion and gender within Puritan communities, the relationship of these villages and towns

with neighboring Native people, and the proximate location of places such as Salem to the violent borderlands of seventeenth-century New England, beset with intercultural warfare. If the history of women and witchcraft remains entangled, it has pushed beyond the place where it was most prominent, New England, and confronted other diverse places and peoples, where it has had to account for varying and complex roles of "witches" and women.[3]

So, Karlsen is right: the history of witchcraft is the history of women. But it is also more and less than that. More: It is the history of gender more broadly, of male as well as female transgression; it is the history of the devastating, gendered encounter between colonial newcomers and Native North Americans and between New World masters and slaves. It is the history of the lowly as well as the powerful. Women's experience occurred within—and thus must be understood within—these dangerous realms, which featured a variety of forms of witch-hunting. And the gender of "witches" was embodied in complicated ways with class, race, and ethnicity. Less: In colonial America, the history of witchcraft is a history of the margins of human life. If belief in the dark art was pervasive, its eruption was peripheral, episodic, or erratic. Not all communities experienced it; most women were not accused, suspected, or directly affected. And yet margins help define the mainstream, in colonial America as in other times and places. The abnormal or unacceptable helped determine the normal and prescribed, offering a negative reference that shaped ideas and practices that were deemed conventional or exemplary. Transgressive acts defined standard behavior in part by demonstrating how not to be, what not to do, while prosecution of transgression policed the boundaries between legal and illegal, benign and evil, approved and forbidden, male and female, Christian and non-Christian, European and Native. As a New World was being constructed in North America, colonists transformed what was already there and remade the lives of Natives, immigrants, and their descendants. Witchcraft and witch-hunting punctuated that history, which offers us a lens on women's place and experience in diverse communities of early America.

For Europeans, witch-hunting operated in a pre-Enlightenment world, a "world of wonders" in which the causes of trouble (ill health, personal misfortune, family trauma, community crisis) were not always

clearly evident yet required explanation nonetheless. Explanations for real or potential problems need not be scientific or rational in a modern sense but instead might resort to accounts that featured the supernatural, religious, or magical. Witch-hunting demonized those believed to be culpable in this fashion and typically embraced as victims those who were socially disempowered but who, it might be imagined, could (and occasionally did) object to that disempowerment—particularly women. The witch represented a negative reference—what one should not be, or how one must not act—and witch-hunting exhibited the penalty for transgression, deterred the crime, cultivated compliance, and encouraged the internalization of accepted behavior for women and other marginalized groups. In cross-cultural situations, the disorder of witchcraft was complicated by the absence of one, single, integrated social order. Restoring (in fact, imposing) order and combating perceived attacks of witchcraft often entailed asserting colonial dominance. And the witch was defined by her complex of attributes—by her hybridity, or what feminist scholars have termed "intersectionality"—that is, by her (or his) ethnicity, class, and non-Christian status as well as by her gender in a complicated and inseparable fashion. Witch-hunting in such circumstances thus became a colonial act that demonized the Other and sought to reduce the Other to subservience. If witches were conventionally women in patriarchal colonial societies, in Native communities (with divergent gender organization that colonists found troubling) witches were not overwhelmingly female—that is, until they were reduced to "civility" and subordination. The course of patriarchy as a construction, prescription, and aspiration in colonial America can be charted in part by tracing the nature and practice of witch-hunting.

Witchcraft

The term "witchcraft" is notoriously difficult to define: In spite of the growing presence of neopaganism today, which has worked to rehabilitate witchcraft as a positive religious practice, in common parlance "witch" still carries nefarious connotations. Witches are those who carry out bizarre rituals—drinking blood, boiling newts, casting spells—with the intent of manipulating the universe, often to bring injury and disaster to those they disfavor. This is the lens through which Europeans

interpreted witchcraft, and in the course of their colonial incursions, when they encountered practices even remotely similar, especially when performed by those they feared or distrusted, they tended to label such practices witchcraft. Thus a host of individuals, practices, symbols, and cultural understandings have been packed uncomfortably under the umbrella labeled "witchcraft."[4]

Yet the varied beliefs and activities promiscuously categorized as witchcraft share some things in common. First, whatever their power source—God, Satan, the Goddess, lesser deities or spirits, some amorphous universal energy source—witches were thought to be effective channels of unseen, invisible forces. Second, witches are often found among the socially marginal. The socially prominent might also practice witchcraft, but as elites with access to social, economic, and political power they were far more likely to seek the witchcraft services of marginal individuals than to directly engage in the dark arts themselves. In intercultural circumstances, the colonial marginalization of Native communities could effect a blanket relegation in which even those with status and authority in that community were rendered marginal—and thus suspect of witchcraft, or sometimes motivated to pursue extraordinary, supernatural means to resist colonial encroachment or oppression.

"Witches," or those so designated, are virtually always socially marked by gender, class, or individual idiosyncrasy.[5] Although they may be male or female, the predominant image of the witch in the West was and is female, and unlike the vast majority of social roles, the witch is referred to conventionally in the female generic (she), with a feminine pronoun (her). In the patriarchal legal world of early modern England—which defined women as socially and legally subordinate to their fathers or husbands—witchcraft was a unique crime in which husbands were not held accountable for the illegal acts of their wives.[6] In some instances, witchcraft could allow the socially disenfranchised to claim power (at times, the only power available to them). More important, through the practice of witchcraft marginalized individuals—and sometimes, through them, marginalized classes—could gain some access to power and earn the respect, or fear, of their social superiors.

The phenomenon of witchcraft always has two aspects, independent of one another: practices of witchcraft and accusations of witchcraft. Both were intimately related to the disruptive interplay between invis-

ible power and the social location or status discussed above. If the practice of witchcraft could embody the hope of social power among the socially disempowered, witchcraft accusations more often embodied the fear generated among elites and authorities over the real or imagined discontent of the unprivileged or lower sorts. Depending on whom communities feared, witches could be personified as foreigners, slaves, transgressors of normative social categories (unmarried adults, or widows, for example), and most commonly women. Often these statuses or characteristics were complex and multiple. In early America, where evidence of the actual practice of witchcraft is limited, when we speak of "witchcraft" we are usually speaking of witch-hunting—the demonization and persecution of others.

Over the long history of "witchcraft," witchcraft accusations have represented the more prominent feature of the connection between witchcraft and political power. As numerous historians have shown, the great witch purges of sixteenth- and seventeenth-century Europe can be characterized as grotesque overreactions to whatever folk religious practices may or may not have been current among women and the lower classes at the time. Thousands of individuals were executed as witches (estimates range from a conservative hundred thousand to an outlandish eleven million) throughout Continental Europe and Great Britain over many decades, with the witch fever spiking and receding periodically, but never being soundly defeated until the mid-seventeenth century. Historians differ as to what prompted the witch persecutions, but few believe—as did the witch hunters and indeed their entire cultural milieu—that they were aimed directly at eradicating the practice of witchcraft. H. R. Trevor-Roper located the primary source of the witch persecutions in power struggles between the Protestant and Catholic churches; Norman Cohn pointed to deeply rooted psychological fantasies prevalent in the West from classical times; Anne Llewellyn Barstow implicated misogyny and male fears in relation to women's growing financial and personal independence. As Trevor-Roper sums it up, "[The witch myth] remained at the bottom of society, like a stagnant pool, easily flooded, easily stirred. . . . [A]ny social fear was likely to flood it, any ideological struggle to stir it, and no piecemeal operation could effectively drain it away." In short, these witch persecutions had more to do with the accusers than with the accused. The European witch hunts

were an essentially conservative political force, seeking to impose dominance, enforce orthodoxy, and preserve an idealized status quo in which social classes were cleanly demarcated and those lacking social power did not challenge those who did.[7]

The much smaller-scale witch trials in colonial New England, and the low-level but persistent witch-hunting elsewhere in colonial Anglo-America, both adhered to and departed from their European forbears. As in Europe, the actual practice of witchcraft was insignificant. Class issues and religious differences played a lesser role in the most historically prominent outbreak, in Salem, Massachusetts, in 1692. Puritans believed that women and men were spiritual equals in God's eyes, yet despite official rhetoric women were disproportionately accused and convicted of witchcraft in America, even in New England, as they had been in Europe. So let's turn to Salem, which even in its peculiarity offers an exemplar that will help us understand the history of women and witchcraft in early America.

The View from Salem

"Thou shalt not suffer a witch to live." The seventeenth-century Puritans of New England lived by this biblical injunction (Exodus 22:18). They were convinced that witches were real and threatening, and they sought to rid their communities of such evil. They were also sure that witches were mostly women. Some 344 persons were accused of witchcraft in New England between 1620 and 1725. Among the 342 who can be identified by sex, 267 were female—representing 78 percent of the accused. Roughly half of the 75 men accused were "suspect by association"—that is, because they were relatives of accused women. At Salem in 1692 over 150 people were formally accused, more than three-quarters of them were female, and nearly half of the males accused were the husbands, sons, or other relatives of accused women. The pattern continued as the crisis took its toll: 22 women and 5 men were ultimately convicted of the offense, and 19 were hanged (14 women and 5 men) before the new governor of Massachusetts halted the proceedings in October 1692.[8]

An easy—but inaccurate—way of explaining such numbers would be to characterize the Puritans simply as misogynists. In fact, Puritan New Englanders considered themselves to be more enlightened than others

when it came to women's place in their society and cosmology. They did not subscribe to the prevailing European view that women were inherently more evil than men and thus more likely to submit to Satan. Rather they maintained that women as well as men could share in the glory of conversion, oneness with Christ, and ultimately salvation. And yet it was women, by and large, whom the Devil tortured, hoping to recruit them into his service as witches. Womanhood and witchcraft were inextricably linked both to each other and to Puritan interpretations of evil and sin, even at Salem.

An accused witch's socioeconomic status and gender mattered, though by the end of the 1692 episode, virtually anyone, including men, church members, and the elite, could incur suspicion. The relentless pursuit of "witches," endorsed and encouraged by the magistrates most vehemently at Salem, was guided by an intense Puritan religious belief concerning sin, damnation, and the Devil's perceived presence in their world. Puritans believed that witches signed a pact with the Devil, thereby enlisting in his army against the godly. They tortured others, both doing the Devil's dirty work and enlisting recruits to Satan's side. Ministers spoke of the Devil's proximity in their weekly sermons, and they articulated the notion that his presence was ubiquitous. The clergy made it clear that intimacy with Satan ended one's chance of attaining saving grace and damned one to an eternity in hell. They preached that unreformed sinners—those who served the Devil rather than God— would be doomed, and they peppered their sermons with images of hell's dark abyss. Calvinism made salvation an uncertain reward for even the most righteous, but it surely damned those who followed the Devil's path. Even within the confines of predestination—a Calvinist Puritan doctrine that emphasized God's ultimate power and foreknowledge, in contrast to humans' weakness and lack of agency—sinners could indeed work their way to hell.[9]

Because complicity with Satan implied such dire consequences, Puritan ministers felt obliged to warn their audiences of the Devil's objectives, which they did without any conscious distinction in gender. Women, though, seemed to have internalized the message differently than men and believed themselves to be virtually unredeemable, slaves of Satan. In weekly sermons and written tracts, ministers repeatedly admonished their congregations not to fall prey to Satan's methods. While

the Devil could not force one to lead a life of sin and degradation, he possessed a frightening array of persuasive tools and temptations and would go to any length to lead people into sin, thereby possessing their souls. Perhaps unwittingly, ministers' evocative language and constant warnings about the Devil's intrusions reinforced folk beliefs about Satan in the minds of both ordinary churchgoers and other clergy. The violent battle between Satan and God, described in glorious and awful detail in ministers' sermons, became during the witchcraft crises a vicious confrontation between the accused and his or (more likely) her alleged victims. Most people in Salem, women as well as men, imagined that women were more apt than men to succumb to the Devil. Evidence brought to court during the trials sought to associate an accused witch with the Devil's deeds. The most convincing piece of evidence would have been an eyewitness account of the accused signing the Devil's book; if such testimony was not available, then evidence of wrongdoing on behalf of the Devil would be brought forward, though not always successfully.

Witchcraft accusations centered on perceived diabolical activity or harmful magic, *maleficium*. The accused usually denied such charges, though typically not the possibility that witches existed or that some did practice these dark arts. In colonial America it was presumed that witches used maleficium to injure others—accusers or their families, their persons or their property. "Witches" were suspected of a range of malefic acts, from relatively minor and annoying deeds, such as turning butter rancid, to more egregious feats, such as making cows ill, inflicting great physical pain on victims, or causing children to sicken or even die.[10]

In addition to proving maleficium, the court at Salem set out to prove that accused women had in fact signed the Devil's book—an act of diabolism that mirrored and mocked the Puritan covenant with God—and had thus become witches. (In other parts of colonial America less dominated by Puritan notions of the covenant, prosecutors focused less on the "black book" and more on proving maleficium.) Authorities hoped to find witnesses to these signings, as the laws of evidence required, but they also realized how difficult it was to obtain such proof; everyone knew that the Devil coerced his signatures in secret. In fact no witnesses to any actual signing ever came forward during the Salem trials.

Confessions were the next best thing. If an accused woman admitted to marking the Devil's book, then the case against her was ensured. Early in the Salem episode, the court departed from normal practice and postponed the hanging of those who confessed, hoping that these "witches" might be persuaded to name others involved in the wicked affair. Surely this unusual decision—and the avenue of reprieve or escape it seemed to open for the accused—helps to account for many of the approximately fifty confessions. Yet self-preservation alone does not explain the admissions of guilt at Salem, even though those accused faced the gallows.

Though it is true that approximately fifty women confessed to making a pact with the Devil, most of the accused denied any association with Satan, and those who did confess often did so unintentionally. Honestly searching their souls for evidence that they had signed the Devil's pact, especially in the fraught circumstances of 1692, Puritan women may have confused ordinary sin with the more grave offense of witchcraft. Because women tended to see themselves as weak and sinful, under pressure they sometimes conflated ordinary sin (in Puritan theology, an implicit covenant with the Devil) with an actual, conscious commitment to serve Satan (signing one's name in the Devil's book). Amid the extraordinary stress of the trials, and the pressure of guilt for ordinary transgressions, women's sense of their own mundane complicity with Satan convinced some that they might indeed be witches and therefore deserving of their fates.[11]

Witchcraft in the English world was an exceptional crime—a *crimen exceptum*—not only dangerous but also difficult to prove. As such, normal procedures might be altered; extraordinary means of extracting confessions or looser standards of evidence might be accepted. Judicial torture in New England was rare or absent, but the Salem trials did rely, in addition to the coerced and unwitting confessions of vulnerable women, on the admission of "spectral evidence"—the supposed appearance, even in courtrooms, of ghost-like figures only accusers could see. The trials ended when such unverifiable sightings of witches were disallowed, and other corroborating evidence was lacking.

Throughout early American history, the concept of the "witch" and charges of witchcraft helped set and police the boundaries of female normality and acceptability. Women who challenged cultural notions of appropriate conduct, whether intentionally or unintentionally—even

women who wholeheartedly embraced conventional social rules—were vulnerable to apprehension and mistrust and in extreme cases to accusations of witchcraft. Although "witches" in early America could be either male or female, witchcraft, witch-hunting, and womanhood are inextricably linked in American history, as we can see even when looking beyond Salem.

Beyond Salem; or, Salem in Context

What does a history of witchcraft tell us about women's experience outside New England? Colonists brought Old World beliefs, practices, and understandings with them to their American settlements, including worldviews in which Satan and his minions posed a credible threat and that in practice held women to be more susceptible than men to the Devil's snare. But much could be altered in the translation of Europeans into American colonists. Reproducing Europe in America proved difficult and was not always promoters' or colonists' conscious objective. Negotiating new and difficult circumstances, new landscapes that included Native people, and pursuing a range of economic, social, and religious experiments in the New World produced unsettlement as well as settlement. Not surprisingly, most witchcraft accusations emerged in those places most like the settings that had spawned them in Europe— the small, dense, face-to-face communities of Massachusetts and Connecticut most able to re-create the patriarchal social structure of early modern Britain. Elsewhere, basic assumptions about patriarchy as the ideal, natural order persisted, but they were less easily applied, at least initially.

The first "witch" brought before an Anglo-American colonial court, predating any New England prosecutions, was actually one Goodwife Wright in Virginia in 1626. But in the Chesapeake region, only one woman was ever executed for the offense (in Maryland in 1685), and Virginia saw but one successful prosecution—of a man in 1656, who was whipped and banished rather than hung. The Chesapeake contrasted with New England on a number of counts. Economically, it emphasized plantation agriculture and commodity production; it depended on unfree labor, both indentured servants and then slaves. Demographically, it was long unstable and unable to increase its population without constant

in-migration (as opposed to reproduction); a skewed sex ratio, with fewer women than men, throughout much of the seventeenth century meant wives were scarce and families small and vulnerable. And Chesapeake settlement was dispersed rather than concentrated in intimate villages and towns like those in New England. White women lucky enough to survive amid the Chesapeake's insecure and dangerous conditions could sometimes escape the yoke of patriarchy and experience greater liberty and opportunity than elsewhere, though at great personal cost. With the premium placed on scarce marriage partners, and with life expectancies typically limiting colonists to little more than forty years, white Chesapeake women in the seventeenth century seemed to have more readily escaped suspicion, or at least prosecution, of witchcraft.[12]

In West and Central Africa, belief in witchcraft was pervasive, as it was in Europe and the Americas. If it helped Africans explain unusual or otherwise inexplicable calamity, as it did other adherents, then the protracted misery of the Atlantic slave trade and New World slavery itself likely inaugurated for Africans a new age of witches. The witchcraft beliefs and practices of Africans were diverse. But we might generalize cautiously that such practice included divination, conjuring, and healing to restore balance and health to individuals and communities. Witches—who might be either male or female—deployed power to harm, but they could also use their skills to defend clients against others' malicious magic or to counteract it. Diviners and healers (called *Obeahs* among the Igbos of West Africa) played an important role by interceding with the spirits that populated these worlds and affected the lives of the living. Obeahs performed rites that appeased these spirits and helped restore or maintain harmony; without their work, illness, disease, suffering, and death would reign.[13]

It is likely that witchcraft beliefs and practices came to America in slave ships and operated widely among enslaved African communities, but the contempt inherent in the slave system militated against close considerations of African spiritual or cultural practices by white masters and precluded the production of firsthand accounts of "witchcraft" that might have survived as written historical documents. And in any case, enslaved Africans often sought to conceal much from white masters, in their efforts to maintain a sense of identity, worth, and autonomy, and to cultivate a means of survival and resistance, perhaps through the use

of fetishes and poisons associated with African witchcraft. Some have suggested that, unlike Europeans, Africans tended to see witches among the powerful rather than the weak and marginal; if so, the context of slavery in the Atlantic world, with its phenomenal abuse of power, was the setting for an unprecedented display of witchcraft.[14]

The history of African American witchcraft was not simply the history of women, at least not exclusively. African "witchcraft" was apparently not gendered female within slave societies, which makes sense given the extent to which white masters sought to dehumanize all their bonds people, considering them as mere machines of production and denying them the statuses and roles normally assigned to their respective sexes—motherhood for women and patriarchy for men. Whites were prepared to denigrate and demonize black men and women alike, even as witches. And they were conscious and fearful of other, more concrete and overt threats from their slaves. Though in the British North American mainland colonies large-scale slave rebellion was usually precluded, the enslaved might use other overt and covert means to subvert or resist masters—malingering, feigned ignorance or incompetence, sabotage, flight, or surreptitious acts like pilfering or poisoning their oppressors. Witchcraft was likely employed as well, though its hidden history makes clear conclusions about the gendered practice and dimensions of witchcraft difficult.

In the Middle Atlantic region, New Netherland (later New York) emerged in the 1620s and developed fitfully under the auspices of the Dutch West India Company and the States General of the Netherlands through the 1660s. Witch-hunting was rare there as well, except among New Englanders who began to encroach on the province by settling eastern Long Island. In the colony's seaport town of New Amsterdam (later New York), the relentless commitment to commerce and the peculiar economic opportunities available to white colonial women under the Dutch regime perhaps deflated suspicion of (or prosecution for) witchcraft. Here, even in the more rural settlements of New Netherland along the Hudson River, an English style of patriarchy did not take shape. Nor did it north of New Netherland in New France—in the Canadian settlements of Quebec, Trois-Rivières, and Montreal and their environs—where witch-hunting was relatively absent. The instability and geographic diversity of the colony, the young and heavily male de-

mographic structure of its habitant population, the dispersed settlement patterns, which did not produce the dense, proximate living conditions that most often fostered charges of witchcraft, and the dominance of Jesuits more interested in their missionary work among Native people than in the work of the Devil among the habitants all shaped the experience of women in New France and shielded them largely from witchcraft prosecutions.[15]

Pennsylvania was founded late in the seventeenth century, quickly grew, and flourished in the eighteenth century as a commercial entrepôt and magnet for European immigration—Quakers from the British Isles predominantly, but additional thousands from German lands as well. These places had been the center of witch-hunting in Europe in the sixteenth and early seventeenth centuries, but Pennsylvania settlement occurred largely after those tumultuous events had ended in Europe, and amid the growing repudiation of America's greatest outbreak at Salem, which had been undertaken by those who had also demonized, "warned out," and in some cases executed those Quakers who insisted on returning to New England. William Penn, his colonial collaborators, and his successors erected a legal culture in Pennsylvania that was unsupportive of witchcraft accusations. Few cases came to trial there, even though white immigrants and residents certainly indulged their beliefs in the supernatural, including black as well as "white" magic (charms, conjuring, divination, magical healing), with the latter at least tolerated. Yet even as late as 1787, in Philadelphia, while representatives were framing the U.S. Constitution, a "witch" was mobbed twice by German residents and ultimately killed for her alleged malefic acts, which supposedly included the murder of a child. Authorities and the press condemned this witch-hunting, but the tragedy reflected a persistence of the belief in witchcraft and its gendering as female.[16]

The limited official prosecutions of witchcraft outside of New England (which generated court records conveniently preserved as evidence for historians) did not mean a lack of belief in witches or the absence of informal or extralegal proceedings against them, as the ugly incident in Philadelphia suggests. Personal slights, dislikes, and disputes could accumulate, cultivating suspicions and at times igniting rumors, accusations, and physical reactions. Though neighbors might not pursue a case of "witchcraft" through formal legal channels, they could deal with

suspected witches on their own, by shunning, pressuring, or harassing them, and by administering their own vernacular punishments. In some cases, as in late seventeenth-century Virginia, colonists enlisted their own magic to counteract the dark arts of a suspected witch. A "witch bottle" unearthed at an archaeological site at Virginia Beach had likely been filled with pins and nails and been buried in an inverted position to counteract a witch's curse and turn it back upon her, or so the fearful hoped. Historians have no way of knowing how many such artifacts have been lost or how many unneighborly acts of harassment against "witches" actually occurred but went unrecorded, lost to our historical archives.[17]

We might trace the experience of white colonists in other provinces that emerged during the period of the English Restoration or later, and in the process we might reconstruct their colonizing motives and assess their performance in constructing new economies, stable societies, and effective legal and political systems. Belief in witchcraft remained common and normal in those diverse places, even as skepticism about its actual deployment in specific settings grew, and the common sense persisted that, when and where it did rear its ugly head, witchcraft would appear in the shape of a woman. Witchcraft simmered as an endemic, dangerous, female disease among white, European colonists—ever circulating, never broadly catastrophic, but never eradicated either. But we might broaden our view and consider another source or reservoir of that diabolical contagion. When peering across cultural frontiers, white colonists could perceive a threat of a demonic pandemic, and they initiated some major witch hunts to combat it.

Witch-Hunting on the Borderlands of Colonial North America

From the beginning of American colonization, European commentators emphasized the cultural differences between American Natives and European colonists, often equating Indian difference with inferiority. Among the most important—and appalling—differences noticed by European observers among the Native people they encountered was the latter's tendency to ascribe higher status, greater autonomy, and more power to women. The tremendous diversity among the peoples of Native North America dictates caution in generalizing about them, on

matters of gender or virtually any other cultural characteristic. Nonetheless, numerous Native societies organized themselves in ways completely at odds with European and colonial norms and expectations regarding women's place and family organization—particularly those nations and communities that lived in clans and families that were matrilineal (reckoning descent through female lines) and matrilocal (households encompassing female relatives). Although some Indian communities organized themselves patrilineally, none embodied European or colonial styles of patriarchy.

Yet, at least in one respect, the similarity among these contending peoples is striking: they uniformly believed in a world of revelation, magic, and witchcraft. This shared belief hardly brought the two peoples together. Indeed, Indian supernaturalism, particularly claims of direct, personal revelation, made Natives suspect in the eyes of colonists and helped to persuade English settlers that Indians liberally practiced the dark arts. Hostile colonists could characterize the Natives' homeland as a "devil's den"; they often portrayed the Indians' natural religion as diabolical, understood Native shamans or powwows as witches, and demeaned Native religious practitioners as slaves of Satan. Thomas Morton, for example, wrote of the "Petty Conjuring Tricks" of Massachusetts Indians in 1637: "If we doe not judge amiss of these Salvages in accounting them witches, yet out of all question we may be bold to conclude them to be but weake witches, such of them as we call by the names of Powahs: some correspondency they have with the Devil out of all doubt, as by some of their actions, in which they glory, is manifested." Or consider the missionary Thomas Mayhew, Jr.'s description of the Wampanoags of Martha's Vineyard in 1652: "When the Lord first brought me to these poor Indians on the *Vinyard*, they were mighty zealous and earnest in the Worship of False gods and Devils; . . . The Devil also with his Angels had his Kingdom among them; . . . by him they were often hurt in their Bodies, distracted in their Minds, wherefore they had many meetings with their *Pawwaws*, (who usually had a hand in their hurt) to pacifie the Devil by their sacrifice. . . . The *Pawwaws* counted their Imps their Preservers, had them treasured up in their friends."[18] Perhaps most disconcerting about this description is that Mayhew, who spoke the Wampanoag language, was himself a knowledgeable and not particularly hostile observer.[19]

Mayhew focused here on the Indians' supposed alliance with the Devil. Often just as damning in the eyes of colonial commentators were Native systems of organizing gender. In 1634, for example, the not unsympathetic observer William Wood in his *New England's Prospect* disparaged the supposed overwork and ill treatment of longsuffering Algonquian women, forced (he claimed) to perform virtually all the toil of their society—building their family dwellings, and rebuilding them during frequent relocations, when they were "often troubled like snails to carry their houses on their backs"; planting and tending crops; processing, storing, and preparing food; fashioning and repairing clothes; watching children; and acting as caterers and porters for their gourmandizing and lazy husbands. Wood's critique was consciously comparative—it elevated English gender norms and suggested how good colonial women had it—and it was reproachful of Native society, even though it seemed to assess Native women positively. Difference equaled inferiority. Wood deemed women's economic responsibility excessive, while he missed (or ignored) important ethnographic details about women's status and the utility of the Native sexual division of labor. For many English commentators, Algonquians were "savage" both because they mismanaged gender arrangements and because they worshipped the Devil. Wood and other observers were not concerned that Native women as drudges lacked power—they condemned the empowerment of women they observed among Iroquois societies, for example. Rather, they objected that Native societies like the one Wood described were not appropriately patriarchal. Patriarchy might lessen women's workloads; cultural transformation would affirm (not challenge) women's subordination to husbands and fathers, while rendering that subordination legitimate, as men earned their natural and just dominance by taking on new kinds of laborious work and adopting a new condescension toward women, now regarded (and protected) as weaker vessels. Native women's liberation, as imagined by English colonial observers, would elevate Algonquians or other Indians by reducing them to civility. Only when so reduced, or absorbed into the margins of white society, might Native women prove more threatening as "witches."[20]

The religious contest between Puritans and Indians—or between Europeans and Native Americans generally in the colonial period—was not principally a battle of modernity against primitivism or reason ver-

sus revelation. It was a contest of power (visible and invisible, physical and magical), and in the minds of Europeans it pit a stronger against a weaker god. Against Christ, they believed, Indian gods—and devils—were simply overmatched. This providential view of triumphant European colonization would continue to set the tone for Euro-American understanding of Indian religion in subsequent eras.

But while colonial representations of Indian witchcraft gave the narrative of American colonization a mythic quality—as an epic battle of good versus evil—Native people (women as well as men) believed *themselves* to be the primary victims of witchcraft. Epidemics decimated Native populations; white encroachment depleted game, destroyed crops, undermined larger subsistence systems, and alienated land. Christian missions subverted Native societies and sought radical, painful cultural transformations that were gendered and could reduce women's authority, status, and autonomy. And chronic warfare brought violent death and turned Native worlds upside down. Like European colonists, Indians often understood these events in providential terms, especially when they proved so catastrophic. When the incomprehensible occurred, and normal explanations were unavailing, they too sometimes located the cause of their crisis in witchcraft. If witchcraft helped explain extraordinary misfortune and evil, then it might follow that the European colonization of America, with its attendant dislocation and misery for North America's Native people, introduced a new age of witchery. As witchcraft seemed to wane in Europe, it waxed in North America amid colonization's eruption of unfathomable conflict and calamity.

Belief in witchcraft likely predated European colonization, though ideas and practices varied among the peoples of Native North America and evolved during the course of their encounters with intrusive European colonial societies. Many Natives lived in a physical, natural, and supernatural world of wonder, populated with diverse animate beings that remained in balance only through cooperation and the faithful fulfillment of ritual obligations. Trouble occurred when that balance was disrupted, particularly when human and nonhuman actors failed to perform their duties—giving thanks, avoiding taboos, paying just tributes, upholding responsibilities. Power was often understood to be neutral, a force or resource that might be used for good or evil, to restore or upset the balance, health, and prosperity of persons and communities.

Shamans and powwows—religious practitioners with access to power and some ability to manipulate it—were critical in this world. Though respected and usually intent on doing good, a shaman was neither essentially good nor essentially evil. Such persons of power who performed harmful acts through invisible means became "witches," though the raw power they deployed was not itself evil or shamans themselves generically diabolical. It is possible therefore that witchcraft was a specialized form of shamanistic practice devoted to evil that developed only after contact with colonizing European Christians. More than a half millennium removed from the pre-colonial world of Native North America, we cannot be sure.[21]

Despite Native diversity and limited sources, it is possible to get a sense of Native witchcraft and witch-hunting from the imperfect historical and ethnographic records historians and anthropologists have amassed. The Haudenosaunee, or Iroquois, who resided in central and western New York in the colonial period, offer an exemplary case. Again, we must distinguish between the "witchcraft" attributed to Indians by ignorant or biased white observers—misrepresentations of misunderstood Native rites and beliefs, which had nothing to do with any diabolical force—and the witchcraft that Indians believed actually troubled their existence, an indigenous craft uniformly regarded by them as nefarious and dangerous.

According to the Jesuit missionary and ethnographer, Father Joseph-François Lafitau, who lived among the Iroquois early in the eighteenth century, "the men and women who cast spells [sorcerers] are regarded . . . as *agotkon* or spirits because of the traffic which people think that they have with the spirits or tutelary geniuses. . . . [T]hose who cast spells have no other aim than to harm and work harm." These "evil ones" are "the authors of their curses and witchcraft."[22] For the Iroquois, *agotkon, utgon,* or *otkon* was the evil force that witches personified, as they mobilized *orenda,* or power, for harmful purposes to injure others, even their own kin. Witches—both women and men—inspired near universal fear among Iroquoians, and those suspected of such maleficence were hated and avoided. Although Lafitau decried Native shamans as *jongleurs* ("jugglers" or charlatans), unlike Puritan commentators he nonetheless distinguished shaman practices from those of witches, who inspired considerable antipathy among the Iroquois.

Witches' afflictions threatened the mental and physical health of individuals and entire communities. Iroquois men and women struggled to discern whether the injuries, illnesses, and misfortunes that periodically beset them resulted from natural processes or sinister magic. When natural remedies failed to produce results, and when rituals to uncover hidden wishes of the soul through the examination of dreams failed to have their therapeutic effect, it became clear that witchcraft lurked nearby. In a society based on consensus and the avoidance of outward expressions of conflict, Iroquois men and women repressed their aggression, but such feelings could still simmer below the surface, waiting for opportunities to express themselves. Witchcraft offered some a covert, wicked means to assault antagonists within Iroquois communities, to indulge one's sense of resentment, rivalry, jealousy, even hatred in secret ways. Behind affectations of serenity or stoicism could lay intense feelings and emotions; disgruntled persons could silently cultivate enmity for years and might be driven, ultimately, to seek the help of witches to punish their enemies or to indulge in the black arts themselves. Fear of witches certainly encouraged circumspection and repression of aggressive acts among the Iroquois, but it also bred endemic suspicion.

Such was the danger of witchcraft that the Iroquois, like English Puritans, would "not suffer a witch to live." They sanctioned the execution of witches, and they exempted witch killing from the rules of kin-based revenge and atonement. In 1653, the Jesuit missionary Francesco Gioseppe Bressani wrote about the culturally similar Iroquoians, the Hurons, that "their confidence . . . in the multiplicity of spells and witchcraft went so far, that upon mere suspicion they often killed and burned even their fellow-countrymen, without any other accuser or judge than a dying man, who said that he had been bewitched by such a one, who was killing him."[23] A witch discovered among one's own lineage or clan, after all, could be more dangerous than one operating from afar—he or she could become a cancer within.

Fear of witches, diabolical sorcery, and witch-hunting were gendered among the Iroquois, but in ways more complicated than we might expect, given the nonpatriarchal nature of this society. Witchcraft and witch-hunting among these Native people reveal, then, not discrimination against women or their oppression, as in European or colonial societies, but rather a greater equality among the sexes and a more el-

evated place for women. Wherever antagonisms tended to surface in seventeenth- and eighteenth-century Iroquois culture, witchcraft might be implicated. Frustrated men, for example, might seek aid in hunting, fishing, or trading activities, to counteract bad luck in such (male) enterprises, and some could be so driven to distraction that they crossed over to the dark side, seeking the services of (male or female) witches. Some may have become witches themselves; others procured magical charms—considered living, nonhuman persons of great power—which required careful handling. Those who failed to propitiate them, by feeding, talking, singing, or listening to them, could endanger themselves and their families, as dishonored charms could "turn on" and "eat" their holders. Similarly, women (or men) sometimes resorted to witchcraft as well as legitimate magic in the interest of love, which might have enticed them to cross the line separating the benign from the malignant. In general, in contrast to European and colonial witch-hunting, those suspected, accused, and executed among the Iroquois were no more apt to be women than men. Iroquois men and women practiced and suffered witchcraft equally; it was a male as well as female art.

If conscientious religious practice ensured balance, health, and prosperity, witchcraft's malignant object was to challenge and frustrate the cosmic order and to afflict suffering on its victims. As the accusation against a Jesuit missionary above suggests, Indians often associated sickness with witchcraft. Who or what caused loved ones to sicken and die, and what force precipitated the unprecedented misery of epidemic disease, which destroyed entire villages and nations? For many, the logical answer was witchcraft. And witchcraft was implicated in the disasters Native people experienced in the late colonial and early national periods as well, when the American Revolution and its aftermath brought new rounds of death, disruption, and dislocation to the Iroquois and numerous other Indian people. As Natives struggled to reconstitute themselves and survive, visionaries emerged among their leaders who offered charters for the future that blended tradition and innovation.

Many such prophets—the Seneca Handsome Lake and the Shawnee Tenskwatawa, for example—distinguished themselves as adept in identifying witches. Native witch-hunting sometimes played a critical role in these postcolonial Indian revivals, identification and prosecution of alleged witches destroyed those deemed responsible for the chaos (col-

laborating leaders who sold land, for example), and continued purges of Native opponents labeled as witches—anyone who dissented or frustrated the prophets' reforms—helped to forge a Native solidarity based on fear but designed to resist the pressures of white encroachment. Ironically, as Indians sought to survive the continuing colonialism of the new American nation after enduring generations of encroachment and Christian evangelizing, and as they struggled internally for solutions, sometimes they indulged in a sort of witch-hunting akin to that which afflicted Salem in 1692, not only in its self-destructiveness but also in its increasing demonization of women. That was the case among the Senecas in the early nineteenth century, as women represented a bloc of resistance to Nativist reform that threatened their property, status, and power.[24]

Thus some of largest and most devastating witch hunts in colonial America after Salem occurred along the borderlands that simultaneously separated and joined European colonists and Native Americans. These too inform and refine our proposition that the history of witchcraft is the history of women. We have discussed English, Dutch, and French colonization, but, more than any other broad colonial enterprise, Spanish efforts brought Natives and European Christian newcomers together, attempted to integrate them closely, and in the course of that difficult (and often oppressive) experiment associated Indians, Africans, and mestizos (those of mixed Indian and European heritage) with witchcraft. As historian Alison Games writes, "The Spanish inclination to link resistance to their political domination to witchcraft had the consequence of making witchcraft seem pervasive in the Americas where it had been of minor importance (in terms of executions and threats to community order) in Spain."[25]

One of the most famous (and successful) Native rebellions against a colonizing power in America occurred in the Pueblo Revolt of 1680 in New Mexico. Spanish conquest and colonization had begun there in 1598 and grew to dominate the various Pueblo towns and peoples of the Rio Grande Valley. The travails of the 1670s—including drought, crop failures, famine, devastating attacks by Apaches and others, and the abuses of both priests and secular officials—created a crisis among the Pueblos and inspired some to more actively resist Spanish domination and Catholicism while restoring their older gods and rites. In response

the Spanish colonial governor, Juan Francisco Treviño, launched a witch hunt against nearly fifty Pueblo medicine men or shamans, whose "sorcery" he blamed for the resistance. Some "witches" were hanged, others whipped and imprisoned, including a San Juan man named Popé. Popé eventually won his release, but he and others organized a coordinated revolt that in 1680 killed some four hundred Spanish colonists, including twenty priests, drove the Spanish from New Mexico for a decade, and established a long-lasting measure of autonomy for the Pueblos. Was witchcraft at the root of this resistance, as Spaniards believed? Probably not, at least not from the Pueblos' perspective, as they deployed power in the interest of a cause they understood to be good (their liberation, health, and prosperity).[26]

Other resistance was similarly connected with witchcraft by Spanish colonial authorities, most dramatically at Abiquiu in New Mexico beginning in 1756 and lasting for ten years. In this instance witch hunts unleashed by the Spanish governor and priests produced two hundred accusations against alleged witches among Abiquiu's Genízaros—Hispanicized Native people, former captives (and often slaves) taken from various Plains Indian tribes who had created a new hybrid community that (often covertly) mixed Native and European cultures. At Abiquiu, social stress and security concerns merged with efforts by local Spanish secular and religious authorities to impose orthodoxy and broader conformity (even some Hispanos sought the remedies of *curanderos*, Native healers). A Genízaro man named El Cojo (the cripple) was accused of making a pact with the Devil, and investigations uncovered among the inhabitants numerous practices that seemed to represent a diverse blend of European and Native magical beliefs, rites, and objects. To local authorities these practices constituted witchcraft, and they tortured to extract confessions, attempted to identify additional "witches," and imprisoned and punished alleged malefactors. But skeptical Inquisitional authorities in Mexico City refused to authorize executions, questioning the evidence of actual diabolism; the trials ended, and the crisis dissipated, though not before five had perished in jail.[27]

These witch hunts, though distinctive, bore some resemblance to the notorious outbreak at Salem, although in Spanish colonial campaigns against "witches" women were sometimes less exclusively victimized (they were prominent at Abiquiu, less so during the Pueblo Revolt).

These incidents nonetheless confirm generalizations about witch-hunting as scapegoating—here by race or ethnicity, or caste, rather than by gender primarily (though gender could be implicated in other ways). They occurred in densely settled, troubled places, where people lived in close proximity and chafed under the imposed patriarchal order. In New Mexico, patriarchy was more centralized than in Massachusetts—in a governor and Catholic *padres* (fathers). The Native inhabitants of New Mexico employed magic as marginal people in order to resist domination, cultivate respect or fear, and sometimes achieve liberty. In this way they were different from those accused at Salem. But the witch hunts of the colonial governors Treviño and Vélez Capuchín in New Mexico, like the one marshaled in Salem, were launched mostly against those who understood themselves *not* to be witches. Both outbreaks thus point to the relative prominence of witch-hunting in colonial America, a pursuit that could be remarkably independent of any actual practice of witchcraft among the inhabitants of early America.

Is the history of witchcraft in colonial New Mexico the history of women, then? In a sense, this "history of witchcraft," as recorded in Spanish records, was not fully a history of witchcraft at all, given that its actual practice, whether by women or men, was often suspect, sometimes conjured by the imaginations of Spanish officials and missionaries facing Native opposition and resistance. Witchcraft in New Mexico was not *exclusively* "the history of women"; Native women were not disproportionately demonized as witches. Yet if "witches" were defined inclusively, by an entangled complex of intersectional statuses (including gender, race or ethnicity, class, caste, or colonial condition), and if Native witchcraft and colonial witch-hunting could victimize women as well as men, often in gendered fashion, then it was. Limited witchcraft accusations against women (or accusations more balanced by gender) within these Native worlds evidenced a nonpatriarchal social organization that European colonizers found odd and troubling. Spanish padres and patrons sought to impose a patriarchal system that would subvert matrilineal social organization (among Pueblo peoples, for example) and subordinate both women and men, while it re-created Native society in its own image, imposing new gendered hierarchies in which men would dominate. Witch-hunting in New Mexico became a colonial act that demonized Native people generally and attempted to reduce them

to subservience—to the Church and the colonial state. The course of patriarchy as a construction, prescription, and aspiration in colonial America—in places as different as Abaquiu and Salem—can be charted in part by tracing the nature and practice of witch-hunting.

Conclusion

The specter of witchcraft haunted North America, infiltrating the worlds of both Natives and newcomers. Witchcraft helped explain the otherwise unfathomable calamities that Indians, colonists, and their slaves sometimes faced, individually and collectively. And under the right circumstances they pursued witch hunts that demonized those who struck them as odd, marginal, transgressive, or threatening. Often, though not uniformly, this meant women. Acts easily defined as witchcraft could be implicated in colonial resistance among Native people, but it is likely that many such magical and physical deeds of defiance were not understood by those who carried them out as witchcraft, as the action of "witches." This was certainly the case among the accused at Salem and most other "witches" pursued through legal and extralegal means throughout the Anglo-American colonies. Nonetheless the extraordinary prosecutions of "witches" set normative boundaries for behavior in ordinary times, and they deterred potential transgressors. Because witchcraft was conventionally gendered female within patriarchal orders, these prescriptions and warnings helped define acceptable female behavior, shaping the parameters of womanhood itself. "Witches" loomed as a negative reference against which all that was right and decent for women could be delineated.

Witch-hunting emanated from fear—a fear that we might now dismiss as fantasy but that was all too real to denizens of colonial America. Witchcraft demanded action, defensive action that paradoxically resulted in aggression, and that aggression often focused on those who seemed to challenge authorities. As such, witch-hunting helped to establish colonial domination, enforce patriarchal authority, and police the norms of Christian "civility" and true womanhood. It simultaneously fashioned a place of subordination for women and served a larger colonizing project in which conquest, expropriation of land and resources, cultural transformation of Native people, and European

settlement of North America were fundamentally gendered. Whether functioning internally or externally, witch-hunting throughout the colonies, even if rarely employed, carried a veiled threat. Its implicit intimidation helps explain the hegemony of patriarchy built not simply (or primarily) through external force, but though the internalized control women and others imposed on themselves, as they sought to survive and prosper by "playing by the rules." Indeed, without conscious misogyny women and men could embrace a world that was profoundly unfair (even oppressive) for most women (and many men), and women and men both could justify their existence and get along by cooperating in the enforcement of the negative prescriptions of witchcraft. It is not surprising therefore to see women condemning other women perceived to be transgressive. Similarly, we should not be surprised to see increasingly imperiled and dependent Native people sometimes cooperating in the suppression of Native "witches" and their rebellions, a complicity that also reflected prudent calculation within the diverse and complex political geography of Native North America. Witch-hunting was thus not simply misogyny or self-hatred but instead an accommodation to power. Disruption and crisis—particularly when they involved the frightening appearance of witches—were to be avoided, clearly worse than the unlikely prospect of success in an effort to change the world. Patriarchy was stifling in its embrace, but it was often unavoidable and at times seemed to offer safety.

NOTES

1. That statute read, "If any man or woman be a witch (that is) hath or consulteth with a familiar spirit, they shall be put to death. Ex: 22.18: Lev: 20.27: Deu: 18.10, 11"; James Hammond Trumbull and Charles Jeremy Hoadly, eds., *The Public Records of the Colony of Connecticut, from April 1636 to October 1776*, 15 vols. (Hartford, Conn.: Brown and Parsons, 1850–90), 1:77. Though the extent and depth of witchcraft in the colonial era might strike us today as astonishing and the belief itself as outlandish, we might contemplate the fears common to modern America, some of them largely imaginary or based more on faith than evidence, and we might consider the results of a 2007 Harris poll reporting that 31 percent of Americans believe in witches, or the evangelical leader Pat Robertson's explanation for the January 2010 Haiti earthquake, which he declared the result of an ancient pact between that nation's people and Satan. See Alison Games, *Witchcraft in Early North America* (Lanham, Md.: Rowman & Littlefield, 2010), 90–91.

2. Carol F. Karlsen, *The Devil in the Shape of a Woman: Witchcraft in Colonial New England* (New York: Norton, 1987).

3. See, for example, Jane Kamensky, *Governing the Tongue: The Politics of Speech in Early New England* (New York: Oxford University Press, 1997); Elizabeth Reis, *Damned Women: Sinners and Witches in Puritan New England* (Ithaca, N.Y.: Cornell University Press, 1997); Reis, ed., *Spellbound: Women and Witchcraft in America* (Wilmington, Del.: Scholarly Resources, 1998); Mary Beth Norton, *In the Devil's Snare: The Salem Witchcraft Crisis of 1692* (New York: Knopf, 2002).

4. On contemporary neopagan religious practice, see especially Cynthia Eller, *Living in the Lap of the Goddess: The Feminist Spirituality Movement in America* (Boston: Beacon, 1995).

5. See John Demos, *Entertaining Satan: Witchcraft and the Culture of Early New England* (New York: Oxford University Press, 1982).

6. In most regions of Europe, women represented approximately three-fourths of those executed as witches. The predominance of women was particularly pronounced in England (amounting to 93 percent in the county of Essex, for example). Gender-specific prosecution was not universal; scholars have found some variation in the sex ratio of "witches," ranging from Iceland, where only 10 percent of the accused were women, to Poland, where women represented 96 percent. Similarly, even within countries that mostly marked "witches" as female, rates of demonization by sex could vary; in France, for example, 81 percent of those accused in the Department of the Nord were women, but in parts of Normandy between 1560 and 1660 some 73 percent of those accused were men; see Games, *Witchcraft in Early North America*, 12–13.

7. H. R. Trevor-Roper, *The European Witch-Craze of the Sixteenth and Seventeenth Centuries and Other Essays* (New York: Harper and Row, 1956), 191–92; Norman Cohn, *Europe's Inner Demons: An Enquiry Inspired by the Great Witch-Hunt* (New York: Basic Books, 1975); Anne Llewellyn Barstow, *Witchcraze: A New History of the European Witch Hunts* (San Francisco: Harper, 1994). Brian Levack, *The Witch-Hunt in Early Modern Europe*, 3rd ed. (Harlow: Pearson, 2006), 22–23, estimates the number of prosecutions for witchcraft in Europe between the fifteenth and eighteenth centuries as approximately ninety thousand, with as many as half of the accused executed.

8. On the Salem episode, see especially Paul S. Boyer and Stephen Nissenbaum, *Salem Possessed: The Social Origins of Witchcraft* (Cambridge, Mass.: Harvard University Press, 1974); Karlsen, *Devil in the Shape of a Woman*; Bernard Rosenthal, *Salem Story: Reading the Witch Trials of 1692* (New York: Cambridge University Press, 1993); Reis, *Damned Women*; Norton, *In the Devil's Snare*.

9. Reis, *Damned Women*, chap. 1.

10. See especially Richard Godbeer, *The Devil's Dominion: Magic and Religion in Early New England* (New York: Oxford University Press, 1992). And see Godbeer, *Escaping Salem: The Other Witch Hunt of 1692* (New York: Oxford University Press, 2005).

11. See Reis, *Damned Women*, chap. 4.

12. Games, *Witchcraft in Early North America*, 39; Mary Beth Norton, "Witchcraft in the Anglo-American Colonies," *OAH Magazine of History* (special edition on Witchcraft, guest ed. Elizabeth Reis) 17, no. 4 (July 2003): 5–9, esp. 6. Norton notes that because many of the records of colonial Virginia were destroyed in the Civil War we do not know the actual extent of the accusation, trials, or executions for witchcraft during this period (6).

13. See John S. Mbiti, *African Religions and Philosophy* (New York: Praeger, 1969), esp. 107–18; Philip D. Morgan, *Slave Counterpoint: Black Culture in the Eighteenth-Century Chesapeake and Lowcountry* (Chapel Hill: University of North Carolina Press, 1998), esp. 612–25; and see Elaine Breslaw, "Witches in the Atlantic World," *OAH Magazine of History* 17, no. 4 (July 2003): 44–45; Games, *Witchcraft in Early North America*, 19–21, 48–55. Note also that the event mostly closely resembling a witch hunt that demonized Africans in colonial America was the persecution following the so-called slave revolt of 1741 in New York City, though in this case the accused were prosecuted for another sort of covert crime—arson; some thirty blacks were hanged or burned at the stake, and another seventy were sent to slave plantations in the Caribbean. See Jill Lepore, *New York Burning: Liberty, Slavery, and Conspiracy in Eighteenth-Century Manhattan* (New York: Vintage, 2006).

14. Mbiti, *African Religions and Philosophy*; Morgan, *Slave Counterpoint*, 612–25; Breslaw, "Witches in the Atlantic World"; Games, *Witchcraft in Early North America*, 48–55.

15. Peter A. Goddard, "The Devil in New France: Jesuit Demonology, 1611–1650," *Canadian Historical Review* 78, no. 1 (March 1997): 40–62; Jonathan Pearl, "Witchcraft in New France in the Seventeenth Century: The Social Aspect," *Historical Reflections* 4, no. 2 (Winter 1977): 41–54; Games, *Witchcraft in Early North America*, 36–38.

16. Games, *Witchcraft in Early North America*, 45–48. Games analyzes this incident, 88–89.

17. Ibid., 39.

18. "Tears of Repentance: Or, a Further Narrative of the Progress of the Gospel amongst the Indians in New-England," *Massachusetts Historical Society, Collections*, 3rd ser. 4 (1834): 201–2. See Matthew Dennis, "American Indians, Witchcraft, and Witch-Hunting," *OAH Magazine of History* 17, no. 4 (July 2003): 21–23, 27.

19. Ironically, as Mary Beth Norton shows, fear of Native people and the very real devastation of Indian war in New England helped create the conditions that led to internal recrimination and witch-hunting that erupted in Salem in 1692; see generally Norton, *In the Devil's Snare*.

20. William Wood, *New England's Prospect* [1634], ed. Alden T. Vaughan (Amherst: University of Massachusetts Press, 1977), 112–16 113. Note that Native women tended to be underrepresented as "witches" only while Native communities maintained a modicum of autonomy vis-à-vis colonial societies.

21. See Matthew Dennis, *Cultivating a Landscape of Peace: Iroquois-European Encounters in Seventeenth-Century America* (Ithaca, N.Y.: Cornell University Press, 1994) and Dennis, *Seneca Possessed: Indians, Witchcraft, and Power in the Early American Republic* (Philadelphia: University of Pennsylvania Press, 2010), esp. chap. 3.

22. William N. Fenton and Elizabeth Moore, ed. and trans., Lafitau's *Customs of the American Indians Compared to the Customs of Primitive Times, Publications of the Champlain Society*, no. 49, 2 vols. (1724; repr., Toronto: Champlain Society, 1977), 1:241.

23. Reuben Gold Thwaites, ed. and trans., *The Jesuit Relations and Allied Documents*, 73 vols. (Cleveland: Burrows Brothers, 1896–1901), 39:27.

24. In addition to Dennis, *Seneca Possessed*, see Alfred A. Cave, "The Failure of the Shawnee Prophet's Witch-Hunt," *Ethnohistory* 42, no. 2 (1995): 445–75; Jay Miller, "The 1806 Purge among the Indiana Delaware: Sorcery, Gender, Boundaries, and Legitimacy," *Ethnohistory* 41, no. 2 (1994): 46–66.

25. Games, *Witchcraft in Early North America*, 27–28.

26. On the Pueblo Revolt, see Alfred L. Knaut, *The Pueblo Revolt of 1680: Conquest and Resistance in Seventeenth-Century New Mexico* (Norman: University of Oklahoma Press, 1995); and see generally Ramón A. Gutiérrez, *When Jesus Came, the Corn Mothers Went Away: Marriage, Sexuality, and Power in New Mexico, 1500–1846* (Stanford, Calif.: Stanford University Press, 1991).

27. See Malcolm Ebright and Rick Hendricks, *The Witches of Abiquiu: The Governor, the Priest, the Genízaro Indians and the Devil* (Albuquerque: University of New Mexico Press, 2006).

4

Servant Women and Sex in the Seventeenth-Century Chesapeake

BETTY WOOD

The histories of women, the constructs of gender, and patterns of sex and sexuality in the early American South continue to attract considerable scholarly attention. Yet apart from their extensive presence in Kathleen Brown's monumental study, *Good Wives, Nasty Wenches, and Anxious Patriarchs*, comparatively little interest has been shown in the hundreds, if not thousands, of women who worked, often in the most appalling of circumstances, as indentured servants in seventeenth-century Virginia and Maryland.[1] This chapter examines the experiences of those women and pays special attention to the regulation and expression of their sexual lives. A focus on sexuality can reveal both the inner strength and the vulnerability of the seventeenth-century Chesapeake's indentured servant women.

It may be thought that the lack of their voices severely hampers any attempt to analyze the personal lives that servant women struggled to construct for themselves. This is the case, but only up to a point. Partly because of an inability to write, partly because of the difficulty in securing writing materials, and partly because of a lack of time, there are no extant letters or diaries attributable to a servant woman who lived in the seventeenth-century Chesapeake.[2] However, often significant numbers of women servants appear in various records usually, but not exclusively, written by men.

As Julia Cherry Spruill correctly observed for the first time back in the 1930s, servant women permeate the records of Virginia and Maryland's county courts, records that contain unambiguous evidence of a continuing, and brutal, employer-inspired concern with their sexual conduct.[3] Yet Spruill's essentially descriptive and decidedly judgmental account—she refers to them as being universally "profligate"—fails

to fully explore the linkage that the Chesapeake's rapacious employers, who included women, made between servant women's reproductive and productive value.[4] Neither did she do anything like full justice to the fortitude and creativity of many of these women.

Conditions in the Early Chesapeake

In 1606, possibly swayed by what they saw as a fatal flaw in the defensive capabilities of the earlier settlement of Roanoke—the presence of women and children—the Virginia Company decided that the first settlers of their colony must be men, heavily armed men.[5] But this did not mean that women would have no place in Virginia; far from it. Within a couple of years of the arrival of the first male colonists, by any definition an unruly group, the company declared its intent to transport women for "the better strengthening of the colony."[6] As wives and mothers, women would be essential to the creation of a self-perpetuating, and thereby permanent, English population. Moreover, it was assumed that their womanly qualities would temper the disorderly behavior of men, thus helping to create both a moral and a stable society.[7]

The most famous of the early embarkations of women to Virginia dates from 1621, when fifty-seven girls and women were sent to the colony to become the wives of planters willing to pay the cost of their passage.[8] The Virginia Company's propaganda was quite explicit: the heavily imbalanced sex ratio in Virginia meant that they would easily find a husband. Some years later Maryland's propagandists followed suit and extolled the opportunities for women in that colony—"no sooner" had they arrived than they would be "courted into a Copulative Matrimony."[9]

The implication was that marriage would enable women to achieve something virtually unattainable for them in England: social advancement. In the Chesapeake they would be transformed from women into ladies. Prospective male servants were offered the eventual prospect of land ownership, in effect freedom from dependence upon others. The lure dangled before women was socioeconomic advancement and social respectability, albeit via the dependence inherent in contemporary understandings of marriage.

To begin with, varying amounts of often backbreaking work would be required of women migrants to help secure, and subsequently advance,

their family's fortunes. However, the Virginia Company believed that their primary value would be reproductive, moral, and social rather than productive. Yet even before the women sent in 1621 arrived in Virginia, three initially unrelated events were already interacting to ensure that these would not be the only roles of the thousands of women servants who came after them. Reproduction and production would be combined by the Chesapeake's employers and the governments they dominated in ways that entailed the continued—and ruthless—mistreatment of women servants, all in pursuit of profit.

Commercial agriculture was missing from the Virginia Company's original plan but, mainly thanks to John Rolfe's experimentation, in 1617 the first tobacco was shipped to England. Quite coincidentally, in 1618 the company introduced two changes that, together with tobacco, would largely define Virginia's future development. First, the headright system gave additional land to migrants who brought servants with them, and second, with the creation of the House of Burgesses, male property owners were granted virtual self-government.[10] Following the introduction of Royal government in 1624, the House of Burgesses continued, at least theoretically, to control not only labor and race relations but also sexual conduct. By 1640 the same was true of Maryland's General Assembly.

During the 1620s tobacco formed the basis of the "First American Boom."[11] Continuing profits depended upon two things: land and sufficient labor to work that land. Following the so-called Massacre of 1622, a Native American assault that almost wiped out Jamestown, Virginia's hard-headed planters made two key decisions regarding Native Americans: they had no legal or moral right to the lands they occupied and, for essentially practical reasons, neither could they be molded into a compliant, productive agricultural workforce.

The enslaved African peoples who already formed the backbone of the sugar economies of the Americas would be denied to the Chesapeake's tobacco producers for as long as the Dutch dominated the transatlantic slave trade. This meant that down to the late seventeenth century it would be England that provided planters with the workers they demanded. Mainly young men and women, of child-bearing age, were willing to indenture themselves—usually for four or five years—in exchange for their transatlantic passage, maintenance during their servitude, and freedom dues at the end of it. From the early 1620s onward,

indentured men outnumbered indentured women by as many as six or seven to one. Planters may have seen these women as prospective sex partners, but they also wanted hard agricultural work from them. The whip was one of their most favored means of trying to obtain just that.[12]

[The use of the lash, as both punishment and exemplar, was not gender-specific, in that women servants did not get preferential treatment.] Indeed, sometimes the severity of the floggings they received shocked some of the men who witnessed them. In 1624, Thomas Gates swore that he had counted, blow by blow, the "500 lashes" inflicted on a woman named Elizabeth Abbott. Unsurprisingly, perhaps, "said wench after that beating ran Away into the woods."[13] But such brutality was not the sole preserve of men. Female employers also inflicted the cruelest punishments on their women servants. When a runaway servant named Elizabeth Hasell was retaken her mistress had her "put her in irons" and "whipt" so severely that "there was a puddle of blood in the room & great wounds in her back."[14] [In the seventeenth-century Chesapeake there was not much evidence of a sisterhood that transcended differences in social status; women servants could not automatically expect support or protection from their mistresses.]

Adding extra time for the time lost when servants ran away was another way in which employers exploited their workers. With the backing of the law, they clawed back as much as ten days work for every day lost to them. What this could mean is shown by Mary Sulivan's experience. [Mary ran away for 29 days before being retaken; she had 252 days added to her term of servitude.[15] As with the whip, these draconian penalties were not gender-specific. However, there was one, by definition, gender-specific way in which employers sought compensation for absenteeism, and that was for time lost during pregnancy. [The number of extra days' work demanded of runaways was often little when compared with those imposed on women servants who gave birth.]

Controlling Women Servants' Sexual Conduct

Maximum productivity and harsh punishments for lost time underpinned the labor regimes of the Tidewater Chesapeake. But employers also tried to further their interests in another way: by attempting to control, and thereby to exploit, the reproductive potential of women

servants. As early as 1619 a template began to be put in place that, later in the century, would form the framework for the similar exploitation of West African women.

Masters did not want their women servants to marry anyone other than themselves for the simple reason that if they did this would mean the loss of not only their labor but also the capital they had invested in securing and maintaining that labor. Of course, mistresses had the same vested interest in keeping their women servants for as long as possible.[16] It was only a year after the creation of the House of Burgesses that employers' concerns about the ways in which servant women's sexual behavior might diminish their profits began to be enshrined in Virginia's public law. Thereafter, women servants' sexual activity would be fraught with danger for them.

There were no religious or moral imperatives in the Virginia law of 1619. This relatively short ordinance said simply that "no maide or woman servant" already in Virginia or any "hereafter to come" would be permitted to marry without the express "consent of her parents," her employer, "or the magistrate & Minister of the place both together." Any clergyman who contravened these restrictions would be "subject to severe censure by the Governour & Council."[17]

The 1619 law continued in force until 1643 when it was supplemented by legislation that addressed a rather different issue. Reacting to what they described as "secret marriages" between servants, which they believed gave rise to "many great abuses and much detriment"—to themselves, of course, rather than to servant couples—Virginia's legislators now focused their attention on the sexual choices of male as well as of female servants. Servant couples who married without securing permission were equally punished in a way indicative of employers' obsession with wrenching as much work as possible from them: "one complete year more" would be added to their term of servitude.[18]

Twenty years later the House of Burgesses turned its attention to sexual relationships of another kind: those they believed were being formed between masters and their servant women. According to the Burgesses, "some dissolute masters have gotten their maids with child," but continued to "claime the benefit of their service." But should a servant woman who gave birth to her master's child retain her servile status, or did paternity constitute a compelling case for her and her baby's legal freedom?

Unsurprisingly, the Burgesses concluded that if they answered yes to this question employers would stand to lose valuable female workers because "such loose persons [would] lay all their bastards to their master." To prevent this they declared that if could it be proved—and it could be a difficult case to prove—that a master had fathered a child by one of his servant women then she would continue as a servant and at the end of her indenture "be sold for two yeares" by the local churchwardens "and the tobacco . . . imployed for the use of the vestry."[19] Masters who impregnated their women servants stood a very good chance of getting off scot-free, the value of the mother's labor would continue to be exploited, and rather than having to support the child, the parish would actually benefit. The reproductive potential of women servants was now being exploited for public as well as for purely private purposes. For all concerned, except of course for servant mothers and their children, whose labor would be sold to the highest bidder, it was a win-win situation.

Although they were slower out of the starting blocks, Maryland's planter-politicians closely followed the precedents already established in Virginia—with some differences. Not until 1662, some thirty years after the colony's founding, did Maryland's General Assembly note that "Divers weomen Servants . . . not haveing husbands liveing with them have been gotten with Child." This, the Assembly continued, was "to the greate dishonour of God" but, more practically, caused "apparent damage to the Mrs [Masters] and Owners of such Servants." Given that there was no legal way in which such "Damage shall bee Recoverable," the time had come to devise a remedy.[20] That which the Assembly came up with differed in some respects from the law enacted in the same year by the House of Burgesses.

In 1662, for the first time employing religious language, the Burgesses expressed their intent to curb "the filthy sin of Fornication," but, as in Maryland, what seems to have concerned them more were the children that might "be gotten in such fornication," particularly by servant women.[21] As with orphans, a continuing problem given the high mortality rates in the Chesapeake, this concern was essentially pragmatic: who would pay for the child's upkeep? Employers had no wish, or in their minds any reason, to do so, and neither did they wish to burden the parish, in effect themselves and other property owners. Initially they looked to the fathers of these children as offering the best solution: if

they could be identified then they could be legally obliged to financially support their offspring, "and save the parish harmless."[22] Of course this meant that the mother must be willing to publicly name her child's father and that he must be both able and willing to pay for the child's upkeep. But what of servant mothers?

Clearly, servant mothers lacked the financial resources with which to compensate their employers for the "losse and trouble [they] sustain by her having a bastard," but there was always the value of their labor to exploit. In 1662 the Burgesses continued with their policy of imposing an extra two years of servitude on servant mothers but now mandated what realistically was never a choice for them: if they paid their employer two thousand pounds of tobacco they would be excused this extra service.[23] A mother's only chance of avoiding this additional servitude was finding someone to pay her fine, and the chances of that were very slim indeed.

The Maryland government also sought financial compensation and additional service for any children born to women servants. If the mother could prove paternity, "either by sufficient Testimony of Witnesses Confession or pregnant Circumstances agreeing with her Declaration in the Extremity of her paynes and Throws of Travaille, or her Oath taken by some Magistrate," then the father, "if a Servant to satisfie halfe the said Damage" and "if a Freeman then the whole damage by Servitude or Otherwise."[24] But, and quite alike the House of Burgesses, the Maryland General Assembly took breach of promise into account. If the servant mother could prove that her child's father, "being a Single person and a Freeman did before the begetting of such Childe promise her Marryage," then he had either to "performe his promise to her or Recompense the Abuse."[25] Significantly, the servant mother was given no say in the matter.

In 1662 Maryland's legislators also decreed that servant mothers would be "lyable to sattisfie the Damage soe Sustayned [to her employer] by Servitude or otherwise."[26] As in Virginia, the "otherwise" included brutal physical punishment. In both colonies, it was a common practice for servant mothers to be made to suffer the humiliation, but above all else what must have been the excruciating pain, of being taken to the county's public whipping post and stripped to the waist before enduring as many as thirty-nine lashes "on the bare back." Increasingly, the sheriffs delegated to inflict this punishment were instructed that, however

many, the lashes must be "well laid on" so that "the blood flows."[27] Such vicious floggings were intended to serve as both punishment and deterrent. By the mid-seventeenth century only the most recently arrived servant woman could have been entirely unaware of what awaited her should she give birth.

By the early 1660s public laws attempting to control the sexual conduct of women servants had been put in place in Virginia and Maryland, mainly because of the different sexual choices being made by a growing number of women, by legally free as well as by servant women. Over the next half century these laws would be augmented and amended. During the late seventeenth century, women's sexual choices were threatening to completely undermine the racial divide that was in the process of being constructed by planter-politicians, who were desperate to retain authority over all women, regardless of their legal status or ethnicity.[28]

As the Chesapeake's planters and governments had long realized, it was one thing to legislate against servant marriage, and sex outside marriage, and to impose the most merciless punishments on those women who erred, but it was another thing entirely to prevent sexual liaisons involving women servants, yet try they did. But exactly who did women servants form sexual relationships with? Were these relationships freely entered into, or was physical and verbal coercion involved? The most comprehensive answers to these questions are in the county court records.

From the mid-seventeenth century onward, when it was usual for the ever-growing number of county courts being established in Virginia and Maryland to meet at least four times a year, and sometimes as often as once a month, servant women were cited quite regularly to answer a charge of bastardy. Literally scores of servant women were tried on this charge, by definition virtually impossible to be refuted.[29]

Unfortunately, several things cannot be gleaned from the court records or, for that matter, from any other of the extant sources. First, the courts were more concerned with bastardy than they were with sexual relationships that did not result in the birth of a child. For obvious reasons, we simply do not know—and can never know—the total number of sexual partnerships that, either through sheer luck or the most rudimentary methods of contraception or a combination of both, and maybe to the great relief of servant women and their lovers alike, failed to pro-

duce a child.[30] In all bar a handful of cases we are told neither when, where, and under what circumstances a particular sexual relationship had begun nor for how long it lasted.

Second, the court proceedings were somewhat formulaic and only occasionally included detailed testimony or any personal details about the women, and their sex partners, being adjudged. We know virtually nothing about these women's ages, where they originally hailed from, their religious beliefs if any, their remaining time to serve, or the work they performed. In most cases we are told simply their names, that of their employer, sometimes the name of their child's father, and usually the court's ruling.

Virginia and Maryland were depicted by their early propagandists as being veritable paradises for women migrants in search of a husband. Yet this possibility was largely denied to servant women. But who were the fathers of their out-of-wedlock children? Did the sex ratio actually work in their favor when it came to making sexual choices, or did it place them under immense pressure to comply with the sexual demands that might have been made of them by the male majority?

Servant women were greatly outnumbered by men regionally, locally, and in their workplaces. If a servant woman was to be found in a workplace, and on most estates this was not the case, then she was likely to be the only one. Obviously, the number, ages, ethnicities, and social standings of the men she encountered on a daily basis varied somewhat. Of course, exactly the same was true of those whom she met less often, but perhaps quite regularly, in the immediate vicinity of her workplace. Such encounters might be with her fellow believers at a Sunday service or for varying lengths of time when she was hired out to a local employer.

Sexual Experiences of Servant Women

The albeit incomplete records of four by no means atypical Maryland county courts—those of Somerset, Kent, Prince George's, and Talbot—offer an illuminating snapshot of the sexual experiences of women servants during the last quarter of the seventeenth century.[31] Between the mid-1670s and 1700 at least ninety-eight servant women in these four counties were charged with bastardy.[32] The courts pressed these women to publicly name their child's father, which sixty-six did under

oath. Seldom did the men they named deny paternity.[33] For one reason or another—death, run away, or dropped charges—all bar two of the remaining women either are not recorded as having made an appearance in court or, if they did, there is no record of the court's proceedings.

The two women in question, Maud McGowen and Dorothy Noble, were remarkable in that they refused to name their child's father.[34] Dorothy was sentenced to twenty-five lashes for bastardy, but she never publicly revealed the father of her baby; to begin with at any rate, Maud was determined to do likewise, but she quickly learned to what lengths the court would go to in order to get the information it wanted. On her first court appearance court, Maud, "refuseing to tell for which contempt she is Ordered ten lashes." She was taken outside to be flogged and "Afterwards . . . was brought to Court again and . . . seemed very Submissive, and willing to sweare to the father, which . . . is John Anderson." In exchange for her "free confession," the court "Only Orders her five lashes more which was likewise performed."[35] Other servant women in Somerset County cannot have been entirely unaware of the punishment Maud received for her initial intransigence, and most likely that was the court's intention.

What emerges from our sample is that servant women entered into sexual liaisons with men of European descent drawn from the entire range of the local social spectrum: from the servants who worked alongside them to some of the most eminent men in the vicinity. However, there was a noticeable, and perhaps not an altogether surprising, imbalance: fifteen of the twenty-eight men whose occupations, and thereby social status, can be positively established were servants, one was a laborer, one a seaman, one a ferryman, and one a horse courser, or horse dealer. Seldom, if ever, did these servant and underclass fathers escape punishment. Those of these men who, more often than not, were unable to financially support their child might find themselves publicly flogged, sometimes alongside their child's mother, forced to do unpaid work for the county, or having time added to their servitude to compensate the mother's employer for her lost work and any expenses incurred as a result of her pregnancy.[36]

Four men in the sample were either planters or farmers, but their exact social standing is uncertain. Either through planting, commerce, or the law, or a combination of each, the remaining five men enjoyed

considerable local prestige. One such was Michael Earle, of Somerset County, an attorney, who was cited by Elizabeth Lipsey, who had "served him Five Yeares," as being her baby's father.[37] For reasons that remain unknown, Earle chose not to challenge Elizabeth. Nor is there any evidence of him being ordered by the court to support a baby whom in all probability he had fathered. Perhaps it was his social standing that saved him not so much from having to pay the child maintenance that he could easily have afforded as from the local gossip that might well have stemmed from such a tacit acknowledgment of his sexual impropriety.

Also of particular note in our sample is that despite lawmakers' concern that unscrupulous women servants would name their master as having fathered their child, in practice this simply did not happen. Only one woman, Elizabeth Teatham, claimed that her master, Abraham Ambrose Sr., was her child's father. Her reward was to be sentenced to "10 lashes." Although Ambrose appears not to have publicly acknowledged his paternal responsibility, the court punished him anyway: not by ordering him to support his child maintenance but to "Sell his Servt. Eliza. Tatham."[38] Ambrose would lose little money—and indeed might make money—by selling Elizabeth's labor. The court offered no explanation for this quite exceptional step. However, its intention may have been to help Ambrose salvage something of his reputation by making him rid himself of a woman whom he might be tempted to, or tempted by, again in the future. It was a decision that also served as a warning to other masters to desist from sexual liaisons with their servant women.

Elizabeth Teatham had been bold, or angry, or desperate enough to publicly name and shame her master, but we can never know exactly how many other servant women held their tongues simply because they feared the often ruthless retribution that would be exacted by men whose servants, women as well as men, in any way displeased them. Although, perhaps simply because of their understandable reluctance to speak out, the evidence might suggest that women servants were not sexually exploited by masters and their grown sons on any significant scale, it is evident from the court records that either voluntarily or under duress they entered into sexual relationships with their employers' equally eminent friends and neighbors.

In some of these cases the servant woman was subjected to constant, and ultimately irresistible, pressure—often verbal pressure—to

sleep with a man who was of a higher social status than herself. For such women, a key reason for failing to report such pressure to her employer seems to have been the entirely understandable assumption that her word would not count against his; that in one way or another she would suffer for bringing into disrepute a man well known to, and probably entirely trusted by, her employer. Few servant women were as audacious, or as angry, as had been Elizabeth Lipsey when she named Michael Earle; Dennis, or more likely Denise or Denice, Holland was one such, but not to begin with.

On January 3, 1673, Dennis was sent by her master, William Cole-bourne, to work for Henry Smith.[39] According to her sworn testimony, soon after she arrived she found herself to be pregnant. That October, while in labor, Dennis "burst out Cryeing'" to Katherine Draper, a local woman who was assisting at the birth, that "She would Due no man wrong for it was Henry Smith that got it." According to Dennis, she had been working for Smith for only "nine Dayes before he Desired to have the use of her body." Katherine asked Dennis why "Did she not Call out," or "come away and make her Aggrievance known there would have been a remedy for her," at which Dennis "Cryde and sighed bitterly" that "She was Loath to Disgrace him." For reasons that are unclear, by January 1664, when she found herself facing a charge of bastardy, Dennis had changed her mind. Supported by Katherine Draper, who validated her claim that she had named Smith as her baby's father, Dennis testified that Smith had "motioned to Lye with me and being much Importuned by him and further Seeing he would not take and Denyall and Coulld not be quiet and being overperswaded by his Sweete oratory I yielded to his unjust request." She went on to describe in graphic detail several other occasions when she had been "overperswaded" to have sex with him.

When Dennis told Smith she was pregnant, he immediately tried to pin the blame on William Colebourne, insisting that surely he had "occupied" her, perhaps "when your mistris was up the bay." This Dennis vehemently denied, but Smith persisted: Dennis must think of her child's future because Colebourne "was best able to maintain it." Yet again, Dennis refused to bow to his wishes. Unfortunately the record remains silent as to the court's paternity conclusion, and Dennis disappears from the historical record. But her daughter Hanna does not. A

few years later she too would appear—unlike her mother twice—before Somerset's county court.

The first of Hanna, or Hannah's, court appearances reveals a confident young woman determined to take on her master in an attempt to end her servitude; the second reveals a slightly older woman who, although no longer a servant, was denied the legal means of challenging, let alone overturning, the punishment meted out to her. If nothing else, Hannah Holland's two courtroom experiences reveal both the assertiveness and the defenselessness of the seventeenth-century Chesapeake's indentured servant women.

Shortly after her birth the county court ordered Hannah to be taken from her mother and, "in Consideracon of her maintenance," to be given to a wealthy merchant named John Kirke who "is to keepe her as his Servant till She Comes to Age."[40] This meant until she was sixteen years old, the age at which Hannah first appeared in court. In her "humble Petition" she explained that Kirke had "disposed" of her to a man named Walter Lane, but that even though she had come of age Lane was refusing to free her. Hannah had "desired" Lane "to goe and search the Records," a request that he had "denyed." Hannah was sufficiently emboldened to ask the court to do just so that she "may know where to she may trust."[41] Through her own determination, Hannah managed to thwart Lane's attempt to extend her servitude.

Two years later, legally free and unmarried, Hannah was back in court again, not of her own free will but on exactly the same charge that her mother had faced nearly twenty years earlier: bastardy. Hannah had little alternative but to confess, and she was sentenced to twenty-one lashes.[42] Like many other women before and after her, Hannah was prepared to name her baby's father. Initially, the man she named, Edmund Beauchamp, denied his responsibility, but the court accepted Hannah's testimony and ordered Beauchamp to give security against the baby, John, becoming a charge on the county.[43] But just like her mother before her, Hannah found her child being taken away from her, ironically by the same John Kirke for whom she had worked as a servant. In all probability, even though legally free, Hannah was either unable to support her son or felt that, despite her own experience in servitude, in the longer term he would be better off with Kirke because of what he could offer. Kirke agreed to apprentice the two-year-old John Holland "until

21," to give him "a heifer" when he reached the age of ten, and, by no means least of all, "to provide him one year of schooling."[44]

[Dennis Holland and her daughter Hannah had each given birth to a child fathered by men of a considerably higher social status than themselves, and in Dennis's case there is compelling evidence that on several occasions Henry Smith had placed her under unrelenting pressure to sleep with him. But as perhaps is only to be expected, it was not only men of a higher social status who harried servant women to have sex with them. In 1671, for example, Randall Revell accused Christopher Newgent, one of his Irish servants, of "having by severall faire pretences and Importunate perswassions Deluded" Margaret Meechalling, another of his servants, "and had gotten her with Child." In her courtroom testimony Margaret affirmed "that She Coulld not rest night nor day for the said Christopher, but he was troubling and Inticeing," so much so that "he hath oftentimes putt her into Strange ffitts in which She hath Layne ffo r Several houres Senceless in a Sad Condicon."[45] Maybe Margaret was simply seeking to defend herself by trying to pin the blame for her pregnancy on Christopher, something she knew would sit well with her master, who was having his own, different, legal wrangles with the assertive Irishman.[46]

Although the records remain largely silent on this issue, it would be both dangerous, and no doubt erroneous, to assume that every sexual liaison involving a woman servant was initiated by a man. Sexual attraction worked in both directions and, whether or not their ultimate objective was marriage, and the material benefits and social advancement that they anticipated would stem from it, or a more temporary relationship, servant women had the means at their disposal, the agency, to make a play for any man who caught their eye. They too could sweet-talk and, with the albeit limited means at their disposal, clothe and in other ways adorn themselves in hopes of attracting a particular man. Of course, they could do likewise in the hope of attracting a female partner, and no doubt some did, but on this possibility the records remain silent.

During the late seventeenth century the court records begin to reveal increasing signs of rather different heterosexual sexual relationships involving women servants, relationships that would wreak even more severe punishments should they give birth, not only on themselves but

also on their children. As far as the latter were concerned, these punishments involved a self-interested exploitation of their productive potential, an exploitation that was tantamount to enslavement in all but name. For girls, just like their mothers, it would also mean the exploitation of their reproductive potential. In its essentials, the origins of this dual exploitation are to be sought in the 1660s, and were intimately bound up with the processes of enslavement and the concurrent invention, or reinvention, of race and racial difference.

The 1660s were marked by the start of legislation that, bit by bit, but inexorably, eroded whatever freedoms Maryland and Virginia's still minuscule black populations enjoyed.[47] The employers' ultimate objective could not have been clearer: to secure for themselves a cheaper self-perpetuating workforce, workers who would not be bound for a fixed term but face a lifetime of servitude. Controlling the reproductive potential of African women was crucial to the success of this endeavor.

A long-standing tradition in English law was that a child's legal status followed that of his or her mother, and in 1662 the House of Burgesses applied that tradition in a way that once more furthered the interests of employers. The Burgesses expressed their concern that "some doubts have arisen whether children got by an Englishman upon a negro woman should be slave or free." Economic self-interest meant that there would be only one way of resolving these "doubts," and it cannot have come as a surprise to anyone in Virginia when the Burgesses declared "that all children borne in this country shall be held bond or free only according to the condition of the mother."[48]

Although not ruling out the possibility of women of European ancestry forming sexual relationships with men of African descent, in 1662 the Burgesses completely failed to say anything about the legal status of the children born to such couples, and English precedent held that they inherit their mother's legal freedom. Over the next few years, women's sexual behavior would prompt the governments of Virginia and Maryland to modify that precedent as part of their ongoing attempt to create an unbridgeable racial divide: miscegenation involving any woman of European descent, regardless of her legal status, became criminalized. Both governments not only sanctioned as many as thirty-nine lashes for those women who gave birth to a child fathered by an African man but also sought to exploit their productive value. Servant mothers faced a

mandatory seven years of extra servitude; legally free mothers would be placed into servitude for seven years.[49]

Just as with their mothers, the productive value of children fathered by men of African ancestry would also be cruelly exploited, an exploitation that turned a blind eye to the legal tradition that a child inherited his or her mother's status. For obvious reasons, enslaved fathers were unable to financially support these children, and the county authorities had no intention of assuming that responsibility. The answer arrived at by Virginia and Maryland's lawmakers was a familiar one, involving virtual commodification of these children. Often within a few months, if not a few weeks, of their birth they would be put up for sale by the county court in a way reminiscent of slave auctions, and sold into servitude to the highest bidder for a fixed term of thirty or thirty-one years.[50] This meant that at most they could expect to enjoy less than half a lifetime of legal freedom, assuming they survived into adulthood.

As Kathleen M. Brown has demonstrated in such vivid detail in the case of Virginia, lawmakers were no more successful in putting a stop to sexual relationships between women of European descent and African men than they were in trying to control and exploit the non-interracial sexual liaisons of servant women.[51] As far as both legally free and servant women were concerned, the pattern of miscegenation in late seventeenth-century Maryland was very similar to that of Virginia. During the first three-quarters of the seventeenth century, in Maryland and Virginia alike, the relatively few African men served to limit the extent of miscegenation involving women of European ancestry. It was only in the 1680s and 1690s, as planters began to switch from a heavy dependence upon indentured servants to an even heavier dependence upon enslaved Africans, that things began to change. Despite the unforgiving punishments meted out to mother and child, Maryland's county courts began to copy what was happening in Virginia: there was a marked increase in the number of women of European descent charged with having given birth to a child fathered by a man of African ancestry. Between 1670 and 1700, only five of the ninety-eight servant women who appeared in the county courts of Kent, Talbot, Somerset, and Prince George's were charged with having given birth to a child fathered by a man of African ancestry; during the next quarter of a century in Talbot and Anne Arundel Counties alone, they numbered thirty-six—Talbot

accounted for eleven births and, on the other side of Chesapeake Bay, Anne Arundel, for the remaining fifteen.[52]

Predictably, the evidence for exploring these interracial sexual relationships is just as threadbare as that for those involving European partners. What is evident, though, is that enslaved African men had to have absolute faith in any women of European descent, whether servant or legally free, before making any sexual advances to them. By the same token, and for precisely the same reason, these men had to be extremely wary of those women who made advances to them lest they allege rape. Significantly, though, during the first quarter of the eighteenth century not a single servant woman in either Talbot or Arundel County claimed that her child was the product of rape.

In seventeen cases the servant woman concerned named her baby's father, and they included one man named Robin, described in the court records as being a "mullato" but whose legal status was not recorded, and one free African man, named Phoenix, who was said to be a "planter."[53] One thing that does emerge from the court records, and perhaps unsurprisingly so, is that among the fifteen cases where the father is known to have been enslaved, ten couples worked for the same employer. Although it is impossible to be entirely certain, the two couples with different employers might have first met as a result of one or the other of them having been hired out.

Unfortunately, we know virtually nothing about the circumstances in which any of these interracial sexual liaisons began, who initiated them and why, what the relationship meant to each partner, how such partnerships were regarded by the couple's family, friends, and coworkers, or how long they lasted. One thing we can be sure of though is that given the legal right of employers to dispose of their servants and enslaved workers as and when they saw fit, even the most loving relationships were fraught with peril.

By the end of the seventeenth century the legal apparatus for taking full advantage of the reproductive, as well as the productive, worth of servant and enslaved women alike, as well as those of any legally free women who breached the racial divide sought by the Chesapeake's planter class, was firmly in place and would not change significantly during the remainder of the colonial period. Denied the right to marry without their employer's permission, women servants who, either by

design or chance, gave birth had no right of appeal against the pitiless punishments inflicted on them by totally unsympathetic governments and county courts; both they and their children were denied the right of unhindered access to one another.

Conclusion

Given the physical and emotional brutality they endured at the hands of their employers and the courts, it is all too easy to depict seventeenth-century Virginia and Maryland's servant women as helpless and hapless victims. They most certainly were victimized in many ways—and not least when it came to their sex lives. However, this should not be taken to mean that when it came to their sexual conduct they were universally converted into mechanical, unthinking victims who simply internalized the many demands made of them by their avaricious employers. True, some were pressured by men into unwanted sexual liaisons, but others were determined enough to forge a relationship with a man of their choice, knowing full well the savage penalties that awaited should they give birth: the public floggings, the years of extra service, and either the temporary or permanent separation from their children.

Whether with male servants, men of a higher social status, or African men, the mutually loving and respectful sexual relationships involving women servants cannot be enumerated, but for that reason ought not to be discarded as insignificant. The emotions that underpinned such relationships meant little or nothing to callous employers. They were emotions that seldom if ever counted in their increasingly racialized, and always pragmatic, calculations of profit and loss, calculations that depended heavily upon the exploitation of women's productive and reproductive potential. But they were emotions that surely must have given these couples the strength to persevere as best they could in what for them, during their terms of indenture if not necessarily afterward, was the truly exacting world of the seventeenth-century Chesapeake.

NOTES

1. Kathleen M. Brown, *Good Wives, Nasty Wenches, and Anxious Patriarchs: Gender, Race, and Power in Colonial Virginia* (Chapel Hill: University of North Carolina Press, 1996).

2. I am grateful to Mary Beth Norton for making this point in a class we cotaught in 2005–6 during her term as Pitt Professor at the University of Cambridge.

3. Julia Cherry Spruill, *Women's Life & Work in the Southern Colonies*, with a new introduction by Anne Firor Scott (1938; repr., New York: Norton, 1972), 314–39.

4. Ibid., 314.

5. There is an extensive literature on Roanoke, but see especially David B. Quinn, *Set Fair for Roanoke: Voyages and Colonies, 1584–1606* (Chapel Hill: University of North Carolina Press, 1985); David Stick, *Roanoke Island: The Beginnings of English America* (Chapel Hill: University of North Carolina Press, 1985); and Karen Ordahl Kupperman, *Roanoke: The Abandoned Colony*, rev. ed. (Lanham, Md.: Rowman & Littlefield, 2007).

6. Broadside of 1609 titled "Concerning the Plantation of Virginia, New Britain," in Alexander Brown, ed., *The Genesis of the United States*, 2 vols. (New York: Houghton Mifflin, 1890), 1:248.

7. For a brief discussion see, Spruill, *Women's Life & Work*, 4. See also Virginia Bernhard, "'Men, Women and Children' at Jamestown, Early Virginia, 1607–1610," *Journal of Southern History* 58 (November 1992): 599–618.

8. David R. Ransome, "Wives for Virginia, 1621," *William and Mary Quarterly*, 3rd series, 48 (January 1991): 3–18.

9. George Alsop, *A Character of the Province of Maryland*, ed. Newton D. Mereness (1666; repr., Cleveland: Burrows Brothers, 1902), 46.

10. The headright system was also an integral part of the George and Charles Calvert's plan Maryland. Anon, *A Relation of Maryland, Together with a Map of the Country, the Conditions of Plantation, His Majesty's Charter to the Lord Baltemore, Translated into English* (London: W. Peasley, 1635), 47–48.

11. Edmund S. Morgan, "The First American Boom: Virginia, 1618–1630," *William and Mary Quarterly*, 3rd series, 28 (April 1971): 169–98. This essay formed the basis of his discussion in *American Slavery, American Freedom: The Ordeal of Colonial Virginia* (New York: Norton, 1975), 108–32.

12. For employer brutality in the 1620s, see Morgan, *American Slavery, American Freedom*, 126–29.

13. H. R. McIlwaine, ed., *Minutes of the Council and General Court of Virginia, 1622–1632, 1670–1676, with Notes and Extracts from the Original Council and General Court Records, into 1683, Now Lost* (Richmond, Va.: Colonial Press, 1924), 22–24.

14. Proceedings of the County Court of Charles County, 1666–1674, 11 January 1669/70, Liber D, Archives of Maryland Online, vol. 60, 233–35 (hereafter AoMO).

15. Somerset County Court, (June) ye (13) 1693, Somerset County Judicial Records, 1692–93, AoMO, vol. 206, 229.

16. Women employers were usually widows who had inherited their estates, and sometimes indentured servants, from their husbands. See Lois Green Carr and Lorena Walsh, "The Planter's Wife: The Experience of White Women in

Seventeenth-Century Maryland," *William and Mary Quarterly*, 3rd series, 34, no. 4 (1977): 542–71.

17. "A Reporte of the Manner of Proceeding in the General Assembly Convened at James Citty in Virginia, July 30, 1619," in H. R. McIlwaine, ed., *Journals of the House of Burgesses, 1619–58/59* (Richmond: Virginia Public Library, 1915), 14.

18. Laws of Virginia, Act XX, untitled, March 1642-3-18 Charles 1–18, in William Waller Hening, ed., *The Statutes at Large: Being a Collection of All the Laws of Virginia, from the First Session of the Legislature, in the Year 1619*, 13 vols. (Richmond, Va.: Printed for the editor by R. & W. Bartow, 1819–23), 1:252–53; Laws of Virginia, Act XIV, Concerning Secret Marriages, 1657–58–9 of Commonwealth, in *Statutes at Large*, 1:438–39.

19. Laws of Virginia, ACT VI, *Women Servants Got with Child by Their Masters after Their Time Expired to Be Sold by the Churchwardens for the Good of the Parish*, December, 1662–14 Charles II, in Hening, ed., *Statutes at Large*, 2:167.

20. An Acte Concerning Those Servts That Have Bastards, Assembly Proceedings, April 1662, Proceedings of the General Assembly, January 1637/8–September 1664, AoMO, vol. 1, 441–42.

21. Laws of Virginia, ACT C Against *ffornication*, March 1661/2, 1661–2–14 Charles II, in Hening, *Statutes at Large*, 2:114–15.

22. Ibid., 2:115.

23. Ibid., 2:114.

24. Proceedings and Acts of the General Assembly, January XXX–September 1664, Acts Made at a Session of Generall Assembly Began and Held at St. Marys the First of April 1662, AoMO, vol. 1, 442.

25. Ibid.

26. Ibid.

27. This instruction is to be found throughout Maryland and Virginia's county court records.

28. This is the central, and entirely convincing, argument advanced by Brown in her *Good Wives, Nasty Wenches, and Anxious Patriarchs*.

29. For the continuing attempt to control sexual conduct, see Catherine Cardno, "'The Fruit of Nine, Sue Kindly Brought': Colonial Enforcement of Sexual Norms in Eighteenth-Century Maryland," in *Colonial Chesapeake: New Perspectives*, ed. Debra Meyer and Melanie Perreault (Lanham, Md.: Lexington Books, 2006), 257–82.

30. For contemporary English beliefs and practices that might have crossed the Atlantic, see Patricia Crawford, "Sexual Knowledge in England, 1500-1750,'" in *Sexual Knowledge, Sexual Science: The History of Attitudes to Sexuality*, ed. Roy Porter and Mikulas Teich (Cambridge: Cambridge University Press, 1994), 82–106.

31. The sample is extracted from the following court records: Proceedings of the County Courts of Kent (1658–1676) Talbot (1662–1674) and Somerset (1665–1688) Counties, AoMO, vol. 54; Kent County Court, Proceedings, 1676–98, AoMO, vol.

557; Court Records of Prince George's County, Maryland, 1696–99, AoMO, vol. 202; Somerset County Court (Judicial Records), September 1, 1670–October 20, 1671, AoMO, vol. 86; Somerset County Court (Judicial Records), October 25, 1671–October 20, 1675, AoMO, vol. 87; Somerset County Court (Judicial Records) November 9, 1675–August 12, 1677, AoMO, vol. 89; Somerset County Court (Judicial Records), November 13, 1683–March 11, 1683/4, AoMO, vol. 90; Somerset County Court (Judicial Record), September 30, 1687–June 12, 1689, AoMO, vol. 91; Somerset County Court (Judicial Record), September 24, 1689–November 12, 1690, AoMO, vol. 106; Somerset County Court (Judicial Record), November 14, 1690–October 3, 1691, AoMO, vol. 191; Somerset County (Judicial Record), 1691–1692, AoMO, vol. 405; and Somerset County (Judicial Record), 1692–93, AoMO, vol. 406.

32. Only those women said to have been servants are included in this sample. Those whose status was not mentioned—some of whom may have been servants—have been omitted.

33. One of the few men who "Solemnly" denied fathering a child was Richard Harris. For making what the court believed was a false claim against him, Elizabeth Williams was sentenced to thirty-nine lashes. Somerset County (Judicial Record), 1683, November Court, 1683, AoMO, vol. 90, 7. Another was Bryan Kellaughane, accused of fornication by Catherin Tully. As "noe proofe [had been] made" Kellaughane was acquitted and "or her Contempt in this Court" Catherin was sentenced to "Tenn lashes." September Court, 1688, AoMO, vol. 91, 74.

34. Kent County Court, Proceedings, 1676–98, September Court, 1686, AoMO, vol. 557, 177, 196.

35. Somerset County Court (Judicial Record), March Court 1689/90, AoMO, vol. 106, 56.

36. Mary Barrett and George Thirle were each sentenced to "twenty Lashes." Following the birth of their child, their master, Henry Coursey, allowed them to marry. Talbot County, January Court, 1672 Proceedings of the County Courts of Kent (1658–1676) Talbot (1662–1674) and Somerset (1665–1688) Counties, AoMO, vol. 54, 518. Robert Murdaugh, who fathered Thomasan Hart's baby, was ordered to "build or cause to be builded . . . A ffote bridge over Capt. Paul Marshes Creek." Somerset County, March Court, 1671, Somerset County (Judicial Records), Oct. 25, 1671–Oct. 20, 1675, AoMO, vol. 87, 80. The terms of extra servitude commonly ranged from three months to a year.

37. Kent County Court, August 1697, Kent County Court, Proceedings, 1676–98, AoMO, vol. 557, 764.

38. Kent County Court, June Court 1703, Kent County Court, Proceedings, 1701–5, AoMO, vol. 740, 85, 190, 195.

39. The following account is taken from Somerset County, January Court 1673/4, Somerset County (Judicial Record), 1671–1675, AoMO, vol. 87, 302–9.

40. Somerset County, August Court, 1674, Somerset County Court (Judicial Record), 1671–1675, AoMO, vol. 87, 368.

41. Somerset County, August Court, 1690, Somerset County Court (Judicial Record), 1689–1690, AoMO, vol. 106, 169.

42. Somerset County Court, September Court 1692, Somerset County (Judicial Record), 1692–1693, AoMO, vol. 106, 406, 408.

43. Somerset County Court, October Court, 1692, Somerset County (Judicial Record), 1692–1693, AoMO, vol. 106, 124.

44. Somerset County Court, November Court 1694, Somerset County (Judicial Record), 1692–1696 (Abstracts), AoMO, vol. 535, 89.

45. Somerset County Court, June Court 1671, Somerset County Court (Judicial Record), AoMO, vol. 86, 135, 139–40.

46. Newgent alleged that he had completed his four-year term of indenture but that Revell refused to free him. The court found in his favor and ordered Revell to give him "Corne and Clothes" as his freedom dues. Ibid.

47. There is an extensive literature on this process. See especially, Morgan, *American Slavery, American Freedom*, 295–337; Winthrop D. Jordan, *White over Black: American Attitudes toward the Negro, 1550–1812*, new ed. (Chapel Hill: University of North Carolina Press, 1995), 71–82; Anthony S. Parent Jr., *Foul Means: The Formation of a Slave Society in Virginia, 1660–1740* (Chapel Hill: University of North Carolina Press, 2003), and T. H. Breen and Stephen Innes, *"Myne Owne Ground": Race and Freedom on Virginia's Eastern Shore, 1640–1676* (New York: Oxford University Press, 1980).

48. ACT XII, Negro Women's Children to Serve According to the Status of the Mother, Laws of Virginia, December 1662–14 Charles II, in Hening, *Statutes at Large*, 2:170.

49. For the most important legislation dealing with miscegenation involving women of European descent, see, for Maryland, An Act Concerning Negroes & other Slaves, Assembly Proceedings, September 1664, Proceedings and Acts of the General Assembly, January, 1637/8–September, 1664, AoMO, vol. 1, 553–54; An Act Concerning Negro Slaves, Assembly Proceedings, May 10–June 9, 1692, Proceedings and Acts of the General Assembly, AoMO, vol. 13, 546–49; An Act Relating to Servants and Slaves, Assembly Proceedings, June 29–July 22–1699, Proceedings and Acts of the General Assembly, March 1697/8–July 1699, AoMO, vol. 22, 546–53. For Virginia, see An Act for Suppressing Outlying Slaves, Laws of Virginia, April 1691–3d William & Mary, in Hening, *Statutes at Large*, 3:86–87; An Act Concerning Servants and Slaves, Laws of Virginia, October 1705–4 Anne, AoMO, vol. 3, 452–54.

50. The selling of these children's labor, but not their persons, was sanctioned by the Maryland government in 1692, and by Virginia in 1705. For the relevant legislation, see An Act Concerning Negro Slaves, Assembly Proceedings, May 10–June 9, 1692, AoMO, 13: 546–549 and An Act Concerning Servants and Slaves (1705), in Hening, *Statutes at Large*, 3:453.

51. Brown, *Good Wives, Nasty Wenches, and Anxious Patriarchs*, 187–211. See also J. Douglas Deal, *Race and Class in Colonial Virginia: Indians, Englishmen, and*

Africans on the Eastern Shore during the Seventeenth Century (New York: Garland, 1993).

52. These figures have been extracted from the Talbot County Judgment Record, 1686–1748, http://www.freeafricanamericans.com/Talbot.htm, and the Anne Arundel County Judgment Records, 1703–65, http://www.freeafricanamericans.com/AnneArundel.htm.

53. In 1719, Mary Munt gave birth to Robin's child, a girl named Massey. August and November Court, 1719, Talbot County Judgment Record, 1686–1746, Judgment Record 1717–19, Liber FT, no. 2, 303, 383, 386–87, http://www.freeafricanamericans.com/Talbot.htm. Two years earlier Margery Johnson, who worked for Clement Sale, "confest" that Phoenix had fathered her baby. November Court 1717, Talbot County Judgment Record, 1686–1746, 6–7. http://www.freeafricanamericans.com/Talbot.htm.

5

Rebecca Kellogg Ashley

Negotiating Identity on the Early American Borderlands,
1704–1757

JOY A. J. HOWARD

On a chilly winter afternoon in February 1753, a small group of Iro-
quois leaders stood near the crumbled, burned remains of the Indian
boys' boarding school in the town of Stockbridge in western Massa-
chusetts. The building, which had included living space for the newly
hired replacement teacher, Gideon Hawley, had been set ablaze in what
appeared to be arson.[1] It was the latest victim in a troubling series of
attacks on the Christian Housatonic Mohicans of the eastern Algonqui-
ans and the Mohawks of the Iroquois federation who lived and worked
in the Stockbridge Mission town.[2] The Iroquois retained much power
in the Connecticut River Valley even as colonization and settlement
encroached on their territory. The debate that engaged the small group
of leaders focused on doing the best for their children and families in
light of the latest violence. They spoke in Iroquois with a smattering
of English and French words. The voices were mostly the deep tenor
of men's voices, but every so often, a woman's voice was heard in the
group. One of the women was a translator in her mid-fifties who went
by the name of Rebecca Kellogg Ashley among the English, although
nothing about her Iroquois accent suggested that she was English. She
wore an English skirt but on her feet were moccasins and snowshoes.
The Iroquois with whom she spoke called her grandmother and cousin.
The leaders' voices carried down the street to another figure that stood
outside despite the bitter February cold.

The Reverend Jonathan Edwards watched the discussion from the
doorway of the parsonage. On the wind, he occasionally caught a French
or English word he recognized amid the Iroquois of which he was not

fluent. Edwards was not surprised to see the Christian Mohawks gathering. He was surprised neither by the Mohawks' anger, nor by Ashley's inclusion in their decision-making process. Ever since the Iroquois contingent agreed to send their children to the school on a trial basis a year and a half earlier, Edwards had been expressing his concerns to members of the mission board and to government officials that the Mohawk families might leave. Although remembered for his part in the Great Awakening, the elder minister was fully committed to the mission work at Stockbridge and had engaged both the Indian and white congregants as passionately as possible.[3] He was concerned about the mission's long-term success as tensions increased between white families and Native American Christians. Edwards knew that most of the Mohawk families had already pulled their boys out of the school because they were not being clothed and fed adequately. After the arson, the decision to leave Stockbridge completely was final. Mohawk leaders pulled out the rest of their boys from the school, despite their vocal appreciation of the new teacher, Gideon Hawley, who had been making incremental improvements. Some families immediately packed their belongings onto horses and sleds, and navigated the cold, snowy terrain on snowshoes. Most waited, however, until warmer spring weather broke open the frozen rivers. By the time planting season arrived, the Mohawks were gone.[4] They moved west out of the Connecticut River Valley into territory that traditionally had been held by their fellow Iroquois nation, the Onondagas. Rebecca Kellogg Ashley, Edwards's "renowned" Mohawk translator, departed with them.[5]

Edwards had harbored no doubts that if Ashley left the mission, all of the Mohawks would be influenced to do likewise. He concluded his 1752 letter to the mission board by predicting the very move the Mohawks discussed after the arson occurred and intimately linked the Ashleys to the Mohawks as he did so many other times in his writing. He pointed out that Ashley was the interpreter the Mohawks had "insisted" upon having at the mission for the schoolchildren and for his Sunday sermons. The verb emphasizes that the Mohawks had hand-selected her.

Ashley may seem like a peculiar choice both for the Mohawks and for Edwards not only because she was white and was an older woman, but also because she was born a Kellogg, one of the families that had kicked Edwards out of his previous church and prominent settlers in the Con-

necticut River Valley. The Kelloggs were also complicit in the abuses against the Christian Natives, which had angered the Mohawks in the first place. Captain Martin Kellogg, Ashley's older brother, mismanaged the school before Hawley took his place. Martin Kellogg preferred to use the Mohican and Mohawk schoolboys as cheap day labor rather than teach them English and Christian catechism as had been promised to their parents. Edwards's choice of "insisted" accurately suggests what the archive reveals about Rebecca Ashley's role in Mohawk community. She identified with the Iroquois, and they marked her as a part of their community. She was much more Mohawk than she was a Kellogg. Mrs. Ashley (as Edwards respectfully called her in his letters) was part of the Mohawk community through the choice Iroquois leadership made and through choices she made. For all of its wealth and prominence in the river region of Massachusetts, her biological family did not seem to figure largely into her life.

Rebecca Ashley had been captured in the 1704 Deerfield attack a few months after her eighth birthday. The Deerfield attack was part of Queen Anne's War (the 1702–13 War of Spanish Succession on the Continent) between the French and English, along with their respective allies from the Mohawk, Huron, Abenaki, and other Iroquois nations. From as far south as Florida and as far north as Nova Scotia, the French and English contested borders and colonial resources as well Native alliances. Although raids like the one on Deerfield were common on both sides in the decade-long war, the 1704 Deerfield attack is uniquely positioned in colonial American history because of its scale, because of the colonial prominence of many of the captives, and because of the well-published stories of John Williams and daughter Eunice Williams that came out of the attack. Allied French, Canadian militia, Iroquois, and Algonquian soldiers captured 112 English Americans settlers during the Deerfield raid. Among the dozens (on both sides) killed was youngest of the Kellogg family, Jonathan, and two of the family's black slaves. Along with their father and two older brothers, both Ashley and her sister, Joanna, were captured and taken north three hundred miles to the Mohawk-controlled town of Kahnawake, across the Saint Lawrence River from Montreal. Ashley's father was ransomed and quickly returned home. Seventeen-year-old Martin—the future army captain—escaped with three other adolescent boys after less than one year. Twelve-year-old

Joseph was imprisoned in the same Mohawk settlement where his two sisters lived until 1714 when Martin came for him after the war ended. Ashley and her older sister grew up in the French Canadian Mohawk town of Kahnawake where they both married and raised children. Ashley eventually returned to English territory and served as a translator for several eighteenth-century Congregational missionaries to Native people.

Although histories of the Deerfield massacre footnote Rebecca Kellogg's presence along side the better known "unredeemed captive" Eunice Williams and although Rebecca Kellogg's life story has been kept alive in family lore, there has been no sustained scholarly or popular treatment of Rebecca Kellogg Ashley's life.[6] At first glance, the historical record appears thin for Rebecca Ashley. She did not leave behind letters or other writings, and unlike Eunice Williams, no one in the Kellogg family wrote about her. Baptism and birth records for the years she would have had babies do not survive. But even though Rebecca Ashley did not leave her own writing, her influence and voice can be read in the historical record.

Using colonial reports, letters, and the journals of missionaries such as Edwards and Hawley, with whom Rebecca Kellogg Ashley interacted, this chapter traces her return to English territory and her work as translator. I examine the ways in which Ashley was represented and what her presence in these documents offers us. Ultimately, I suggest how a feminist epistemology offers us ways to recover and recuperate women such as Ashley who challenge the cultural, political, and religious histories of the English and Indian borderlands in the eighteenth century. In other words, Rebecca Kellogg Ashley's life story and the manner in which she was represented textually speaks to two assumptions that still often plague current studies of women in early America. The first is the assumption that it is impossible to recover the history of many women in early America because they did not often leave sufficient written records of their lives as their male contemporaries did, and even when we do have record, it is highly mediated and therefore inaccurate. The second is that feminist studies has done enough work on the subject in the past thirty years, and we can now "move on" to gender discussions that do not solely focus on women.[7]

Through reconstructing the life of Rebecca Kellogg Ashley from multiple archival texts, this chapter demonstrates that it is possible to

recover the lives of women even as those representations were indeed mediated. The process of textual representation included not only the imaginations of the Euro-American male colonists who wrote the texts but also the lived experience of Ashley and her influence over their texts. Through Rebecca Kellogg Ashley's life, this chapter also illustrates a way scholars can explore how women actively negotiated their textual identity on the early American borderlands. From the day she was captured until her death among the Iroquois, Ashley's ability to create and sustain relationships even "within radically asymmetrical relations of power" on the borderlands shaped her life as an early American woman.[8] As an interpreter of the early eighteenth-century borderlands, Ashley was also an exemplary hybrid individual who mediated cultural exchange on the borderlands.

"Yet They Carried Our Children": Transculturation and Family in Kahnawake

Young Rebecca Kellogg Ashley survived the trip north, as most captured children did, because she was buffered from the hardship and horror that adult captives experienced. Unlike adult captives who were forced to walk through snowstorms often with inadequate clothing, food, and water, their captors cared for young children well. John Williams's narrative—which depicts his capture in the same attack as well as his subsequent imprisonment in Quebec and ransom—reveals that while adults were prized for their ransom value, children were seen for their potential familial and cultural value in Indian communities. Many of the Iroquois near Montreal along the Saint Lawrence River practiced a blended faith of Catholicism and centuries-old Iroquois customs such as "mourning-war." The mourning ritual functioned to restore community and wholeness in war. Captives were adopted into families who had lost individuals of their own to war.[9] "[T]hough they had several wounded of their own to carry upon their shoulders . . . yet they carried our children, incapable of travelling, in their arms, and upon their shoulders," wrote Williams in *The Redeemed Captive* regarding his Iroquois captors.[10] The group moved quickly at thirty to forty miles every day. The pace was grueling for the adults, especially for those without snowshoes in drifts that could reach three feet deep, but the children were warm

and safe from the freezing weather.[11] "My youngest daughter," he writes of Eunice Williams, only one year younger than Ashley, "was carried all the journey, and looked after with a great deal of tenderness."[12] Mohawk soldiers had brought extra horses, leggings, blankets, and wraps on dog sleds, and so Ashley most likely was warm. Williams continued, "My son Samuel and my eldest daughter were pitied so as to be drawn on sleighs when unable to travel."[13] Unlike the adults with the French troops, the children with the Mohawk were fed when food was scarce. These details do not lessen the horror the children must have felt as victims of a brutal colonial war and sudden captives of those their families held as enemies; however such details do suggest why many young captives adjusted so quickly to life with the Mohawks.

Transculturation into Mohawk society began as early as the trip north because the Mohawks did not see captive children as possessions to be ransomed for money, guns, or other tradable goods; they were potential daughters, sons, sisters, or brothers. In contrast to English child-rearing practices of the period, the Iroquois were known to dote on their young children, and so children slated for adoption would have likely been treated with high regard from the men who carried them. Ashley and the other girls would have been the object of tenderness. Williams's narrative continues that the children taken by the Mohawks were quickly "very much like Indians, and in manners very much symbolizing with them."[14] And they did adjust quickly. While the adults and teenage boys were taken to Quebec City or Montreal for ransom, Ashley was adopted into Kahnawake.

Although the Iroquois had harsh adoption rituals for adults such as the much feared gauntlet, the process of adopting a child presumably excluded violence. The mourning family likely chose Ashley and her sister from the group and then conducted a brief "requickening" ritual. Requickening was a ceremony that transferred the role and duties of the deceased to the adoptee.[15] It restored spiritual balance in the family longhouse. It also signaled the end of mourning for that family. Of his daughter, Williams lamented that the Mohawks "would as soon part with their hearts as the child." If the adopted child tried to fit in to the new family, she was loved and accepted. Adoption was neither temporary nor subservient. Children were given names in the Iroquois language, as well as French names. Family tradition says that Ashley's

Indian name was Wausaunia—which possibly meant "bridge" or "connection" or "tie." Her French name has been lost. Many adoptees converted to Catholicism but also embraced Iroquois beliefs and rituals.

Informed by the well-known Eunice Williams story, we can presume that life for a young Ashley in Kahnawake would have been similar to life in the borderlands in Deerfield. Kahnawake was a large, bustling Mohawk community that stretched along the shores of the Saint Lawrence. Ashley would have lived in an agrarian rhythm similar to that in Deerfield, although Kahnawake would have offered additional advantages and safety given that it was a well-established settlement on a major trade route. Ashley learned to speak Iroquois and French, but she also retained English. Keeping one's first language was not something altogether common among children adopted into Mohawk families. Ashley's brother, Joseph Kellogg, wrote that children were kept away from adult captives who could speak English with them.[16]

But Ashley retained her native language well enough to later become a good interpreter. Perhaps Ashley's retention of English can be explained by the circumstance that she and Joanna were adopted into the same town—perhaps even into the same family longhouse since records show they had the same clan identity. It is not difficult to imagine them spending long hours after dark in bed wrapped up in warm blankets protecting them against the northern winter wind, whispering to each other in English like so many sisters do, far past the bedtime. Because they were so close in age and because the Iroquois were matrilineal, valuing sister relationships, their relationship and language likely survived well into marriage, child bearing, and family rearing.

"A Mind to Come Home": Returning to British Territory

John Williams wrote to his son, Stephen, in 1718 that Joanna and Rebecca both wanted to come home, but neither did immediately after the war: "Jonathan Small is come from Canada . . . One, if not both, of the Kellogues [sic] have a mind to come home."[17] When her older brother Martin came to fetch Joseph from Kahnawake after the war, he did not take his two sisters. Given how deeply John Williams mourned for Eunice, it seems questionable that the Kellogg patriarch sent his oldest son to fetch his other son but not his daughters. This odd omission

suggests that Joanna and Rebecca Kellogg, both nearing twenty years old, had married, just as Eunice Williams had by the time the war officially ended. The historical narrative has consistently maintained that Joanna married or, as one early twentieth-century family historian put it, that Joanna "could not be induced to take up her residence with [her brother Martin], her love of her wild wood being too strong, and she returned to her Indian home. Her husband was chief of the Caughnawaga [sic]."[18] The fact that Ashley did not leave with Martin and Joseph suggests that she had married in the community as well.[19] Given their values, their Mohawk families would not have been willing to part with them; meanwhile, the powerful Kelloggs would have most likely rejected mixed-race children had the Kellogg sister brought with them small children.

Rebecca Kellogg Ashley returned to Massachusetts in 1729, and rather than depending on her brothers to fetch her, she negotiated her own way back into an English settlement. Joseph Kellogg presented a request in 1718 for such money from public funds to repatriate his sisters, and this request was approved in 1728.[20] When Ashley returned to English territory, a Mohawk man and a boy accompanied her. Colonial officials treated these two individuals as either captors or agents of her captors. Colonial governments released funds when necessary to ransom British-American citizens from the French and from Native Americans in Canada. After receiving their ransom, the man and boy returned to Canada. If Ashley's husband had died, her sons reasonably were the two ransomers.

It is plausible that Ashley found herself in the position of being the sole provider for her two sons. Because many of Williams's family trips to Kahnawake to beg for Eunice's return included Martin or Joseph Kellogg, Ashley was aware of her brothers' growing prominence as translators.[21] Possessing the same language skills as her brothers, she took the steps necessary to provide for sons. One son was old enough to be regarded as a man. If she had married at fourteen or fifteen, which was common among Mohawk girls at that time, her oldest child could have been as old as seventeen. He probably participated in the assault against the Abenaki. Already battle weary and facing the loss of his mother to an uncle he barely knew, this son was old enough to be presumed a man by the government officials who paid her ransom. The other son was

still a child, but old enough to travel south with his brother through the borderlands. The sons left with a sum that would have been helpful for a family whose father had passed away recently. It seems reasonable then that these two children would have gone back home to their Auntie Joanna. Ashley probably hoped they would be better off with their cousins and their aunt than with her in foreign English territory. She kept track of her sons though, for, as will be seen, the ministers for whom she translated remarked every now and then that she was missing just when they needed her for church. Although I cannot be sure, it seems that she had traveled north to Kahnawake to see her children and grandchildren.

Not much is known about Ashley's life during the subsequent ten years, but we know that Rebecca Kellogg married Benjamin Ashley in 1745 even though the marriage was an unlikely one in many regards. Ben Ashley was twenty years younger than Ashley and an ecstatic New Light from the recent Great Awakenings. The union offered Ashley the currency to function as an interpreter since missionaries could hire her husband when it was really her services that were sought. Gideon Hawley described hiring Ashley after the Stockbridge Mission in this way: "It was also agreed that Mrs. Ashley should be our interpreter and that Benjamin Ashley her husband should be employed and have a salary. This could not be avoided if we had his wife but he was a fanatick [sic] and on that account unfit to be employed in the mission. His wife was a very good sort of woman and an extraordinary interpreter in the Iroquois language. She was captured at Deerfield when that town was destroyed."[22] Even though the ministers with whom Ashley worked did not like Ben, the marriage was a good match. Hawley's journals illustrates that Ben was comfortable in the backwoods. He knew how to trap furs, trade for weapons, guide a canoe, and hunt. He spoke a bit of Iroquois, a bit of Mohican, and some French. He was comfortable with Ashley's kinship ties to her adopted clan and accompanied her into Iroquois territory.

"The Difficulty of the Want of an Interpreter": Translation and Leadership

By the late 1740s, Rebecca Ashley was interpreting for missionaries and would do so until her death in 1757. The colonial project of

Christianizing the Indians was still very much in full force throughout the eighteenth century. Ashley's life in Kahnawake had prepared her well for work among Native faith communities. The Mohawk town was known for its gentle, sincere Catholic beliefs. Perhaps the town offered Ashley an example of mission work done well—where Native believers and converts maintained cultural and spiritual agency to a large extent. Before she translated for Hawley, or even for Edward, Ashley worked with Elihu Spencer and Job Strong. The Society for the Propagation of the Gospel in New England—usually called the New England Company—hired Spencer and Strong after they finished Yale on the recommendation of the legendary missionary David Brainerd. Spencer was Brainerd's brother-in-law.

In an October 1748 letter, Jonathan Edwards articulates his support of Spencer, and, although he does not mention Rebecca Ashley by name, he gestures to her importance to the mission. When Spencer and Strong started the mission, they did not have an interpreter, but Ashley's presence not only helped get the mission off the ground but also promoted fund-raising. Edwards's congregants in Northampton were pleased that she was the interpreter: "[T]he difficulty of the want of an interpreter is now got over; a very good one has been found; and Mr. Spencer was ordained on the 14th of the last month, and is gone with the interpreter, to go to the country of the Oneidas, about 170 miles beyond Albany, and about 130 miles distant from all settlements of the white people. . . . The people of Northampton have also had their hearts remarkably opened to contribute to the maintenance of Mr. Spencer's interpreter."[23] It makes sense that Ashley's presence "opened" Edwards's church members so much so that they contributed money for her salary. To many of the people sitting in the pews, Rebecca was a "redeemed" captive, not just a translator. Her story of captivity, survival, and redemption became a metaphor for the church in New England as someone saved from the Devil's clutches by God's grace. The mission work in which Spencer and Strong engaged needed financial backing from established churches just as much as mission work today requires special collections in churches. The majority of their funding would have come from churches giving the mission board special offerings to support specific evangelical work.

Despite Ashley's ability to "open up" the hearts of Edwards's congregants, Spencer and Strong's mission was short-lived. Edwards blamed

Ashley in a 1749 letter for the failing of Spencer and Strong's mission for which he had held such high hopes. In this letter, like all of his letters, she appears in his narrative next to her husband, but it is clear that she—not him—is the translator and the figure that catches his attention:

> As to the affair of preaching the gospel to the Indians, Mr. [Elihu] Spencer went the last fall, far into the western wilderness . . . where he continued almost through the winter; and went through many difficulties and hardships, with little or no success, through the failing of his interpreter; who was a woman that had formerly been a captive among the Caghnawauga [*sic*] Indians in Canada, who speak the same language with those Oneidas, excepting some small variation of dialect. She went with her husband, an Englishman, and is one of the people we here call Separatists: who showed the spirit he was of there, in that wilderness, beyond what was known before. He differed with and opposed Mr. Spencer in his measures, and had an ill influence on his wife; who I fear was very unfaithful, refusing to interpret for Mr. Spencer more than one discourse in a week, a sermon upon the sabbath; and utterly declined assisting him in discoursing and conversing with the Indians in the week-time. And her interpretations on the sabbath were performed very unfaithfully, as at last appeared, so that Mr. Spencer came away in discouragement in the spring.[24]

The pressure that rested on the translator to the missionary is manifestly apparent. Spencer and Strong had failed, and Edwards placed the blame at Ashley's feet. Edwards did not explicate how her translations were "performed very unfaithfully." One can only speculate what about her style or methods made the Spenser and Strong believe she was not faithful—perhaps her body language was "too Indian" or other forms of cultural display that marked her as Mohawk distracted the young missionaries. I suspect that since Ashley had been bilingual from an early age, she could translate simultaneously while the preacher was still talking. Both missionaries were likely uncomfortable with her voice on top of theirs, as this type of translation takes practice and study for most. Also she possibly interjected herself into the conversation and answered questions herself as would have been expected in Iroquois speech making. Edwards seemed to harbor some doubt regarding the validity of his

own claims, though, because he couches his final assessment of her with "as at last appeared," but nonetheless the mission ended. Note, however, that Ashley created professional boundaries between her work and the work of the mission. She translated on Sundays as she was hired to, but during the week she did not make herself available.

In 1751, Jonathan Edwards accepted the pastorate in struggling Indian mission town of Stockbridge, Massachusetts. His Northampton congregation had voted to remove him as pastor in 1750, and Edwards was officially installed at Stockbridge in August 1751.[25] The New England Company tasked Edwards with preaching to both the Indian and white churches and with strengthening the town's relations with the Mohawks. When Edwards arrived, the mission was made up of mostly Housatonic Mohicans, but the mission board (and the colonial government) wanted the mission to include Iroquois in the area as well.[26] Although the town of Stockbridge was thriving, with more English Americans arriving every spring, the mission of Stockbridge was not. White families were claiming and farming land supposedly set aside for Native believers.[27]

Dismissing his own previous misgivings, once in Indian country Edwards saw how crucial Rebecca Kellogg Ashley was to the success of the mission. And to be clear, he did want the mission to succeed. Edwards had always been supportive of missions, as his letters about Spencer and Strong illustrate, and there is no evidence that he took advantage of land or resources beyond what the mission paid him. The Ashleys wrote letters encouraging the Mohawk to "bring their children hither. . . . She is Captain Kellogg's sister," Edwards says, "[and] had long been in captivity among the Mohawks, was well acquainted with their language, and has a great interest in their affections . . . she being our interpreter for the Mohawks." The pronoun "she" signals that the Ashleys were at the mission because of her skills. The Indians knew her and trusted her; thus Edwards realized that she was the key to success of the mission despite her older brother's claim: "The Captain and his abettors have much insisted that he was the chief instrument of the Mohawks first coming hither. . . . Mr. Ashley and his wife seem to have a much fairer claim to that honor."[28] Ashley's presence drew other Christian Mohawks to the mission because they knew her and Edwards recognized that the Mohawks had insisted on her involvement even though Martin Kellogg did not want her involved. Kellogg had worked briefly as the Indian

schoolteacher. Although the Williams family was pleased with the ease with which they could hire schoolboys from the school, Edwards was not impressed: "The parents of Captain Kellogg's boys and the Indians of the town in general were extremely uneasy at Captain Kellogg's conduct and have often loudly complained in my hearing of Captain Kellogg's ill treatment of their children."[29] Edwards emphasizes that the parents were not impressed with the Stockbridge school and he blames Martin Kellogg for the failure. He initially downplays the mismanagement because of the captain's advanced age, but ideological differences became starkly apparent. Edward believed the Indian children should be educated kindly, while Kellogg disagreed.[30]

Although Rebecca Ashley was born a Kellogg, Edwards's admonition did not extend to her. There is not a single line in any of Edwards's letters that suggests Ashley was even cordial with her brothers or the other powerful family friends in the valley. The language of affection and emotional ties bind Ashley to the Mohawks. "When [the Mohawks] heard that another master was coming," Edwards writes about needing to change school teachers once again, "they were at first much alarmed for fear Mr. Ashley and his wife would be turned out. . . . I told 'em that Mr. Ashley and his wife were not to be turned out, but would still assist, which they took particular notice of in their reply, as what they were very glad of. And that they indeed greatly insisted on it appeared afterward by what they very largely delivered on this subject in a public speech by their sachem."[31] The Ashleys were not "turned out"; they chose to leave the mission with other Mohawks. In 1753, Edwards writes, "Mr. Ashley and his wife [Rebecca Kellogg Ashley] in this case are fully determined to go away and to go and live among the Mohawks in their own country, whom all the Iroquois love, and especially the Onohqua-gas [sic] are exceeding found and have manifested it in their public speeches from time to time. I am very apprehensive that their going away and going to live in the Iroquois country would entirely break up the Mohawk affair."[32] The syntax here is typical of Edwards, but he realizes that if he lost Ashley, "whom all the Iroquois love" (not *what* they love, as he would have written if he was referring to the Mohawk country), he would lose the entire Iroquois contingent at Stockbridge, some of whom were Mohawk and some of whom were Onondagas. Edwards uses language of affection and love here to mark where Rebecca Ashley's

identity lay. The Mohawks "have long shown themselves very jealous for Mr. Ashley and his wife, that they are not well treated by those that have the management of things, and have very publicly complained of it."[33] Edwards uses a sense of the word "jealous" common in the seventeenth and early eighteenth centuries, meaning devoted, fond, or "zealous for the well-being of something esteemed."[34]

Edwards rightly assumed that Ashley was important in the overall decision-making process because of how she was addressed in their public rhetoric. Important decisions that affected the whole community required consensus—traditionally leaders did not hold the right to unilaterally choose a course without the input of other adults, men and women. The Iroquois name Ashley "in their public speeches from time to time" because they considered her as an insider to their community. More clearly, they cared about her and she about them. Public rhetoric in Iroquois life defined and shaped loyalty, so it would have been prudent for the Mohawk leaders to emphasize to whom they were most bound. Her name was mentioned enough so that Edwards noticed it and commented on it. Mohawk rhetoric used speech making as a mode of government and a way of constructing community. Although it might be tempting to ignore Rebecca Kellogg Ashley because she did not write her own account of these events, Mohawk public rhetoric demonstrates a way we might access her story. Edwards was correct when he wrote, "I am very apprehensive that [the Ashleys] going away and going to live in the Iroquois country would entirely break up the Mohawk affair. . . . But they are above [all] attached to Ashley and his wife, and 'tis beyond all doubt they will not settle here, if those persons are not with 'em, and that the fairest prospects will be dashed."[35] It is not clear who abandoned Stockbridge first, Ashley with husband Ben or the Iroquois contingent. Regardless, by 1754 Edwards had only a handful of Indian Christians left in the mission. He left in early 1758 when Princeton asked him to replace his recently deceased son-in-law as president.

The Mohawks from Stockbridge joined their fellow Iroquois Onohquagas farther west that spring 1753. Gideon Hawley, the schoolteacher who had been appreciated by the Iroquois, was now an ordained pastor and had followed the Indians west.[36] Edwards had lost hope for the mission project at Stockbridge but held out hope for a mission away from white Christians. In April 1755, Edwards reported to the Scottish

Congregational pastor and his personal confidant, John Erskine, that the mission Hawley started was successful: "I have but little success, & many discouragements here at Stockbridge, yet Mr. Hawley, Missionary among the six Nations . . . has of late had much Encouragement. Religion seems to be a growing spreading Thing among the savages in that Part of America, by his means; And there is an hopeful Prospect of way being made for another Missionary in those Parts."[37] It is difficult not to overemphasize just how much hope Edwards held for the new mission, but his commitment can be grasped more tightly when we see that he sent his ten-year-old son to join Hawley and the Ashleys soon after they left Stockbridge.[38]

Hawley's journal reveals that he depended heavily on Rebecca Ashley as he learned to travel and live in the borderlands. Rebecca Kellogg Ashley shapes Hawley's experience of the Iroquois in this new mission as she had done for Spencer and Edwards. Like Edwards, Hawley writes "Mrs. Ashley" in his journal when he mentions her. He writes that she "was a very good sort of woman and an extraordinary interpreter in the Iroquois language."[39] Repeatedly, he uses the word "extraordinary" to describe her. Later, further into his mission, he simply calls her "my Interpreter" as she becomes an ever-present character in his letters and diary. In the summer of that first year, Hawley recorded that without Ashley, there was no preaching to be had: "Lord's Day July 22nd my Interpriter being sick & none to be had yt Could understand English. I did not preach to ye Indians."[40] With Ashley present, Hawley was able to preach and hold Sunday school for the children: "[H]ad some assistance in Speak[ing] to ye Indians . . . after meeting I with the Help of my Interpriter Chatechised ye Children & Youth." Several months later, he wrote, "I read and expanded part of Mat. XXII by ye help of Mrs. Ashley my Interpriter afterwards I preached."[41] "With the help of my Interpreter" he preached to the Mohawk; "with the help of" his interpreter he ministered to the sick; "with the help of my Interpreter" he baptized converts.

Hawley's vulnerability without Ashley is striking in the following passage from August 1753 as well as in others: "truly our Situation is very melancholy . . . we are far from our Fr[ie]nds, in ye Wilderness [sic] away from ye Comforts we want. What . . . adds to our gloomy circumstances is we are both of us sick. . . . Tho' Mr Ashley & his Wife were very kind to us & did wt. they conveniently could . . . we dread to have ye Night

come."[42] Hawley was known to suffer from depression and worried about himself and the mission when Rebecca Ashley fell ill, as he says in a draft of a July 1753 letter: "What adds to our many Anxieties is, yt here we have the unhappiness to be advised yt our Interpriter is very dangerously sick."[43] This entry exemplifies a larger situational mystery regarding Hawley's mission and Ashley's part in it. Who "advised" Hawley that Ashley was ill? Hawley mentions Ben by name in many other places in the journal, and so the messenger must not be him. He also mentions Ashley's black slaves, Hannabel, Dorothy, and their baby, as well as "Mr. Ashley's hired man who was half blood" by name.[44] Although Rebecca Ashley was mentioned in his journal more than anyone else during this period of Hawley's ministry, there exists a puzzling distance between Hawley and his interpreter. One would expect him to live in closer proximity to her and know when she was ill since she was the interpreter for his mission, but this was not the case.

Ashley was often away, deeper into Indian country and out of reach of the missionaries for whom she worked. Hawley sometimes had to look for Ashley and only then was able to preach: "Yesterday Afternoon finding our Interpriter, I offered to preach to a few Families of Indians."[45] In another journal entry, he records, "Having found Mrs. Ashley we took her & Co and went to the Mohawks and had a meeting and pray ed & preached. Sunday is here a day of festivity."[46] Perhaps Rebecca Ashley was busy doing the farming, gathering, and other necessary work of a woman in an Iroquois town. She likely traveled to Kahnawake during good weather to see her children and grandbabies, utilizing kin networks of Iroquois towns in the borderlands.

Gideon Hawley's mission to the Iroquois failed; he later led a successful lifelong mission for Christian Indians at Mashpee, Massachusetts, where he preached and taught nearly five decades until his death. In April 1756 Hawley wrote in his journal, "Having advised with my Indians as to [the] expediency of tarrying with them in the present situation . . . they unanimously agreeing . . . of [the] inexpediency of it . . . at [the] same time called for Mrs Ashley my Interpreter & advised her to return with her Husband to their native Country."[47] The French and Indian war had begun. The Iroquois to whom Hawley ministered instruct him that he should go home because they could not keep him safe. He also writes that the Indians tell him to tell Ashley to stay put in

Indian country. In other words, the Native leaders advised that Hawley leave Indian country for his safety and that Rebecca Ashley return deeper into it for her safety. In the entry, Hawley added Ben Ashley as an afterthought. He added the prepositional phrase "with her Husband" with carets above the original sentence so that the sentence originally read that the Mohawks called for "Mrs Ashley my Interpriter" and "advised her to return to their native Country." This close reading clears up a problem with the syntax. Rather than being a problem, it reflects Rebecca Ashley's relationships with the Mohawk. Hawley struggled to account for relationships he did not understand. "[T]heir native Country" refers to Indian's country and to Ashley's country, whereas Ben is an afterthought. The Native leaders emphasized that "we" Iroquois need to go home. For her safety, as a Mohawk, Ashley needed to "return" home too. She could continue to stay with Gideon Hawley. She was not safe among white Protestant English men she would be in her "native" country among her own people.

While the possessive pronoun "their" might not seem to amount to much on its own, added to Edwards's stories of public speeches and his concerns about Ashley leading the Mohawk away, we see a figure who challenges our notions of the "redeemed captive." Hawley, Edwards, and others may have seen her as a white Protestant like themselves, but the Iroquois saw her as Mohawk, a member of the turtle clan, raised on the shores of the Saint Lawrence in Kahnawake. She obviously thought of herself as Mohawk too. Hawley relayed the message from the leaders because Ashley died of illness in the very community that sent Hawley away. Hawley writes repeatedly in letters and in his journal that the Indians loved her and greatly "lamented" her when she died. Hawley's poetic choice of words signals the depth of mourning he sensed in the Iroquois community.

Ashley negotiated a network of families, religion, and communities—both American and Iroquois. The historical record we have in Hawley's and Edwards's writings, although mediated, illustrates that Ashley had indeed become Mohawk. Through her work as a translator, she found ways to skillfully navigate the borderlands and troubled relationships between white settlers and the Iroquois. Lisa Logan asserts, "We need to study *women* as actual people whose experiences comprise daily material realities—participation in work, family, love, politics, religion,

community, and so on. Women often must negotiate a particular set of experiences that they obtain *because* they are women, and these recorded experiences in patriarchy form literary histories that should and do compel us."[48] Indeed Rebecca Kellogg Ashley's recorded experience is compelling not because it is one of a captive who returned to English civilization from a savage frontier experience but rather because it is the story of one who successfully navigated contact with multiple disparate cultures throughout her lifetime. As Ashley was a captive during the Deerfield raid, her body was the first site where she experienced cultural interchanges within that complex network of family, religion, and community. The mission church, including the ambition of preachers like Edwards and Hawley, became a later site of cultural expression; nonetheless, it offers us today a concrete example of the "material realities" of women in the early American borderlands.

NOTES

I am grateful to Margaret Bendroth, Claudette Newhall, and Robin Duckworth of the Congregational Library in Boston, Massachusetts, who helped me find Gideon Hawley's writings in their collection, to Harold F. Worthley, who transcribed Hawley's journals, and to Karl P. Stofko, the East Haddam Municipal Historian. I am grateful to Patrick Cesarini, Becky McLaughlin, Elizabeth Thompson, Emily Wardorp, Kristina K. Bross, Megan Hughes Morton, Nicole Livengood, Daniel R. Mandell, Richard Bell, Randall Miller, and Richard Fusco. Special appreciation is reserved for my fall 2012 "Captivity Narratives in Early America" course at Saint Joseph's University: Niki Backos, Alyssa Bartholomew, Ann Bonasera, Katie Cedzidlo, Brenna Dinon, Rosemary Martin, Kaitlyn McSwiggan, Marie Vitale, Barry Wilkes, and Alex Zarpa.

1. George M. Marsden, *Jonathan Edwards: A Life* (New Haven: Yale University Press, 2004), 375–413.

2. The Iroquois were a loosely bound confederacy of the Seneca, Cayugas, Onondagas, Oneidas, Mohawks, and Tuscaroras, who had emigrated from the Carolinas at the beginning of the eighteenth century to join the federation. See Daniel K. Richter, *The Ordeal of the Longhouse: The Peoples of the Iroquois League in the Era of European Colonization* (Chapel Hill: University of North Carolina Press, 1992).

3. Rachel Wheeler, "Jonathan Edwards: Missionary," in *Works of Jonathan Edwards Online. Jonathan Edwards Center* (New Haven: Yale University, 2008), http://edwards.yale.edu/research/about-edwards/missionary.

4. Rachel Wheeler, *To Live upon Hope: Mohicans and Missionaries in the Eighteenth-Century Northeast* (Ithaca, N.Y.: Cornell University Press), 210–11.

5. Thomas S. Kidd, *The Great Awakening: A Brief History with Documents*. (Boston: Bedford/St. Martin's, 2008), 205.

6. John Demos, *The Unredeemed Captive: A Family Story from Early America* (New York: Knopf, 1994); Barbara L. Covey, *Rebecca Kellogg Ashley, 1695–1757: From Deerfield to Onaquaga* (Westminster, Md.: Heritage Books, 2008); and Evan Haefeli and Kevin Sweeney, *Captors and Captives: The 1704 French and Indian Raid on Deerfield* (Amherst: University of Massachusetts Press, 2003).

7. Lisa M. Logan, "The Importance of Women to Early American Study," *Early American Literature* 44, no. 3 (2009): 644.

8. Annette Kolodny, "Letting Go of Our Grand Obsessions: Notes toward a New Literary History of the American Frontiers," *American Literature* 65, no. 1 (March 1992): 1–18; and Mary Louise Pratt, *Imperial Eyes: Travel Writing and Transculturation* (New York: Routledge, 1992).

9. Daniel K. Richter, "War and Culture: The Iroquois Experience," *William and Mary Quarterly*, 3rd series, 40, no. 4 (1983): 528–59.

10. John Williams, *The Redeemed Captive Returning to Zion* (1707; repr., Bedford, Mass.: Applewood Books, 1989), 14.

11. Emma Coleman, *New England Captives Carried to Canada between 1677 and 1760, during the French and Indian Wars* (Portland, Ore.: Southworth Press, 1925), 43.

12. Williams, *Redeemed Captive*, 22.

13. Ibid., 22.

14. Ibid., 27.

15. Richter, "War and Culture," 533.

16. Joseph Kellogg, "When I Was Carried to Canada, c. 1740," in *Captive Histories: English, French, and Native Narratives of the 1704 Deerfield Raid*, ed. Evan Haefeli and Kevin Sweeney (Amherst: University of Massachusetts Press, 2006), 181–90.

17. As quoted in John Demos, *Unredeemed Captive*, 168.

18. Timothy Hopkins, *The Kelloggs in the Old World and the New* (San Francisco: Sunset, 1903), 38.

19. Haefeli and Sweeney suggest that Joseph forced his sister to stay, perhaps even tricked her into staying, but they do not offer any guesses as to whom the man and the boy in the record are. See Haefeli and Sweeney, *Captive Histories*, 8.

20. Demos, *Unredeemed Captive*, 293n5.; Records of the Council of Massachusetts Bay, 25 February 1718, in MA, VII: 18.

21. Demos, *Unredeemed Captive*, 113, 183.

22. Gideon Hawley, "A Letter from Rev. Gideon Hawley of Marshpee Containing a Narrative of His Journey to Osohoghgwage. 1791," in *The Documentary History of the State of New-York*, ed. Christopher Morgan and Edmund O'Callaghan (New York: Weed, Parson, 1850), 1033–46.

23. Jonathan Edwards, "Letter 90. To the Rev. John Erskine. 1748," in *Letters and Personal Writings. Works of Jonathan Edwards Online*, vol. 16, ed. George S. Claghorn (New Haven: Yale University, n.d.), http://edwards.yale.edu.

24. Jonathan Edwards, "Letter 93. To the Reverend John Erskine. 1749," in Claghorn, *Letters and Personal Writings*.

25. The context behind Jonathan Edwards's dismissal from Northampton is complex both theologically within the framework of an international revival movement and culturally as Edwards interacted with powerful colonial families in the Connecticut River Valley. See Christopher Grasso, "Misrepresentations Corrected: Jonathan Edwards and the Regulation of Religious Discourse," in *Jonathan Edwards's Writing: Text, Context, Interpretation*, ed. Stephen Stein (Bloomington: Indiana University Press, 1996), 19–38; Wilson Kimnach, Kenneth Minkema, and Douglas Sweeney, eds., *The Sermons of Jonathan Edwards: A Reader* (New Haven: Yale University Press, 1999), xxxiii–xxxiv; Marsden, *Jonathan Edwards*; Stephen Nichols, "Jonathan Edwards: His Life and Legacy," in *A God Entranced Vision of All Things: The Legacy of Jonathan Edwards*, ed. John Piper and Justin Taylor (Wheaton, Ill.: Good News Press, 2004), 35–54; and Gerald R. McDermott, "Missions and Native Americans," in *The Princeton Companion to Jonathan Edwards*, ed. Sang Hyun Lee (Princeton, NJ: Princeton University Press, 2005): 258–73.

26. I follow Rachel Wheeler's example in *To Live upon Hope* and use the term "Mohican" because that is the name by which the tribe identifies itself today.

27. See James Axtell, "The Rise and Fall of the Stockbridge Indian Schools," *Massachusetts Review* 27 (1986): 367–78; Lion G. Miles, "The Red Man Dispossessed: The Williams Family and the Alienation of Indian Land in Stockbridge, Massachusetts, 1736–1818," *New England Quarterly* 67, no. 1 (1994): 46–76; and Gerald McDermott, "Jonathan Edwards and American Indians: The Devil Sucks Their Blood," *New England Quarterly* 72, no. 4 (December 1999): 539–57.

28. Jonathan Edwards, "Letter 152. Letter to the Reverend Isaac Hollis. 1752," in Claghorn, *Letters and Personal Writings*.

29. Jonathan Edwards, "Letter 144. To Speaker Thomas Hubbard. 1752," in Claghorn, *Letters and Personal Writings*.

30. For a succinct synthesis of Edwards's philosophy of education, see Kenneth Minkema, "Informing of the Child's Understanding, Influencing His heart, and Directing Its Practice: Jonathan Edwards on Education," *Acta Theologica* 31, no. 2 (2011): 159–89.

31. Jonathan Edwards, "Letter 164. To Speaker Thomas Hubbard. 1753," in Claghorn, *Letters and Personal Writings*.

32. Edwards, "Letter 144."

33. Ibid.

34. "jealous, adj.," *OED Online*, (December 2012), http://www.oed.com (accessed January 29, 2013).

35. Edwards, "Letter 144."

36. Jonathan Edwards, "A171. Letter to Thomas Foxcroft, May 24, 1753. From Stockbridge," in *Correspondence by, to, and about Edwards and His Family. Works*

of Jonathan Edwards Online, vol. 32, ed. Jonathan Edwards Center (New Haven: Yale University), http://edwards.yale.edu.

37. Jonathan Edwards, "A203. Letter to John Erskine, April 15, 1755," in Jonathan Edwards Center, *Correspondence by, to, and about Edwards and His Family*.

38. Jonathan Edwards, "A204. Letter to Jonathan Edwards, Jr., May 27, 1755," in Jonathan Edwards Center, *Correspondence by, to, and about Edwards and His Family*.

39. Hawley, "A Letter."

40. Gideon Hawley missionary journals, 1753–1806, vol. 2, MS1237, Congregational Library & Archives, Boston.

41. Ibid., vol. 1.

42. Ibid., vol. 2.

43. Ibid., vol. 3.

44. Ibid., vol. 1. The practice of slaveholding would not have been outside the norm for Ashley as a Mohawk.

45. Ibid., vol. 2.

46. Ibid., vol. 3.

47. Ibid.

48. Logan, "Importance of Women," 643.

6

Womanly Masters

Gendering Slave Ownership in Colonial Jamaica

CHRISTINE WALKER

In his early eighteenth-century play *The Islanders, or Mad Orphan*, Jamaican-born playwright John Kelly imagined the lives of free women and enslaved people as hopelessly intertwined. In Kelly's estimation, slavery increased free women's subservience within the household. As one character exclaimed, "our West India husbands look upon their Wives, as very little above their Slaves, nay very often treat 'em worse."[1] A planter's wife would expect to be "buried" alive on a plantation where she would be "employ'd all day in making Breeches and Pettecoats for the Slaves." Living in a slave society dramatically increased the domestic work that free women typically performed as they shouldered the responsibility of caring for enslaved people in addition to family members. Integrating enslaved people into household economies also placed new demands upon free women. A plantation wife would spend her days "taking an Account of the weight of sugar; which goes out of the plantation, with the quantity of Rumm" while also operating "a Hucksters Shope" where she sold "drams and Tobacco" to the enslaved people who lived on her plantation.[2]

Kelly perceived of the expansion of slavery as increasing free women's degradation and servitude. In requiring free women to serve both husbands and enslaved people, slavery intensified female subservience. Even the material rewards that free women received as recompense for serving enslaved people were marred by slavery. Though wives might enjoy the extravagance of "a coach and six horses," the ultimate status symbol in the early modern period, her horses would be employed grinding sugarcane during the day and a "a negro coachman, with a pair of ozzenbrig breeches, a half hat, and livery coat . . . with two or

three naked negro wenches be hind," would "compleat the equipage."[3] Slavery transformed this epitome of British luxury into a vulgar display of wealth, which according to Kelly would be "a sufficient demonstration" of a husband's affection for his wife. The playwright imagined free women and enslaved people as engaged in acts of reciprocal exchange, whereby wives were treated to carriage rides about town in return for providing those who served them with clothing, tobacco, and rum.

In portraying colonists as hedonistic and rapacious gluttons, *The Islanders, or Mad Orphan* fit into a growing body of eighteenth-century British literature that critiqued West Indian social and cultural practices. However, Kelly's attention to the plights of free women distinguishes his work. While British authors used long-standing female types to portray colonial women as either strumpets or indolent children, Kelly considered them to be agents in their own right. Having grown up on the island, the author possessed an insider's knowledge of local society. He chose to highlight the deeply entangled relationship between gender and slavery. The play focused on the limited life choices available to the free female protagonists, who like enslaved people would be considered as the legal dependents, and in certain respects the property of husbands upon marriage.[4] Kelly did not invent the long-standing association between enslavement and the social, economic, and legal constraints placed upon women. However, by setting his play in Jamaica, Kelly transformed this metaphorical relationship into a realistic account of how slavery influenced free women's lives in the colony.

Kelly's play is a fascinating and rare study of social relations in the early stages of Jamaican settlement. Yet, his negative portrayal of the impact of slavery on the lives of free women requires further examination. An abundance of archival sources indicate that slavery increased the wealth and authority of women, rather than having a deleterious effect on their lives as Kelly presumed. Women of European and African descent were major stakeholders in Atlantic slavery. They were involved in every aspect of slave ownership, from buying and selling enslaved people, to bequeathing them to future generations. Free women composed a diverse group in the colony. Some were born into wealthy families. They were white, privileged, and powerful. Others were born into slavery, achieved freedom, and preciously guarded it. The majority fell somewhere in between these extremes. Only nonwhites could be en-

slaved in Jamaica. Yet, racial categories based on ancestry and complexion did not necessarily determine free women's lives. Similarly, slavery was a diversified experience and sometimes an escapable condition. By the mid-eighteenth century, free people of color made up one quarter of the island's free population.[5] In this chapter, I will identify whether a free woman had European or African ancestry when possible while also recognizing the potential fluidity of racial identity in early modern Jamaica.

Regardless of economic position or racial identity, most free women were involved in slaveholding, from renting, buying, and selling enslaved people, to bequeathing them to future generations. Enslaved people performed the double function of serving as both novel financial assets and as laborers who generated unprecedented female fortunes. Slavery provided women with immaterial, as well as material benefits. As slave owners, women accrued authority that contradicted their customary positions as social and legal dependents in relation to men. The rapid expansion of slavery mitigated the importance of upholding traditional gender differences in colonial society while making the status of being free of utmost importance.

In the eighteenth century, British colonists imported enslaved Africans to Jamaica on an unprecedented scale. Enslaved laborers rapidly transformed an insignificant Caribbean island into the wealthiest colony in the British Empire.[6] Jamaica became the apotheosis of the extraordinary commercial success that could be wrested from slave labor. Yet, women are either absent or marginal from accounts of how Atlantic slavery transformed the island. Instead, scholars have characterized colonial society as hypermasculine and deeply patriarchal in nature.[7] This scholarship fits into a broader historical narrative, which fixates on white men as the principal agents of chattel slavery in America and insists upon the importance of patriarchal beliefs in constituting the ideological framework for this labor system.[8] A handful of scholars have studied how beliefs about gender and sexuality shaped and were shaped by the expansion of slavery.[9] However, Jennifer Morgan has rightly argued that "gender continues to be an acknowledged but largely under-theorized area in slavery studies or in the study of early modern racial formation." Moreover, "women still tend to disappear from broad assertions of what slavery was and whom it affected."[10] The dearth of information about women's involvement in advancing slavery has left us with an in-

adequate account of one of the most significant historical developments in the early modern Atlantic world.

Using Jamaica as a case study, this chapter explores the varied nature of women's participation in slavery. It repudiates the now canonical belief that white men single-handedly accelerated the slave trade and ensured the continuation of slavery in the colony. Slavery inestimably altered British customs and values in Jamaica, where policing the boundaries between free and enslaved people took precedence over upholding male prerogatives. Rather than relying upon older patriarchal ideologies, colonists adopted practices that resulted in greater gender parity between free people. Colonial inheritance conventions turned enslaved people into the primary form of capital that women received from spouses and relations. In addition to inheriting slaves, women actively participated as buyers and sellers in the slave market, thus helping to fuel the slave trade. They also personally managed enslaved people who worked inside their households and on their plantations. By the mid-eighteenth century, slave ownership was endemic to all free people who lived in Jamaica, irrespective of race or gender.

Inheritance and Slavery

Inheritance was a primary means through which free unmarried women became involved in slavery. Colonial wills capture a broad cross section of free society. Most women did not identify their race in their wills. They may have been white, but other evidence indicates that free women of color either actively or inadvertently elided racial categorization.[11] While British legal traditions aimed to ensure male authority within and outside of the household, colonial circumstances lessened the importance of upholding patriarchal customs.[12] High mortality rates resulted in frequent redistributions of wealth within families and often eliminated male heirs altogether from lines of inheritance.[13] Free people died frequently, but they died rich. On average, colonists in Jamaica were considerably wealthier than anyone else in the British Empire.[14] Enslaved people simultaneously constituted capital and produced colonial fortunes through their labor. Thus, free people needed to perpetuate slavery in order to maintain the chief means of prosperity

for their families. This priority required the involvement of all family members, male and female alike.

Colonists adapted to the local contingencies of death, wealth, and slavery by transferring larger portions of estates to female relations. Vesting free women with greater legal authority to manage property and slaves enabled free families to keep estates intact and operational. Instead of favoring the eldest males, resources were allocated more equitably among children regardless of birth order and gender. Colonial wills exhibit this pragmatic approach toward inheritance. Nearly half of the three hundred husbands studied for this chapter bequeathed all "real and personal" property to wives when they died.[15] This pattern signaled a departure from the British common law of dower, which entitled widows to one-third of family estates "for life."[16] In Jamaica, widows commonly assumed legal control of substantial resources. Likewise, daughters, granddaughters, and nieces were given larger legacies in the form of money, enslaved people, and property.[17] Rather than adhering to patriarchal customs that benefited male kin, colonists transmitted resources and authority to women who understood the intricacies of family enterprises.

Free and predominantly European women from varying social backgrounds acquired considerable wealth through inheritance, and enslaved people constituted the majority of their newfound riches. In the eighteenth century, slaves accounted for the primary assets inherited by women. More than half of all men who were married and/or had children bequeathed enslaved people to wives and daughters.[18] These estimates are conservative and do not account for slaves who were part of less descriptive bequests of "real and personal estates." Realistically, three-quarters of all women who received legacies from men were given enslaved people. This inheritance pattern took shape early on in the colony's settlement. For instance, in 1678 planter Joel White gave his daughter Mary all of his plantations along with "twenty and seven old and young negroes, thirteen horses and mares and five colts."[19] In 1699 surgeon Edward Smith offered his estate to his wife but forbid her to sell any of the enslaved people who belonged to the family. They would all descend to the couple's daughters.[20] Planter Francis Flowaires bequeathed a boy named Bezanna and three girls, Daphiney, Nanny,

and Mimbo, to his daughter Mary. Likewise, he gave four slaves to his daughter Rebekah.[21]

Long-standing gendered inheritance practices also helped to naturalize female slave ownership. In Britain, "real" property or real estate remained within male control, while women assumed possession of personal property, or "moveable" goods such as furniture and bedding as well as livestock. In the colony, enslaved people were frequently treated as personal property, which identified them, like clothing, furniture, and jewelry, as feminine possessions. This trend increased in the first half of the eighteenth century and was not limited to wealthy planters.

Free men from all walks of life bequeathed slaves to women, revealing an unspoken cultural assumption that they were the "natural heirs" of slavery. John Frazier, a bricklayer, allotted enslaved people to his wife Ann and expected her to hire them out to support the couple's children.[22] Nicholas Redkey, a shoemaker from Saint Catherine, provided his wife Eleanor with two slaves, Peter and Grace, during her lifetime, in addition to the use of his house in Spanish Town.[23] A girl named Prudence stood to inherit a thousand pounds, a house, and three enslaved people, Adam, Venus, and a "mulatto" woman Sarah from her father John Gale, who was a carpenter by trade.[24] Samuel Hinton, a tavern keeper in Kingston, provided his daughter Hannah with several adult male slaves, in addition to seven enslaved boys and three women.[25] These colonial inheritance practices contributed to widespread female slave ownership. Approximately three-quarters of all women who made wills during the first century of British settlement in Jamaica owned enslaved people.[26] A survey of probated inventories of women's estates made between 1674 and 1784 supports evidence of endemic female slave ownership. During this time period women possessed approximately fifteen thousand slaves.[27]

Like men, free women from all levels of society used inheritance as a means of perpetuating and expanding female engagement in slavery. Women overwhelming bequeathed the majority of their estates to other women, which consolidated the possession of enslaved people within families along female lines.[28] For instance, Mercy Bars provided only five slaves to her son, while she gave her daughter, Sarah Ricketts, several large families of enslaved people.[29] Another woman, Catherine Byn-

dloss, received her husband's consent to bequeath "my slaves whereof I am seized in my own right." Byndloss chose to allot one enslaved man, Cufee, to her son Henry, whereas she devised four enslaved women, including Betty and her daughters Hannah and Quasheba, along with another woman, Quasheba, to her daughter Jane.[30] Bars and Byndloss disclose the commonplace practice of providing more enslaved people to daughters than to sons in the colony.

Slave ownership was a ubiquitous feature of colonial life that crossed the boundaries of gender, status, ethnicity, and race. Free people who were of African descent strengthened their financial and legal claims to liberty by participating in slavery. Goody Jacobson, who identified himself as a "free negro" and a butcher, gave his wife Esther two enslaved women, Molly and Phillis, along with the rest of his real and personal estate.[31] Many free women of African descent also engaged in slavery. Elizabeth Keyhorne, who may have been enslaved herself earlier in life, was the mother of four daughters, Molly, Margaritta, Flora, and Franky, who were still enslaved. Despite her familial ties to slavery, Keyhorne also owned four enslaved people, a woman named Jenny and another, Daphne, along with Daphne's daughters Catalina and Fortune.[32] While Keyhorne gave her wearing apparel to her enslaved daughters, she provided her free son Joseph with property in Kingston and ownership of the aforementioned slaves.[33]

Colonists demonstrated a clear preference for allocating resources to the most deserving, needy, or competent family members regardless of gender. Relations understood that their survival and prosperity, which depended upon slave labor, required the participation of their closest allies. More egalitarian inheritance practices increased the number of female slave owners and encouraged the growth of slavery in Jamaica. These practices had significant material and ideological consequences. Giving women absolute power over other human lives was fundamentally different from offering them material objects like gowns and tea tables. In early modern society independence was predicated upon having authority over dependents. Men normally assumed this status when they became the husbands and fathers of dependent wives and children. Slave ownership offered free women new means of supporting themselves without male assistance. By wielding authority over enslaved dependents women further enhanced their status as independent subjects.

Slavery eroded patriarchal modes of ordering relations within the family, which in turn worked to neutralize gender differences in colonial society.

The Commerce of Slavery

In 1777 Grace Graham, a "free mulatto woman," purchased a "tall thin negro wench." This enslaved woman was identified as an "Ebo" who had "yellow skin" that was marked with the smallpox. Two years later she escaped from Graham.[34] This brief ad for a "runaway slave" opens up the door to the complexities of women's participation in the marketplace for enslaved people. It also countermands the dominant assumption that white men were the primary players in the slave trade. Free women of color like Grace Graham were also typical agents in the commerce of slavery. In addition to acquiring slaves through inheritance, free women actively capitalized on the opportunity to buy and sell enslaved people. As consumers and purveyors of human flesh, women increased the demand for more people to be forcibly transported from Africa to Jamaica, and helped to intensify the British slave trade.

Parents often initiated female contact with the slave market by setting aside money expressly for daughters to purchase "new negroes," or enslaved people who had recently been transported from Africa to the colony. Widow Bonny Tamasin gave eighty pounds to her granddaughter Elizabeth Savory, which she ordered to be "laid out in negroes."[35] Edward Phips furnished his daughter Ann Coles with three hundred pounds and instructed his executors to use the money to purchase "choice new negroes two men and two women" as well as "a new negro girl to wait on her."[36] Though children did not purchase enslaved people themselves, such bequests engaged free women in the slave trade at a young age.[37] Many women experienced slave ownership during their infancies. Such childhood experiences established a precedent for female participation in the slave market at an early age. Within this social context, it is unsurprising that free woman had the capacity to value, buy, and sell enslaved people later in life.

Women were raised to perceive of enslaved people as financial assets. Sisters Dorothy Watson and Elizabeth Lasselles, who operated a business in Kingston together, expressed this mentality. They described

enslaved people as commodities that could be divided into "shares." Watson offered her sister her "half part and share in two negro women slaves which we bought between us named Marina and Belinda" in her will of 1740.[38] Another slave owner, Mary Elbridge, advised her niece Rebecca Woolnough to sell several enslaved people. She described a woman named "bety" as "sickly" and "hanah" who had two small children as "a very lazy creture," writing, "hir work will scarce maintain hir children." Another slave, Ned, was "very much ruined since he came to the island."[39] Elbridge was anxious to receive permission from another woman to sell Betty, Hannah, and Ned, whom she claimed caused her "so much vexation" and made her "quite tired." She shrewdly calculated the relative value of each slave and declined responsibility for any idle, unhealthy, or recalcitrant laborers.

Mary Elbridge's depictions of enslaved people and her capacity to operate in the marketplace for slave labor provide one instance of the power that women assumed to determine the fates of other human beings. Furthermore, men relied upon female relations to buy and sell enslaved people. Such activities were an ordinary feature of colonial life. For instance, Charles Price directed his wife Sarah to purchase more enslaved people "for the better carrying on and advancement of my estate" in his will.[40] James Parker, a self-described gentleman from Kingston, conveyed ownership of eleven enslaved people to his wife Margaret, and instructed her to sell them and use part of the money to pay off a fifty-pound debt that he owed. Then, she could use the remainder of the proceeds to finance her move to England and to finance the couple's mortgage on a building called the "Fox & Goose" in London.[41] Bricklayer John Frazier wanted his wife Ann to sell land that he had recently purchased in order to buy more enslaved laborers. Like James Parker, he also instructed his wife to sell the enslaved people in order to finance her move to England.[42]

Studying female slave ownership offers one means of accessing the variegated nature of the colonial economy. Jamaica has become synonymous with the sugar plantation regime. These monochromatic depictions of endless cane fields obscure the existence of a more diversified and bustling service economy. High mortality rates left many free women to "shift for themselves." However, possessing enslaved workers significantly enhanced single women's economic opportunities. Female

colonists tended to own enslaved people who worked as seamstresses, servants, cooks, washerwomen, and coachmen whom they "hired out" or rented to others who needed temporary workers for a profit.

The practice of renting enslaved people to work in the service economy was especially common in the urban areas of Kingston, Port Royal, and Spanish Town, where larger numbers of transient people were willing to pay for meals to be cooked and clothing to be washed. Ads for "runaway slaves" in local newspapers attest to free women's reliance upon the wages earned by enslaved people. When Martha Ewers died, the enslaved women, Chloe and Sylvia, whom she hired out to work as washerwomen absconded with "several months wages."[43] Though Chloe and Sylvia performed grueling labor to earn "several months wages," they had no right to this income. It was for the sole benefit of Martha Ewers and her family. The practice of renting out slaves crossed racial boundaries. A free "mulatto" woman named Christian Gregory, also relied upon the income earned by an "an elderly negro woman of the Congo country named Abigail" who worked as a washerwoman.[44] Like Chloe and Sylvia, Abigail also chose to escape from a life of drudgery and absconded from her owner.

This practice was not unique to female slave owners in Jamaica. Women throughout the Atlantic world survived on the wages earned by enslaved people who they "hired out." Historian Ellen Hartigan-O'Connor has studied how female colonists turned domestic work into paid labor by renting out enslaved women to work in colonial Newport, Rhode Island, and Charleston, South Carolina. The similarity of the economic strategies developed by women who lived in the port towns of Kingston, Charleston, and Newport intimates the existence of distinctively female manifestations of slave ownership. This practice also afforded enslaved women opportunities to exercise their own entrepreneurial skills, to earn additional money, and to achieve greater autonomy.[45]

Authority and Slavery

Free women's engagement in slavery far surpassed the oversight of enslaved people who worked as servants, washerwomen, and cooks. The fragility of life on the island demanded that all relations, regardless of

gender, be involved in family enterprises. Plantations, in particular, had to operate for years in order to realize a profit. If a man died shortly after making substantial capital expenditures in infrastructure and slaves, his family could be liable for onerous debts. Thus, men preferred to delegate ownership of family plantations to female kin rather than to sell off estates when they died. These circumstances made women accountable for administering large agricultural enterprises that employed numerous slaves.

Men's wills divulge one form of evidence that disavows the virtually unquestioned assumption that the typical planter in British America was male. Husbands regularly expected wives to assume responsibility for agricultural endeavors when they died. For instance, Planter John Stretch directed his wife Ann to supervise the family's "whole estate" in his absence. In return for her efforts she would receive all of the plantation's profits.[46] John Campbell offered his wife Elizabeth a handsome annuity of £550 per annum, a furnished house, and a coach and eight horses in recompense for commanding the family plantation. He also provided her with eighteen enslaved people and gave them the "liberty of the provision ground" to grow food and the right to "clear woodland" on the plantation.[47] Francis Rose ordered his wife Elizabeth and the couple's son Thomas to administer the family's sugar plantation "at their joint charge and expense." Elizabeth Rose would earn half of the "rents profits and produce" generated by all of the Rose family estates. In addition, she inherited a house in Spanish Town, which was staffed by ten enslaved servants and had a cattle pen that sixteen enslaved people managed.[48] When her spouse died, Elizabeth Rose effectively became responsible for overseeing enslaved people who worked as servants, along with those who labored in the sugar cane fields and operated as cattle ranchers.

Free women such as Elizabeth Rose were not merely "deputy husbands" who temporarily managed family businesses in the absence of household patriarchs.[49] Male relations gave no indication of perceiving of wives and daughters in this light. On the contrary, men recognized the expertise of female kin and sought to invest them in the ongoing success of family ventures by offering them significant stakes in the profits they generated. Family enterprises in Jamaica frequently differed in scale and in kind from those in Britain and elsewhere in British North

America. Some women operated large-scale plantations. Growing and producing sugar required expensive mechanical equipment and the labor of numerous enslaved people. Women who oversaw such outfits needed to understand how to grow finicky crops and transform them into consumer goods. They also had to possess the mercantile expertise and business connections to distribute these goods throughout the Atlantic world.

Widow Mary Elbridge displayed exactly the sort of business competence that managing a plantation required. While most of Elbridge's relations relocated to England, she stayed in Jamaica to oversee the family estate, Spring Plantation, for decades after her husband's death. Elbridge acted as a local expert and repeatedly emphasized how her prudent oversight enriched the value of Spring Plantation. She demanded that her family compensate her for the time and money that she poured into the business and insisted that she could "prove by the accounts" that she "made more mony for it and saved more than ever was under any person management," especially "considering that the land was very much worn out the seasons more uncertain."[50] During her tenure, Elbridge constructed new buildings and purchased more enslaved people and livestock for the plantation. She estimated her total investment in the agricultural business to be £1,954.

The economic, legal, and social benefits that women such as Mary Elbridge derived from slavery necessitated their participation in every aspect of the system. As was commonplace in the colony, Elbridge evinced a ruthlessly utilitarian attitude toward enslaved people.[51] She perceived them as expendable business investments that were "not valued at anything" once they were "worn out" and could no longer work. Slaves who were "old and past labor" were a useless drain on the plantation's finances, as she explained, "the taxes and cloaths and other things for them when often sick is more than any manner of service they can do for it." Her business pragmatism led her to urge her family to sell the plantation before "any of the negroes dye or cattle," which would reduce its value.[52] Elbridge perceived of enslaved people as commodities, which had depreciating values. Most colonists shared this point of view, regardless of gender.

Women also employed coercive and violent measures to maintain authority over enslaved people who had few motivations to perform

backbreaking, unpaid labor other than fear. Female slave owners lived in a society where slaves significantly outnumbered them. Rumors of brewing conspiracies and rebellions among the enslaved population fostered a mentality of paranoia and constant vigilance among slave owners. This outlook encouraged the use of draconian punishments against slaves who committed minor infractions. When Mary Ricketts moved to Jamaica from England with her husband, she disparaged the enslaved people whom she encountered as "sulky wretches" who "require a whip for, every trifle." However, she also perceived of the punishments that colonists exacted upon slaves as excessive, writing, "I don't think that sufficient excuse for the barbaritys exercised upon 'em here."[53] Though Ricketts did not discuss the actions of female slave owners, other sources reveal that they too participated in the "barbaritys" that she found disturbing.

Women devised means of surmounting any physical inferiority that might hinder them from exercising power. Evidence from colonial wills, court cases, correspondence, and newspaper ads indicates that women were as likely to own male slaves as female slaves. They maintained control over people who outnumbered them and in all likelihood possessed greater physical strength than they did, by hiring others to do their dirty work. It was commonplace for male and female slave owners alike to delegate the physical punishment of enslaved people to overseers, lower-ranking employees, or other slaves. Female slave owners also sent those who challenged their authority to prison or sold them. The account book kept by Hannah Jacobson divulges the violent measures that she employed in order to maintain control over enslaved people. Jacobson recorded "sundry charges" for "attending the negroes," which included payments for "whipping Tom, whipping Adam, ditto Darby, catching Chaplin, and whipping him, catching, imprisoning and whipping four negroes, d. for Cambridge and Chaplin and whipping them, whipping Jonathan" and "prison fees for six negroes."[54] Another woman named Elizabeth Turnbridge ordered her executors to put an enslaved man named Simon, "in irons till the first opportunity serves to send him off to be sold."[55]

The constant need to preserve authority and to compel people to work took its toll on all of the colonists who sought to uphold slavery. In a rare and revealing letter, planter Mary Elbridge described the physi-

cal and emotional strains of managing enslaved people on a daily basis, writing, "all that I have any vew of is a little quiet and ease from the troble and vexation of negros."[56] In another letter, she referred to "what I have gone through in my Body & Mind" as a result of the "troubles wth these negroes."[57] Elbridge was not alone in her struggles to exert power over other human beings who possessed their own needs and desires. The diary of planter patriarch Landon Carter resonates with Elbridge's writings. The enslaved people who lived on Carter's plantation in colonial Virginia regularly contested his authority, and several escaped from him to join the British Army during the American Revolution.[58] Though Elbridge and Carter lived at different moments in the eighteenth century, and in different locations in the British Empire, they both characterized slavery as an unending battle of wills. Regardless of gender, there was no peace for those who assumed mastery over others.

Historian Rhys Isaac contends that Landon Carter's internal conflicts resulted from the tension he experienced in adhering to older patriarchal values while also embracing nascent democratic principles. Isaac is not alone in using early modern patriarchal and paternal ideologies to understand the attitudes of slave owners toward those who they held in bondage.[59] Yet, the scholarly fixation on masculinity and the limits of male authority in relation to slavery fails to account for women's attitudes toward slavery. The similarities shared by Mary Elbridge and Landon Carter indicate that patriarchy and paternalism are inadequate models for understanding free people's perceptions of those whom they enslaved. In societies that depended upon slavery throughout British America, the need to assert authority over enslaved populations mitigated the importance of the gender differences that paternal and patriarchal beliefs enshrined.

Conclusion

The extent of women's involvement in nearly every aspect of slavery eschews narratives that marginalize female participation in this brutal regime. Female colonists survived and prospered independently based upon their abilities to strategically and sometimes mercilessly produce income from enslaved laborers. Slaves constituted a significant part of female-held wealth while also providing the labor that built women's

fortunes. The wealthiest female slave owners from Jamaica were members of the new class of colonists whose riches surpassed those held by anyone else in the empire.

Women's engagement in slavery had ideological as well as monetary implications. Slavery mitigated customary beliefs and practices, which emphasized the importance of male independence and authority within the household, and in society at large. In Jamaica, all slave owners, male and female alike, wielded the same authority over enslaved people. The prevalence of female slave ownership indicates that the principles of patriarchal power, which traditionally upheld male privileges in Britain, were giving way to new forms of economic, legal, and social inequalities overseas. However, women's financial and social gains came at a terrible price. They helped to construct an unstable society where the enslavement and poverty of the majority of the population enhanced the wealth and independence of a small minority.

By exploring several aspects of female slave ownership, this chapter offers an alternative to a narrative of American slavery that is gendered masculine, and impeaches long-standing claims about the ineffable influence of patriarchal beliefs on the dynamics of slavery in early America. The authoritarian and, by early modern standards, masculine positions of female slave owners may seem antithetical to a British Atlantic cultural milieu that idealized the qualities of sensibility and delicacy in women.[60] However, gentility and slavery were not necessarily incompatible. Like colonists throughout the Atlantic world, women sought to manifest "genteel" and polite qualities in their clothing, furniture, and comportment.[61] Rather than being anomalous aberrations, female slave owners embodied an emerging British imperial culture whose participants simultaneously accommodated savagery and refinement in their behaviors.

NOTES

1. John D. Kelly, Esq., *The Islanders, or Mad Orphan*, 1737, King's 301, p. 19, British Library (BL), London.
2. Ibid., 19.
3. Ibid., 29.
4. Colonial laws grouped women together with children and insane people. Slaves had virtually no legal rights in Jamaica. For more on gender, slavery, and the legal system on the island, see Diana Paton, *No Bond but the Law: Punishment, Race,*

and Gender in Jamaican State Formation, 1780–1870 (Durham, N.C.: Duke University Press, 2004).

5. Of the 13,408 free people who lived in Jamaica in 1752, 3,408 were identified as being of African descent. Numbers taken from Trevor Burnard, *Planters, Merchants, and Slaves: Plantation Societies in British America, 1650–1820* (Chicago: University of Chicago Press, 2015).

6. The demise of the Royal Africa Company's monopoly charter in 1713 led to an increase in the slave trade by at least 60 percent. Jamaica contributed significantly to the upsurge in the slave trade. William Pettigrew, "Free to Enslave: Politics and the Escalation of Britain's Transatlantic Slave Trade, 1688–1714," *William and Mary Quarterly*, 3rd series, 64, no. 1 (2007): 33.

7. Trevor Burnard described white men's "penchant for virile heterosexual libertinism" as the driving force behind the social and sexual dynamics in Jamaica. Trevor Burnard, "Rioting in Goatish Embraces': Marriage and Improvement in Early British Jamaica," *History of the Family* 11 (2006): 189. More recently, Burnard asserted that "patriarchal values were extremely strong, especially among whites . . . white men (and white men alone) had a degree of freedom to do as they pleased." "'Impatient of Subordination and Liable to Sudden Transports of Anger'; White Masculinity and Homosocial Relations with Black Men in Eighteenth-Century Jamaica," in *New Men: Manliness in Early America*, ed. Thomas A. Foster (New York: New York University Press, 2011), 134.

8. Edmund Morgan, Eugene Genovese, and Richard Dunn developed similar narratives about American slavery in which the relentless pursuit of capital compelled European and later American men to rely upon slave labor. Women were considered to be irrelevant in all three accounts. Edmund S. Morgan, *American Slavery, American Freedom: The Ordeal of Colonial Virginia* (New York: Norton, 1975); Eugene D. Genovese, *Roll, Jordan, Roll: The World the Slaves Made* (New York: Pantheon, 1974); Richard S. Dunn, *Sugar and Slaves: The Rise of the Planter Class in the English West Indies, 1624–1713* (New York: Norton, 1973).

9. In her groundbreaking work, Kathleen Brown contended that legal changes in Virginia defined slavery as matrilineal and embedded it in a concept of biological race. Kathleen Brown, *Good Wives, Nasty Wenches, and Anxious Patriarchs: Gender, Race, and Power in Colonial Virginia* (Chapel Hill: University of North Carolina Press, 1996). Important works followed on the heels of Brown's investigation, including Kirsten Fischer, *Suspect Relations: Sex, Race, and Resistance in Colonial North Carolina* (Chapel Hill: University of North Carolina Press, 2001) and Jennifer Morgan, *Laboring Women: Reproduction and Gender in New World Slavery*(Philadelphia: University of Pennsylvania Press, 2004).

10. Jennifer Morgan, "Gender and Family Life," in *The Routledge History of Slavery*, ed. Gad Heuman and Trevor Burnard (New York: Routledge, 2012), 141.

11. See Brooke Newman, "Gender, Sexuality and the Formation of Racial Identities in the Eighteenth-Century Anglo-Caribbean World," *Gender & History* 22 (2010): 585–602; Linda Sturtz, "Mary Rose: 'White' African Jamaican Woman? Race and

Gender in Eighteenth-Century Jamaica," in *Gendering the African Diaspora: Women, Culture, and Historical Change in the Caribbean and Nigerian Hinterland*, ed. Judith Byfield, La Ray Denzer, and Anthea Morrison (Bloomington: Indiana University Press, 2010), 59–87.

12. The common law of femme covert, or coverture, divested married women of legal rights and entitled husbands to wives' estates. As an anonymous author of a text published in 1777 explained, "The very being or legal existence of a woman is suspended; or at least it is incorporated and consolidated into that of the husband . . . she is therefore called in our law a *feme-covert.*" Quoted from Joanne Bailey, "Favoured or Oppressed? Married Women, Property and 'Coverture' in England," *Continuity and Change* 17 (2002): 351. In addition to the law of coverture, parents adhered to primogeniture, the custom of leaving family estates to the eldest son, while the aristocracy practiced entail, which ensured that land would pass to the eldest sons born to future generations. Such measures upheld male control of family estates in Britain.

13. The historian Vincent Brown has explored the cultural and social impacts of the ever-present specter of death on free and enslaved people in Jamaica. Married people often lost spouses, and parents regularly witnessed the deaths of their children. Immigrants could expect to die within thirteen years of arrival, and island-born colonists commonly died before they turned forty. Vincent Brown, *The Reaper's Garden: Death and Power in the World of Atlantic Slavery* (Cambridge, Mass.: Harvard University Press, 2008), 17.

14. In the eighteenth century the average worth of a free white person in the British West Indies was £1,042, in contrast to the £42 pound average worth of someone who lived in England or in New England. Brown, *Reaper's Garden*, 16.

15. A total of 141 men bequeathed the majority of their estates to wives. Jamaica Wills, 1661–1770, vols. 1–38, Jamaica Registrar General's Department, Island Record Office (IRO), Twickenham Park, Jamaica.

16. Many husbands who made wills explicitly stated that bequests to wives were "in lieu of" or "in bar of" dower and regularly made spouses "sole" executrixes. Ibid.

17. The conclusions reached in this essay differ from the findings of Trevor Burnard, who also studied colonial wills. Burnard used a sample of 182 wills made by men from one parish to contend that patriarchal beliefs significantly influenced inheritance practices. In contrast, this essay draws upon a study of over 1,200 wills made by men and women from every parish in the colony. Burnard, "Inheritance and Independence: Women's Status in Early Colonial Jamaica," *William and Mary Quarterly*, 3rd series, 48 (1991): 93–114.

18. Nearly 30 percent (93 out of 300) of men who described bequests for wives explicitly included enslaved people as part of these bequests. Enslaved people would also have constituted part of the "real and personal" estates wives inherited. We can conservatively estimate that at least half of the wives who received legacies from husbands were given enslaved people. Free men followed a similar pattern in bequeathing enslaved people to daughters. Of 204 men who provided legacies

to daughters, nearly 50 percent (94 men) specifically identified enslaved people as part of these bequests. Jamaica Wills, 1661–1770.

19. Will of Joel White, 1678, vol. 1, IRO.
20. Will of Edward Smith, 1699, vol. 6, IRO.
21. Will of Francis Flowaires, 1710, vol. 13, IRO.
22. Will of John Frazier, 1748, vol. 27, IRO.
23. Will of Nicholas Redkey, 1740, vol. 22, IRO.
24. Will of John Gale, 1699, vol. 9, IRO.
25. Will of Samuel Hinton, 1730, vol. 18, IRO.
26. Of the 741 free women who registered wills between 1665 and 1770, 446 women mentioned slaves whom they owned or intended to purchase. This estimate is conservative and does not include the women who referred only to "real and personal" estates, who were in all likelihood also slave owners. This figure coincides with patterns in bequests made by free men to female relations. Nearly three-quarters of all men who made wills gave enslaved people to wives and daughters. Jamaica Wills, 1661–1770.
27. Totals for female slave ownership were derived using information from the historian Trevor Burnard's inventory records. Jamaica Inventories, 1674–1784, Jamaica Archives (JA), Spanish Town, Jamaica. The aggregate value of £573,190 in 1784 would be worth £54,700,000 in 2010. This value was derived using the tool on the website "Measuring Worth," developed by Lawrence H. Officer and Samuel H. Williamson, professors of economics at the University of Illinois at Chicago, www.measuringworth.com.
28. It is difficult to assess the motives behind colonial bequests. Parents often provided sons with land and gave cash and enslaved people to daughters. Yet, the records contain many exceptions to this pattern. Detailed evidence, which explains how families customized bequests to suite personal needs and circumstances, rarely exists.
29. Will of Mercy Bars, 1720, vol. 15, IRO.
30. Byndloss also provided her daughter Mary with an enslaved woman named Cubba and her daughter Bella. Will of Catherine Byndloss, 1728, vol. 17, IRO.
31. Will of Goody Jacobson, 1724, vol. 16, IRO.
32. Keyhorne described her daughters as "now being slaves." Will of Elizabeth Keyhorne, 1713, vol. 14, IRO.
33. Another free woman, Sarah Harrison, who identified herself as a "free Negro Woman," instructed her executors to sell an enslaved woman Flora. The profits from the sale of Flora would be divided equally among Harrison's four children, who "belonging to John Ayscough" were also enslaved. Will of Sarah Harrison, 1738, vol. 21, IRO.
34. *Jamaica Mercury & Kingston Weekly Advertiser*, July 31, 1778, National Library of Jamaica (NLJ), Kingston, Jamaica.
35. Will of Tamasin Bonny, 1727, vol. 17, IRO.

36. Will of Edward Phips, 1740, vol. 22, IRO. Likewise, William Farrell gave an enslaved girl named Cretix and £100 for the purchase of "new negroes" to his daughter Mary. Will of William Farrell, 1740, vol. 22, IRO.

37. It is likely that many children also witnessed their mothers, who were responsible for following directives in husbands' wills, purchasing enslaved people.

38. Will of Dorothy Watson, 1727, vol. 19, IRO.

39. Mary Elbridge to Rebecca Elbridge, July 29, 1737, Woolnough Papers, Ashton Court Archives, Bristol Record Office (BRO), Bristol, England.

40. Will of Charles Price, 1730, vol. 18, IRO.

41. Will of James Parker, 1710, vol. 13, IRO.

42. Will of John Frazier, 1748, vol. 27, IRO.

43. *Jamaica Mercury & Kingston Weekly Advertiser*, July 16, 1778, NLJ.

44. *Jamaica Mercury & Kingston Weekly Advertiser*, October 9, 1779, NLJ.

45. Ellen Hartigan-O'Connor, *The Ties That Buy: Women and Commerce in Revolutionary America* (Philadelphia: University of Pennsylvania Press, 2009), 40.

46. Will of John Stretch, 1699, vol. 9, IRO.

47. Will of John Campbell, 1740, vol. 22, IRO.

48. Will of Francis Rose, 1721, vol. 15, IRO.

49. The historian Laurel Thatcher Ulrich described the role of the "deputy husband" as a temporary and largely undesirable position for women. Ulrich, *Good Wives: Image and Reality in the Lives of Women in Northern New England, 1650–1750* (1982; repr., New York: Vintage, 1991).

50. Mary Elbridge to Henry Woolnough, June 19, 1739, Woolnough Papers, Ashton Court Archives, 24e, BRO; Mary Elbridge to John Elbridge, January 29, 1739, Woolnough Papers, Ashton Court Archives, 16/22a, BRO.

51. At the end of the eighteenth century, those who supported the emerging abolitionist movement as well as defenders of slavery employed the rhetoric of sentimentality to justify their positions. Mary Elbridge lived prior to this historical moment.

52. Mary Elbridge to John Elbridge, January 29, 1739, Woolnough Papers, Ashton Court Archives, 16/22b, BRO.

53. Mary Ricketts to unknown recipient, June 23, 1757, Ricketts & Jervis Papers, Add. 30001, BL.

54. James Stout v. Thomas Verdon and wife (late Martha Stout), September 28, 1739, Chancery Court Records, vol. 10, JA.

55. Will of Elizabeth Turnbridge, 1727, vol. 17, IRO.

56. Mary Elbridge to Thomas Elbridge and Henry Woolnough, November 22, 1739, Woolnough Papers, Ashton Court Archives, 24g, BRO.

57. Mary Elbridge to John Elbridge, January 29, 1739, Woolnough Papers, Ashton Court Archives, 16/22b, BRO.

58. Rhys Isaac, *Landon Carter's Uneasy Kingdom: Revolution & Rebellion on a Virginia Plantation* (New York: Oxford University Press, 2005).

59. Scholars who identify slavery as a masculine institution in British America have identified a cultural shift away from the rigid patriarchal values of the seventeenth century to the softer paternalism of the late eighteenth century in slave governance. A few key works on this subject include Morgan, *American Slavery, American Freedom*; Philip D. Morgan, *Slave Counterpoint: Black Culture in the Eighteenth-Century Chesapeake and Lowcountry* (Chapel Hill: University of North Carolina Press, 1998); and Brown, *Good Wives, Nasty Wenches, and Anxious Patriarchs*.

60. Inge Dornan observed that female slave owners in colonial South Carolina had to "shed the image of the 'poor afflicted widow' who was at the mercy of the cruel world, and instead cultivate attributes of mastery and power: authority, discipline and control." Dornan, "Masterful Women: Colonial Women Slaveholders in the Urban Low Country," *Journal of American Studies* 39 (2005): 388.

61. A large body of scholarship that examines politeness, taste, sensibility, and sentimentality in eighteenth-century Britain and its colonies also exists. Key works include David S. Shields, *Civil Tongues and Polite Letters in British America* (Chapel Hill: University of North Carolina Press, 1997); Richard L. Bushman, *The Refinement of America: Persons, Houses, Cities* (New York: Knopf, 1992); Dror Wahrman, *The Making of the Modern Self* (New Haven: Yale University Press, 2004); John Brewer, *The Pleasures of the Imagination: English Culture in the Eighteenth Century* (New York: Farrar, Straus and Giroux, 1997).

7

Women at the Crossroads

Trade, Mobility, and Power in Early French America and Detroit

KAREN L. MARRERO

Beginning in the late seventeenth century, many women of New France's elite merchant classes who were married to, born of, or siblings of men involved in the extensive trade with Native American nations that operated between Quebec and the continental interior wielded considerable influence that was unique in its time and place. Because of the increasing clout of these merchants in New France due to the state's dependency on their business activities, the women had unprecedented opportunities to participate at every level. The demands of this trade required the involvement of women when husbands were absent for long periods, and wives, daughters, and sisters managed extensive trading operations. The trade also exposed French men and women to alternative gendered arrangements that existed in Native communities. In Haudenosaunee (Iroquoian) and Algonquian nations, Native women moved their homes and families to seasonal hunting grounds and agricultural fields and took part in political, economic, and military matters. The French-Native trade, as well as marriage of French men to Native women, created a world linked by extended families ranging across vast geographic distances. It also provided an opportunity for French, Native, and mixed-blood women of these families to navigate the various gender norms for their own benefit and the benefit of their families. By continuing to move between French and Native worlds these women were able to optimize their potential for commercial success and at times avoid the dangers or penalties associated with transgressing the boundaries of European notions of proper behavior for women.

This chapter considers some of the ways in which French, Native, and mixed-blood women navigated and expressed their authority in

the multicultural world shaped by the French-Native trade. In order to understand the nature of these opportunities, we first consider the series of distinct norms for women's behavior that existed in French and Native nations. The French state attempted to control women's bodies through practices used to recruit French women to the colony and by controlling their movement outside the colonial capital at Quebec. It also attempted to convert Native women to French standards of behavior and to police their manner of reproduction. Conversely, in Native nations such as the Haudenosaunee, where women held systemic political power, female leaders operated at the highest diplomatic channels and moved about within the extensive territory of their nation. Through the use of stories that highlight the experiences of specific French and Native individuals at Quebec and at key locations in the continental interior such as Detroit, this chapter demonstrates that Native women's power surprised and frustrated imperial authorities and sometimes caught them off guard, sometimes to their peril. At the same time, French and mixed-blood women modeled this behavior, often with a similarly negative result in the eyes of the French state.

The first story discussed in this chapter details the experience of one man newly arrived from France who, once immersed in Haudenosaunee society, was shocked at the freedom and authority of its women. The last story considers the same man's great-granddaughter, born into a world of French-Native interaction, who moves easily in the extended orbit of her family's commercial empire at Detroit and in the Great Lakes. By this time in the mid-eighteenth century, French and mixed-blood women had adapted Native norms for women when it suited them, while pressing those facets of the French legal system that benefitted them at other times. Successive generations of women of the shared world of the French-Native trade came to be regarded as exhibiting Native-like tendencies that could be useful to family commerce but could also threaten male authority. The ultimate symbol of the failure of imperial authorities to control the interactions of French and Native individuals and to regulate the trade they conducted were the women of the French-Native trade, who ventured far outside the sphere of state control and who drew their power from various norms for women's behavior. These women succeeded in thwarting Euro-

American attempts at control by navigating the multicultural world of the trade and crafting a hybrid identity.

By focusing attention on Detroit and considering how its early French, Native, and mixed-blood women may have influenced each other, this chapter builds on a relatively small but growing body of literature on interactions between French and Native nations, and of French and Native women in particular.[1] Over ten years ago, historian Devon Mihesuah called for more nuanced portrayals of Native women that considered their lives and activities through the lens of gender relations particular to their individual nations, not through the eyes of the Euro-Americans with whom they interacted.[2] Other scholars acknowledge the adverse effect of Euro-American policies on Native women's status and well-being that attempted to force them into "proper" standards of womanly behavior. But these scholars caution against assuming this process took place across all Native nations in all places and at all times.[3] Indeed, as the present chapter illustrates, Frenchmen at Detroit and at Quebec were aware that Native women of various nations held pivotal positions of authority, and that their favor and cooperation were required before European operations could commence or continue.

This need to fine-tune our analysis of the experiences of early Native and mixed-blood women extends to French women as well. Because Euro-American men (mostly imperial officials, including governors, commandants, notaries, and Catholic priests and missionaries) created the bulk of the primary sources, our understanding is shaped by their impressions of women. Used with caution, however, these multitudinous records are rich with information. French and Native women of early French America can be found in a variety of sources, including Catholic Church records of baptisms, marriages, and burials; the *Jesuit Relations*, a multivolume series of translated accounts and letters of the French Jesuits who missionized throughout the Laurentian Valley and the Great Lakes; and the collected and translated records of the early French government published by Midwestern state historical associations in the late nineteenth and early twentieth centuries. A large number of the French imperial records held by the National Archives of Canada in Ottawa have never been translated and contain thousands of references to early French, Native, and mixed blood women.[4]

Controlling Bodies: French and Native Women in Early New France

Like England and Spain, France sought to extend its political influence and bolster its economic stability by establishing colonies in North America. Unlike its European neighbors, however, the French state never consistently invested the necessary monies or people to encourage colonization on a large scale. Compared to the large number of emigrants who left England in the seventeenth and eighteenth centuries, many of them as families, French immigration to North America was paltry. About forty thousand people made their way across the Atlantic Ocean, most of them single men in the military or indentured servants. Although the majority settled in the Laurentian Valley (Quebec and Montreal), the French also established themselves throughout an area that eventually extended from what are today the Canadian Maritime provinces and Maine, to Michigan, Indiana, Illinois, and Wisconsin, and, in the South, Missouri, Louisiana, Alabama, Florida, and Texas.[5] The string of widely spaced and poorly provisioned military forts stretched over the vast interior of the continent necessitated the cooperation and extensive assistance of hundreds of Native nations whose populations far outstripped that of the French.

In the 1660s, for every woman between the ages of sixteen and thirty in the colony, there were twelve unmarried men of the same age range.[6] The French state experimented with different methods of compensating for this gender inequality among the first waves of immigrants. Jean Talon, the first intendant of New France, legislated marriage and procreation, controlling who could marry and rewarding the birth of children. A decree of 1669 honored fathers who were heads of the largest families by awarding them with civil offices. Talon also conceived of the idea of *filles du roy* or "daughters of the king" in his continuing quest to increase the population of the colony. Between 1663 and 1673, almost one thousand such women made the trip to Canada. The women had their passage from France paid by the king and were given a dowry of fifty livres. Only after their arrival and marriage to the men of New France did the colony realize a significant demographic increase.[7] All matters of family in the colony were the basis for government opinion and legal intrusion, with the ultimate purpose of increasing the profitability of

the colony. Indeed, sex was "intimately linked to the formation of the colonial state."[8]

Imperial interest in the intricacies of procreation extended to Native women and their reproductive capacity. Because the number of Native Americans far exceeded that of the French, early officials considered remedying this unbalance by raising the children of Native women to be French citizens. This was part of the state's policy of "francization," literally "Frenchifying" of indigenous peoples by exposure to French customs and Roman Catholicism. The reasoning was that these "converted" individuals would, for all intents and purposes, become French individuals dedicated to furthering the state's colonial ambitions. Although they were outnumbered by Native Americans, the French felt overwhelmingly confident nonetheless that their society was economically, politically, and culturally superior to that of Indians, and Native nations would quickly realize this fact.[9]

By the turn of the eighteenth century, it was becoming clear that francization had failed. Jean Talon was frustrated that Native women were not birthing a sufficient number of babies, due, he believed, to their engaging in too much heavy work and breast-feeding their babies too long. He considered enacting legislation to curb these "impediments" to his plans.[10] Eventually, the seventeenth-century belief that French society would attract Native converts to French systems and lifestyles gave way to a more cynical vision based on the truth that Native groups did not desire or feel they needed to make such a change. The French state correspondingly altered its view on French-Native marriages, seeing them not as opportunities for the conversion of Native women and their families to French customs, but as occasions for French men and women to become indigenized and their loyalties to the state put in jeopardy.[11] In order to control the men who traveled to the interior and to Native communities, authorities suggested that they be required to carry *certificats de bonnes moeurs* ("certificates of good moral practices") that would be issued once Catholic clerics determined they were acting in accordance with appropriate standards of behavior.[12] Efforts at curbing the activities of these individuals reflected the state's determination to control trade with Native nations and reap the profits.

But the state's desire to police behavior and the expression of cultural proclivities remained as illusory as its attempts to control commerce as-

sociated with the trade in furs and other goods. This world between French and Native nations therefore became a place in which mixed blood children and Native and French men and women skilled at navigating the multiple cultures held sway. It was also a transitional zone, one in which French and Native familial and gender arrangements were in flux, with a multitude of possibilities for behavior existing simultaneously. The first generations of French men and women became adept at navigating these alternative lifeways through immersion in Native societies. Some of these encounters were recorded and illustrate a fascination with differences in cultural norms, particularly those exhibited by Native women. One such account by René Cuillerier testified to the political power of Native women, their physical prowess in comparison to French women, and the freedom with which they traveled across the territory of their nations.

Cuillerier, whose children and grandchildren, both men and women, would play significant roles in French-Native trade at Quebec, Detroit, and throughout the interior, launched his family's commercial business as a captive of the Haudenosaunee (meaning "People of the Longhouse," known to Euro-Americans as the Iroquois). Cuillerier was struck by the enhanced role of Haudenosaunee women in a society that was matrilineal and matrilocal. This meant that familial descent was passed down through the mother's line, and that women had authority over the home and all who resided within it. Haudenosaunee women determined the entire course of Cuillerier's experience, from his capture to the decision as to whether he would live or die, his adoption into a Haudenosaunee family, and the freedom of movement that would eventually allow him to escape.

In 1661, Cuillerier had only recently emigrated from France when he and three other men were taken captive in Montreal by the Oneida, a Haudenosaunee nation, among whom he would spend eighteen months before he managed to escape. Haudenosaunee women routinely exercised the right to call their warriors to make war, which meant that Cuillerier and the men with him were captured at the behest of an Oneida clan matron. These women had the authority to demand captives to replace family members who had died or had themselves been taken captive by other nations.[13] On first arriving at the Oneida village, René's fellow captives were killed, but a woman saved Cuillerier from death by choosing him to become part of her family.

During the course of his captivity, a pregnant woman of his adopted family asked that he accompany her on an extended journey to join her husband at their winter hunting grounds. Perceiving that she was about to give birth during the journey, the woman sent Cuillerier ahead to prepare a fire for her arrival at a lodge on the other side of a river. Sometime later, the woman joined Cuillerier with her newborn baby, having crossed through snow and the thigh-high waters of the river to reach the lodge. The woman warmed herself briefly, washed her baby in the river and swaddled it, stayed overnight at the lodge with Cuillerier, and proceeded on with him to meet her husband. This Haudenosaunee woman's actions were at odds with the prevailing European belief that women giving birth were ill and therefore needed to be sequestered and confined to bed. Cuillerier described the woman as "falling sick in childbirth" but surprisingly to him without "the least attack of fever." He concluded that Native women were "strong, robust, and not very susceptible to illness."[14] His experience among the Oneida-Haudenosaunee provided him with an opportunity to observe an entirely different configuration of gendered behavior. Cuillerier would eventually escape from the Oneida, but he parlayed his experience in a multitude of ways that allowed him to reap the benefits of French-Native commerce. He acted as an interpreter between the Haudenosaunee and the French government and traveled between Quebec and the continental interior on trade voyages.[15] As we will learn later in this chapter, his great-granddaughter would be raised from infancy in this world of intercultural relations. Her expertise and the facility with which she negotiated the varying norms of gendered behavior in Euro and Native worlds would allow her Euro-American husband to benefit economically.

Cuillerier's comments on the Haudenosaunee suggest that women possessed authority and freedom of movement at every level of their society.[16] The fact that gifts were designated for pivotal women at meetings between the French and Haudenosaunee is evidence of the importance of these women to the maintenance of diplomatic relations. At one such conference held between Governor General Louis de Buade de Frontenac and the Onondaga leader Niregouentaron (like the Oneida, the Onondaga were a member nation of the Haudenosaunee), Frontenac specifically mentioned two women of Niregouentaron's family, referring to one of them as his adopted daughter. He arranged for beads and scar-

let fabric trimmed in gold to be sent to her, along with an invitation to an upcoming diplomatic meeting and a promise of additional gifts.[17] By referring to the woman as his daughter, Frontenac fulfilled the requirement that metaphoric kinship—the primary organizing principle in Native societies—was established before political or economic negotiation could take place.[18] Also, by acknowledging important Native women, the French recognized the power they could play in the affairs of the colony.

Among the Haudenosaunee, a woman variously known as Jigonsaseh, New Leaf, the Mother of Nations, the Peace Queen, the Great Woman, the Fire Woman, and the Maize Maiden was the Head Clan Mother of her nation.[19] She cultivated both corn and peace, and her duties included feeding war parties and all visitors, no matter what their nation. During this process, she was responsible for discovering the business of these visitors and whether they were threats. Her longhouse was a place of sanctuary, and she was charged with keeping the peace through mediation and negotiation at every level: individual, clan, and nation. If war could not be avoided, she had the right to assemble and command armies. Because of her, only women could declare war since they held the peace in their hands. As the Head Clan Mother, she convened all meetings of the Clan Mothers and sent their decisions on issues forward to the men's Grand Council. The men could not act on these matters without the prior consensus of the Clan Mothers.

A seventeenth-century woman who held the title of Head Clan Mother emerged as a savior of her people in 1687 when Governor General Denonville of New France decided to invade Iroquois territory to quash their resistance to the French. Denonville put a plan into action, inviting the Iroquois men's Grand Council and some of the Clan Mothers to attend a peace meeting. Once they were all together, Denonville seized them and sent them to France to serve as slaves. Through his actions, Denonville believed he had effectively leveled the Haudenosaunee government. Denonville was unaware, however, that he had not captured the Head Clan Mother because it was customary for her to send representatives to official meetings while she remained in her home territory. She immediately assembled a war party that consisted of several women and appointed war chiefs, leading this army herself in a decisive battle. She drove Denonville out of Haudenosaunee territory

and back to Montreal. She also demanded the return of the members of the Haudenosaunee government who had been shipped to France.[20] The Head Clan Mother operated in accordance with gender norms of her society, thereby benefitting from the ignorance of Euro-American officials who ignored at their own peril the systemic power of these women. There would be French women versed in the cultural norms of Native societies, who acquired this knowledge from their participation in the French-Native trade and who used this experience to realize profits for themselves and their families. French women adapted to the new "gender frontier" and some took advantage of new opportunities.[21] As the following story of Charlotte-Françoise Juchereau illustrates, women who hailed from families of merchants and fur traders made use of business connections outside of New France to enhance their economic and political positions.

Because the French and English states were frequently at war in Europe and in their colonial domains in North America, trade between them was strictly regulated and often prohibited. Despite this interdiction, individuals and their families involved in French-Native commerce continued their activities across these colonial realms, to the chagrin of imperial officials who were powerless to stop them. Charlotte-Françoise Juchereau held extensive business interests in this trade as it operated between the English Albany, French Montreal, and Mohawk (another nation composing the Haudenosaunee) territory that stretched across these Euro-American cities. Known as Isacheran Pachot (the latter moniker was her married name) to English imperial officials at New York, she would play a key role in the resumption of trade after the War of the Grand Alliance between Britain and France ended in 1697.

Mayor of New York Colonel David Schuyler and the Reverend Godfrey Dellius, an influential negotiator for the English government, traveled to Montreal after the peace to arrange to resume trading relations with the French. Newly appointed governor general of New France Louis-Hector de Callière, who was anxious to meet the Englishmen and talk business, asked Madame Pachot to delay a planned trip by a few days to meet the men from New York. Pachot did postpone her journey and attended all of the meetings, despite the fact that she was in the last month of a pregnancy at the time (a situation, in any case, that would not have prevented her from undertaking her original travel plans). She met

Dellius and Schuyler at Montreal, where she resided, and they and their party departed in four canoes for the six-day journey to Quebec to meet with Callière. The two men brought trade goods from English colonies, including lemons, oranges, and coconuts from Barbados and Curacoa, as well as New York oysters. In turn, Dellius and Schulyer sampled fresh salmon, a rarity in New York. Pachot arranged to have the much coveted salmon sent to the men once they returned to New York.[22]

Isacheran Pachot was the highly influential and savvy businesswoman Countess Charlotte-Françoise Juchereau in New France. She was sister to Louis Antoine Juchereau de Saint-Denys, who extended French trade in the South in the second decade of the eighteenth century from New Orleans to Natchitoches and to the Spanish at Rio Grande. Charlotte-Françoise was first married to François Viennay-Pachot, a wealthy and influential merchant and director of the Compagnie du Nord, an organization of merchants given royal backing to exploit the fur trade throughout the North American interior. After Pachot's death in 1698, Charlotte-Françoise married Captain François Dauphin de La Forest, a man who held trade licenses at French forts on the Mississippi, and who funded numerous trips into the interior.[23]

Charlotte-Françoise amassed a considerable fortune, bought the Île d'Orléans near Quebec after her first husband's death, acquiring with it the title of countess, and became more openly defiant of imperial authority. With her second husband and her brother, she funded numerous trade expeditions to the Mississippi River and other western locations. Many of these endeavors were conducted without imperial approval, and were therefore illegal, bringing the trio to the attention of colonial authorities. French minister of the navy Louis Phélypeaux, Comte de Pontchartrain called her a "dangerous woman," and intendant of New France Antoine-Denis Raudot, who was involved in protracted legal proceedings with Charlotte-Françoise, referred to her as "haughty and capricious."[24]

Charlotte-Françoise became a very prominent businesswoman who regularly advanced large sums of capital to a number of individuals involved in the French-Native trade. Charlotte's second husband, de La Forest, would become commander of the fort at Detroit, where she would use her influence to acquire a paid governmental commission for

her son Jean Daniel Marie Viennay-Pachot.[25] Jean Daniel Marie would serve as a paid interpreter for the Huron-Wendat at Detroit during and after his stepfather's command, distinguishing himself for keeping the Detroit tribes out of the English orbit, and for his heroics in military expeditions against the Meskwaki (Fox), Mascouten, and Kickapoo nations.[26] Like his mother and because of her commercial and diplomatic successes, he would continue his involvement in Native affairs in the colony.

It is certainly a mark of Charlotte's large wealth that she and her second husband did not draw up the usual marriage contract establishing a *communauté de biens* or marital community of goods that protected the survivor of the marriage when one of the partners died. This was a highly unusual arrangement that was acknowledged in legal records. According to the French legal system known as the Coutume de Paris, a couple normally formed a marital community that was made official by a contract drafted at the time of their marriage.[27] At the death of one of the marriage partners, the surviving spouse took half of the estate and divided the other half among the couple's children. If there were no children, the surviving spouse had the use of the entire estate for life. The wife also had access to a *douaire* (dowry), which was guaranteed to her if her husband died.[28]

The many contracts of Charlotte's business dealings describe her as the wife of La Forest who had not entered into a marriage agreement.[29] This addition to the contract was almost certainly inserted to alert business partners that she possessed wealth acquired from her first marriage and through her own business dealings that she wished to retain. This also entailed that she was not responsible for her husband's debts, and that he, in turn, was not responsible for any of her business losses. Women such as Charlotte-Françoise lobbied on behalf of their sons for commissions and titles and expanded their families' economic prospects, often to the great chagrin of business rivals and imperial agents attempting to maintain control in the upper country of the continental interior. French, Native, and mixed-blood women, skilled at navigating the multicultural world of the French-Native trade, would expand their influence to the Great Lakes and continental interior when the French state established a settlement at Detroit at the turn of the eighteenth century.

Women of the French-Native Trade at Detroit and the Challenge to Empire

Detroit was established as a French settlement in July 1701, immediately following the Great Peace of Montreal held that summer to end hostilities between the French and the Haudenosaunee. Detroit was the narrowest point on a long series of waterways that linked Montreal and Quebec on the Saint Lawrence River—cities that operated as the commercial and political centers of French imperial power—to the Great Lakes, an area controlled by a vast number of Native nations. The establishment of Detroit's early population followed a similar pattern as that of the Laurentian Valley. Over 90 percent of the French who arrived were single men. Only thirty-two women came to settle at Detroit in its first sixty years, a third of whom hailed from families in which a male member had been engaged in the French-Native trade in the interior, reflecting Detroit's prime location and importance in this commerce.[30]

With permission of the Haudenosaunee and the backing of their Native allies (including the Wendat [Huron], Myaamia [Miami], Ho Chunk [Winnebago], Odawa, Potawatomi, Illinois, Meskwaki [Fox], and Sauk), the French were able to gain a tenuous toehold in the upper country, known as the *pays d'en haut*. In the midst of negotiations for the Great Peace, Antoine de la Cadillac sailed to Detroit to begin construction of the fort and become its first commandant. At this pivotal moment when peace hung in the balance that would determine the future outcome of his settlement and a continued influx of government money, Cadillac took great care to report to his superiors on events that presaged good relations with the Haudenosaunee at Detroit.

In a letter sent to the governor general describing the events and accomplishments of his first year at Detroit, Cadillac made a point of mentioning a significant meeting between Haudenosaunee and French women. Cadillac was anxious to impress his superiors as to the importance local Native groups ascribed to the arrival of the wives of Cadillac and his second in command Alphonse Tonty. According to Cadillac, both Iroquois and Algonquian groups were unaccustomed to seeing the wives of commandants and other officers accompany and live with their husbands at forts in the upper country. When Marie-Thérèse Guyon and Marie-Anne Picoté de Belestre, the wives respectively of Cadillac

and Tonty, followed their husbands to Detroit, arriving in September 1701, Cadillac reported that the Iroquois were astonished to see the women and viewed the arrival of wives of this rank as proof that Governor General Callière intended to keep the peace he had negotiated in Montreal earlier that summer. Haudenosaunee women were said to have kissed the hands of the French women and to have wept tears of joy, proclaiming that they had never seen French women come willingly to *their* country.[31] The presence of the French wives had an overall symbolic value in Cadillac's report to his superiors as an indicator of French imperial strength at Detroit. Because Haudenosaunee women were keepers of their nation's territory, their role in welcoming the French women was equally significant, and their approval of a French presence at Detroit essential.

There would be other occasions on which the French acknowledged pivotal women of the Native nations of the continental interior in order to maintain good diplomatic relations. At Michilimackinac, an Odawa woman named La Blanche, noted as being wise and capable and the daughter of a chief, was given gifts by the governor general to maintain an alliance with her nation.[32] When Peoria-Illinois leader Chachagouesse and his daughter traveled to Quebec for diplomatic talks, Governor General Philippe de Rigaud Vaudreuil presented gifts to both the leader and his daughter as a sign of his gratitude for having made the trip.[33] At times, the goodwill of women was crucial to keeping peace and continuing trade between the French and Native nations. During a period of tension between the Odawa and French at Michilimackinac, two leading Odawa women threatened to call their warriors to attack the French fort at Michilimackinac. To maintain peace, they requested gifts and the opportunity to sell their trade goods at a price they would determine. French imperial agents bowed to their demands.[34]

French women in the upper country became equally conversant in piloting the course of political and commercial affairs, sometimes for the good of the state but often to benefit themselves and their families. Marie-Anne Picoté de Belestre was the wife of Alphonse Tonty who would eventually succeed Cadillac as commandant at Detroit, and the daughter of a Montreal-based officer and successful merchant in the fur trade. She fully participated in her husband's business affairs, including those deemed illegal by French imperial authorities. Upon

her death, her husband married Marie-Anne de La Marque, another woman hailing from a family with extensive involvement in the trade with Natives. Like Charlotte-Françoise Juchereau, de La Marque married twice, both times to men who had significant economic interests in the French-Native trade. As well, de La Marque conducted trade in the English colonies and in New France. Just a few years before her second marriage, Marie-Anne and two business associates, one of whom was a Haudenosaunee man named Thomas Leguerrier, were accused of illegally trafficking in English stroud, a fabric much coveted by Natives. French authorities claimed that the merchandise was designated to pass into the hands of Leguerrier, a member of the Sault-St-Louis community of Haudenosaunee near Montreal whose members routinely traded at both Albany and Montreal.[35]

Marie-Anne de La Marque married Alphonse Tonty the same year he assumed the position of commandant of the fort at Detroit. After this marriage, Marie-Anne appears to have periodically shared her husband's position of commandant at Detroit during his tenure from 1717 to 1727. Church records refer to Marie-Anne on three occasions as "commandante of said place" when she stood as godmother at baptisms, once on December 4 and twice on December 8 in 1722. On two of these occasions, the record lists her as *commandante*, with the final "e" representing (in French) the feminine version of "commandant," while on the third occasion she was designated simply as "commandant."[36]

This seems to be the only case in which the wife of a commandant at Detroit was designated as sharing that position, which may attest to a unique position of prestige held by this second Madame Tonty. It also attests to her role as her husband's most trusted business partner. At the time she was sharing a leadership role with her husband, he was embroiled in scandals that threatened his position as commandant at Detroit. In 1722, Alphonse Tonty was fighting accusations of misconduct from French settlers at Detroit who were signing positions to oust him, local Native nations who were calling for his recall, and concerned imperial authorities at Quebec. This situation required him to travel to Quebec to answer to governmental officials for his activities. In such a situation, his wife may have been the only person he would have trusted to conduct the business of the fort in his absence. De La Marque also acted on many occasions as her husband's *procuratrice* (literally, pro-

curer), acquiring the goods he needed to operate in Montreal and at Fort Detroit, and petitioning imperial authorities for compensation for her own expenses to maintain Native alliances and the commandant's residence at Detroit.[37]

Although the first census taken at Detroit in 1710 did not enumerate women, the way in which it was organized nonetheless attests to the symbolic importance of marriage and wives as indicators of their family's lifestyle and involvement in trade. The census was arranged with separate categories for single Canadian men, Canadian men who had their wives at Detroit, widowers, Frenchmen whose wives refused to move to Detroit, soldiers who had their wives at Detroit, and men who had wives and children at Detroit. Of thirty-four men counted, only eight had their wives with them at Detroit. The census also separated those who cultivated land from those who did not wish to farm. All those listed as holding land were married with children. Of the men who did not engage in farming, 90 percent were single or had wives who did not live with them at Detroit. These categories are evidence of the importance placed on marriage to French women as indicators of a man's potential willingness to engage in an agrarian lifestyle and remain settled at Detroit. The numbers suggest that men who were not tethered to the land through farming were free to engage in the French-Native trade, which required they remain mobile, and that their wives were either Native and/or equally mobile as their husbands.[38]

Despite the fact that they were not included in the census of 1710, Algonquian and Iroquoian women at Detroit and other locations of French settlement in the interior ranged great distances to participate in activities not normally engaged in by French women. At a battle between the French and the Meskwaki, five hundred Meskwaki men and three thousand Meskwaki women composed the fighting force. Recounting the conflict later in a report to his superiors in France, Governor General Vaudreuil described the Meskwaki women as "fighting furiously on these occasions," setting their behavior apart in his eyes as more violent because they had participated in an activity reserved for men in French society.[39]

A French commandant at Detroit marveled at and described the extensive activities of the women of resident Native nations. Potawatomi women were responsible for raising and tending crops, which included

cultivating Indian corn, beans, peas, squash, and melons. When the men left to hunt in the autumn, the women and children accompanied them to spend the entire winter at hunting camps. Everyone returned together in the spring and planting of crops began again. Wendat (called Huron by the French) men hunted intermittently throughout the year, while the women tended to every other task. When the men left for the autumn hunt, a significant number of women, many of them older, remained to guard their fort and gathered wood for the fires in their longhouses. Mississauga (Ojibwa) women participated alongside men in making canoes, sewing the skin for the vessel and gumming the seams to make it watertight while the men constructed the ribs and floor.[40] Women of Native nations routinely butchered the game caught by the men and tanned skins to make clothes, including the moccasins worn by Natives and Euro-Americans alike.[41] Indeed, French and later British imperial officials would realize that the massive trade with Native Americans was run almost exclusively by Native women.[42]

French women such as Charlotte-Françoise Juchereau, Marie-Anne Picoté de Belestre, and Marie-Anne de La Marque profited by their involvement in the highly lucrative trade with Native nations and were protected by the particularities of French law in the Coutume de Paris. Native women routinely participated in a multitude of political and economic activities alongside men of their nations. Alternatively, French, Native, and mixed-blood women of the leading trading families of the upper country and continental interior learned to utilize those aspects of French and Native cultural systems, which benefitted them and their families. Their trails through imperial correspondence crossing vast distances is evidence that they used their mobility to escape situations limiting their autonomy or, in some cases, threatening their lives, to seek greater opportunity elsewhere. This ability to disappear into alternative gendered worlds, however, could be used against them by French imperial agents and their own kinsmen.

One such example was the court case mounted in New Orleans in 1739 by Louis Turpin against his sister-in-law Marguerite Faffart. Marguerite had been married to Louis's brother Jean Baptiste, the latter of whom had died. Louis set about extinguishing any claim Marguerite, Jean-Baptiste's widow, had to the couple's communauté de biens. The couple had been married at Detroit almost thirty years previous to Jean

Baptiste's demise, and their activities while residing there became the crux upon which Marguerite's family struck back in court, challenging Louis's efforts to exclude his sister-in-law in the division of the deceased's estate.

Both the Turpin and Faffart families had extensive ties to the trade with Natives. Marguerite Faffart's father had made multiple trips to the upper country and was an official interpreter capable of speaking several Native languages. Marguerite's mother was half French and half Algonquin and sister to the influential trader and interpreter Madame Montour who worked for both the French and English governments. Jean-Baptiste Turpin had made multiple business trips throughout the Great Lakes and down the Mississippi. At the time of his death in 1737 in New Orleans, Jean-Baptiste and Marguerite had not resided together for many years. Jean-Baptiste's brother Louis arranged to have his deceased sibling's goods inventoried in May 1739, and an equitable division of the estate instituted. Marguerite, the surviving spouse, was not included as a recipient of the proceeds of her husband's inheritance.

Marguerite's brother-in-law Louis Metivier, who was married to Marguerite's sister Marie and resided at Fort Chartres in the Illinois country, challenged Louis Turpin, filing a petition in October 1740 to have the case heard before the Superior Council of New Orleans. He claimed that Louis Turpin had "obtained false judgment in his sister's absence and he has therefore been obliged to appeal and prays to be allowed to produce evidence of Marguerite Faffart's good conduct and to prove that the separation with her husband was due only to his ill treatment and in order to preserve her life and that of her son." Metivier's request for a hearing was granted. He was able to produce several witnesses who had lived at Detroit with Jean Baptiste Turpin and Marguerite Faffart and who attested to Turpin's violent behavior toward his wife. In February 1741, Metivier produced his first witness—Michael Vien, who was still living at Detroit. Vien reported that on two occasions Turpin had attacked Marguerite, once with an axe and once with a gun with "intent to kill." Two months later, four additional witnesses, all now living in the Illinois country, gave testimony that supported the accusations of abuse suffered by Marguerite. One of these men stated that "if Turpin's wife left him it was owing to ill treatment and to save her life." A third man claimed that Marguerite Faffart was "a good and honest woman who was compelled

to leave her husband by ill treatment" and a fourth witness called her "brave and honest." Finally, Jean Paré, who like the others (except for Vien) was now living at the Illinois, testified that when he was at Detroit, "he heard the inhabitants speak of Jean Baptiste Turpin as ill-treating and beating his wife."[43]

It appears that Marguerite Faffart had indeed fled her abusive marriage with Turpin. A 1717 report written by Detroit's commandant tells us the critical moment at which Marguerite may have left Detroit. The commandant wrote with alarm that a Native man named Ouytaouikigik had arrived bringing gifts as an enticement to the Detroit Native groups to bypass the French and trade with the English. According to the commandant, as he departed, Ouytaouikigik had "carried away La Turpin" to the English.[44] This comment suggests that La Turpin, who was most assuredly Marguerite Faffart referred to by her married name, had been removed from Detroit against her will.

We cannot be entirely certain under what circumstances Marguerite departed her husband and Detroit, but we can hypothesize with some precision that she found her way to the English colonies. It is highly likely that a woman who figures prominently in Pennsylvania colonial records was none other than Marguerite Faffart. She became known by the name "French Margaret" and was referred to by Moravian missionaries in Pennsylvania as "sister's daughter"—a designation that highlighted the importance of her relationship as niece to the powerful Madame Montour.

Marguerite, now known as French Margaret, married the Caughnawaga Mohawk man Katarioniecha, also known as "Peter Quebec," with whom she had four children. By 1733, the two were living in Pennsylvania and by 1745 they could be found living on the Alleghany River, where a missionary encountered French Margaret at her cousin, Andrew Montour's home. In 1744, French Margaret was present with her aunt Madame Montour at the proceedings of the Lancaster Treaty between the Haudenosaunee and the colonies of Virginia and Maryland. By 1753, she had moved to a settlement close to Madame Montour, which became known as French Margaret's Town, where Margaret prohibited liquor.[45]

French Margaret was probably not in need of the proceeds from her French husband's estate. Perhaps she was unaware of the death of a man she had long since ceased caring for, and at whose hand she had suffered

physical abuse. In separating herself physically from Turpin and moving out of the home they had shared at Detroit, she had, for all intents and purposes, divorced him. Although Turpin and Marguerite had been married in the Catholic Church, an institution that prohibited divorce, many Native societies allowed for a change in marital partners. Marguerite therefore had options available to her, and chose the one that best served her purposes.[46] She had also taken another husband, was raising their four children, and had become a person of influence and authority in her Mohawk-English community. She was operating in another corner of the vast territory covered by the extensive merchant family networks.

From what we know, she was not directly involved in the legal proceedings at New Orleans involving Turpin's estate. We hear about her trials only through the words of others. Her brother-in-law and sister may have pressed her case in order to obtain some or all of her portion of what would have been a sizeable inheritance, since the Turpin family members were wealthy residents of Kaskaskia in the Illinois Country. For his part, in settling his brother's estate, Louis Turpin may have forgotten about his sister-in-law, believed she had no claim in a New Orleans court because he too considered her divorced from his deceased brother, or assumed she would not learn of her estranged husband's death since she lived at such a great distance. Marguerite had used Native concepts of marriage to divorce Jean Baptiste Turpin, but now her family chose to present this marriage as an indissoluble union, as it had been originally contracted in the Catholic Church, and to press the legal rights that accompanied such a marriage.

The testimonies on Marguerite's behalf were meant to counter the challenge to her right to the community of goods she had shared with Jean Baptiste Turpin. The witnesses rebuffed any effort Louis Turpin might make to cast dispersion on Marguerite's character, namely that she had made light of her marriage to Turpin and had casually wandered away from him, and that her move to the English colonies meant she was not to be trusted. Marguerite's sister's husband went to great lengths to counter any suggestion that Marguerite Faffart was a dishonorable and treacherous woman. The commandant who reported on her departure from Detroit appears to have depicted her as an unwilling captive taken by force by an English-allied Native man. Indeed, knowing as we

do that Marguerite was niece to Madame Montour and a member of a powerful extended family network alerts us to the potential significance of the commandant's solitary reference to Marguerite in his report.

By the time the British assumed control of the upper country in 1760 after their military victory over the French, women of the merchant family networks had so skillfully fused the multiple strands of gendered behavior of European and Native worlds, they became much sought-after marriage partners to English merchants. As illustrated by the case of Marie Angelique Cuillerier dit Beaubien, once their expertise had been incorporated in this manner, however, these same men regarded the Native-like behavior of these women as unbefitting the wife of afflu-ent businessmen.[47] When Marie Angelique Cuillerier dit Beaubien was born at Detroit in 1735, her family had been engaged in trade with Native groups for seventy-five years. Her great-grandfather, René Cuillerier, whom we met at the beginning of this chapter, had been the means by which the family entered into this lucrative trade. René had parlayed his immersion in Haudenosaunee culture into a lucrative commercial and political career. His sons and their wives became involved in the French-Native trade, some operating among the Illinois and in the Missouri basin and some trading at Hudson's Bay.

Marie-Angelique had been raised from an early age to engage in the French-Native trade and was considered to be an excellent interpreter of different Indian languages at Detroit.[48] Some members of her family acted as interpreters for the newly arrived British commanders and she forged a personal connection with British superintendent of northern Indian affairs Sir William Johnson. She married James Sterling, a Scots-Irish merchant who had left a profitable business enterprise in New York to engage in trade at Detroit in the period following British ascendancy in the Great Lakes in 1760. When he had arrived at Detroit, Sterling's belief that British military victory would translate into a victory over French merchants in the marketplace had been dashed. He consistently failed to sell to his French and Native clientele until his marriage to Marie Angelique. In a letter to his eastern business partners he described her as a "very prudent woman and a fine scholar" who hailed from a family that was held "in great esteem amongst the Indians." Within a day of his marriage, local Native groups promised him they would engage in exclusive trade with him.[49] Sterling wasted no time writing a letter to Sir

William Johnson. He relayed the news of his marriage and Marie Angelique's compliments to Johnson, and followed with a request that he be employed in the Indian service.[50] As his interpreter and fellow clerk, and with her extensive knowledge of the local economy and close connection to British power brokers, Marie Angelique changed her husband's business prospects by bringing him into her family network, allowing him to compete with French traders in the Great Lakes.

After her marriage Marie Angelique continued to conduct business in her own right. She engaged in local trade, buying items such as silver and gold through her husband's eastern business partners for sale at Detroit and other locations in the Great Lakes, while selling furs and rare and unusual items of fur clothing from the Great Lakes in eastern markets. In one of his letters, Sterling asked one of his New York–based partners to sell four packs of fur that belonged to Marie Angelique. Sterling also conveyed a message and gift on his wife's behalf to Duncan's wife. Marie Angelique sent her compliments and a northern fox fur muff that she had acquired from a local Frenchman who, in turn, had procured it from a Native man at the far end of Lake Superior. Sterling stressed the exotic and valuable nature of the muff, commenting that "it is look'd upon as curious here."[51] Marie Angelique helped Sterling bring Native goods into the British North American marketplace, where they became highly valued as curiosities. Sterling reserved such special items as gifts to curry favor with influential individuals in British North America.

Once Sterling had forged ties with high-ranking British officers, thanks in large part to the efforts and influence of his wife, he appears to have begun to distance himself from the culture of the French and Native families into which he had married. He expressed his displeasure with the Native-like activities of his wife, most notably her mobility for the purposes of trade. Although he was happy to utilize his wife's services as an Indian-language interpreter, he was unwilling to allow her to "ride after the Indians" as was the habit of traders at Detroit.[52] It appears that Sterling believed it was unacceptable or at least unnecessary for the wife of an affluent British trader to travel to Native communities in order to conduct trade. His statement illustrates that he sought to control Marie-Angelique and to separate the Native-like aspects of her behavior that marked her extensive participation in commerce from what he viewed as those attributes more acceptable of wealthy British women.

* * *

Through their travels and business investments, the French merchant families of Marie-Angelique Cuillerier, Marie-Anne de La Marque, and Charlotte-Françoise Juchereau gained considerable knowledge that could be utilized as new forts were built and trade negotiations established throughout the upper country. Alternatively, as was the case with Marguerite Faffart, who fled an abusive husband, assumed a new identity, and started a new family at another location, the freedom of movement of women of the French merchant family networks could be read in a variety of ways, depending on the context in which the women were operating, and the vested interests of the men with whom they interacted. The women involved in the French-Native commerce were equally comfortable in Iroquoian, Algonquian, French, and English domains and operated as part of family-based networks that stretched west and south from Quebec to Detroit, and beyond. They learned to navigate the contingencies of the French imperial system by drawing on the different configurations of gendered power offered by exposure to the norms operating in the Native nations in which they operated.

The women of the merchant families exhibited traits and engaged in practices of both European and Native cultures that ensured their families' economic survival. In every instance, women smoothed the road for economic exchange through marriage, acted on behalf of or sometimes in spite of their husbands in their handling of family businesses, conducted trade on their own that frequently escaped the notice of and censure of imperial authorities, or initiated trade between nations at the request and with the approval of these same authorities. They also engaged in illegal trade, participated in wars, and took multiple husbands or sexual partners. These women utilized a wide range of gendered behavior in order to gain power and prestige and to thwart imperial agendas. French women's freedom of movement was modeled on their experiences of Native women, who moved with male members of their families, and who worked alongside their husbands at a multitude of tasks. The French merchant families were also composed of women who acted as business partners to husbands absent for extended periods, which necessitated that wives single-handedly shepherd commerce. Finally, French women had a vested interest in seeing the family business

thrive, thanks to the particularities of French law that allowed them to share in a community of goods with their husbands and children.

The women worked both with and against the imperial state. At times their business activities allowed them to be integrated into the system, while at other times that same system sought to control or even expel them. Women of the commercial family networks were empowered from a number of different directions: their symbolic importance as agents of procreation in a colony that, in its early years, lacked sufficient bodies to defend itself and produce its crops; their legal protection accorded them by the Coutume de Paris; their participation in a trade on which the French state depended to ensure the colony remained viable; the economic opportunity the Native women provided to Frenchmen through marriage; and the example of and cultural norm of the Iroquoian and Algonquian women who exercised authority across political, economic, and spiritual realms. In all of these cases, power was realized when women of the networks had the opportunity to recognize and experiment with a variety of gendered practices.

NOTES

1. For French and Native women at Detroit, see Karen Marrero, "Founding Families: Power and Authority of Mixed French-Native Lineages" (Ph.D. diss., Yale University, 2011); Marrero, "On the Edge of the West: The Roots and Routes of Detroit's Urban Eighteenth Century," in *Frontier Cities: Encounters at the Crossroads of Empire*, ed. Jay Gitlin, Barbara Berglund, and Adam Arenson (Philadelphia: University of Pennsylvania Press, 2013), 66–86; Catherine Cangany, "Frontier Seaport: Detroit's Transformation into an Atlantic Entrepot, 1701–1837" (Ph.D. diss., University of Michigan, 2009); Suzanne Boivin Sommerville, "The Other Women and Early Detroit," *Michigan's Habitant Heritage*, five-part series (2001–5); and Sommerville, "Madame Montour and the Detroit Connection," *Michigan's Habitant Heritage*, five-part series (1998–2000). For French-Native relations at Detroit in general, see Andrew Sturtevant, "Jealous Neighbors: Rivalry and Alliance among the Native Communities of Detroit, 1701–1766" (Ph.D. diss., College of William and Mary, 2011) and Guillaume Teasdale, "The French of Orchard Country: Territory, Landscape, and Ethnicity in the Detroit River Region, 1680s–1810s" (Ph.D. diss., York University, 2010).

2. Devon A. Mihesuah, "Commonality of Difference: American Indian Women and History," in *Natives and Academics: Researching and Writing about American Indians*, ed. Devon A. Mihesuah (Lincoln: University of Nebraska Press, 1998), 37.

3. Katherine Beaty Chiste, "Aboriginal Women and Self-Government: Challenging Leviathan," in *Contemporary Native American Cultural Issues*, ed. Duane Champagne (Walnut Creek, Calif.: AltaMira Press, 1999), 77.

4. The French Canadian Heritage Society of Michigan has published articles on the women of early Detroit in its journal *Michigan's Habitant Heritage* based on close readings of primary source materials in French, and they are currently cataloging all women at Detroit in its first decade as a French fort. Some of these articles, most notably those of Suzanne Boivin Sommerville, are noted here: Sommerville, "Other Women and Early Detroit"; and Sommerville, "Madame Montour and the Detroit Connection."

5. Leslie Choquette, *Frenchmen into Peasants: Modernity and Tradition in the Peopling of French Canada* (Cambridge, Mass.: Harvard University Press, 1997), 2.

6. Peter Moogk, "Reluctant Exiles: Emigrants from France in Canada before 1760," *William and Mary Quarterly* 46, no. 3 (July 1989): 482.

7. Bertrand Desjardins, "Family Formation and Infant Mortality in New France," in *Infant and Child Morality in the Past*, ed. Alain Bideau, Bertrand Desjardins, and Héctor Pérez Brignoli (Oxford: Oxford University Press, 1997), 17.

8. Jennifer Spear, "Colonial Intimacies: Legislating Sex in French Louisiana," *William and Mary Quarterly* 60, no. 1 (January 2003): 76.

9. Saliha Belmessous, "Assimilation and Racialism in Seventeenth and Eighteenth-Century French Colonial Policy," *American Historical Review* 110, no. 2 (April 2005): 323. For a nuanced discussion of French imperial philosophies behind francization, see Gilles Havard, "'Protection' and 'Unequal Alliance': The French Conception of Sovereignty over Indians in New France," in *French and Indians in the Heart of North America, 1630–1815*, ed. Robert Englebert and Guillaume Teasdale (East Lansing: Michigan State University Press, 2013).

10. Jean Talon, "Mémoire sur l'état present du Canada," in *Habitants and Merchants in Seventeenth Century Montreal*, ed. Louise Dechêne, trans. Liana Vardi (Montreal: McGill-Queen's University Press, 1992), 7.

11. Belmessous, "Assimilation and Racialism," 339–40.

12. "Mémoire de Denonville à Seignelay," January [1690], series C11A, Correspondence générale, vol. 11, folios 187v–188, Bibliothèque et Archives Canada/Library and Archives Canada (hereafter BAC).

13. Barbara A. Mann, "Adoption," in *Encyclopedia of the Haudenosaunee (Iroquois Confederacy)*, ed. Bruce Elliot Johansen and Barbara Alice Mann (Westport, Conn.: Greenwood, 2000), 3.

14. For René Cuillerier's captivity narrative, see José António Brandão, ed. and trans., with K. Janet Ritch, *Nation Iroquoise: A Seventeenth-Century Ethnography of the Iroquois* (Lincoln: University of Nebraska Press, 2003), 102–5.

15. Cuillerier acted as interpreter between the governor general of New France and the speaker of the Five Nations Iroquois in 1682; see "Paroles addressées à Frontenac par Teganissorens deputé des Cinq Nations iroquoises," Montréal, September 11, 1682, series C11A, vol. 6, folio 16, BAC. An English translation can

be found in "Conference between Count Frontenac and a Deputy from the Five Nations/Speech of the Delegate from the Five Iroquois Nations to Count de Frontenac," September 11, 1682, in *Documents Relative to the Colonial History of the State of New York*, ed. E. B. O'Callaghan (Albany, N.Y.: Weed, Parsons, 1854), 9:184–85.

16. For a recent review of the scholarship on and reconsideration of the issue of Haudenosaunee women's power, see Jan V. Noel, "Revisiting Gender in Iroquoia," in *Gender and Sexuality in Indigenous North America 1400–1850*, ed. Sandra Slater and Fay A. Yarbrough (Columbia: University of South Carolina Press, 2011), 54–74.

17. "Count de Frontenac's Answer to the Speech of the Deputy from the Five Nations," September 12, 1682, in O'Callaghan, *Documents Relative to the Colonial History*, 9:189.

18. Raymond J. DeMallie, "Kinship: The Foundation for Native American Society," in *Studying Native America: Problems and Prospects*, ed. Russell Thornton (Madison: University of Wisconsin Press, 1998), 307.

19. Lisa Brooks, *The Recovery of Native Space in the Northeast: The Common Pot* (Minneapolis: University of Minnesota Press, 2008), 109.

20. Barbara Mann, "Jigonsaseh," in Johansen and Mann, *Encyclopedia of the Haudenosaunee*, 176–79.

21. Kathleen Brown, "The Anglo-Algonquian Gender Frontier," in *Negotiators of Change: Historical Perspectives on Native American Women*, ed. Nancy Shoemaker (New York: Routledge, 1995).

22. David Arthur Armour, *The Merchants of Albany, New York: 1686–1760* (New York: Garland, 1986), 54. For Pachot meeting with Dellius and Schuyler, see Hugh Hastings, ed., *Ecclesiastical Records State of New York* (Albany, N.Y.: James B. Lyon, 1901), 2:1409–11.

23. For biographies of Charlotte-Françoise Juchereau and her husbands, see Antonio Drolet, "juchereau de saint-denis, charlotte-françoise, Comtesse de Saint-Laurent," in *Dictionary of Canadian Biography*, vol. 2 (Toronto: University of Toronto/Université Laval, 2003–), http://www.biographi.ca/en/bio/juchereau_de_saint_denis_charlotte_francoise_2E.html (accessed June 19, 2014); Jean Hamelin, "VIENNAY-PACHOT, FRANÇOIS," in *Dictionary of Canadian Biography*, vol. 1 (Toronto: University of Toronto/Université Laval, 2003–), http://www.biographi.ca/en/bio/viennay_pachot_francois_1E.html (accessed June 19, 2014); Louise Dechêne, "DAUPHIN DE LA FOREST, FRANÇOIS," in *Dictionary of Canadian Biography*, vol. 2 (Toronto: University of Toronto/Université Laval, 2003–), http://www.biographi.ca/en/bio/dauphin_de_la_forest_francois_2E.html (accessed June 19, 2014). For information on the activities of Charlotte-Françoise's brother Louis Antoine, see Elizabeth A. H. John, *Storms Brewed in Other Men's Worlds: The Confrontation of Indians, Spanish, and French in the Southwest, 1540–1795* (Norman: University of Oklahoma Press, 1996), 1975. The Compagnie du Nord was originally chartered by French King Louis XIV to encourage trade at

Hudson's Bay. At the turn of the eighteenth century, it morphed into the Compagnie du Colonie and funded the establishment of French forts in the interior, including a fort at Detroit in 1701. A few years later, the Compagnie du Colonie became insolvent.

24. For Pontchartrain's and Raudot's descriptions of Charlotte-Françoise, see Antonio Drolet, "juchereau de saint-denis, charlotte-françoise, Comtesse de Saint-Laurent," in *Dictionary of Canadian Biography*, vol. 2 (Toronto: University of Toronto/Université Laval, 2003–), http://www.biographi.ca/en/bio/juchereau_de_saint_denis_charlotte_francoise_2E (accessed June 19, 2014).

25. Résumé d'une lettre de Mme de La Forest avec commentaires [1708], series C11A, folio 90, BAC.

26. For Jean Daniel Marie Viennay Pachot, see "Délibération du Conseil de Marine sur des lettres de Vaudreuil et Louvigny," December 28, 1716, and "Délibération du Conseil de Marine sur une requête du sieur Pachot," April 9, 1717, series C11A, BAC.

27. Allan Greer, *The People of New France* (Toronto: University of Toronto Press, 1997), 69.

28. Susan C. Boyle, "Did She Generally Decide? Women in Ste. Genevieve, 1750–1805," *William and Mary Quarterly* 44, no. 3 (October 1987): 781.

29. "Sale Madame de La Forest to Mon. de la Mothe Cadillac," Quebec, January 29, 1706, in *Collections and Researches Made by the Michigan Pioneer and Historical Society* (Lansing, Mich.: Wynkoop Hallenbeck Crawford, 1905), 34:229 and 310.

30. Lina Gouger, "Le Peuplement Colonisateur de Détroit 1701–1765" (Ph.D. diss., Laval University, 2002), 199–207.

31. "Mémoire de Lamothe Cadillac au Ministre donnant la description du Détroit," Québec, September 25, 1702, series C11E, folio 119, BAC.

32. "Lettre du jésuite Joseph-Jacques Marest à Vaudreuil," Michilimackinac, June 21, 1712, series C11A, vol. 33, folio 72, BAC.

33. "Reponse de Vaudreuil aux paroles de Chachagouesse," 1712, series C11A, vol. 33, folio 102, BAC.

34. "Lettre du père Joseph-Jacques Marest à Vaudreuil," Michilimackinac, August 7, 1706, series C11A, vol. 24, folios 259v–260, BAC.

35. For the accusation against Anne Marie de La Marque, Quenet, and Leguerrier, see "Ordonnance de l'intendant Bégon," Québec, October 23, 1714, series C11A, vol. 35, folios 190–195v, BAC.

36. Registre de Ste. Anne Detroit, vol. 1, no. 1252, reel 1, 176–77, Burton Historical Collection, Detroit Public Library.

37. Jan Noel, "'Nagging Wife' Revisited: Women and the Fur Trade in New France," *French Colonial History* 7 (2006): 47.

38. "Recensement nominatif de Détroit," 1710, series C11A, vol. 31, folios 160–160v, BAC. Canadians were those men who had lived first in the Laurentian Valley before taking up residence at Detroit. Frenchmen had come directly from France. It is interesting to note that in the category of Canadian men at Detroit with

wives, two of the four listed had Native wives, although this fact was not noted, nor did this census include names or numbers of local Native groups.

39. "Lettre de Vaudreuil au Conseil de Marine," Québec, October 14, series C11A, vol. 36, folio 73v, BAC. This figure tells us that for every one Meskwaki male there were six Meskwaki women who participated in the battle with the French (a fighting force composed of 86 percent women and 14 percent men). Vaudreuil described the women as fighting "en désespérées" (furiously) on these occasions.

40. "Mémoire de Sabrevois sur diverses tribus de l'Ouest," 1718, series C11A, vol. 39, folios 356–357v, BAC.

41. Catherine Cangany, "Fashioning Moccasins: Detroit, the Manufacturing Frontier, and the Empire of Consumption, 1701-1835," *William and Mary Quarterly* 69, no. 2 (April 2012): 268.

42. Colonel John Bradstreet to Captain Donald Campbell, September 12, 1764, Gage Papers, American Series, William L. Clements Library, University of Michigan.

43. Historian Sophie White has conducted extensive research on this New Orleans legal case, and I am grateful to her for bringing it to my attention; see Sophie White, *Wild Frenchmen and Frenchified Indians: Material Culture and Race in Colonial Louisiana* (Philadelphia: University of Pennsylvania Press, 2012), 89–90. A transcript and translation of excerpts of Louis Metivier's legal challenge to Louis Turpin and the testimony of the witnesses appear in *Louisiana Historical Quarterly* 6, no. 3 (1923): 506–8.

44. "Extrait d'une lettre de Sabrevois à Vaudreuil," Detroit, April 8, 1717, series C11A, vol. 38, folio 166, BAC.

45. Barbara J. Siversten, *Turtles, Wolves, and Bears: A Mohawk Family History* (Westminster, Md.: Heritage Books, 1996), 211–12.

46. White, *Wild Frenchmen*, 90.

47. Marrero, "On the Edge of the West," 82–83.

48. James Sterling to John Duncan, Detroit, February 26, 1765, James Sterling Letterbook, William L. Clements Library, University of Michigan.

49. Ibid.

50. James Sterling to William Johnson, Detroit, April 27, 1765, in *The Papers of Sir William Johnson*, ed. Alexander C. Flick (Albany: University of the State of New York, 1925), 4:733–34.

51. James Sterling to John Duncan, Detroit, May 31, 1765, James Sterling Letterbook.

52. James Sterling to John Porteus, Detroit, September 4, 1765, James Sterling Letterbook.

The Agrarian Village World of Indian Women in the Ohio River Valley

SUSAN SLEEPER-SMITH

Huron women raised "a very large amount of Indian corn, peas, beans, and sometimes French wheat," and their "Indian corn [that] grows from ten to twelve feet high" in fields that were so "very neat . . . that one cannot find a single Weed in them, although they are very exhaustive."[1]

This description, penned as Jacques Charles Sabrevois de Bleury traveled to Detroit, echoes his praise for the Indian women whom he encountered in the Ohio and Wabash River Valleys, sometime between 1714 and 1718.[2] He was especially laudatory of the Huron, Potawatomi, and Odawa women, whom he considered "highly industrious." On Grand Island, one of four islands at the entrance to the Detroit River, Sabrevois admired the large numbers of apple trees that Indian women had planted, their orchard covered almost the entire seven leagues of the island. "Those who have seen the apples on the ground claim that they lie more than half a foot thick," and although the apples were large, Sabrevois considered them as sweet as the French *pommes d'api* or small bee apples.

Indian women's agrarian skills went far beyond the cultivation of corn, the crop commonly associated with them. In highly fertile regions like the Ohio River Valley women's labor was extensive; they cultivated corn fields that stretched for miles along the riverways and even incorporated familiar European crops, such as wheat. Sabrevois commented on the agricultural innovation of Indian women, who grew European crops and raised domesticated animals, well before the arrival of the French. "Many tribes, especially those in the lower Mississippi Valley acquired hogs, chickens, and European fruit trees so early that many explorers reported them indigenous."[3] In the Ohio River Valley Indian women obtained peach pits, first carried to Florida by early Spanish

priests, and planted them alongside the apple trees that grew so abundantly in the Great Lakes region. These trees grew wild along many riverways, but in the villages women produced consistently reliable fruit through grafting and pruning.[4]

Women's agrarian practices were directly influenced by environmental factors. The wetlands basin of the Ohio River extended across two hundred thousand square miles, and its intersection by a multiplicity of rivers and streams made it possible to situate villages in close proximity while sustaining high population levels.[5] Indian women sited their villages where there were fertile soils, nearby forests, and adjacent wetlands. Europeans favored dry land and waterways deep enough to transport large river craft, eventually draining and eliminating most wetlands. But deep water held little interest for Indian women because it was shallow, fresh water from which Indian women gathered an ongoing supply of wild plants. They learned how to recognize, harvest, and prepare a multiplicity of food resources that grew in the region's extensive wetlands.[6]

The tributary rivers that sectioned the Ohio wetlands basin created ecologically distinctive niches and sustained high population levels, leading Indians to configure their lands differently from the bounded homelands of other Native people. Far less land was required to sustain many more people. Since the Ohio River flooded unpredictably following winter snow melts, Indian villages were located along the tributary rivers. For most of the year the river meandered through the valley for hundreds of miles, once it escaped the Alleghany foothills. With a drop of only 430 feet, or an average slope of less than six inches a mile, the Ohio River was easy to navigate and crossing was not a formidable obstacle.

This chapter examines Indian women's agrarian work in the Wabash River Valley, a major tributary of the Ohio, to show how this region was a sedentary village world before the arrival of the French. Indian women grew corn, beans, and squash and harvested the diverse wetlands foods that were crucial to the daily diet. Their labor was complemented by that of male hunters who provided fresh meats from adjacent forest lands and fish from the rivers, thus supplying the animal protein that was essential to a healthy diet. Women were responsible for giving life, and therefore did not shed blood and rarely killed animals or fish.[7]

Women's Agrarian Labor

Jacques Charles Sabrevois de Bleury's eyewitness description of the Ohio River Valley focused French attention on an unfamiliar region. Sabrevois provided an overview of the Great Lakes and the Ohio River Valley in a journey that began at Fort Niagara.[8] Surprisingly he started out on horseback, following the Indian trails that paralleled the lakes. When he reached the southern shore of Lake Erie he described it as far more "attractive than . . . the Northern side." He commented on the ease of travel along the trails that enabled Indian furs to be transported to Detroit from Vincennes, Ouiatenon, Miamitown, and Detroit. When Sabrevois followed the pathway along the Sandusky River to the Ohio, he traveled for two to three days and then portaged about a quarter of a league "over a fine road." There his men stopped to construct elm bark canoes that would carry them the rest of the way. They launched their canoes into the Scioto River and paddled south until they entered the Ohio, the "beautiful" river that he described as having "a fine current without rapids, except a single Cascade which is only half an arpent long." "Any one wishing to reach the misyspy would only need to follow this River on the Sandosquet, and would run no risk of going hungry, for all those who have traveled over this road have often assured me that there was all Along that beautiful River so vast a number of buffalo and all other wild animals that they Were Often oblidged to discharge their guns in order to clear a passage." Sabrevois echoed those previously recorded by the Jesuits about the Lake Erie region.[9] In 1675–76 the priests noted the presence of "fine apple trees," and described Wendat lands as a "great tract covered with wild apple-trees." These orchards were the creation of Indian women, who had planted them at the confluence of nearby rivers.[10] Peach tree cultivation was also common in the Ohio River Valley; the Delaware had obtained the peach stones through trade from sixteenth-century Spanish priests in Florida.[11] Pits from these fruit trees were transported westward along the Ohio River and traded to villages in the Mississippi River Valley and north into the Great Lakes.[12] Most outside observers considered fruit trees indigenous and failed to consider them the result of Indian women's labor. However, these informal orchards were a reliable source of food and a sweetening agent for

foods.[13] The number of fruit trees along the riverbanks of the Ohio amazed eighteenth-century Americans. In 1778, U.S. geographer Thomas Hutchins traveled along the Ohio River Valley and noted, "All European fruits:—Apples, Peaches, Pears, Cherrys, Currants, Gooseberrys, Melons, & thrive well here." Indian women identified the fertile environmental niches that allowed them to plant an incredible variety of foods and incorporated the varieties of crops that grew best on these lands. Because women tilled the soil, one can reasonably assume that women also created a demand for agricultural tools.

Most ethnological studies suggest that women first learned to cultivate plants because domestic responsibilities kept them closer to home. Their initial agrarian efforts began with wild cultigens, which they transplanted adjacent to their villages, those first crops included sunflowers, goosefoot, and sump weed.[14] It is difficult to identify specific dates and events that pinpoint when Indian women began to cultivate corn but sufficient evidence suggests that this was at least five millennia before the birth of Christ. By AD 1000, women evolved a highly complex agriculture that was based on three major crops: corn, beans, and squash.[15] Women developed five distinct types of corn, which included dent, flint, flour, sweet, and pop corn, and which grew in the same fields, side by side. Indian women not only perfected specific types of corn but also selected seeds according to their length of maturity and recognized that different growing seasons required different types of seeds. Indian women raised corn in a variety of climatic conditions and transferred through successive generations the knowledge that was required to stabilize different varieties of seeds. Several centuries were required to produce new varieties of corn because the gradual acclimatization of the corn plant took place farther and farther away from the Mayan site where corn was first introduced. Edward Everetts, an agriculturalist in President Franklin Roosevelt's administration, noted the incredible achievement of Indian women in refining corn: "The time required to stabilize all these forms and the subsequent precision of domestic routine that preserved their racial integrity to the present among some of the surviving natives, is one of the most impressive facts in the history of corn."[16]

Sabrevois's tour of the Ohio River Valley included an extended visit to the Wabash River Valley where the Indian villages, known collectively as Quiatenon, contained one of the highest population levels in this

region. Here, Indian women cultivated a substantial number of acres, nearly "two Leagues of fields, where they raise Their Indian corn, pumpkins, and melons." These were well-maintained fields, free of weeds, and Sabrevois's journey along the cornfields took two hours. If he rode on horseback that distance would have equated to 1,000 to 2,000 acres of corn. Large Huron communities of a thousand residents generally had 360 acres of corn under cultivation, but the villages at Ouiatenon would have required four to five times that amount of land, or approximately 1,500 cultivated acres to sustain the higher population level.

Sabrevois described the Ouiatenon villages as capable of raising approximately 1,000 to 1,200 warriors, which equated to 4,000 to 5,000 people. His journal confirms that "[4,000–4,800 souls in all] . . . live here in these villages." Sabrevois used the term "Ouyataonons" to refer to the five separate Indian villages located at this site. The "[f]ive villages, all built close together" consisted of distinctively different communities. "One is called ouyatanons, another peangnichias [Piankashaw], another Petitcotias [Pepicokes], another Les gros; as for the last, I do not Remember its name. But they are all ouyatanons." The villages were in close proximity, and he considered them closely aligned to the Miami because "[t]hey speak like the miamis [on the Maumee river], and are their brothers" and indeed all the miamis have "the same customs and style of dress."[17]

The Ouiatenon villages were unusual because of the fort located in the middle of the five villages. It was a gathering place for village residents, but it was also a defensive structure. It was scrupulously maintained by the Indian women from the nearby Indian communities. Perhaps this was one of the intricate garden and earth fortified structures that characterized much of the Ohio's precontact landscape.[18] Archaeologists have suggested that most precontact villages "were organized around a central plaza that served as focal points for communal activities" and that "at some settlements, a notably large structure adjacent to the plaza might have acted as a public building."[19] Sabrevois described the fort as a public structure because people walked along its plaza. This place was "very clean. They do not allow grass to grow there, and the whole fort is strewn with Sand, like the Thyleris [Tuileries]; and if a dog drops any excrements about the fort, the women pick them up and carry Them outside." Women had probably transported sand from the riverbanks

and spread it on the ground to identify and define the pathways. The French later replaced this Indian fort with a fortified stockade.

Most of the Ouiatenon villages were "situated near the mouth of the Wea River, a place where fish of many kinds were very plentiful." The Wea was an eastern branch of the Wabash, and nearby were the Patoka, White, Sugar, Wild Cat, Mississinaway, and Siamania Rivers. On the west side of the Wabash were the Little Wabash, Fox, Vermillion, Tippecanoe, and Little Rivers. Wetlands surrounded these villages, with all of these tributaries adjacent to the grassy plains and close to forest lands. Sabrevois described these lands as having "fertile soil, easy of cultivation and well adapted to the simple agricultural methods of the times. Within easy reach were to be found extensive prairies and thickly wooded forests each supplying its own particular kinds of game. . . . While easy of access yet within signaling distance were elevations that commanded a view of the country in all directions."[20]

In the hands of Indian women, this environmental combination produced extensive and almost unlimited food resources and led to increased village sedentism.[21] Even isolated patches produced high yields of naturally occurring edible plants, and in this complex ecosystem Indian women situated their villages in ecologically distinctive landscape niches and exploited those environments to feed their households.[22] Archaeologists contend that it was not maize cultivation that increased sedentism but rather access to a variety of environmental resources that allowed women to focus their foraging activities in a prescribed area. Archaeologists working in New England claim that access to shellfish, an adequate supply of meat, and wampum production increased sedentism along the New England coast. In the Ohio River Valley the alluvial rich soils of the riverways produced high crop yields, rivers had abundant fish and mussels, and harvesting wetlands plants created ecologically parallel circumstances to the resources available in many New England villages. Men hunted in adjacent forests and fished in lakes, rivers, and streams while bison that grazed on the prairies supplemented the food supply. Women processed buffalo robes and beaver pelts for the fur trade. This multiplicity of food resources in close proximity, along with involvement in the fur trade, led to sedentism and supported the high population levels of these villages.[23]

Indian women retrieved diverse plants from the wetlands, and recently scholars have reassessed the importance of these resources. Many

wetlands plants were poisonous, and Indian women skillfully identified edible plants and learned to prepare them to be nutritional. Retrieving these plants from the wetlands was often arduous and complicated. Plants were region specific, and south of the Ohio Shawnee women harvested Tuckahoe. It grew in freshwater bogs where "one individual could gather in a day sufficient quantity to furnish . . . subsistence for a week." Women dug up the Tuckahoe's starchy tubers, removed the stems and leaves, gathered them into large bunches, and then placed them on the ground and covered them with leaves and ferns, over which they layered dirt. Then, women kindled fires alongside the mound, and after twenty-four hours of roasting the Tuckahoe was palatable and nourishing, adding meal and sorrel to further enhance the flavor.[24]

Near the Wabash Indian women primarily gathered Macopine from the wetlands; it was larger and more nutritious but difficult to harvest. One Frenchman visiting among the seventeenth-century Illinois described this difficult process:

> I have seen the women pull the roots up from the ground at the bottom of the water into which they wade sometimes up to their waist. . . . There are some as big as one's leg. . . . The women have peculiar difficulty in cooking them. Sometimes three or four cabins combine and dig a hole in the ground five or six feet deep and ten or twelve square. They throw a great deal of wood into it . . . and when it is aflame they throw in a number of rocks, which they take care to turn over with big levers until they are all red; then they go in quest of a large quantity of grass which they get at the bottom of the water and which they spread as well as they can over these rocks to the thickness of about a foot, after which they throw on many buckets of water, and then as fast as they can each cabin puts its roots in its own place, covering them over with a dry grass and bark and finally earth. They leave them thus for three days.[25]

Other wetland roots and vegetables required far less effort than Macopine: "[O]ther roots which are as big as one's arm and which are full of holes. These give them no trouble to prepare; they merely cut them into pieces half as thick as one's waist, string them, and hang them to dry in the sun or in the smoke. . . . They also store up onions, as big as Jerusalem artichokes, which they find in prairies, and which I find

better than all the other roots. They are sugary and pleasing to the palate. They are all cooked like macopines."[26] Numerous foods came from prairies and forest lands—women made bread from sunflower seeds and from the Mattoon, both of which were eaten with deer suet.[27] They gathered acorns from white oaks and ground the nuts into meal, from which they also made into bread.[28] In the fall they gathered such fruits as persimmons and mulberries, which were dried and added flavor to winter dishes—much as we today use cranberries.[29]

Much of what we know about these natural landscapes has been destroyed, and there is probably no better example of this devastation than the annihilation of bison in the Ohio River Valley. Sabrevois's journal hinted at the vast bison herds on the prairies adjacent to the Ouiatenon villages. He noted that "[the Wea] village is situated on a high Elevation" and that beyond this village stretches extensive prairie lands that "stretch . . . farther than the eye can reach and abound . . . in buffalo."[30] Early nineteenth-century gazetteers, published for Indiana, also identified these extensive prairies along the Wabash, which "[a]fford[ed] fine ranges for immense herds of cattle."[31] But these grassy plains were bison ranges during the earlier centuries, and they provided plentiful sources of protein during the summer months. During the fifteenth century, bison became part of daily diets, and before the corn ripened Indian villages fed their inhabitants with meat from bison hunts. Sabrevois described the bison during his 1715 visit, but there are earlier, more complete descriptions of the role that bison played in feeding these villages. In the 1690s, a Frenchman name Deliette accompanied the Illinois on a five-week buffalo hunt. His description suggests the skill, tenacity, and courage required of Indian men and outlines how women's skills complemented the work of the male hunters. Women constructed the summer housing, smoked the meat, and distributed it among the households. Deliette's eyewitness description provides a full sense of the complementary role that men and women, elders and young men played in this event.

> [T]hey started out in two bands, running always at a trot. When they were about a quarter of a league from the animals, they all ran at full speed, and when within gunshot they fired several volleys and shot off an extraordinary number of arrows. A great number of buffalos remained on the ground, and they pursued the rest in such a manner that they were driven

toward us. Our old men butchered these. As for me, I did not shoot. Their appearance filled me with terror. . . . The cows are as big as the big oxen here. They have a hump about eight inches high which extends from their shoulders to the middle of their backs. They have their whole heads covered with fine hair so that their eyes can hardly be seen. . . .

[T]hey killed 120 buffalos from which they brought back a hundred tongues. The people from my cabin smoked these and distributed them among themselves. . . . We remained a week in this place in order to dry all this meat. They make for this purpose a kind of cradle ten feet long, three feet wide, and four feet high, which they call *gris*, upon which they spread out their meat after preparing it. Under this they kindle a little fire. They are at it for a day, when they wish to dry a flat side. There are two of these in a buffalo. They take it from the shoulder clear to the thigh and from the hump to the middle of the belly, after which they spread it out as tin as they can, making it usually four feet square.

The drying of this meat by the women and girls does not prevent they young men from going to the chase every day for himself. . . . These little hunts are ordinarily for bucks, bears, and young turkeys, on which they feast, not failing to invite the strangers they have among them (a very frequent thing), such as Miami, Ottawa, Potawatomi, Kickapoo, and others; so that there were days when I was invited as many as ten times.

Until the corn ripened at the end of August, bison hunts fed village inhabitants. These extended hunts lasted from two to three weeks, and people lived in temporary camps that were a short distance from their main village. Indian women built the lodges that housed the hunters, collected the firewood, cooked the meals, prepared the feasts, and smoked the meat. Large numbers of bison were killed, and the women sent meat to other women who tended the corn fields in the main village. Bison formed one part of a rich animal landscape that fed village inhabitants and Indian men worked equally hard during the summer months, when food supplies were low and corn was not yet ripe. Men also hunted waterfowl, which were far less dangerous to hunt.[32] "There is such a vast amount of them in the river, and especially in the lake . . . on account of the abundance of roots in it . . . one could not get through in a canoe without pushing them aside with the paddle, and yet the lake is seven leagues long and more than a quarter of a league wide in the broadest part."[33]

The Ohio River Valley had a great variety of game—men hunted deer, elk, bear, and turkey, and British traders who journeyed down the Ohio marveled at the number of large animals that roamed the banks. In 1765, the fur trader George Croghan wrote that "[t]he country hereabouts abounds with buffalo, bears, deer, and all sorts of wild game, in such plenty that we killed out of our boats as much as we wanted." James Audubon, who lived beside the Ohio, claimed that "[t]he margins of the shores and of the river were . . . amply supplied with game. A wild Turkey, a Grouse, or a Blue-winged Teal, could be procured in a few moments." Another traveler, who described the wasteful ways of his newly arriving white neighbors, noted that in one season a single hunter had killed two hundred deer and eighty bears. There were also panthers and wildcats, fox and lynx, cranes by the thousands, ducks, geese, partridge, and thousands of pheasants.

The slow and steady current of the Ohio's main channel provided the ideal habitat for an unusually large number and variety of fish. More than a hundred species of fish lived in the slow, deep, pristine pools of the river, including "white and black bass, crappie, sturgeon, sunfish, rockfish, and several varieties of catfish—mud cats, channel cats, Mississippi blues, as well as mullet, perch, and carp."[34] Even unusual species of large fish had survived from the precontact landscape: among the largest were the shovelnose sturgeon, which probably originated in the Mississippian world around AD 600, as well as paddlefish, lake sturgeon, alligator gar, skipjack herring, and blue sucker.[35] The Ohio was also an important habitant for freshwater mussels, and because doing so shed no blood, women and children probably harvested the mussels. Over seventy-five species of mussels grew in the Ohio River bottom and the Lower Wabash and White Rivers. Distinctive varieties included the fat pocketbook, white cat's paw, tubercled-blossom, pink mucket, and Wabash riffleshell. In the vicinity of the present-day Wabash and Ohio Rivers there are numerous shell middens or mounds that are the extant residue from mussels consumed and discarded shells along the riverbanks; they date to both the precontact and postcontact eras.

The French thought that the word Ohio meant "beautiful" to the Indians, and although they were far from correct about the Indian name for the river, French descriptions convey a sense of the breathtaking nature of this landscape. "Grapevines, heavy with fruit in season, laced tree

to tree along the banks, and mistletoe clotted the branches. Sometimes a tree chopped through at the base would be held upright by the entangling vines." Along the rivers there were huge thickets of cane with stalks that were twelve to twenty feet high and that could hide a man on horseback. The shores were lined with beech, maple, oak, ash, hickory, tulip poplar, locust, cedar, sassafras, elm, chestnut, cottonwood, buckeye, and juniper. In this virgin forest trees reached an awesome size, with oaks that were over six feet in diameter and rose fifty feet before they branched toward the sky. Red and white oaks and maples reached 150 feet toward the sky, and buttonwoods and sycamores had girths that spanned eighteen feet. Giant sycamores with hollow trunks were often large enough to hold several people and their horses. In the spring dogwood, redbud, and magnolia bloomed profusely. There were numerous indigenous fruit trees: persimmon, mulberry, and paw paw, while "lithe willows . . . and white-flecked sycamores" added to the picturesque nature of the Ohio's shoreline. Indian women harvested the fertile and luxuriant vegetation of the riverbanks. Grapes were dried, persimmon, mulberry, and paw paw were eaten uncooked or dried and added to stews, sassafras leaves were used in beverages, the riverbank cane was woven into mats, and elm, chestnut, and poplar trees provided lumber for framing Indian homes.[36]

* * *

By the time these lands were claimed by Americans their version of this landscape was based on a settler colonialism that considered Indians primitive and nomadic, dismissing Indian women's agrarianism as insignificant. Land ordinances were passed for the lands west of the Appalachia by the Continental Congress, well before Indians were forced to the treaty table to cede their lands. During the first years of the new nation, George Washington, together with his secretary of war, Henry Knox, attempted to destabilize this agrarian Indian world and develop a federal land policy that annexed and refashioned the Trans-Appalachian frontier into a landscape of individual homesteads. But government leaders underestimated the strength of Indian opposition and failed to appreciate the organizational strength of the Indian world that they set about to conquer and destroy. Sadly, their efforts actually enhance our understanding of the agrarian nature of the river valley

because the reports that Washington received from his military officers offer vivid descriptions of the Indian houses they razed and the thousands of acres of cornfields that they reduced to ashes.

During the Revolutionary War, following Clark's capture of Vincennes, the lands south of the Ohio River were often destabilized by squatters. Virginia's province of Kentucky appropriated Shawnee lands, and following repeated village attacks the Shawnee eventually took refuge among the Miami north of the Ohio. These highly populated and long-established agrarian villages more effectively resisted American intrusion. With passage of the 1787 Northwest Ordinance, General Arthur St. Clair, the newly appointed territorial governor, sent repeated messages to the Indians north of the Ohio, inviting them to several conferences. Treaty conferences were associated with land concessions, and along the Wabash, at both Ouiatenon and Miamitown, Indians were interested in peace but refused to meet with the general and did not intend to relinquish any of their lands.[37]

Despite multiple treaties with other Indians, the Wabash villages remained adamantly opposed to meeting with St. Clair. Despite repeated attempts, St. Clair failed to get them to the treaty table, and President Washington and Secretary Knox ordered St. Clair to orchestrate an attack, under the commanding general of the U.S. Army, Josiah Harmar, on the agrarian villages along the Wabash. The first was aimed at Ouiatenon and the second and larger offensive was launched against Miamitown, near the Wabash-Maumee portage. The attack on Ouiatenon was called off several days after Harmar left to attack Miamitown. Harmar's painfully slow and poorly organized trek through the wetlands to Miamitown allowed the Indians to evacuate Miamitown. Not surprisingly, the army encountered deserted villages. Harmar, eager to fight Indians, divided his army into smaller units and sent out several regiments to scour the countryside for Indians. This allowed the much smaller Indian force, under Little Turtle's leadership, to defeat the much larger invading U.S. Army. Harmar's strategy proved so disastrous that he lost over half of his force, 180 out of 330 men.

Harmar exacted his revenge by ordering the total destruction of the Miami, Delaware, and Shawnee villages at Miamitown. For three days the army burned and looted six villages, reducing buildings as well as the winter stores of grain to ash. In an attempt to draw attention away

from his defeat, Harmar described his successful destruction of hundreds of acres of cornfields, extensive apple orchards, and well-built log cabins and bark clad houses.

President Washington, infuriated that a small group of Indians had defeated the much larger U.S. Army, shaped a military policy infused with revenge and anger and driven by humiliation. Although Washington deplored the unruly men that moved uninvited into the western borderlands that became Kentucky, he now used these men to punish the Indians. He reversed previous attempts to control the Kentucky militia and instead called on them "to impress the Indians with a strong conviction of the power of the United States." Working through Knox, he ordered the militia "to inflict that degree of punishment that justice may require," destroying Indian homes, cornfields, crops, and orchards and slaughtering livestock. Washington targeted the agrarian villages at Ouiatenon,[38] and an enthusiastic Congress financed the attack.[39]

Knox, acting on instructions from Washington, ordered the total destruction of these villages and then added a destructive new twist, inflicting a degree of cruelty that Indians did not anticipate.[40] The Kentucky raiders were ordered to kidnap Indian women and transport them to Fort Steuben, at the Falls of the Ohio. Knox and Washington believed that there were "from fifteen hundred to two thousand warriors" in the river valley, which equated to a population of six to eight thousand women and children.[41] They believed "that the probability would be highly in favor of surprising and capturing at least a considerable number of women and children" and would prove to the Indians that they "are within our reach, and lying at out mercy."[42]

Knox told Scott that he was "to proceed to the Wea, or Ouiatenon towns of Indians, there to assault the said towns . . . either by surprise, or otherwise . . . and capturing as many as possible, particularly women and children. And . . . that they be carried and delivered to the commanding officer of some post of the United States upon the Ohio."[43] But Scott's expedition proved a failure as great as Harmar's. Yet no one chastised him, perhaps because he did not lose any men. Washington and Knox thought that Scott's militia would strike the Indians with lightning speed, but during his painfully slow and noisy march the Indians evacuated their villages and took refuge in the adjacent forests. Washington and Knox assumed that the militia could terrorize Indian

Country and capture a "considerable number of women and children." But they captured only forty-one women, who were left behind to care for sick family members. Scott abandoned the infirm and elderly, taking their caregivers hostage. The rest of the Indians remained hidden, and Scott was left without an enemy to fight. Like Harmar before him, Scott engaged in a burning frenzy that destroyed the recently planted corn. He described the wholesale burning of homes and storehouses in the Ouiatenon villages.

A second invasion of the Wabash villages took place on August 7, 1791. Scott was replaced by James Wilkinson, who left Fort Washington with 523 men and headed toward Kenapakomoko. This village was north of Ouiatenon, but the muck of the wetlands hindered travel, and following a week of arduous travel through the wetlands they discovered an almost completely abandoned village. Wilkinson's 500 mounted militia killed "six warriors . . . two squaws, and a child" and captured thirty-two women and children.[44]

Kenapakomoko, what the French called L'Anguille, was just east of present-day Logansport, Indiana, and was a peace village.[45] L'Anguille, which means eel in French, was referred as Snake-fish Town by Americans. The village was noted for its exquisite setting; it stretched along the riverbank for several miles, and dense orchards of wild plum trees lined the banks. Spread along a series of low plateaus, it overlooked the winding and gently flowing Eel River and was watered by three sizeable creeks. Wilkinson learned from a white captive that the Indians had evacuated most of the families and had packed up their household goods and buried them. Before leaving Wilkinson's men burned the cornfields and reduced the houses to ashes.

Brutality, death, torture, kidnapping women and children, and burning villages became central to successfully carrying out an "Enterprise against the Indians from our Country."[46] Scott and Wilkinson, like Harmar, filled their reports with descriptions of these agrarian villages and in recording the names of the women they captured, the agrarian nature of these villages becomes self-evident. Undoubtedly, Indian women invented the names they provided to their captors, and those names reflected the agricultural orientation of their villages. Their earth was gendered female and was filled with "Green Willows" and "Short Groves" where the "Soft Corn" was "Proper and Tall."

TABLE 8.1. List of Indian Prisoners, 1791.

Indian name of the prisoner	English translation
1. Mass-wockcomwah, Queen in English	Thunderstruck
2. Wonong-apate, her daughter, 17 years old	Speckled Loon
3. Kenchestonoquah, 2nd daughter	Swift Waves
4. Keshequamas-anongwah, prince, 7	Clear Sky
5. Otohemongoquah, 3rd daughter	Mermaid
6. Kesshockoquah, 4th do.	Cook Wife
7. Puckcontomwoh, cousin to the queen	Crack Nuts
8. Kechemataquah, warrior, about 32	Short Grove
9. Katankellocaset, his wife	Speckled Over
10. Nepehhequah, his child, a girl, 4	Green Willows
11. Mekehquah, his daughter	Old Mother
12. Wanpingivet, squaw	White Face
13. Kehewoh, her daughter	Cat
14. Mataquah, son to the last	Grove
15. Nokingwahmenah, do.	Soft Corn
16. Packocockcoset	Proper and Tall
17. Equahcong, squaw	Short Neck
18. Cateweah	What's Here?
19. Kenonesane	Deep Moss
20. Waughpochke	White Stalk
21. Kanketoquah, squaw	
22. Huntechelapelo	Look Yonder
23. Pamenkishlopelo	High-Look
24. Nepahkaquah	Green Willows
25. Cataholoquah	Striped Huzzy
26. Wecaupeminche	Lynn Tree
27. Kechewanpaume	Close Look
28. Kechemetaquah	Bushy Grove
29. Mossoolocaset	Dear Nothing
30. Puckcontomwuh	Cracked Nut
31. Pakakenong	Trod Ground
32. Wahpequagh	White Huzzy
33. Kehenackashwoli	Gash Hand
34. Onsiongwet, squaw	Yellow Face
35. Wecawpeminah	Roasting Ears
36. Mecah-cats	Eat All
37. Pacomequah	Muddy Water
38. Taqualanah	Grove Man
49. Packosequah	Pretty Girl
50. Machonsackquah	Beaver Girl

Source: *American State Papers*, vol. 4, pt. 1, 133. This list of Indian prisoners was attributed to General James Scott in the *American State Papers*. Scott captured forty-two women and children, and Wilkinson captured thirty-two prisoners. This list contains fifty names. Because the final tally of prisoners at Fort Washington was close to one hundred, it is likely that there was no list of prisoners captured by Wilkinson and he left his prisoners at Fort Washington, rather than dropping them off at Fort Steuben.

At Fort Washington, these women were imprisoned for over a year amid primitive, overcrowded, and unsanitary conditions.[47] St. Clair constructed a *ravelin*, or extended lean-to attached directly to the fort, to house the prisoners.[48] Women and children lived in shacks within the ravelin, which were adjacent to the army barracks. They were denied visitors and remained isolated from their families and communities. There were ever-present American soldiers, surrounded by many of the veterans from Harmar's campaign, men who had burned the homes of their families and kin and now held them prisoner. Soldiers embodied the terror of war and remained daily reminders of the violence that had swept them from their villages.[49]

Following the destruction of the Ouiatenon villages, Congress enthusiastically supported President Washington's plans to fund a larger army and a second major assault on the recently reestablished Miamitown. Arthur St. Clair replaced Harmar and was instituted leader of a three-thousand-member army, which was also soundly defeated by the Indians.[50] The Indians were well prepared and highly disciplined, and Little Turtle, Blue Jacket, and Buck-ong-a-he-las divided their warriors into three forces and pinned down the Americans in their own camp before they could reach Miamitown. The army had advanced by carving a single-lane road out of the woods, and the fleeing army stumbled in confusion along that stump-ridden, swampy route. St. Clair himself described the retreat as "a very precipitate one while Sargent described it as a flight"[51] and considered "[t]he quitting of the army after leaving the ground . . . in a most supreme degree disgraceful. Arms, ammunition, and accoutrements were almost all thrown away, and even the officers in some instances divested themselves of their fussees."[52] St. Clair lost $33,000 worth of equipment and supplies, and the Indians retrieved almost twelve hundred muskets and bayonets, eight cannon, and the personal possessions and uniforms of the officers.

Following the American retreat, the Indians returned to desecrate the bodies left on the battlefield. Several Americans silently observed from the swamplands and described how the wounded, who lay helpless on the battlefield, were tossed on the army's campfires and burned alive.[53] In the past, the wounded had often been held as captives, but now, as Indians abandoned many of their long-established practices and death became intentional, the wounded were put to death. Those dead left

on the battlefield were marked with a powerful and direct message as warriors "crammed clay and sand into the eyes and down the throats of the dying and the dead." Other Indians "stuffed the mouths of the slain with dirt and grass," warning Americans that they would choke to death on their greed for land if they again invaded Indian villages, destroyed agricultural fields, burned houses, or kidnapped and imprisoned Indian women and children.

Military historians who attempt to explain why the American army suffered this large number of fatalities frequently focus on the leadership skills and military logic of leaders like Little Turtle, Blue Jacket, and Buck-ong-a-he-las. At a deeper and perhaps more emotional level it was Indian women whose kidnapping and imprisonment determined the events that scared this battlefield. Indians viscerally responded to the invasion of the Ouiatenon villages where the Kentucky militia had abandoned the sick and elderly, skinned alive an elderly chief, kidnapped women and children, burned hundreds of homes and miles of crops, and then imprisoned almost one hundred Indian women and children at forts filled with U.S. soldiers. This was not a battlefield with anonymous contestants; it was filled with the men who had raided Indian villages and then joined St. Clair's forces for the subsequent attack on Miamitown. The presence of the Kentucky militia sealed the army's fate. Indians fought men they recognized and consciously targeted those same men who had attacked and destroyed their villages. Indian men had watched silently from the woods when their women were marched at bayonet point to the nearest federal fort, and they avenged the kidnapping of their wives and children. Their ire was also directed at General St. Clair, who had orchestrated Harmar's assault on Miamitown, ordered the repeated attacks on the Ouiatenon villages, and then transported the imprisoned Indian women from Ft. Steuben to Ft. Washington, where he was the commanding officer.

When Little Turtle assembled his warriors for the early morning attack on St. Clair's forces, he drew warriors from the Kickapoo, Wea, Miami, Wyandot, Shawnee, Illinois, and Delaware, but also from among the Six Nations Iroquois, Potawatomi, Chippewa, Ottawa, and Ojibwe. News about the kidnapping of women from the Ouiatenon villages had spread rapidly through Great Lakes Indian Country, and warriors arrived from along Lake Michigan's eastern shoreline, and from as far

north as Michilimackinac. What had happened to those kidnapped women potentially threatened daily life in every village of this interconnected Indian world. Many warriors came from villages with kinship ties and alliances to the Wabash villages.[54] St. Clair seriously underestimated the impact of his decision when he ordered the deliberate second destructive attack against Kenapakomoto and the abduction of women and children from that village. Warriors did not live here, and the village was thus defenseless. This was the home of Kaweahatta (Porcupine), a highly respected Miami leader who frequent spoke at treaty conferences throughout the Great Lakes. It was his household, his wives and children, that Wilkinson's men had captured. Unfortunately for St. Clair, Porcupine was also the brother of Little Turtle.

Those warriors who stuffed grass into the mouths of the dead soldiers vividly marked St. Clair's defeat with a brutal message that emphasized the central role that Indian women played in the creation of these agrarian villages. When Washington targeted those villages along the Wabash he believed that destroying women's cornfields and homes and kidnapping them would economically cripple and destabilize this region. Federal leaders used the façade of the nomadic Indian to claim that Indians lacked all sense of the land as agriculturally productive and that federal leaders were justified in dispossessing Indians from their lands. For President Washington to have acknowledged the agrarian skills of Indian women would have called into question the gender claims of men to farm and would have undermined the creation of a republic of independent male yeomen farmers.

The Ohio River Valley was transformed by the agrarian labor of Indian women, and placing gender at the heart of these events suggests alternative reasons why Washington chose these specific villages to attack and why St. Clair's defeat was scared by high levels of Indian brutality. This defeat simultaneously suggests a different trajectory about how we might understand U.S. history and why federal leaders chose to target Indian women in the Wabash River Valley. Past experience had taught Washington that the destruction of agrarian villages undermined Indian resistance, but now in the Ohio River Valley that lesson was no longer applicable. Instead, these attacks united a diverse and distant Indian world.

U.S. history textbooks contain no discussion of these repeated attacks, and when the defeats of Harmar and St. Clair are cited, the purpose is to

hint at Indian opposition to the federal government and their intransigence at becoming civilized and farmers. But considering the agrarian orientation of these villages and the large numbers of people fed by Indian women, the new nation should have welcomed and incorporated these agrarian villages. Federal leaders did not intend for Indians to occupy an equivalent position, to be participants, much less citizens, especially when women were doing what was gendered a male responsibility in the new nation. Releasing these Indian women and children in the summer of 1792, following St. Clair's defeat, diffused Indian anger but also allowed Washington another three years to build an army that was sufficiently large and well trained enough to eventually defeat Indians at the Battle of Fallen Timbers in August 1794. The defeat of Indians on this battlefield by General Anthony Wayne opened the lands north of the Ohio to American colonization and provided an interlude of peace in this region in the run-up to the War of 1812.

NOTES

1. "1718: Memoir on the Savages of Canada as Far as the Mississippi River, Describing Their Customs and Their Trade," *Wisconsin Historical Collections* 16 (Madison, 1902): 363–76 (translated from a manuscript in the archives of Ministere de Colonies, Paris: pressmark, "Canada Corresp.gen, vol.39, c.11, fol 354").

2. In 1682, Jacques Charles Sabrevois de Bleury received a commission as lieutenant on half pay in the regiment from the post and returned to France to defend himself. It was not until 1720 that he returned from France and occupied the post of commandant at Fort Chambly. The following year Sabrevois was appointed town major at Montreal. He died there on January 19, 1727. He had been made a knight of the order of Saint-Louis in 1718. *Dictionary of Canadian Biography, Vol. 2: 1701–1740* (Toronto: University of Toronto Press, 1969), 588–89.

3. Everett E. Edwards, *Agriculture of the American Indians: A Classified List of Annotated Historical References with an Introduction*, 2nd ed., no. 23 (Washington, D.C.: U.S. Department of Agriculture, 1919).

4. Michael Pollan points out that "anyone wanting edible apples grafted trees" and that apple trees grown from seed often produced bitter, inedible apples. Michael Pollan, *The Botany of Desire: A Plant's Eye View of the World* (Princeton: Princeton University Press, 2004), 9.

5. Kim M. Gruenwald, *River of Enterprise* (Bloomington: Indiana University Press, 2002), 3–4; R. E. Banta, *The Ohio* (Lexington: University of Kentucky Press, 1949), 7–17. The major tributaries of the Ohio include the Muskingum, Kanawha, Scioto, Miami, Kentucky, Wabash, Cumberland, and Tennessee. Today those tributaries create a drainage basin that stretches into fourteen states.

6. Recent archaeological evidence suggests that wetlands or wild plants were a small but significant part of the Huron diet; see Stephen Monckton, "Huron Paleobotany" (Ph.D. diss., University of Toronto, 1990), 122.

7. For a discussion of gender roles in Indian societies, see Theda Perdue, *Cherokee Women* (Lincoln: University of Nebraska Press, 1998), 1–40; Helen C. Roundtree, *The Powhatan Indians of Virginia: Their Traditional Culture* (Norman: University of Oklahoma Press, 1944), 32–57; Anthony F. C. Wallace, *The Death and Rebirth of the Seneca* (New York: Knopf, 1969); Patricia Albers and Beatrice Medicine, *The Hidden Half: Studies of Plains Indian Women* (Washington, D.C.: University Press of America, 1983); Nancy Shoemaker, ed., *Negotiators of Change: Historical Perspectives on Native American Women* (New York: Routledge, 1995); Janet Spector, *What This Awl Means: Feminist Archaeology at a Wahpeton Dakota Village* (St. Paul: Minnesota Historical Society Press, 1993); Gunlög Maria Fur, *A Nation of Women: Gender and Colonial Encounters among the Delaware Indians* (Philadelphia: University of Pennsylvania Press, 2009).

8. "1718: Memoir on the Savages."

9. William Kerrigan, "Apples on the Border: Orchards and the Contest for the Great Lakes," *Michigan Historical Review* 34 (Spring 2008): 1, 25–41.

10. Henry Nouvel, "Journal of the Last Winter Mission of Father Henry Nouvel, Superior of the Missions of the Outawacs," in *Jesuit Relations*, ed. Reuben Gold Thwaites (New York: Pageant Books, 1959), 60:217, 222.

11. Terry G. Jordan and Matti E. Kaups, *The American Backwoods Frontier: An Ethnic and Ecological Interpretation* (Baltimore: Johns Hopkins University Press, 1989). John Heckewelder described the Indian-created town at Schonbrunn (Welhik-Tuppeck, the Beautiful Spring) on what is now the Tuskarawas branch of the Muskingum River, near New Philadelphia, Ohio. There, the Indians had constructed sixty log dwelling houses, had laid out intersecting streets, and had established a distinctive agrarian landscape where they had "large fields under good rail fences, well pailed gardens, and fine fruit trees; besides herds of cattle, horses, and hogs." John Heckewelder, *A Narrative of the Mission of the United Brethren among the Delaware and Mohegan Indians, from Its Commencement in the Year 1740 to the Close of the Year 1808* (1820; repr., Cleveland: Burrows Brothers, 1907), 157; Paul A. W. Wallace, ed., *The Travels of John Heckewelder in Frontier America* (Pittsburgh: University of Pittsburgh Press, 1985), 101.

12. Thomas Hutchins, "A Topographical Description of Virginia, Pennsylvania, and North Carolina," in *Indiana as Seen by Early Travelers*, ed. Harlow Lindley (Indianapolis: Indiana Historical Commission, 1916), 7–9.

13. Helen Hornbeck Tanner, *Atlas of Great Lakes Indian History* (Norman: University of Oklahoma Press, 1987), 30–34.

14. Richard I. Ford, "The Processes of Plant Food Production in Prehistoric America," in *Anthropological Papers no. 75, Museum of Anthropology, University of Michigan*, ed. Richard I. Ford (Ann Arbor: University of Michigan, 1985), 1–18; R. S. MacNeish, "The Origins of American Agriculture," *Antiquity* 39 (June 1965): 88;

John P. Hart and William A. Lovis, "Reevaluating What We Know about the Histories of Maize in Northeastern North America: A Review of Current Evidence," *Journal of Archaeological Research* 21 (2013): 175–216.

15. R. Douglas Hurt, *Indian Agriculture in America: Prehistory to the Present* (Lawrence: University Press of Kansas, 1987), 11.

16. Edwards, *Agriculture of the American Indians*, 2, ix.

17. The estimates made by scholars who worked on the formal reports submitted to the Indian Claims Commission equate one warrior as representative of four people. Erminie Wheeler-Voegelin and Emily J. Blasingham, with Dorothy R. Libby, *Miami, Wea, and Eel River Indians of Southern Indiana* (New York: Garland, 1974), x.

18. Many nineteenth-century Americans who moved into the Ohio River Valley recorded visual descriptions of the many of precontact landscape markings that remained in the valley. These descriptions were accurate renderings of the remaining earthworks, which have since been destroyed. Many writers created a fictive past for Indians and believed that Indians were from one of the lost tribes of Israel, but their drawings provide a visual panorama of many of the landscape markers that no longer remain. For instance, in 1877 Col. Chas. Whittlesey published "Ancient Inhabitants of the Mississippi Valley and Lake Regions" in *Ancient Early Forts of the Cuyahoga Valley, Ohio* (Cleveland: Western Reserve and Northern Ohio Historical Society, 1877).

19. Penelope B. Drooker and C. Wesley Cowan, "Transformation of the Fort Ancient Cultures of the Central Ohio Valley," in *Societies in Eclipse: Archaeology of the Eastern Woodlands, A.D. 1400–1700*, ed. David S. Brose, C. Wesley Cowan, and Robert C. Mainfort, Jr. (Washington, D.C.: Smithsonian Institution Press, 2001), 91–92.

20. Oscar J. Craig, *Ouiatanon: A Study in Indiana History, Indiana Historical Society Publications*, vol. 2, no. 8 (Indianapolis: Bowen-Merrill, 1893), 328.

21. Gayle J. Fritz, "Levels of Native Biodiversity," in *Biodiversity and Native America*, ed. Paul E. Minnis and Wyne J. Elisens (Norman: University of Oklahoma Press, 2000), 224.

22. Women's agrarian responsibilities have been well documented. It was the early Jesuits who recognized that women planted, weeded, and harvested the crops, especially corn, beans, and squash. See Reuben Gold Thwaites, *The Jesuit Relations and Allied Documents* (New York: Pageant, 1959), especially the early accounts of Gabriel Sagard (he also wrote *Le grand voyage* and *Histoire du Canada*). For an overview of agrarian practices, see William Cronon, *Changes in the Land: Indians, Colonists and the Ecology of New England* (New York: Hill & Wang, 2008), 34–51; for specific overall views, see Dean Snow, *The Iroquois* (Cambridge, Mass.: Blackwell, 1994), 69–71; Bruce G. Trigger, *The Huron: Farmers of the North* (New York: Holt, Rinehart and Winston, 1969); Janet D. Spector, "Male/Female Task Differentiation Among the Hidatsa: Toward the Development of an Archaeological Approach to the Study of Gender," in Albers and Medicine,

Hidden Half, 77–99. For an overview of gender changes in precontact society, see Cheryl Classen, "Changing Venue: Women's Lives in Prehistoric America," in *Women in Prehistory: North America and Mesoamerica*, ed. Cheryl Classen and Rosemary A. Joyce (Philadelphia: University of Pennsylvania Press, 1997), 66–87.

23. Mary Beth Williams and Jeffrey Bendremer, "The Archaeology of Maize, Pots, and Seashells: Gender Dynamic in Late Woodland and Contact-Period New England," in Classen and Joyce, *Women in Prehistory*, 136–49.

24. Philip Alexander Bruce, *Economic History of Virginia in the Seventeenth Century: An Inquiry into the Material Condition of the People, Based upon Original and Contemporaneous Records* (New York: Macmillan, 1896), 166.

25. The De Gannes Memoir was probably written by the nephew of Henri Tonti, an Italian who had journeyed with René-Robert Cavelier, Sieur de La Salle, into the western Great Lakes. La Salle left Tonti to defend Fort Crèvecoeur in Illinois, while La Salle returned to Ontario. Sieur Deliette's writing is anthropological in nature; he was an astute observer of daily life and wrote in a straightforward manner which makes this document one of the most insightful portraits of early encounters that we possess. "Memoir of De Gannes Concerning the Illinois Country," in *The French Foundations: 1680–1693: Collections of the Illinois State Historical Library*, ed. Theodore Calvin Pease (Springfield: University of Illinois Press, 1934), 23:345–47.

26. "Memoir of De Gannes," 23:345–47.

27. Bruce, *Economic History of Virginia*, 165.

28. Ibid., 140.

29. Ibid., 166.

30. "1718: Memoir on the Savages," 376.

31. John Scott, "The Indiana Gazetteer or Topographical Dictionary," in *Indiana Historical Society Publications*, vol. 18, no. 1 (Indianapolis: Indiana Historical Society, 1954), 119.

32. "Memoir of De Gannes," 23:ix–x. An original transcription of the De Gannes Memoir is held at Newberry Library, Special Collections, Chicago.

33. Ibid., 23:349–50.

34. Marion T. Jackson, ed., *The Natural Heritage of Indiana* (Bloomfield: University of Indiana Press, 1987), 217–20.

35. Ibid., 217–20.

36. Scott Russell Sanders, "The Force of Moving Water," in *Always a River: The Ohio River and the American Experience*, ed. Robert L. Reid (Bloomington: Indiana University Press, 1991), 20; George W. Knepper, *Ohio and Its People* (Kent, Ohio: Kent State University Press, 1989), 8; Landon Y. Jones, *William Clark and the Shaping of the West* (New York: Hill & Wang, 2004), 3.

37. Dorothy Libby, *An Anthropological Report on the Piankashaw Indians* (New York: Garland, 1974), 148.

38. The best known of these raids was the inept operation launched by George Rogers Clark against the Wabash villages, which led to the establishment of federal

authority at Vincennes. Wiley Sword, *President Washington's Indian Wars: The Struggle for the Old Northwest* (Norman: University of Oklahoma Press, 1993), 31–35. Patrick Brown's raid defied Hamtramck's order to disband and defiantly used the army's canoes to cross the Wabash in 1788. "Hamtramack to Harmar, August 31, 1788," in *Outpost on the Wabash, 1787–1791: Letters of Brigadier General Josiah Harmar and Major John Francis Hamtramck, and Other Letters and Documents Selected from the Harmar Papers in the William L. Clements Library*, in *Indiana Historical Society Publications*, vol. 19, ed. Gayle Thornbrough (Indianapolis: Indiana Historical Society, 1957), 182, 115–16; Harvey Carter, *The Life and Times of Little Turtle: First Sagamore of the Wabash* (Urbana: University of Illinois Press, 1987), 76. The third attempt took place on August 3, 1789, and was led by Major John Hardin of the Kentucky militia when he left Clarksville and headed for the Wea towns on the Wabash. They returned several days later, following the death of two men, but failed to cross the Ohio. Hamtramck to Harmar, July 29, 1789, in Thornbrough, *Outpost on the Wabash*, 182.

39. Instructions to Brigadier General Charles Scott, March 9, 1791, in *American State Papers: Indian Affairs*, vol. 4, pt. 1 (Washington, D.C.: Gale and Seaton, 1832), 129.

40. Barbara Graymont, *Iroquois in the American Revolution* (Syracuse, N.Y.: Syracuse University Press, 1972), 192.

41. John B. Dillon, *History of Indiana, from Its Earliest Exploration by Europeans to the Close of the Territorial Government in 1816* (Indianapolis, 1859; repr., New York: Arno Press, 1971), 217–20.

42. Andrew R. L. Cayton, *Frontier Indiana* (Bloomington: Indiana University Press, 1996), 155.

43. John D. Barnhart and Dorothy Lois Riker, *Indiana to 1816: The Colonial Period* (Indianapolis: Indiana Historical Bureau, 1971); Dillon, *History of Indiana*, 261.

44. "Lieut. Colonel-Commandant Wilkinson's Report," Frankfort, Ky., August 24, 1791, in *American State Papers*, vol. 4, pt. 1, 133–35.

45. Robert B. Whitsett, Jr., "Snake-Fish Town: The Eighteenth-Century Metropolis of Little Turtle's Eel River Miami," *Indiana History Bulletin* 15 (January 1938): 72.

46. "Representatives of the Counties Composing the District of Kentucky Now in the General Assembly of Virginia" to Washington [1790], Charles Scott Papers, Margaret I. King Library, Special Collections, University of Kentucky, Lexington.

47. Sword, *President Washington's Indian Wars*, 90–91. Fort Washington had been hastily constructed of hewn timber and planks from dismantled flatboats in 1789. The fort stood two stories high, was surrounded by a wooden palisade that varied in height from ten to sixteen feet, and contained four log blockhouses, situated at the corners of the fort. Along the walls were the barracks for the men.

48. Arthur St. Clair, *Narrative of the Manner in Which the Campaign Against the Indians, In the Year One Thousand and Ninety-One, Was Conducted, under the Command of Major General St. Clair Together with His Observations on the Statements of the Secretary at War and the Quarter Master General, Relative Thereto, and the Reports of the Committees Appointed to Inquire into the Causes of*

the Failure Thereof: Taken from the Files of the House of Representatives in Congress (Philadelphia, 1812).

49. While there were no reports of rape at Fort Washington, undoubtedly, these outrages occurred during numerous frontier raids, and it must have terrified Indian women to live this close to army soldiers. Knox's orders to General Scott forcefully indicated that "it is the positive orders of the President of the United States, that all such captives be treated with humanity and that they be carried and delivered to the commanding officer of some post of the United States upon the Ohio." Scott reported to Knox "that the men had behaved admirably." These assurances suggest that abuse, rape, and murder were recurring problems during attacks on Indian villages and an ongoing legacy of Sullivan's campaign against the Iroquois during the Revolutionary War. *American State Papers*, vol. 4, pt. 1, 130. John Grenier, *The First Way of War: American War Making on the Frontier, 1607–1814* (New York: Cambridge University Press, 2005), 197.

50. Temple Bodley and Samuel M. Wilson, *History of Kentucky: The Bluegrass State* (Chicago: S.J. Clarke, 1974), 1:474.

51. Dillon, *History of Indiana*, 280.

52. *Winthrop Sargent's Diary while with General Arthur St. Clair's Expedition against the Indians* (Columbus: Ohio Archaeological and Historical Society, 1924), 33:259.

53. Ibid., 33:271; James H. Perkins, *Annals of the West: Embracing a Concise Account of Principal Events* . . . (Pittsburgh: W.S. Haven, 1857), 377.

54. Ouiatenon ranked fourth among western Great Lakes sites for the amount of furs collected. This was a widely known trading village where Indians from the Great Lakes gathered following the winter hunt. The furs exported from Wabash villages equaled the number of pelts acquired at more distant and well-known places like Michilimackinac, and thus many distant Indian villages had kinship ties to these Wabash villages. R. Cole Harris, *Historical Atlas of Canada: From the Beginning to 1800* (Toronto: University of Toronto Press, 1987–1993), vol. 1, plate 40.

Loyalist Women in British New York City, 1776–1783

RUMA CHOPRA

The Revolutionary War scattered loyalist families and overturned their world. Revolutionary politics intruded into their domestic lives, and rearranged their relationships with their communities. Women were affected as much as men. Overnight, their commitment to their husbands became defined as a political act. As their husbands, fathers, and sons fled to join the British side, women left alone to tend to children and the elderly came to symbolize opposition, resistance, and even treason. Unable to attack the loyalist men who escaped to British-protected regions and left their wives behind, patriot committees targeted the wives, punishing them through harassment, insults, persecution, and sometimes banishment. Attached to their homes and local surroundings, used to the security of friends and neighbors, and accustomed to relying on men to direct and guide their lives, almost all loyalist women feared a transformed world. For the most part, loyalist women made decisions that lent support to the choices made by the men in their lives.

In many ways, patriot and loyalist women endured similar wartime experiences. Sickly soldiers carried epidemics such as smallpox when they passed through rural communities, and women generally had lower immunity to communicable diseases than men because of poor diet and lack of inoculation. Women also suffered profoundly from the loneliness and anxiety of separation from husbands. Some men served in militias or regiments with only short visits home. Communication was slow, and wives often were unsure if their husbands were alive until they received return letters. As they had in other wars, colonial women adapted to the novel circumstances and of necessity transformed from helpmates to surrogate husbands: they labored in fields, ran the farms or shops, supervised servants and slaves, armed themselves, and protected

their families from danger. Frontier women used knives and muskets to protect their communities.[1]

Unlike other wars, the Revolution was also a civil war where neighbors and relatives cut ties with friends now deemed enemies, and associated only with men and women of like opinions. As part of a political minority, however, many loyalist women faced greater hardships than patriot women. Scholarship on loyalist women has not sufficiently addressed the experiences of ordinary women who remained loyal to their husbands and thereby supported the king and reunion. They were not perfect heroines, victims, or villains. Their gender made them more vulnerable but also, at times, offered security. Faced with a limited set of options, these women adapted quickly and acted resourcefully to protect their families and to support an American future within the British Empire.

New York is an excellent location for examining loyalist women's experiences. A minority of women, exhausted from living amid enemies and hoping to reunite with their husbands, fathers, or sons petitioned patriot committees for safe passage and permission to find refuge in British territory. Between 1776 and 1783, hundreds of loyalist families—men, women, and children—fled rebel-governed areas to seek asylum in New York City. Until the final peace treaty, New York City served as the headquarters for British administration and as the major haven for loyalist refugees. The British suspended civil law and civil courts, and governed the city through a series of military commandants. Loyalists lived under martial rule for the duration of the war.[2] The city's civilian population climbed from five thousand in 1776 to thirty-three thousand in 1783, and the British troops numbered another ten thousand.[3]

An extraordinary record of military registers, provisioning lists, refugee returns, and prison reports allow us to trace loyalist women's experience in the British New York City during the war period. Loyalist women welcomed British soldiers, served as camp followers in the British Army, provided intelligence to the British administration, and, in hundreds of petitions, requested that the British provide for them as they would provide for men considered legitimate and loyal subjects of the empire. These women also made claims for compensation during the war, and British authorities recorded supervising and provisioning them. Collectively, these records show how loyalist women maneuvered

and planned, and cheated and pleaded, to survive the miserable circumstances in the city.

Women's Wartime Actions

Some loyalist women expressed staunch ideological convictions from the outset. Far from expressing their views privately or choosing neutrality, they publicly supported reconciliation with the British. On September 15, 1776, when the British troops and administration first arrived into New York City, men and women together jubilantly welcomed them, and asserted their heartfelt attachment to Britain. As a newspaper reported, "Nothing could equal the Expressions of Joy, shewn by the Inhabitants, upon the arrival of the King's officers among them. They even carried some of them upon their Shoulders about the Street, and behaved in all respects, Women as well as Men, like overjoyed Bedlamites. One thing is worth remarking; a Woman pulled down the Rebel Standard upon the Fort, and a Woman hoisted up in its Stead His Majesty's Flag, after trampling the other under Foot with the most contemptuous Indignation."[4] The refugees in New York City included blacks and whites, young and old, men and women, families with many dependents, and children. On July 18, 1777, less than a year after the British military forces entered New York, an aide reported the presence of not only "servants and laborers," but also "washer-women in each company."[5] As the war went on, the proportion of women and children attached to the British Army in New York City steadily increased.[6] Camp followers were part of a long British military tradition. Impoverished women formed a readily available and cheap labor force and indeed, almost all the British Army's nurses were female by 1750.[7] Although the British recognized that women followed the army for personal reasons rather than broad political convictions, they tolerated their expense because women provided valuable services: they created a sense of domestic comfort and continuity, supplied spirits, and kept conditions sanitary. Women performed the same work in the army as they did in their households: they cooked, washed, cleaned and sewed clothes, hauled water and firewood, and tended the sick and wounded.[8] Women worked individually, primarily to be with and to serve the men in their lives. It is unlikely that a sense of community emerged from shared hospital or washing services.

Some loyalist women were totally indifferent to disciplinary rules prescribed by the British Army. They exploited British military protection to loot homes and cause havoc in rural communities. Indeed disorderly women, loyalists and patriots, appear repeatedly in British military memorandums. Unlike many other British officers, Captain Patrick Ferguson, Scottish aristocrat and career soldier in the British Army, trusted loyalist soldiers. But along with African American male followers, women's conduct frustrated him. In 1779, Ferguson's "Proposed Plan for Bringing the Army Under Strict Discipline with Regard to Marauding" explicitly ruled that women, as much as servants, drummers, and negroes "distress[ed] and maltreat the inhabitants infinitely more than the whole army." They entered homes unaccompanied by a senior officer, indiscriminately plundered, cut up beds, broke windows and furniture, robbed men of their watches and buckles as well as money. Ferguson ordered that every "woman, negro or follower of the army" who approached a civilian's house to loot be punished and fined. Even without the disorderly women, the very act of armies ranging over the countryside alienated and displaced thousands of civilians. Ferguson worried that these insults would transform wavering civilians—potential loyalists—into ardent rebels.[9]

African American men and women also joined the army as camp followers. Because loyalist women, as much as men, benefited from slave labor, they resented British protection of runaway slaves. On June 6, 1780, a frustrated James Simpson, royal attorney general of South Carolina, wrote that he "was pestered to death with vexations, complaints about the Negroes." One lady, after "a catalogue of grievances and complaints," lamented the "defection of her slaves."[10] Apparently, this Mrs. Hary had lost more than her fair share of slaves during the British occupation of Charleston. Although African American men served as valuable foragers, guides, and manual laborers, they also upset British protocol when they burned homes, destroyed crops, and carried away slaves.[11] The British understood that both these undisciplined but necessary constituents—white women and slaves—joined the war for a secondary purpose. The women's first motivation was joining their men and the goal of African American men and women was liberation. Still, British military customs and their need for labor directed toleration of their conduct.

Loyalist women, as well as men, gathered vital information about the rebel army around New York City. The British requirement for intelligence mandated a heavy reliance on loyalist spies. As early as August 1777, Mrs. Ogden observed the "discontent" in Washington's army as "marching with bad provisions distresses them exceedingly."[12] Unfortunately, loyalist spies did not always report accurately. Mrs. Ogden also informed the British that General Burgoyne "was absolutely in possession" of Albany. Just two months later, the British would learn of Burgoyne's disastrous campaign and his surrender in Saratoga, New York.

Loyalist wives worked alongside their husbands in gathering intelligence and rescuing captured British soldiers in hopes of earning rewards. In November 1780, Joe, "a Negro servant," along with his wife Dinah, "a Negro woman," reported that the rebel army was "very ill off for provisions."[13] Five months earlier, Hannah Tomlinson, along with her husband, served the government by "assisting & secreting our troops (who had fallen into the hands of the Enemy) that wished to escape from them."[14] But women served for compensation as much as from conviction, and when the reward proved insufficient and British treatment arrogant, women expressed outrage and disappointment. In July, one woman "with tears" complained that she had been "detain'd Nineteen Days upon the promise of reward." Worse, she "was now dismiss'ed in a manner which seem'd to suspect her veracity." Convinced it was the "utmost importance" to assuage her bitterness lest she return "to her family in disgust & anger," the British officer asked her to write the names of the men she had assisted so he could procure a larger gratuity than the eighty guineas already paid.[15] Like Ferguson, this officer worried about the political effects of women's disillusionment with the British. Undecided colonists would begin to distrust British promises and British benevolence.

Hardships

Women in contested regions—those living in the northern colonies during the first years of the war and those living in the southern colonies after 1778—faced hostility from neighbors and patriot committees. Many loyalist women were targeted not for their own independent acts of resistance but for their association with loyalist men. By insulting the

women or attacking their homes, vigilante groups struck a blow against the absent husband, son, or father. According to colonial law, husbands were responsible for crimes committed by their wives, but during the Revolutionary era wives sometimes paid the price for the loyalism avowed by their husbands. Some women, unable to tolerate the insults and harassment, and burdened with too much work without adequate resources, were obliged to leave their farms and communities.

Women's class, region, and family obligations also contributed to their decision to endure the war in their communities or to join their men in British territories. Some wealthy women, like Esther Sewall, married to the attorney general of Massachusetts, Jonathan Sewall, departed for England.[16] A few of high status remained to prevent rebel confiscation of their homes. Grace Galloway, wife of prominent loyalist Joseph Galloway, stayed in their Philadelphia estate while her husband left for British New York City, and eventually for London. Grace hoped her presence would prevent the state government from confiscating their property. Women such as Grace, in fact, who remained behind to protect estates or consented to manage family farms, may have allowed loyalist men to actively aid the British. Indeed, they may have permitted men to *act* on their political beliefs.[17]

Wealth and status did not save Grace Galloway from humiliation. In 1778, she fell from her pinnacle as the wife of one of Philadelphia's most influential politicians to the depths of powerlessness. She felt publicly humiliated when her carriage was confiscated and she, a lady of great status and influence, was compelled to walk the streets of Philadelphia like a common laborer. In a letter to her daughter in London, written on May 15, 1779, she explained her resolution: "And I am determined to vear [wear] with patience what I cannot prevent and not by opposition put it in the power of my enemies to hurt me in my mind or corrupt my manners and my mind may be affected and uncalled my mind shall not be subdued my soul is still my own and it will be my fault if it is made worse."[18] Evicted from her house, she lived the remainder of the Revolutionary years in rented rooms. Yet Galloway, like so many other women, refused to be cowed.

Against rebel accusations of tyranny, the British struggled to preserve the empire's image of constitutional order and fairness. But repeatedly, disciplining underpaid and underfed soldiers proved difficult. A 1780

British memo titled "Proposed Reformation Necessary in the American Army" suggested the nature of the soldiers' defiance: "Where private plunder is permitted at all, it is impossible to limit or regulate it. You cannot prevail on the soldiery to distinguish between friends and foes. All will be plundered alike."[19] Undoubtedly, some soldiers found it convenient to believe that every colonist was a rebel, and his property—and sometimes his women—fair game. Since both loyalists and rebels were composed of the same people and could not be distinguished easily by language, religion, complexion, and manners, this excuse proved especially useful.

Women living alone in farms in close proximity to New York City complained of British regulars stealing firewood, butchering livestock, and stealing produce. But British soldiers pointed out that the seizure of property did not always involve abuse of the inhabitants or owners. On December 12, 1778, when Sarah Sammies accused Lieutenant Colonel Pattison of taking three or four ox-load of hay without payment, Pattison insisted that Sammies did not deserve payment because she was married to a rebel. When Temperance Titus also accused Pattison, he answered, "She is the wife of a Rebel and therefore thought it no harm to take it for his own use & the horses employed in His Majesty's service."[20] In 1782, Mrs. Jane Cadmus did not deserve compensation for firewood and livestock taken because "one of the heirs of George Cadmus [her husband] is among the rebels." But when Mrs. Cadmus reported "she had been severely beat by a white man and most severely threatened and abused by a Negro," the British immediately agreed to "give her satisfaction."[21] The British officers severely punished violence against any women, whether they had a rebel son or not.

The presence of large numbers of women refugees did not inspire the British to erect institutions or create regulations that would offer them protection. Like men, women were left to fare alone. Consequently, some unprotected loyalist women—single women and widows—living among British and Hessian soldiers became prey to sexual violence.[22] Flight to British New York City may have ended rebel persecution but led to worries about unwanted attention from British soldiers. Schooled in a long military tradition that regarded sexual aggression as much as pillaging and burning as compensations for war, British soldiers did not regard their conduct as particularly wanton or barbaric.[23] The British

administration forbade the abuse of civilians, especially women, but warnings, orders, and examples of swift and deadly punishment could not entirely prevent incidents of rape.

In 1779, the British commander in chief, Sir William Howe, defended the conduct of British soldiers in New York City and Philadelphia during a parliamentary inquiry. He denied loyalist accusations that "wives and daughters were violently polluted by the lustful brutality of the lowest of mankind, and friends and foes indiscriminately met with the same barbarian treatment." He accused the rebels of circulating propaganda to turn the minds of colonists against empire by portraying the British government as violent and tyrannical. With rebel accusations of abuse, "the force of the rebels was increased, the British weakened, and the humanity and glory of Britons received a disgraceful tarnish, which time can never efface."[24] Like other British officers hoping for reconciliation with the colonies, Howe worried about the ideological effects of rumors about British atrocities. In his determination to defend British conduct, Howe understated the sexual violence committed by soldiers: "I do not recollect to have heard of more than one rape imputed to the soldiery, and that was said to have committed in Chester County, in province of New York. The criminal was secured; an enquiry immediately took place; but the accused refused to prosecute."[25] Howe did not mention the court-marital of the soldiers who were tried for rape in Newtown, Long Island. On September 3, 1776, John Dunn and John Lusty, soldiers in His Majesty's 57th Regiment of Foot, were accused of raping Elizabeth Johnstone, a widow. They came to her house when she was putting her child to sleep. When Dunn advanced to "have his will of her," she threatened to report him to his officers. He replied, "Damn you and the officers too," and turned out the "Negro wench" from her house. As reported in the court-martial records "Dunn then threw her on the bed; she hallowed [sic] and screamed and they swore that if she did so, they would kill her; that Lusty then held her fast, whilst Dunn lay with her; and when he had done, he held her, whilst Lusty lay with her; that her daughter who is about four years old stood by crying when Lusty said that if she did not leave off that he would knock her brains out."[26] Johnstone was fortunate to have two other women confirm her accusations. Spinster Freelove Hollowbird described the two men—one as "tall sturdy

swarthy" and the second as "a little man pitted with smallpox with sandy hair." Hannah, the African American servant referred to as the "Negro wench," also testified on behalf of Elizabeth Johnstone. Dunn and Lusty received death sentences.

Soldiers' infractions such as desertions, disobedience, robberies (anything from guns to silver spoons and watches to rum), pillaging and plundering, and besmirching an officer's reputation all merited court-martials, but the most severe punishments were reserved for rape, equal in harshness to committing murder. Between July and August 1778, Bartholomew McDonough, soldier of the First Battalion of Brigadier General DeLancey's Brigade, faced trial for the rape of Phebe Coe, another widow.[27] Coe became a victim when she tried to prevent McDonough from "ravishing her daughter, who was all her life subject to fits for nearly twenty years past has been so helpless as not to be able to walk alone nor to dress or feed herself." In anger, McDonough "laid violent hands on her, threw her on the bed, and there by force and against her inclination . . . he not only penetrated but she believes emitted in her body." McDonough also received a death sentence.

Despite the orders of the military commandant, robberies, pillaging, and sexual abuse pervaded New York women's lives—whether of rebel or loyalist sympathies. Between October and November 1779, two soldiers from loyalist regiments—William Green from the Queen's Rangers and Thomas Salem from the Bucks County Dragoons—faced accusations for breaking in and burglarizing three homes in Long Island and for raping the seventy-year-old mother-in-law of Hannah Dray. According the testimony of Samuel Wercks, men disguised in white shirts rushed in, pronounced they were "friends to King George," called him a "damned rascal," and threatened to take his life. They then entered the home of Hannah Dray, "forced and laid" with her mother-in-law, and then endeavored to "commit the same act on the body of a young girl in the house." As they "tied her hands with a rope and applied a handkerchief to her throat to prevent her from making a noise," Private Green interfered and she escaped unhurt. The gang pointed guns at the people in the house, took silver spoons and money, broke open a large chest and took trifles, broke a looking glass, broke two guns, and took a bottle of rum.[28] Green escaped the death sentence for his timely intervention.

Petitions and Allegiance

For the first two years of occupation, no clearly articulated strategy guided British actions toward the large population of New York's loyalists though thousands of loyalist New Yorkers came to rely on British military administration to assist them in dire circumstances. They asked the British for rations, fuel, housing, and compensation for their abandoned lives. The British welcomed their loyalty and enthusiasm but distrusted their involvement; they worried that angry and embittered loyalists would antagonize the wavering colonial populace and put an end to reconciliation. In 1778, the British commander in chief, Sir Henry Clinton devised a policy to deal with loyalist families who pleaded for assistance. He appointed an inspector of refugees to examine their claims. Clinton expressed his concerns about the loyalist refugees in need: "Amidst the multiplicity of business which pours in upon me from almost every part of this continent nothing distresses me so much as the application I hourly receive from great numbers of Refugees who crowd to this place from all quarters many of whom have been reduced from affluent circumstances to the utmost penury by their attachment to Government." He added, "Humanity and good policy requires that some attention should be paid to them."[29] The British could not afford to alienate subjects who had demonstrated the most fidelity.

Through submitting carefully-crafted petitions, New York's loyalists maneuvered to position themselves as beneficiaries of British goodwill. Loyalist women and men related their sufferings in remarkably similar ways. Overwhelmingly, the petitions were submitted from parents who had five or more dependents in the city. Like loyalist men, women rendered their appeals acceptable by fashioning themselves as earnest and sincere Britons and as authentic loyalists. They crafted an image of rebel tyranny and anarchy against the generosity of British constitutionalism. In July 1779, Mary Price, a loyalist refugee from New Brunswick, New Jersey, wrote that she was among the "numerous unhappy persons who have suffered by the *unnatural rebellion* [emphasis mine] of this country."[30] Like Price, many loyalists considered the war as an unnatural separation, as sinful, squalid, and selfish. They feared the rebellion would lead to the anguish and miseries associated with a state of nature, one in which might makes right.

All petitioners placed their hopes in the generosity of the British government, personified many times in the commander in chief, who could take care of their woes, relieve of them of suffering, and return the colonies to a state of peace. In his February 1782 petition, David Dobson (from Long Island) reminisced of the days when he "enjoyed the sweets of that liberty which no other government than that of HM is capable of diffusing."[31] The refugees solicited on behalf of the commander in chief's "benevolence," "innate goodness" or "compassion."[32] One Pennsylvania widow, Mary Donnelly spoke of the commander in chief as the "father to the people" who would "act with that dignity becoming your exalted station."[33] Just as patriot men and women replaced King George with George Washington, loyalist families clung to the idea of a political father. Amid a longing for home and a war-weariness, they modeled a paternalistic and benevolent commander in chief who would attend to their needs.

Both men and women portrayed themselves as turning to British assistance only as the last resort. Loyalists expected justice, not charity. Many petitions began with an assertion that the loyalist was unwilling to be a drain on the British government. Some women represented themselves as particularly weak and helpless without British help. In February 1781, a widow, Jerusha Miller, wrote, "I have since the death of my husband endured many distresses and indeavored to support myself & children without being a burthen to government."[34] Only when she was unable to manage any longer did she appeal to Government. Similarly, in March, John Ketchum (from Long Island) said he supported himself without "becoming burdensome to government" until he was "seized with violent epileptic fits which have continued by repeated strokes ever since whereby he is rendered altogether incapable of doing any labor." The point was unmistakable: the loyalists were not exploiting British resources but only petitioned because of their desperate circumstances.[35]

Strikingly, loyalist women probably benefited from British officers' assumptions about women's apolitical role and British acceptance of female work as limited to the patriarchal household. Whereas men had to provide evidence of their fidelity to the empire to merit compensation, women emphasized their allegiance to their men and their children: they had suffered for their men and were now responsible for their children. Loyalist women had more warrant: their distresses were obvious and did

not require proof in the same manner as men's loyalty. Men competed for British assistance by emphasizing their early loyalty to the British to distinguish themselves from those who chose sides later in the war. In December 1779, Griffen Carey (from Westchester), emphasized that he "behaved himself as a loyal subject from the *beginning* [emphasis mine] of the present rebellion" and hence deserved greater consideration.[36] Women's pain was genuine if suffered in the name of their men; it need not have resulted from loyalty to the empire. In November 1781, Margaret Wyman created a tragic picture of her circumstance: she herself through disease had been long incapable of hard labor; her husband and eldest son died lately after a long and expensive sickness; she had four children to support; and she was reduced to real necessity and distress.[37]

British assumptions about women's narrower work sphere as much as the army's labor requirements allowed younger loyalist women to seek assistance not permitted to men. The British commander in chief, Sir Henry Clinton, specified that "no able bodied single man used to labor or having a trade which he can exercise shall be permitted to draw rations or receive any bounty except *in cases of sickness* [emphasis mine] nor shall any one whatsoever whose trade is equal to his and his family's support be put amongst those who receive assistance from government."[38] The younger loyalist men not only had to demonstrate an injury (wounds or amputations) but needed authentication from a physician in the city. In May 1782, John Harlock (Bergen County) explained that he had maintained his wife and six children until he lost his eyesight.[39] Appended to his petition was the testimony from surgeon Sam Isaacs. Only older or handicapped men could be beneficiaries of British assistance, but women of all ages qualified. Male petitioners repeatedly emphasized their elderly (or infirm) status, while female petitioners did not find it necessary to specific their age. In 1780, John Hitchcock, sixty-seven years old, explained that he "fell from a wagon and was now incapable of maintaining himself."[40] But in 1782, Patience Johnston from Rhode Island did not mention age or infirmity when she wrote of her dependent children, "five of whom were under eight years of age."[41]

Revealingly, no loyalist petitions mentioned any abuse from British soldiers. Women did not describe incidents of looting, pillaging, or rape. Instead, they constructed a "fatherly" British administration that should assist desperate subjects who had sacrificed and suffered. The

women represented themselves as victims of rebel tyranny—and not British violence—and they depended on British administrators as saviors. But less orderly loyalist women do appear in British prison returns, women who may have entered British lines to escape homelessness, poverty, slavery, or servitude. On June 19, 1780, they included the following: Elizabeth Mason, along with her husband, accused of robbery; Rebaca Carry, accused of "being accessory to the death of her husband," Thomas Carry, of the loyalist corps, Bucks County Volunteers; and Chrisa Scotland, "Negress, suspected of having been assisting in convaing [*sic*] intelligence to the rebels."[42]

The British respect for the male-headed domestic household may have benefited some runaway slave women. By 1783, many African American slaves had fled to New York as families. During the war, they lived in neglected, crowded, and disease-ridden parts of the city, suffering from exposure, hunger, and smallpox in hopes of finally gaining emancipation. In May 1783, A. Burtram hoped to embark for British Nova Scotia with his two daughters, Nancy and Flora. When Henry Rogers of Queen Street detained Nancy so he could send her to her former master in Connecticut, Burtram appealed to the British Board of Commissioners superintending the embarkations. He provided a certificate showing that he and his daughters had come within British lines in July 1779. When Rogers could not produce "any authority" for detaining Nancy, the British ordered "the child to be set at liberty."[43] In spite of their racial prejudice, the British commitment to the patriarchal family as much as to legal processes may have kept Burtram's family intact, and saved Nancy from re-enslavement.

Large numbers of loyalist women did not feminize the British Army or British headquarters. Disorderly camp required disciplinary measures. Some women, as much as men, were thieves, vagabonds, and villains. Impoverished black and white women drained British resources. In principle if not in practice, British commitment to the patriarchal family compelled wives of respectable men to receive some consideration. But these women diverted attention from military imperatives and drained precious resources. Their many children and continuing requests for housing, firewood, and rations were onerous. When single women and widows, cloaked with less virtue than attached women, became an easy target for plunder—and sometimes rape—the British ad-

ministration conducted elaborate court-martials to punish soldiers and to appease the civilians. From the British perspective, loyalist women were a nuisance.

Though loyalty came with a price, it was not the loyalists—whether men or women—who created the crisis that proved to be so expensive. The loyalists suffered for their allegiance. A more enlightened British government would have much more thoroughly protected and nurtured them, for the loyalists, especially the women, represented a people willing to defend the values at the heart of empire. They believed in an imperial structure that offered social order and discipline, and political freedom to its members.

NOTES

1. Carol Berkin, *Revolutionary Mothers: Women in the Struggle for American's Independence* (New York: Knopf, 2005), 6, 11.
2. Ruma Chopra, *Unnatural Rebellion: Loyalists in New York City during the Revolution* (Charlottesville: University of Virginia Press, 2011).
3. Mary Beth Norton, *The British-Americans: The Loyalist Exiles in England, 1774–1789* (London: Constable, 1974), 32.
4. Edward H. Tatum Jr., ed., *The American Journal of Ambrose Serle, Secretary to Lord Howe, 1776–1778* (San Marino, Calif.: Huntington Library, 1940), 104.
5. Captain Friedrich Von Muenchhausen, *At General Howe's Side, 1776–1778: The Diary of General William Howe's Aide de Camp*, ed. Ernst Kipling and Stelle Samuel Smith (Monmouth Beach, N.J.: Philip Freneau Press, 1974), 22.
6. Linda Grant DePauw, "Fortunes of War: New Jersey Women and the American Revolution," in *New Jersey's Revolutionary Experience*, ed. Larry R. Gerlach (Trenton: New Jersey Historical Commission, 1975), 26:26. By 1781, the loyalist New Jersey volunteers reported 179 women for their 582 men.
7. Holly A. Mayer, *Belonging to the Army: Camp Followers and Community during the American Revolution* (Columbia: University of South Carolina Press, 1996), 8.
8. Ibid., 14.
9. Patrick Ferguson, November 1779, Clinton Papers, vol. 78, William L. Clements Library, University of Michigan.
10. James Simpson to John Andre, June 6, 1780, Clinton Papers, vol. 104:25s.
11. Mayer, *Belonging*, 16.
12. Intelligence from William Shirreff, August 9, 1777, Clinton Papers, vol. 22:42.
13. From Joe, November 6, 1780, Deserter's Deposition, Clinton Papers, vol. 128:43.
14. John Watson Tadwell, June 4, 1780, Clinton Papers, vol. 109:32.
15. William Scott to John Andre, July 11, 1780, Clinton Papers, vol. 111:10.
16. Berkin, *Revolutionary Mothers*, 102.

17. Linda K. Kerber, "'History Can Do It No Justice': Women and the Reinterpretation of the American Revolution," in *Women in the Age of the American Revolution*, ed. Ronald Hoffman and Peter J. Albert (Chapel Hill: University of North Carolina Press, 1989), 22.

18. Grace Galloway, letter to Elizabeth, May 15, 1779, Huntington Library, San Marino, Calif.

19. Supplemental, "Proposed Reformation Necessary in the American Army," Germain Papers, vol. 17:41, William L. Clements Library, University of Michigan.

20. Sir Thomas Stirling, Proceedings of Court of Injury Against J. Patison in Jamaica, December 12, 1778, Clinton Papers, vol. 48:13.

21. Mrs. Jane Cadmus to Guy Carleton, June 19, 1782, Clinton Papers, vol. 194:27.

22. Laurel Ulrich Thatcher, "'Daughters of Liberty': Religious Women in Revolutionary New England," in Hoffman and Albert, *Women in the Age of the American Revolution*, 228. Sharon Block observes that patriots circulated incidents of rape by British and Hessian soldiers to emphasize American innocence and show the illegitimacy of British rule. See Block, *Rape and Sexual Power in Early America* (Chapel Hill: University of North Carolina Press, 2006), 231–34.

23. Linda DePauw notes, "In contrast to British armies, the women on NJ farms might find the American soldiers a nuisance, but they did not fear them." See "Fortunes of War," 26:20.

24. William Howe, *Observations upon a Pamphlet, &c.* (London, 1779), 58.

25. Ibid., 59–60.

26. British War Office Papers, vol. 71/82, British National Archives (Kew).

27. Ibid., vol. 71/86.

28. Ibid., vol. 71/90.

29. Sir Henry Clinton to George Germain, July 28, 1778, Clinton Papers, vol. 255.

30. July 1779, Sir Guy Carleton Papers, National Archives, Kew, UK.

31. David Dobson, February 15, 1782, Carleton Papers.

32. Sophia Terrell, December 1782 petition, Carleton Papers.

33. Mary Donnelly, 1780, Carleton Papers.

34. Jerusha Miller, February 7, 1781, Carleton Papers.

35. Joshua Ketchum, March 15, 1781, Carleton Papers.

36. Griffen Carrey, December 21, 1779, Carleton Papers.

37. Margaret Wyman, November 21, 1781, Carleton Papers.

38. Sir Henry Clinton to Col. Roger Morris, est. 1782 (n.d.), Carleton Papers.

39. John Harlock, May 23, 1782, Carleton Papers.

40. John Hitchcock, December 28, 1780, Carleton Papers.

41. Patience Johnston, June 11, 1782, Carleton Papers.

42. Weekly State of Prison in NY, W. Cunningham, June 19, 1780, Clinton Papers, vol. 105:17.

43. Board of Commissioners Superintending Embarkations, May 30, 1783, Carleton Papers.

"I Knew That If I Went Back to Virginia, I Should Never Get My Liberty"

Ona Judge Staines, the President's Runaway Slave

ERICA ARMSTRONG DUNBAR

Whilst they were packing up to go to Virginia, I was packing to go, I didn't know where; for I knew that if I went back to Virginia, I should never get my liberty. I had friends among the colored people of Philadelphia, had my things carried there beforehand, and left Washington's house while they were eating dinner.
—Ona Judge Stains, May 22, 1845

Absconded from the household of the President of the United States, ONEY JUDGE, a light mulatto girl, much freckled, with very black eyes and bushy hair. She is of middle stature, slender, and delicately formed, about 20 years of age.
—*Philadelphia Gazette*, May 23, 1796

Born sometime around 1774, Ona Judge was raised as a slave on George and Martha Washington's Mount Vernon estate. As a slave and then a fugitive, Judge lived in rural Virginia toward the end of the colonial period and then traveled to the busy cities of New York and Philadelphia during the infant years of the new nation. Judge's bold and risky decision to flee her masters eventually landed her in a quiet hamlet near Portsmouth, New Hampshire, where she remained until her death in 1848. Although the most revered family in America owned her, George and Martha Washington were never able to recapture Ona Judge. This essay focuses on the escape of one of the most understudied fugitive slaves in America and simultaneously serves as a startling example of

just how complicated slavery and freedom became in the late eighteenth and early nineteenth centuries.

In many ways, this essay is an intervention. Until the latter half of the twentieth century, very little attention was given to the accomplishments and devastating losses of women and people of color who lived and toiled in America. The life of Ona Judge, later Ona Judge Staines, provides for a significant departure point from the traditional narrative of slavery and freedom in the eighteenth and nineteenth centuries. No scholarly monograph or article exists about the young female slave who managed to wrestle her freedom away from the U.S. president.

Presenting Judge's story is no easy task, for it requires the historian to be part detective, part archivist, and part psychologist. Judge, who remained illiterate, offered her life story through two oral interviews given to abolitionist newspapers toward the end of her life. Historians are fortunate to have these sources, as most enslaved and fugitive women have been written out of the master narrative of American history. Judge's story gained some national recognition during the apex of the abolitionist movement. Her first interview appeared in a New Hampshire newspaper, the same year Frederick Douglass published his autobiography. Although Judge did not gain similar recognition as Douglass, her story lends texture to a fugitive experience that is too often described from the viewpoint of the male runaway. Young slave women did indeed run away, and some were successful.

The first president also contributed to the telling of this story. George Washington and his secretaries were scrupulous note takers, and many details about Ona Judge, her life at Mount Vernon, in New York, and in Philadelphia, is revealed to us through their quill pens. Washington never conceded his quest to capture Ona Judge. Only his death in 1799 ended the concerted efforts to reclaim her. Following Martha Washington's death in 1802, Judge was never again pursued by bounty hunters hired by the Washington/Custis heirs. The young fugitive found a husband and had three children (all of whom were fugitives) and tackled new challenges for a northern fugitive slave. Judge's newest and lengthiest challenge was survival.

* * *

February 1796 brought a palpable unease to the executive mansion. A thick tension prompted Ona Judge and her enslaved companions to tread lightly around George and Martha Washington. Enslaved men and women always moved about their days with caution, not knowing what events could sour or sweeten a master's mood. For slaves who resided within the same walls as their master, life could be akin to walking through a minefield. The unpredictability of everyday life forced slaves to perform their tasks with the almost impossible agility of staying one step ahead of their master. The smallest of matters such as the accidental breaking of a dish or inconveniently timed bad weather could alter the mood of an owner. Although the president did not earn the reputation of a violent or physically punishing slave owner, he did on occasion lose his temper.[1]

Ona Judge maneuvered through her daily tasks at the president's house with a smooth watchfulness, perhaps attending to Martha Washington with extra care as she helped her dress for the day. For seven years Judge served her mistress well, becoming Martha Washington's closest slave. All who knew the Washingtons on a personal level were familiar with Judge, for she often accompanied her mistress on her social calls. Since moving to New York and then Philadelphia, the First Lady's life was filled with socializing and public events. The Washingtons' social calendar was quite full, and the upcoming birth night ball in honor of the president's sixty-fourth birthday involved considerable planning.[2]

Judge understood her mistress and knew just how much Martha Washington cared about her grandchildren. Having outlived each child fathered by her first husband, Martha turned her attention, worries, and adulation toward Eleanor, George, Elizabeth, and Martha (called Patsy by her family and friends). High mortality rates, especially for children, claimed the lives of two Parke Custis heirs before they reached their fifth birthdays. Two older children were lost in young adulthood, leaving Martha Washington devastated. She had no choice but to look toward her grandchildren for hope and enjoyment. Although she was only twenty-seven years old when she married George Washington, their marriage never yielded offspring, a subject that must have been difficult for both the president and his wife to accept. After the death of her son John (affectionately referred to as Jacky), Martha and George

Washington welcomed two of Jacky's small children into their home, raising them through adulthood. Two of Jacky's older children remained with their mother after she remarried, however they lived in Abingdon, only a few miles away from Mount Vernon, and then at Hope Park in Fairfax County.[3]

Judge must have witnessed the shock and concern of her masters after they read through the mail on February 6. The president had received a letter from Elizabeth, his nineteen-year-old step-grandchild (called Betsey by her family members and Eliza by her adult friends) informing her grandparents of her intention to marry. Eliza wrote of her engagement to Thomas Law, a British businessman who had spent a considerable amount of time in India as a policy maker. Law immigrated to America in 1794 and became involved in land development in and around Washington, D.C. Law met Eliza, who was twenty years his junior, and a romance blossomed into an engagement.[4] As Eliza's father was deceased, George Washington stood as the appropriate surrogate to approve or reject the marriage proposal.

The news must have sent the executive mansion into a tailspin. Although this was very personal family business, everyone who lived within the walls of the president's house knew all the details. As a slave, Judge had to negotiate the boundaries between a house slave and slave master, an intricate relationship that made her privy to the most intimate and delicate details of her owners' lives. Slaves were so very integrated into the personal lives of white masters that on occasion, the boundaries were blurred. Slaves attended births, deaths, birthday celebrations, and engagement announcements. In these kinds of situations, slave owners sometimes looked to their slaves for good counsel and most certainly for comfort. A master's reliance upon the fidelity of a slave played to nineteenth-century stereotypes of the faithful mammy.[5]

Judge was most likely left with the task of consoling her mistress. Neither George nor Martha Washington knew about the seriousness of the relationship between their granddaughter and Thomas Law, and there was much to be concerned about with this union. Law arrived in America with two of his three children, both of whom were the offspring from a relationship with an Indian woman. His biracial children and his age most certainly raised the eyebrows of the Washingtons. However, it was his British citizenship that gave Martha and George Washington reason

to pause. Would their dear Betsey be spirited away to a foreign country with her new spouse, or would he consent to remain in America? Judge was still a young woman, only about twenty-two years old and unable to provide the kind of informed comfort that older, more seasoned slaves were expected to offer in situations such as these. The laws of Virginia denied Judge the ability to live within a legal marriage, so she had no practical advice to offer her mistress.

It was perhaps Judge's youth that provided Martha Washington with some consolation. Judge was young yet very competent, and Martha Washington watched her mature into what she presumed was a faithful house slave. Judge was approximately the same age as Eliza when news of the engagement reached the executive mansion. Martha Washington watched the skilled and experienced Judge on a daily basis, and perhaps this was enough of a reminder that Eliza was not too young to marry. Surely, the First Lady must have remembered that she herself was only eighteen when she married her first husband.[6]

Ona Judge watched her owners navigate the dramatic events of February 1796. The First Lady's concerns must have turned to optimism, for by the end of the month Martha Washington began to publicly announce the upcoming matrimony to her friends and acquaintances. She not only publicized the imminent marriage of her granddaughter, but by many reports was in good spirits and excited by the event. It was clear, however, that many in the Washingtons' inner circle thought the marriage to be highly irregular, fueling the fire for presidential gossip. John Adams, the president's political ally and vice president, wrote to his wife Abigail about the upcoming wedding, revealing how the tongues of political insiders were wagging over this event:

> I have a great deal of News to tell you.—Mrs Washington told me the last time I dined at the Presidents that Betcy Custis is to be married next Month, to Mr Law the English East India Nabob. The good Lady is as gay as a Girl and tells the story in a very humerous stile. Mr. Law says he is only 35 Years of Age and altho the Climate of India has given him an older look yet his Constitution is not impaired beyond his Years. He has asked Leave and a Blessing of the President & Mrs W.—He is to finish a House in the Federal City and live there. He has two Children born in India: but of whom is not explained.[7]

* * *

As political insiders and friends talked about the president's grand-daughter, Martha Washington made peace with the provocative union. Her attempts to diminish the irregularity of Eliza's marriage through humor may have come across as "gay" and lighthearted, but the First Lady was a thoughtful and caring grandmother. She couldn't possibly shrug off what would be the biggest decision of her young granddaughter's life. The First Lady may have been laughing at the president's birthday celebration, but she was busy making plans for the future and did all she could to ensure that the marriage was supported, even if it inconvenienced the family. The acceptance of the marriage by both George and Martha began the unraveling of Ona Judge's life. Judge had no clue that the fast and unsteady decision making of her owner's grand-daughter would have such a direct effect upon her own life.

Eliza Parke Custis married Thomas Law on March 21, 1796, at Virginia's Hope Park. The marriage signaled the beginning of major changes for the Washingtons—and their slaves. Judge watched her mistress transition from shock and surprise to cheerful celebration over the marriage of her granddaughter. Judge most certainly knew that her time in Philadelphia was limited. By the March wedding of Eliza Custis, the news of the president's retirement was no longer a secret, and the slaves living at the executive mansion knew their lives would change once they returned to Mount Vernon. The idea of reconnecting with loved ones in Virginia must have given some of the slaves on Market Street reason to celebrate, but Judge had lived in the North for seven years and the thought of returning to Mount Vernon did not settle well. In her later interviews, Judge never mentioned a desire to return to Virginia, nor did she mention any feelings of attachment to Mount Vernon. Judge's biggest concern would be the likelihood of never seeing her mother and sister again.

Betty Davis, Judge's mother, remained at Mount Vernon with the expectation of being reunited one day with her daughter. Ona Judge's sister, Delphy, also remained at the plantation where she and her mother spent their days sewing for the Washingtons.[8] Judge's other sisters, Nancy and Lucinda, were deceased, and while the welfare of her mother may have weighed on her mind, Judge knew that Delphy was at Mount

Vernon to assist Davis as she moved toward old age.[9] Judge's concern about her mother would have been well founded, for by 1795 Washington wrote with animosity about Davis. The president accused Davis of feigning illness, laziness, and occasional indolence, all of which could be punished by sale. The likelihood of Betty Davis fetching a high price at auction was low, as she was an older woman beyond her reproductive peak. Judge may have known that her mother was not within the good graces of her master.[10]

What kind of world would Ona Judge return to once the president retired to Virginia? Her duties would change to include some of the more typical responsibilities of house slaves in the South, some of which would be more physically taxing. Although a slave, Judge was accustomed to a certain kind of labor, one that centered upon the care of Martha Washington within a northern city. The frenetic pace of the Washington's social calendar kept Judge busy, but also allowed for some personal time. As the president and his wife entertained guests, Judge stole moments of privacy she devoted to her needlework or conversation with house slaves and staff.[11] This kind of lifestyle would come to a screeching stop once Judge returned to the South.

All of the slaves at the executive mansion must have wondered what the future had in store for them. An uncertain outlook was something that slaves who resided in the North and South had to confront on a daily basis. The constant threat of sale and the breaking up of families loomed over the heads of most bondsmen and women. A return to Mount Vernon was a reminder to Judge and her enslaved companions that they were the property of another person, and after they had lived in a free northern city, this must have been difficult for them to accept. For Ona Judge however, the uncertainty vanished as her fate was revealed. The marriage of Eliza Custis and a change in life circumstances would cut Judge's residency in Philadelphia short. Unlike the other slaves at the executive mansion, Ona Judge would not return to Philadelphia from her annual summer sojourn to Mount Vernon, would not be around to witness the president's final year in office.

Martha Washington's deep concern for her granddaughter trumped any relationship that she may have forged with Judge. Sensing that Eliza had entered into a marriage for which she was unprepared, the First Lady decided to help her granddaughter navigate the transition by giv-

ing Judge to Eliza. This decision may have been expedited by the quick pregnancy of Martha Washington's granddaughter.[12] A new marriage, a first baby, and a new home formed a significant transition for any person, and the First Lady wanted to ensure her granddaughter had the best support, the best house slave Martha knew.

* * *

Although Judge had earned the top spot among Martha Washington's personal slaves, there was no way for her to amass enough personal or emotional capital to convince her owner to change her mind. Judge's fate was now in the hands of Eliza Custis Law, a woman who was approximately the same age and known for having a difficult and volatile temper. Those who were acquainted with the president's granddaughter knew that she was an atypical eighteenth-century woman in that she was assertive, knew what she liked, and acted upon it—and this was clearly demonstrated by her quick engagement. Family members stated that the new Mrs. Law was petulant and that in "her tastes and pastimes, she is more man than woman and regrets that she can't wear pants."[13] On her trips to Philadelphia, Eliza was known for having a "violent and romantic disposition" as she often appeared angry, completely shirking the social responsibilities of attending church and dances.[14]

While her grandmother did not appreciate her obstinate behavior, Eliza's antics amused George Washington. Those who were placed in a position to serve Eliza would have found her disposition to be anything except difficult. The Washingtons had a reputation of doting upon their grandchildren, and the household slaves and servants knew this. Ona Judge would have been on call to assist Eliza during her visits to the executive mansion, and undoubtedly encountered her ire on more than one occasion. As Martha Washington's personal slave, Judge knew her duties and was intimately acquainted with the needs and feelings of her mistress. A shift to the household of the irritable and volcanic Eliza Custis Law would have doomed Judge to poor treatment and uncertainty.

Another major concern for Judge must have focused upon the new member of the Washington family. Thomas Law was somewhat of a wildcard. Having made a good deal of money in India, he arrived in Washington and speculated on land. Purchasing nearly five hundred lots

in the eventual home of the nation's capital, Law appeared more like an opportunist than a savvy businessman.[15] However it wouldn't have been Law's money that worried Judge—she would have been more concerned about Law's principles and behavior, especially given the knowledge of his illegitimate children. Biracial children were far from uncommon at Mount Vernon, and Judge herself was the product of such a union, but the shroud of secrecy around Law and his family must have been worrisome.

For female slaves, a master's sexual desires were always a threat. Would Judge become the victim of a new master with a sexual interest that fell outside the realm of his marriage? Slave women were at the mercy of their male owners, and for women such as Judge who worked in the close proximity of the household, there would be very little opportunity to avoid her master. The realities of female enslavement included rape and forced breeding, and no matter a slave woman's position in the slave hierarchy, a bondswoman was never safe from sexual attack.[16] Young slave girls were taught from an early age that they were in constant threat of rape. Very graphic and direct conversation made its way to the ears of girls aged eight years and older—to help protect and prepare slave girls for the future. Author, activist, and fugitive slave Harriet Jacobs described her battle against sexual aggression once she found herself in the household of a new master: "No matter whether the slave girl be as black as ebony or as fair as her mistress. In either case, there is no shadow of law to protect her from insult, from violence, or even from death; all of these are inflicted by fiends who bear the shape of men."[17]

* * *

For a young, childless woman such as Judge, the dangers of the unfamiliar must have served as yet another prompt to run away. Living in Philadelphia exposed Judge to the benefits not only of owning one's own labor, but of also being able to select a mate, have the relationship sanctioned by law, and bear children who did not belong to a white master. Judge watched the cross and difficult Eliza Custis Law select a husband—without regard or concern for what others thought. She began a life of her own and was now married and on her way to motherhood. A legal marriage would be an impossibility for Judge if she returned to Mount Vernon, and the ability to select a mate might also be far from reach.

The passing of Judge to Eliza Custis Law was a reminder to everyone enslaved at the executive mansion that they had absolutely no control over their lives. The time spent in New York and Philadelphia changed Ona Judge. Slaves all over the young nation always dreamed of emancipation, but Judge had the tangible experience of living among free blacks. Indeed Judge was a slave and never forgot her place in the social hierarchy of the slavocracy of Virginia, but in Philadelphia she could see, feel, and experience freedom in the smallest of ways. Judge's time spent in the North, in conjunction with her imminent departure back to Mount Vernon, forced her to act, pushing her to seriously consider a new life as a fugitive slave.

[One of the first obstacles for fugitive slaves to confront was the very tricky issue of northern environments, as the weather was in constant seasonal flux.] Punishing winters along the northeastern seaboard pushed fugitives to contemplate spring or summer escapes. The frozen Delaware River made travel by water an impossibility for two to three months out of the year. Smaller rivers across the Northeast suffered the same problems, no longer providing direction to fugitives but instead serving as dangerous icy conduits that could splinter and break, sending the bravest of souls to an icy death. Heavy snow turned dirt roads impassable, and freezing temperatures took the lives of countless fugitives in the fields, barns, and alleyways of the North.[18] Fugitive slaves from the Upper and Lower South were often woefully underprepared, unable to procure a proper winter coat, shoes, and other outer garments needed for the long winters.

Foraging for food during the winter months proved terribly difficult as nutrient-providing vegetation disappeared until midspring. Fishing and hunting small game were not impossible but were much more difficult in rural or urban locales over the winter. Slaves on the run sometimes turned to farm animals as a dietary supplement, but stealing from farmers was risky business. Fugitives would have to wait for spring to supplement their diets with fruits and vegetables.[19]

The decision to escape during the spring or summer months was not met without challenge. Brutal and intense heat could easily send a fugitive to an early grave as temperatures upward of a hundred degrees produced dehydration and heat stroke. Heavy spring rains turned dirt roads into muddy rivers, and densely fogged pastures could confuse fugitives,

making eighteenth-century passage even more difficult. Of course, antiliteracy slave laws throughout the Upper and Lower South made them unable to read signs.

Finding safe shelter was also problematic for fugitives. Prior to the Underground Railroad of the nineteenth century, runaway slaves relied on the secrecy that came with forests and wilderness. Thick brush of the spring and summer months could conceal a fugitive, as did abandoned cabins, barns, and caves.[20]

The majority of fugitives in the Mid-Atlantic and Virginia were male, representing nine out of every ten runaway slaves. The historian Deborah Gray White reminds us that similar statistics permeated South Carolina and parts of the Upper South.[21] There were a variety of reasons for the imbalanced sex ratio of fugitives. However, historians have focused on a connection to kinship and children as a main deterrent for female slaves. On rural farms, slave mothers were much more likely to live with their children than were fathers. Abroad marriages, between slave men and women from different plantations, often placed miles between the dwellings of a husband and a wife.[22] The inability to marry legally and the capricious sale of human property often split children from their fathers, making strong bonds with their children difficult (but not impossible) to form and foster.

The majority of runaways were between sixteen and thirty-five years old, and most slave women, especially across the South, were pregnant, nursing, or caring for a child. Leaving behind a child would prove difficult for most women to do as an escape could place the anger of a master squarely on the shoulders of the runaway's child. This of course tethered slave mothers to the homes and farms of their masters. Successful escapes with children in tow were rare, as long-distance travel with infants and toddlers proved nearly impossible. Children's cries of hunger and exhaustion could not be easily tamed in the dark forests and cold caves of the wilderness. As small children were unable to walk or move quickly, they slowed down the run to freedom. It was challenging enough for a healthy adult male to escape his master, but for women with children the task was nearly impossible.

Washington remained vigilant about the slaves who attempted to escape from Mount Vernon, even while living in Philadelphia. Although the president preferred to keep slave families together, he was not com-

pletely averse to punishing or selling difficult slaves. During the early 1790s, Washington shipped at least two difficult slaves to the West Indies after becoming exasperated with their repeated defiance. Washington warned a slave named Ben that he would not tolerate disobedient behavior and that "if a stop is not put to his rogueries, and other villanies by fair means and shortly; that I will ship him off (as I did Waggoner Jack) for the West Indies, where he will have no opportunity of playing such pranks as he is at present engaged in."[23] The slave referred to as Waggoner Jack was traded for a quantity of wine in 1791.[24]

Judge knew that her master was not beyond selling a slave for serious rule infractions. Judge also knew that the slaves at Mount Vernon were susceptible to physical violence. In January 1793, Washington condoned the whipping of a slave woman named Charlotte. Mount Vernon estate manager Anthony Whitting wrote to the president about the seamstress whom he found to be repeatedly disobedient. Recounting Charlotte's constant insubordination Whitting wrote, "gave . . . a very good Whipping," and his plans for continued physical violence were made clear when he stated that he was "determined to lower her Spirit or skin her Back."[25] Washington responded to his estate manager, "and if she, or any other of the servants, will not do their duty by fair means or are impertinent, correction (as the only alternative) must be administered."[26] Ona Judge knew that the consequences of fleeing would be steep and that if her attempt were unsuccessful, she would most certainly face a difficult life far away from the executive mansion in Philadelphia and her childhood home of Mount Vernon, for Judge anticipated that if she fled her punishment could be the auction block.

Recent changes in the law made an escape from slavery even more difficult and riskier. In February 1793 (one month after the condoned beating of his bondswoman), the president signed into law the Fugitive Slave Act, creating a legal mechanism for the capturing and reclaiming of fugitive slaves. Under this new law, a slave owner or the owner's agent could legally seize a runaway and force the apprehended slave to appear before a judge or magistrate in the locality in which he or she was apprehended. After "proof" was offered in the form of an oral or written affidavit by the slaveholder, a judge could order the return of the alleged fugitive. Those who purposely interfered with the recapturing of a slave, or who offered aid or assistance to a fugitive, could be fined five

hundred dollars, imprisoned, and sued by the slaveholder.[27] Enabling slaveholders to cross state lines to track down fugitive slaves was considered a legal triumph among southern slave masters. However it proved problematic for states that no longer enforced or were dismantling the system of human bondage.

Ona Judge's decision to run away was careful and calculated. She used veiled language to describe her escape in an 1845 interview that appeared in the abolitionist newspaper the *Granite Freeman*. Judge's oral testimony revealed her fear and her confusion, but also demonstrated that in the face of uncertainty she turned to a community of free blacks who would help her navigate her way to freedom. Once Judge learned of the change in her ownership, she determined to leave the Washingtons, but only after consulting with knowledgeable free blacks with whom she had presumably become acquainted during her years in Philadelphia. Judge explained that she was uncertain about her route or final destination on her flight, but she had cultivated a community of friends in Philadelphia who would guide her. Judge never revealed the identity of her friends, as aiding a fugitive slave remained a federal crime until the Civil War. Judge remained loyal to her Philadelphia friends in her silence, but scholars believe that the Reverend Richard Allen may have played a part in Judge's successful escape.

Perhaps one of the most influential black leaders of the early republic, Allen is often given credit for building the free black community of Philadelphia. By the late 1790s, Allen not only served as a spiritual leader to the growing black community but also was an entrepreneur, owning and operating a chimney sweep business.[28] Among the clients served by Richard Allen was the president himself. Washington's records demonstrate that Allen was paid several times to service the executive mansion, including in March 1796 when Judge must have formulated her escape plans. Judge never publicly admitted to receiving help from Allen or any other African American friend.

Washington's account books from 1793 to 1797 clearly report the financial transactions that occurred in the executive mansion, including those pertaining to slaves. On May 10, 1796, Judge received money to purchase a new pair of shoes, which would have offered Judge the opportunity to visit Richard Allen's home.[29] In addition to his chimney sweep business, the well-known minister was skilled as a cobbler, and he was

eventually listed on the Philadelphia tax rolls as operating a shoe shop from his home on Spruce Street.[30] In need of shoes for a journey north, Judge could have completed much more than a simple purchase, instead planning her entire escape with the famed black leader, who was himself an ex-slave and was known to have assisted fugitives.

Judge was careful, and her intentions to escape remained undetected by her owners. In her interview, Judge made reference to her calculated escape, noting that she packed her clothes while the rest of the slaves and servants did the same for the summer return to Mount Vernon. Judge worked in tandem with the rest of the household, all of whom were extremely busy with all of the necessary preparations for a lengthy trip. It is probable that none of the other slaves knew about Judge's planned escape. On too many occasions, jealous or fearful slaves were responsible for foiling the attempts of fugitives.

Ona Judge had to not just pack her things but also formulate a plan of escape. As a house slave, Judge experienced what most domestic slaves encountered—minimal amounts of unsupervised time. In the urban North, domestic slaves were typically few in number and lived under the microscope of their owner. Although the executive mansion possessed more slaves and servants than did most northern residences, Judge was the First Lady's preferred bondswoman and had to be available at all times. Although Judge took care of many things for Martha and the executive mansion, she was exempt from meal preparation. The famed Hercules prepared most of the meals and had earned quite a reputation as a fantastic chef. The president was known for his like of simple fare, much of which had to be easy to chew. Washington's terrible dental problems plagued him for the majority of his life, and by the time he took up residence in Philadelphia he possessed only two of his original teeth.[31] Morning meals usually centered around hot cereals, and when guests were not present supper consisted of simple dishes. The eccentric and always well-dressed enslaved chef prepared the evening dinner for the president and was allowed to take solitary walks about town as the Washingtons enjoyed their meal.

It appears as though Hercules was not the only one who took advantage of the dinner time hour. Ona Judge must have received her own free time as well during supper, as other servants or slaves were assigned to serve the Washingtons. The president often entertained guests, extend-

ing the dinner hour into the evening as guests retired to the parlor for wine and conversation. It was for this reason that Judge chose to escape while the Washingtons ate their supper, disappearing undetected into the free black community of Philadelphia.

Judge knew that the moment she left the president's mansion her status as a trusted house slave for the most powerful American family would abruptly end. She would no longer be the favored slave of her mistress but instead a fugitive who would have to go to extremes to protect herself from federal laws and vicious slave catchers. Judge knew that she must leave the city of Philadelphia as fast as possible and with the help of unnamed friends. This was a daunting task, as federal law made every state in the young republic a danger zone for fugitives.

The more accessible locations for fugitives, such as Philadelphia and New York, offered larger populations with a considerable number of free blacks who could help conceal the identity of a woman on the run. Although a few scholars suggest that Judge may have spent a considerable amount of time hiding among the free black community of Philadelphia, it is highly unlikely that this came to pass. Free blacks would have urged Judge to leave the city urgently. Harboring a fugitive was punishable by a fine and/or imprisonment, and to assist the president's slave in her escape would have proven even more dangerous. Those who aided Judge most certainly pushed for an expeditious departure as she was recognizable, and it was certain that the president would use his immense power to recapture his property. Judge looked to the wharves of the Delaware River to make her urgent escape.

Eventually, the Washingtons realized that Judge was gone, and that it was highly unlikely that she possessed any intention to return. Washington was accustomed to slaves running away from Mount Vernon, and on occasion they would return after several days or weeks. It was much more difficult for slaves to escape in the South due to the long journey, lack of proper food and clothing, and absence of a free black community. Slaves returning to their master did so knowing the punishment they would face.[32] Judge's escape was smoother, yet she knew that time was not on her side as her escape became public knowledge. On May 23, 1796, Frederick Kitt, the household steward to George Washington, placed an ad in the *Philadelphia Gazette* acknowledging the disappearance of Ona Judge. The language of the ad was similar to others that

appeared in the newspaper founded by Benjamin Franklin, describing Ona Judge and announcing her defiance of the president.

* * *

Judge's runaway ad went on to describe the possessions that she had packed up and sent off to her free African American friends and noted that Judge had "many changes of good clothes, of all sorts, but they are not sufficiently recollected to be described."[33] Unlike the majority of runaway slaves, Judge was not confronted with a lack of adequate clothing, and as a slave in the president's household she was always dressed in appropriate fashion. The Washingtons were very aware of maintaining appearances, and poorly dressed slaves would have embarrassed them before guests to the executive mansion. As Judge prepared to escape she had in her possession ample clothing and a new pair of shoes.

Kitt's ad alerted slave catchers to Judge's probable escape route—the Delaware River. In his advertisement, Kitt sent a strong warning to anyone who worked on the docks of Philadelphia's busy port stating, "but as she may attempt to escape by water, all matters of vessels are cautioned against admitting her into them."[34] Kitt's assumptions were correct, for Judge did escape the city by boat. In her 1845 interview, Judge told of her journey to Portsmouth, New Hampshire, on a vessel commanded by Captain John Bolles. Judge remained secretive about her escape for the entirety of her life, announcing the name of the captain only more than a decade after his death: "I never told his name till after he died, a few years since, lest they should punish him for bringing me away."[35] Judge protected the identity of Bowles until very late in her life and revealed very few specific details about her journey to New Hampshire. She was extremely grateful and in many ways owed her life to Bowles. She honored the captain's name and reputation.

Judge sailed out of the port city of Philadelphia sometime during the later part of May on a sloop named the *Nancy*. Like many other eighteenth century seafaring men, Bowles operated a shipping business with his partner, Thomas Leigh. The two ran their freight business along the northeastern coast, transporting lumber, foodstuffs, and fish to the hub cities of New York and Philadelphia. The businessmen sold their items at market and brought back leather goods such as boots, bridles, and

saddles to sell in Portsmouth.[36] Bowles had a long relationship with the sea as he conducted his business across the Atlantic, within the Caribbean, and up and down the north Atlantic coast for many years. Scholar Evelyn Gerson writes that Bowles most likely began as an apprenticed deckhand and did not relinquish his post as the commander of the *Nancy* until the English Navy captured his ship in 1800.[37]

The local Portsmouth newspaper, *Oracle of the Day*, announced the departures and arrivals of ships that were exporting or importing items for sale. The Portsmouth Customs House offered the *Nancy* permission to sail on May 12, 1796. If Bowles left the Portsmouth harbor immediately, the journey to Philadelphia would have taken four to five days—weather permitting. If Bowles made a direct voyage to Philadelphia, he would have arrived sometime around May 17, six days before Frederick Kitt advertised Judge's escape. By June 3, Bowles was back in New Hampshire and once again advertising in the *Oracle*, promoting his new cargo and announcing his plans to sail again on June 25.[38] Although Bowles sailed to Philadelphia once again in late June, it is much more probable that Ona Judge embarked on her voyage to freedom as soon as possible. She would have boarded the *Nancy* in late May and most certainly had enough money to purchase her fare. The president often gave small sums of money to his slaves as token gifts, and it is likely that Judge saved this money for emergencies and her freedom. The Free African American community may also have contributed additional funds for Judge's escape, but more important they likely steered her in the direction of Captain Bowles.

The commander of the *Nancy* was not publicly known for his abhorrence of slavery, but he must have been a relatively safe bet and was not known to be a slave catcher. Judge's fair skin, her clothing, and perhaps her demeanor may have led Bowles to believe that she was a free woman. While her appearance may not have alerted Bowles, her independent journey as a young woman would have caused most people to raise an eyebrow. At the end of the eighteenth century, few women (black or white) traveled unaccompanied as the social norms dictated that women travel with a chaperone, especially for lengthy sojourns. Young women who traveled by themselves were most likely running from someone or something, so Captain Bowles must have turned a blind eye to the unusual passenger.

✳ A combination of preparation, assistance from the black community, and steely nerves pushed the trusted slave woman to begin her life anew—as a fugitive. Ona Judge made her way to freedom and lived out her days in and around Greenland, New Hampshire. She evaded Washington's slave-catching acquaintances for the entirety of her life and established a family for herself. Judge married Jack Staines, a free black, bore children, and labored as a domestic until the end of her days. Although she endured the trials of poverty and fugitive status until her death in 1848, Judge moved forward. Her life was a difficult one, but freedom was worth it.

NOTES

1. See James Thomas Flexner's *George Washington*, 4 vols. (Boston: Little, Brown, 1965–72), 2:519. Also see Ron Chernow's *Washington: A Life* (New York: Penguin, 2010), 103, for Washington's behavior with slaves. Washington was not known for being particularly cruel to his slaves, but he was not a stranger to harsh reprimands or reprisals.

2. Letter from John Adams to Abigail Adams, February, 23, 1796, Adams Family Papers: An Electronic Archive, Massachusetts Historical Society, http://www.masshist.org/digitaladams/. Adams writes that he attended an elaborate ball on February 22 to celebrate the president's birthday. Also see Isaac Weld, Jr., *Travels through the States of North America during the Years 1795, 1796, and 1797* (London, 1799).

3. Joseph E. Fields, *"Worthy Partner": The Papers of Martha Washington* (Westport, Conn.: Greenwood, 1994), 201.

4. Henry Wiencek, *An Imperfect God: George Washington, His Slaves, and the Creation of America* (New York: Farrar, Straus and Giroux, 2003), 290.

5. See Deborah Gray White's *Ar'n't I a Woman? Female Slaves in the Plantation South* (New York: Norton, 1985), chap. 1. White's book is the seminal work on the construction of the "mammy" and the mythology of female slavery.

6. See Helen Bryan, *Martha Washington: The First Lady of Liberty* (Hoboken, N.J.: John Wiley, 2002), 57–65. Also see Patricia Brady's *Martha Washington: An American Life* (New York: Penguin, 2005), 32–33. Martha Dandridge married Daniel Parke Custis on May 15, 1750.

7. Letter from John Adams to Abigail Adams, February 23, 1796, Adams Family Papers.

8. See overseer John Neale's "Weekly Report of Mount Vernon" written to the president, July 30, 1796. Betty Davis and Delphy both spent close to six days making clothing. In *The Papers of George Washington Digital Edition*, ed. Theodore J. Crackel (Charlottesville: University of Virginia Press, Rotunda, 2008),

Retirement Series (March 4, 1797–December 13, 1799), vol. 1 (March 4, 1797–December 30, 1797). Also see farm reports April 23–29, 1797.

9. Although we don't know for certain that Nancy and Lucinda were deceased, they do disappear from the plantation records. It is possible that they could have run away, but there would probably have been some kind of correspondence to confirm this. More than likely, they succumbed to a disease or illness that took the lives of many slaves on eighteenth-century tobacco plantations. See Allan Kulikoff's *Tobacco and Slaves: The Development of Southern Cultures in the Chesapeake, 1680–1800* (Chapel Hill: University of North Carolina Press, 1986).

10. Betty Davis (also noted as Betsey) was later described by George Washington as one of the most indolent slaves at Mount Vernon. In a letter to William Pearce, the president complained about Davis, stating, "a more lazy, deceitful & impudent huzzy, is not to be found in the United States." See "Letter from George Washington to William Pearce, 8 Mar. 1795" and "Letter from George Washington to William Pearce, 15 Feb. 1795," in Crackel, *Papers of George Washington Digital Edition.*

11. See Evelyn B. Gerson's master's thesis, "A Thirst for Complete Freedom: Why Fugitive Slave Ona Judge Staines Never Returned to Her Master, President George Washington" (Harvard University, 2000), 71. Judge was known as an expert seamstress and followed in the footsteps of her mother who remained behind on the Mount Vernon estate as a spinner.

12. Eliza Custis Law gave birth to a daughter on January 19, 1797, suggesting that if her baby was delivered at full term, she most likely became pregnant sometime in April. We don't know when Martha Washington became aware of the pregnancy, but it is clear that Eliza wanted to start a family immediately, and that her grandmother knew that children were in the immediate future.

13. Rosalie Stier Calvert, "Letter to Isabelle Van Havre, February 18, 1805," in *Mistress of Riverdale: The Plantation Letters of Rosalie Stier Calvert, 1795–1821,* ed. and trans. Margaret Law Callcott (Baltimore: Johns Hopkins University Press, 1991), 111.

14. Ibid.

15. Chernow, *Washington: A Life,* 748.

16. Beginning in the 1980s, a growing historiography regarding slave women and rape emerged. See Deborah Gray White's *Ar'n't I a Woman?*; Jacqueline Jones's *Labor of Love, Labor of Sorrow: Black Women, Work and the Family from Slavery to the Present* (New York: Vintage, 1985); Stephanie Camp's *Closer to Freedom: Enslaved Women and Every Day Resistance* (Chapel Hill: University of North Carolina Press, 2004); and Daina Ramey Berry's *Swing the Sickle for the Harvest Is Ripe: Gender and Slavery in Antebellum Georgia* (Urbana: University of Illinois Press, 2010).

17. Harriet Jacobs, *Incidents in the Life of a Slave Girl Written by Herself* (Cambridge, Mass.: Belknap, 2009), 34.

18. See Billy G. Smith and Richard Wojtowicz's *Blacks Who Stole Themselves: Advertisements for Runaways in the Pennsylvania Gazette, 1728–1790* (Philadelphia: University of Pennsylvania Press, 1989), 11. Smith and Wojtowicz note that only 11 percent of the 959 runaways advertised in *Pennsylvania Gazette* between 1728 and 1790 attempted to escape in December, January, or February.

19. Ibid.

20. According to Ira Berlin, between one-half and three-quarters of young enslaved men in the Philadelphia environs fled their masters sometime during the 1780s. The Revolutionary era as well as the gradual abolition laws of the North served as ample enticement for slaves to take leave of their masters. See Berlin's *Many Thousands Gone: The First Two Centuries of Slavery in North America* (Cambridge, Mass.: Belknap, 2000), 233.

21. White, *Ar'n't I a Woman?*, 70. According to White, 77 percent of the runaways advertised in the colonial newspapers of South Carolina were male. Of the 1,500 newspaper advertisements in Williamsburg, Fredericksburg, and Richmond, Virginia, from 1736 to 1801, only 142 were women.

22. Camp, *Closer to Freedom*, 25–29. Abroad marriages occurred when enslaved men and women lived on separate farms. According to Camp, it was often the male slave who visited his wife.

23. George Washington to Anthony Whitting, March 3, 1793, in John C. Fitzpatrick, *The Writings of George Washington from the Original Manuscript Source, 1745–1799* (Washington, D.C.: Government Printing Office, 1931–44), 32:366.

24. Mary V. Thompson, "Control and Resistance: A Study of George Washington and Slavery" (paper, Historical Society of Western Pennsylvania, October 2000).

25. Anthony Whitting to George Washington, January 16, 1793, manuscript A-301, Mount Vernon Ladies' Association, typescript.

26. George Washington to Anthony Whitting, January 20, 1793 in Fitzpatrick, *Writings of George Washington*, 32:307.

27. For more on the background of the Fugitive Slave Law of 1793, see Paul Finkelman's *Slavery and the Founders: Race and Liberty in the Age of Jefferson* (Armonk, N.Y.: M.E. Sharpe, 2001), chap. 4.

28. Richard Newman, *Freedom's Prophet: Bishop Richard Allen, the AME Church, and the Black Founding Fathers* (New York: New York University Press, 2008), 56–57.

29. See "Washington's Household Account Book, 1793–1797," *Pennsylvania Magazine of History and Biography* 31 (1907): 182.

30. Newman, *Freedom's Prophet*, 142.

31. Washington for decades suffered from serious dental problems. As he grew older, dentures and implants were suggested and attempted by the president, but by the time Washington took office in 1789, he had only one remaining tooth in his mouth. See Chernow's *Washington: A Life*, 438–39.

32. In 1964, the historian Benjamin Quarles reminded scholars just how very difficult a planned escape by an enslaved person could be. Living off of the land, traveling alone in unknown locations, and of course fear of reprisals if the escape was

unsuccessful were very large obstacles. See Benjamin Quarles, *The Negro in the Making of America* (New York: Collier Books, 1964), chaps. 2 and 3.

33. Ibid.

34. Ibid.

35. *Granite Freeman*, May 22, 1845.

36. Gerson, "Thirst for Complete Freedom," 83.

37. Ibid.

38. See "For Philadelphia and Back to the Port," *Oracle of the Day*, May 12, 1796, and June 9, 1796; and the *New Hampshire Gazette*, June 4, 1796.

11

"The Need of Their Genius"

A Women's Revolution in Early America

MARY C. KELLEY

In the wake of the Revolution and establishment of the republic, Judith Sargent Murray looked to a more radically transformed future than other Americans of her generation had anticipated. "I expect," she declared in the collection of essays, plays, and poems she published in 1798, "to see our young women forming a new era in female history." Basing her claim upon already visible changes in the schooling of women, Murray told readers "female academies are everywhere establishing." The presence of these schools demonstrated that "studies of a more elevated and elevating nature" were being integrated with the training in the arts of the needle that had been thought sufficient to a woman's instruction.[1]

That Murray cast this advancement as a "revolution" testifies to the importance she attached to female education in changing the course of American women's history. Scholarship on schooling in colonial America has addressed women's education only tangentially. Historians have also scanted post-Revolutionary women's education, suggesting instead that Murray's "revolution" occurred in the latter decades of the nineteenth century. The markers they have cited are the admission of women to the nation's public universities and the founding of all-female private colleges. This chapter argues that the "revolution" Murray predicted actually took place before the Civil War. In the decades between 1790 and 1850, female academies and seminaries welcomed women into the world of higher education. Those who attended these institutions became actors in one of the most profound changes in gender relations in the course of the nation's history—the movement of women in public life. In asking how and why these women shaped their lives anew, historians have found that education played a decisive role in the transforma-

tion of their individual and social identities. Acting upon the felt reality of their collective experience as students and employing the benefits of their schooling, women redefined themselves and their relationship to civil society. As educators, writers, editors, and reformers, they entered the "public sphere," or the social space situated between the institutions of the family and the nation-state. The large majority of the women who claimed these careers and who led the movement of women into the world beyond their households were schooled at female academies and seminaries.[2]

Educated at institutions created exclusively for women, they attended schools with a clearly articulated mission, a faculty that offered inspiring role models, and a curriculum that introduced them to female exemplars. In educational practices ranging from classroom instruction to literary societies to reading protocols to emulation of intellectually accomplished women, students were schooled in a curriculum that matched the course of study at male colleges. Embracing the convictions of principals and teachers who held that an improved mind was a woman's greatest treasure, they committed themselves to earning the mantle of learned women. Those who taught them also called on their students to "vindicate the equality of female intellect," as Sarah Pierce, a head of an early academy, had charged her students in 1818.[3]

The Richest of Earthly Gifts

The large majority of colonial women had been taught only the rudiments of reading, writing, and cyphering. In the towns and cities of British America, girls and boys were introduced to these skills by their families or by privately funded schools, many of which were opened by women who taught in their homes. Along with arithmetic, children learned the basics of oral pronunciation, letter and word formation, spelling, and elementary reading. In all of the colonies, both girls and boys were instructed in reading before writing. However, in contrast to that of boys, who received training in both skills, girls' schooling in the fundamentals of literacy was more likely to conclude with reading, at least until the early eighteenth century. In New England, there were also public schools, which introduced their charges to these basics. Most of these locally supported schools in the region took only boys. Those that

admitted girls did so almost as an afterthought, instructing them separately in the early mornings or late afternoons. In contrast to practices in New England, schools in the middle colonies offered girls a more equal share in early schooling. European colonists, whether English, German, Dutch, or Swedish, provided daughters and sons with the same opportunity for elementary instruction. There, as elsewhere, secondary and higher education was reserved for males. In the more scattered settlements of Virginia, Maryland, Georgia, and the Carolinas, girls received little if any formally institutionalized education, although a minority did attend small neighborhood schools, known as "Old Fields Schools."[4]

Families who counted themselves members of British America's elite introduced the one exception to an education that ended with reading, writing, and cyphering. Beginning in the middle decades of the eighteenth century, those who resided in towns and cities had daughters schooled in ornamental needlework, French, music, and dancing, the social accomplishments with which a lady marked her status. These daughters were also sent to privately funded schools that offered a smattering of English grammar and composition, geography, natural philosophy, and history. Some of these families went further, installing the much more extended education in which their counterparts in Great Britain were being instructed. The daughter of a prominent merchant in Portsmouth, New Hampshire, Polly Warner, had such an education. Already bolstered by considerable economic and social capital, all Warner needed to complete Pierre Bourdieu's triptych of capital was a library, the embodiment of cultural capital. Warner's family arranged to have that library shipped from London in 1765. Volume by volume, periodical by periodical, it replicated the curriculum that other elite families were importing from Great Britain. With a twelve-volume edition of Charles Rollin's *Ancient History*, a two-volume edition of Joseph Addison's *Works*, a three-volume edition of Rollin's *Belles Lettres*, three volumes of the *Ladies Library*, fourteen volumes of the *Spectator and the Tatler*, and *A Word to the Ladies*, which was appended to the *Gentleman Instructed in the Conduct of a Virtuous and Happy Life*, the sixteen-year-old Warner was ready to make herself into a fully accomplished woman.[5]

The 155 volumes in Polly Warner's library illustrate the linkage between the books on its shelves and the eighteenth-century's institutions of sociability. *The Gentleman's and Lady's Key to Polite Literature, The*

Beauties of Shakespeare, An Essay on the Genius and Writing of Pope, and *The Preceptor* were all designed as conversational tools. In presiding at salons and tea tables, which had emerged as counterparts to the male clubs and coffee houses, women of Warner's standing were expected to "give Life to civil Conversation," as the *Word* from *Gentleman Instructed* reminded Warner. Proper deportment was no longer sufficient—"your Addresses in the Modes and Gestures of Salutation, your graceful Entrance into a Room, and all the other pretty Accomplishments of the Sex" went only so far in impressing the company assembled. Indeed, and perhaps most strikingly, the accomplishments were considered "dead, unless enlivened by a handsome Discourse." Little wonder then that Warner was sent the *Key,* the *Beauties,* and the *Essay.* Dedicated to inculcating "the first principles of polite learning" as the *Preceptor* informed readers, these volumes were instructional manuals that indexed, defined, condensed, and explained the literature women were expected to command at tea table and salon.[6]

Polly Warner's library served several purposes. Perhaps most obvious, the material artifact testified to the family's membership in British America's elite. Bound in calf and stamped with "Miss Warner" on the boards, the volumes lining the library's shelves distinguished this daughter from the lower and middling sorts, as did the refinement they taught in manners, speech, and dress. The schooling they offered in gentility did considerable service as yet another marker of the social standing Warner and her family had achieved. Primers in the transatlantic discourse of sociability, they instructed her in polite letters, the stock in trade for the institutionalized practices of civility in British America.[7]

Despite the more advanced education that Jonathan and Mary Nelson Warner offered Polly, neither the parents nor the daughter could have anticipated the revolution in women's educational opportunities that began in the wake of the other Revolution with which we are more familiar. Those who called for an end to the long-standing tradition of "educational disadvantaging," as Gerda Lerner has described the practices that denied women access to learning for centuries, had notable success in building upon the sense of expansiveness generated by Revolutionary ideology. Insisting that learning was both an individual right and a social necessity, they participated in the design of a female ideal, who displayed a variety of faces. A model with an ancestry dating back

to the earliest colonial settlements, she might resemble British America's sensible and industrious "good wife," whose most visible characteristic was devotion to her family's spiritual and secular needs. Alternatively, she might bear a closer resemblance to a variation on the "gentleman's companion," the gracious and refined lady who had made her initial appearance in the middle of the eighteenth century. Schooled in the worldly accomplishments of tea table and salon, she was a woman who distinguished herself in the arts of sociability. In varying proportions, all these attributes were visible in the persona of the republican wife who, as an essayist in *Boston Weekly Magazine* told readers, excelled "as a companion and a helper." And more, so far as moral authority was concerned, in wielding influence on a man's character, she was expected to play a political role of no little significance. Men's behavior, their "virtue and decorum," was said to depend on the "good sense, firmness, and delicacy of the fair sex," as another of post-Revolutionary America's weekly magazines declared. The republican wife might also wear the face of an equally influential mother. Taking on the additional responsibility for schooling sons and daughters in the tenets of virtue, she committed herself to preparing them for adult lives as informed and engaged citizens.[8]

The model that individual advocates of women's schooling chose to emphasize mattered less than the perspective they shared on intellectual equality and educational opportunity. Two letters, both written by highly accomplished women who had come to maturity in pre-Revolutionary America, illustrate the linked claims made by virtually everyone who took a stand on behalf of women's learning. The first of the letters was written by Pennsylvania Quaker and prolific poet Susanna Wright, who used the genre of the verse epistle to articulate the basic tenet of the English Enlightenment on both sides of the Atlantic. "Reason Govern, all the mighty frame," as she declared in a letter to close friend and fellow Quaker Eliza Norris. Despite the use of universalist language, those who elaborated on the implications of the English and American Enlightenments typically defined as masculine the "reason" celebrated by Wright and Norris. These women's resistance to a gendering of cognitive faculties that excluded them was manifest in the claim with which Wright completed her couplet—"And Reason rules, in every one, the same." In practicing their own form of universalist language, Wright and Norris may have presumed that all women's capacities were the "same,"

whatever their social standing or racial identification. But in the hierarchical context of Revolutionary America, only elite white women had the opportunity to cultivate their "reason." Practices of exclusion based on class and race meant that "every one" was actually every woman like themselves.[9]

Insisting that the only inherent distinction between women and men was bodily strength, women like Wright and Norris called for equal membership in the "Empire of reason," as Annis Boudinot Stockton, the author of the second letter, characterized the domain in which post-Revolutionary Americans constituted civil society. Herself a poet and a widely respected member of this "Empire," Stockton understood that in order for any woman to be a full-fledged participant she needed as thorough and rigorous an education as a man received. In the decades bridging the eighteenth and nineteenth centuries, newly established female academies began to provide women with that education. According to the husband of Julia Stockton Rush, the daughter of Boudinot Stockton and the recipient of her letter, women in America's republic required no less. Prominent physician, educational reformer, and founder with John Poor of the Young Ladies Academy, Benjamin Rush called for schooling that fitted the nation's women for enlarged responsibilities. Most notably, as he told the academy's students and their parents on July 28, 1787, they included "the instruction of children" and particularly the instruction of "sons in the principles of liberty and government." (In Rush's statement we can locate the origins for one of the oldest clichés in American political life. "It has been remarked," he himself remarked, "that there have been few great or good men who have not been blessed with wise and prudent mothers.") Rush noted as well the salutary influence of the republican wife. Husbands, in fulfilling the role of "the patriot—the hero—and the legislator, would find the sweetest reward of their toils, in the approbation and applause of their wives."[10]

Published simultaneously in Philadelphia and Boston, Benjamin Rush's widely circulated call for a more advanced female education exposed the compromise that was being struck in the decades immediately after the Revolution. Newly independent Americans attached the fulfillment of gendered social and political obligations to a woman's right to educational opportunity. No matter if women were acknowledged the intellectual equals of men, they were still denied the Enlightenment's

promise of self-actualization. Instead of using for themselves "the richest of earthly gifts," as one of the Academy's valedictorians characterized the knowledge the Enlightenment honored, they were expected to place their learning at the service of two families, the family they had constituted in taking husbands and bearing children and the family that had been constituted for them in the establishment of an independent United States.[11]

Some of Wright's and Stockton's contemporaries went beyond Rush's position to project a larger role for themselves in the second of these families, the nation, and its civic discourse. In keeping with the position he had taken, they acknowledged that a woman's responsibilities centered in the household, but, in a significant revision of republican womanhood, they insisted that the reach of female influence be extended to men and women other than the members of one's immediate family. The philosophers of the Scottish Enlightenment offered them an expansive model of gender relations. Although this Enlightenment's philosophers expected both sexes to cultivate the "affections," or the "sympathies," luminaries Lord Kames and David Hume looked to women to refine and reinforce male manners and morals. Once considered only men's subordinates, women were now seen as their "faithful friends and agreeable companions," according to Kames's *Six Sketches on the History of Man*, which was published in an abridged version in Philadelphia in 1776. In characterizing the relationship between women and men who participated in institutions of sociability, David Humes's "Of Refinement in the Arts" made the point succinctly. "Both sexes," he told readers in 1742, "meet in an easy and sociable manner, and the tempers of men, as well as their behaviors, refine apace." Using Kames and Hume for explicitly gendered ends, members of the post-Revolutionary elite validated the increasingly visible role they were playing in civil society.[12]

The sites at which members of the post-Revolutionary elite chose to practice this more expansive influence were the female-centered institutions of tea table and salon, both of which they inscribed with explicitly political purpose. These institutions of sociability had been established in colonial cities and towns from Boston to Charleston. Participants in salons, literary clubs, assemblies, and tea tables, sites at which the provincial elite engaged in polite conversation and in performance of belles lettres, practiced a conversational ideal of reciprocal exchange. In

linking themselves to their British counterparts, members of the elite partook in a transatlantic culture of sociability that was grounded in shared affections, genteel manners, and social pleasures. Revolution and republic, transformation in material and ideological context all led a post-Revolutionary and early republican elite to elaborate on these premises and practices. They more definitively yoked civility to the Enlightenment ideal of unfettered pursuit of knowledge. They conditioned the sympathetic identification cultivated by their colonial predecessors with a greater emphasis on rational reflection. And they sought to temper displays of aristocratic elegance by invoking the need for republican simplicity. Most notably, female members of this elite enacted a model of behavior that empowered them in relation to men. Naming themselves the superintendents of manners and morals, they instructed their male counterparts in republican virtue, the discursive and behavioral mode required for citizenship in a newly independent America. Presiding at these institutions of sociability, elite women validated claims to intellectual equality and educational opportunity that the Wrights and the Stocktons had voiced a generation earlier. And they did much more. In the production of public opinion, they signaled the opportunity for a fundamental change in a system of gender relations inherited from British America.[13]

Female Academies Are Everywhere Establishing

In the decades between the American Revolution and the Civil War, hundreds of newly established female academies and seminaries introduced women to the subjects that constituted post-Revolutionary and antebellum higher education, teaching them natural sciences, rhetoric, history, logic, geography, mathematics, ethics, and belles lettres. Latin and to a lesser extent Greek were also taught at these schools. In the decades immediately after the Revolution, the instruction Elizabeth Sewall received at a female academy in Concord, New Hampshire, was typical—"grammar, geography, writing and reading," as she told her father in 1805. Increasingly, however, Sewall's experience was the exception. Beginning in the third decade of the nineteenth century, female academies and seminaries installed a course of study more akin to the schooling at Sarah Pierce's Female Academy in Litchfield, Connecticut.

When Sarah Pierce opened the doors of her academy in 1792, she had offered students the same course of study as the school Sewall attended. (There was one exception: from the academy's founding, Pierce included history, a subject on which she published the four-volume *Universal History*.) After Pierce's nephew John Brace began teaching at the school in 1814, she and Brace designed a curriculum based on the subjects then being taught at the male colleges. They expected Litchfield's students to command mathematics, moral philosophy, logic, the natural sciences, and Latin. Assigned the same texts as Brace had read as a student at Williams College, young women instructed themselves in William Paley's *Principles of Moral and Political Philosophy*, Hugh Blair's *Lectures on Rhetoric*, and Archibald Alison's *Essays on the Nature and Principles of Taste*. Pierce's curriculum was gendered in one telling respect. Inaugurating a tradition that teachers and students subsequently practiced at many of these schools, the woman who identified with British luminaries Hannah More, Maria Edgeworth, and Hester Chapone invited her students to read books by and about learned women. Women for whom the exercise of intellect was a daily practice, the Mores, the Edgeworths, and the Chapones became the exemplars upon whom students were expected to model themselves.[14]

In a letter written to her cousin in 1819, Maria Campbell of Virginia spoke to the difference the presence of these schools made in women's lives. "In the days of our forefathers," she reminded Mary Humes, then a student at the acclaimed Salem Academy of Salem, North Carolina, "it was considered only necessary to learn a female to read the Bible." Salem made Humes a reader of many books. In the process, she made herself a learned woman. Schools such as Salem had a profound impact on the nation's women, in terms of both the number of students they educated and the role they played in shaping the trajectory of their subsequent lives. Comparisons of the numbers of students enrolled in female academies and seminaries show that relative to the male colleges, these schools were educating at least as many students in early nineteenth-century America. The fact that approximately the same number of women and men were enrolled in institutions of higher learning is striking in its own right. It also provides the key to understanding why many women educated at these academies and seminaries pressed the boundaries that limited a woman's engagement with the world beyond her household.

Claiming membership in post-Revolutionary and antebellum civil so-
ciety, women educated at these schools exercised rights and obligations
of citizenship previously thought to be beyond their domain. In their
communities, regions, and nation, they were becoming makers of public
opinion.[15]

In the decades between 1790 and 1830, the exclusively female schools
that offered more than the reading, writing, and ciphering taught in the
common schools almost always called themselves academies. Despite
the diversity in the course of study at these schools, they shared basic
patterns in curricular organization and scholastic requirements. Nearly
all of the academies established between 1790 and 1820 instructed stu-
dents in reading, grammar, writing, history, arithmetic, and geography.
Some also taught rhetoric. The transition to a more advanced course of
study that matched the offerings of the male colleges occurred in the
1820s. Academies began to offer the natural philosophy, chemistry, al-
gebra, botany, astronomy, and Latin that Sarah Pierce had been requir-
ing since 1814. Circulars and catalogues of already existing and newly
founded academies scattered across the United States included these
courses. At Lafayette Female Academy in Lexington, Kentucky, students
were taking all of these subjects as early as 1821. Their counterparts at
First Female School in Portsmouth, New Hampshire, pursued a similar
course of study, as did the students at Elizabeth Academy in Washing-
ton, Mississippi, at Boston's Mount Vernon Female School, and at the
Female Academy in Albany, New York. Additional offerings in logic
were highlighted in the catalogues for the schools in Boston and Ports-
mouth. Moral philosophy was taught at Elizabeth Academy. In addition
to the Latin taught at Mount Vernon, Greek, Hebrew, and French were
included as electives. Teachers and principals at academies also began
to introduce a ranked course of study that was divided into collegiate
and preparatory departments. The latter were designed as the adjective
indicated—to prepare students for more advanced studies. Beginning
in 1831, students enrolled in Preparatory Class in Knoxville, Tennessee,
took the courses in the reading, writing, ciphering, geography, and his-
tory in which their predecessors had been schooled at the early acade-
mies. They then proceeded to a three-year course of study that included
natural philosophy, rhetoric, chemistry, history, astronomy, logic, and
moral philosophy. Latin and Greek were included as electives that could

be taken in the last two years at the academy. The departmental organization that Knoxville's Female Academy adopted was being installed at schools throughout the country in the 1820s and 1830s, and by the 1840s had become the established pattern. In addition to the academies, Emma Willard's Troy Female Seminary, Catharine Beecher's Hartford Female Seminary, and Zilpah Grant's Ipswich Female Seminary, all of which were designed to instruct students in a course of study that paralleled those at the male colleges, opened their doors in 1821, 1823, and 1828, respectively.[16]

The linkages that principals and teachers at these schools began to forge in the 1820s accelerated the development of local, regional, and national networks. A nationally uniform curriculum was perhaps the most visible result of these collaborations. The founding of still more schools and the replication of teaching strategies were equally important institutional outcomes. In terms of the subjectivity students themselves were fashioning, principals and teachers who constituted these networks made decisive contributions. In classrooms across the nation, they privileged intellectual achievement, propagated knowledge in the arts and sciences, and instilled perspectives that promoted engagement in civil society. The impact of Emma Willard is telling in this regard. A survey of 3,500 of the 12,000 students who attended Troy Female Seminary in the five decades after Willard founded the school in 1821 showed that approximately 40 percent of these students committed themselves to teaching. Nearly 150 of them either founded or administered a school. Together they established a network of schools modeled on the "Troy idea" in Ohio, Maryland, New York, Indiana, South Carolina, Georgia, and Alabama.[17]

Sources such as student-initiated publications, cumulative examinations, and commencement addresses document not only the range of subjects students commanded, but also the subjectivity they were fashioning as learned women appareled in the values and vocabularies of republican citizenship. Prospective graduates demonstrated "Projection of Eclipses" at the Female Classical Seminary in Brookfield, Massachusetts; recited from Susannah Rowson's Present for Young Ladies at the academy the author had founded; delivered orations on "True Greatness Not Conferred by Station" at Brooklyn's Female Academy; read compositions on "True Sensibility—Its Effects on Female Character" at Fe-

male College in Yorkville, South Carolina; and advocated for "Woman's Influence" at the Female College in Harrisburg, Pennsylvania. Decades after Harriet Beecher Stowe had graduated from Sarah Pierce's Litchfield Female Academy, Charles Edward Stowe recalled the steps his mother had taken to save a composition she had presented at one of the school's exhibitions. The essay had been "carefully preserved," and as he noted, "on the old yellow sheets the cramped childish hand-writing is still distinctly legible." In tucking away the composition and taking it with her as she moved from Litchfield to Hartford to Cincinnati to Brunswick to Andover and finally back to Hartford, Stowe testified to the importance this exposition of learning had meant to her.[18]

Performances such as Stowe's played an important role in shaping the subjectivity of students at female academies and seminaries. In the latter regard, Emily Dickinson can be seen as the exception who proves the rule. The poet, who would later refuse to appear in public under any circumstances, "dread[ed] that time for an examination in Mt. Hol. Sem." The interrogation at Mount Holyoke Seminary was "rather more public than in our old academy and a failure would be more disgraceful," as Dickinson reported to Abiah Root. We know Dickinson fervently hoped that "that I shall not disgrace myself." Unfortunately, we do not know how she actually performed in what may well have been her first and last appearance before the public. One of Eliza Adams's former classmates at a seminary in Concord, New Hampshire, felt the same sense of dread, at least initially. As she reported in August 1829, her "limbs and voice trembled so much at the first, that I was obliged to take my seat." Then, however, she had risen to the occasion. What she recalled as a "want of confidence" had been overcome. And, as she proudly told Adams, she had acted as a "rational being." In sharp contrast, Mary Beall, a student at Greensboro Female College in Greensboro, North Carolina, was entirely self-possessed. Telling her brother, who was enrolled at the University of North Carolina, "there seems to be a universal ambition existing among the girls in College to receive first honors at the commencement," Beall acknowledged that she was one of those girls. With an anticipation that bespoke her confidence, Beall declared, "I am going to try mighty hard to get first honor." (She admonished him to enter the lists, saying "you must too.") Dickinson, Adams, and Beall embraced the intellectual achievement embodied in these performances. It

was the public dimension that elicited the varied responses. All of them understood that standing and speaking before the public represented a challenge to conventional models of womanhood, which designated the household the only site at which women performed the responsibilities of citizenship. In 1829, Adams's friend felt fully the force of the prescription. However, and what proved to be crucial, she was still more drawn to the subjectivity she had been crafting during her years as a student. She now experienced herself as a "rational being." Hesitant to the point of trembling before the challenge she was mounting to feminine conventions, Adams's friend at the last moment was able to bring that subjectivity to the fore. She stood and spoke. Twenty years and a generation of students later, the prescriptive force had lessened. Beall and her classmates anticipated the performance of intellectual achievement with an eagerness that would have astonished Adams. The difference between Adams's friend and Beall can also be reckoned in the role the latter played in encouraging those who might be intimidated by standing and speaking. In 1849, it was not classmates who seemed to need her support. Perhaps her brother did not require it either. But if he did, Beall was ready to rally him.[19]

During their years at female academies and seminaries, students displayed the knowledge they were acquiring in still other appearances before the public. Essays, dialogues, poems, homilies, songs, and tales they had written were published in local and regional newspapers, in broadsides and pamphlets issued by academies and seminaries, and in student-initiated newspapers and magazines. Many of these publications, lapsing with the graduation of editors and contributors, lasted for only a year or two, but others soon replaced them as succeeding generations made their way into print. Examples are numerous, including the *Star of Literature* at Dickinson Seminary, the *Schoolgirl's Offering* at Poughkeepsie Female Academy, the *Young Ladies Magazine* at Patapsco Female Institute, the *Female Student* at Louisville Female College, and the *Forest City Gem* at Cleveland Female Academy. At Miss Porter's School, students published in succession the *Budget* and the *Revolver*. The affiliations with alumnae manifested a material benefit in the magazines they sponsored. The *Messenger-Bird* at Brooklyn Female Academy was published by the school's graduates, as was the *Monthly Rose*, a magazine issued jointly by alumnae and students at Albany Fe-

male Academy. The *Monthly Rose* was one of three imprints generated by Albany's notably expansive publishers. Students also issued the *Planetarium*, a weekly newspaper, and graduates sponsored the *Exercises of the Alumnae*, an annual publication of prose and poetry.[20]

The intensity with which students pursued knowledge and the pride they took in their achievements testified to the significance they attached to newly available educational opportunities. That intensity, that pride were manifest in the readiness with which they embraced the books and learning that had been the preserve of men. And yet the role articulated by the likes of Benjamin Rush placed limits on what women ought to do with their well-stocked minds. Might graduates of female academies and seminaries refuse the post-Revolutionary compromise that had made the right to educational opportunity contingent upon the fulfillment of gendered obligations? Might they insist on the exclusive pursuit of self-actualization? Whether they did or not, and with few exceptions they did not, any woman who commanded the same learning as a college-educated male risked the label "bluestocking." It was said that bluestockings were ostentatious. They were conceited pedants. They were heartless blues. Virginia lawyer and U.S. attorney general William Wirt captured the essential feature of all that was lurking in these caricatures. "The ostentatious display of intellect in a young lady is revolting," as he told three of his daughters in 1829.[21]

How, then, might women educated at these schools negotiate the tension between the gender-neutral ideals that informed their education and the gender-specific roles they were expected to emulate? In counseling his granddaughter, Florida planter Marcus Stephens limned a model that replicated the self-representation elite women had been performing since the last decades of the eighteenth century. Ostensibly, Stephens was simply taking the measure of Mary Ann Primrose's education at the Burwell School in Hillsborough, North Carolina. He did that and much more in a narrative that illuminated the promise and the problematic inherent in a woman's education. Although he acknowledged that Primrose's schooling should include music, drawing, and French, Stephens stressed "the higher branches of education." Immerse yourself in "History, Geography, and some of the best Ethical writers," he told her. Focusing on these subjects would set Primrose apart from young women, who, after displaying their social accomplishments, "retire to

their seats and sit mumchanced until some dandy of a beau sidles up to them." In dedicating herself to academic studies, in adding to her "stock of ideas," Primrose would be able to talk about more than the "last ball or some such frivolities." She would have at her command the learning required "to take part in a rational conversation." Any student at an antebellum academy or seminary would have been familiar with the relative value Stephens ascribed to ornamental and academic instruction. She would have been equally familiar with the underlying premises that shaped his perspective on women's intellectual potential. Insisting that the minds of women and men were equal, that hers was "equally vigorous as his," Stephens nonetheless cautioned Primrose to defer to her male counterparts. Should she act as a man's equal, she would be "instantly denounced as a bas bleu or blue stocking." It mattered little that the censure had no basis other than a lingering prejudice against women who openly displayed the learning men had long claimed as their privilege. In French or English, the label "blue" had to be avoided. Primrose should disguise her learning in conventions of gendered deference and decorum, or as her grandfather cautioned her, she should use her knowledge "with prudence and discretion."[22]

The Privilege of Reading

The women who attended academies and seminaries were schooled by teachers who placed an almost equal value on the reading students did informally as on the instruction they offered in classrooms. Those who had been introduced to the world of reading by their parents found that world expanded and their habits of reading reinforced during their years as students. Others were welcomed into the world of reading. Whichever their situation, these learned women in the making were instructed by teachers who privileged books. "We learn by example," New Hampton Female Seminary's Sarah Sleeper declared in the opening sentence of a memoir honoring Martha Hazeltine, the woman who had taught her at the Seminary Sleeper now headed. The testimonial was more than rhetorical. Many students at academies and seminaries shared in Sleeper's formative experience—interacting with and adopting as a personal ideal a teacher who had already made books the vehicle for pursuing knowledge. Sarah Porter, the founder of Miss

Porter's School in Farmington, Connecticut, was one such teacher. A woman who looked to books as "fountains of knowledge," Porter integrated reading into the rhythm of daily life, spending a morning with Euripides's *Alcestis*, turning a few days later to Hildreth's *History of the United States*, setting aside an hour here and there for Wordsworth's *Excursion*, and devoting an afternoon to Novalis's *Journal*. Porter spent evenings reading to students, introducing them to James Hamilton, Harriet Beecher Stowe, and Susan Warner. She stocked her school's library with recently published history, biography, and fiction. "Reading," as one M. S. R. titled a composition she wrote while enrolled at the school, was an imperative for Sarah Porter. Already instructed by Porter in the tenet nineteenth-century Americans had inherited from colonial readers of the Tatler, M. S. R. opened her composition with a paraphrase from Richard Steele's Isaac Bickerstaff—"reading is to the mind what exercise is to the body as it is strengthened and invigorated by it," as Bickerstaff had told readers nearly 150 years earlier. M. S. R. was hardly alone in rifling the pages of the *Tatler*. Students at other academies and seminaries did the same. Recording maxims such as Steele's in journals, in compositions, and in debates of literary societies, they testified to the persistence of reading in polite letters. M. S. R. and her counterparts had been taught the corollary maxim—reading was more than a matter of matching mental to physical fitness. Books, as Porter's student had learned, were endowed with the same foundational purpose as they had served in colonial America—"improving their morals or regulating their conduct."[23]

In giving books to reward accomplishments, in sharing personal libraries, in sponsoring literary societies, and in using reading to strengthen bonds with students, the Sarah Porters of female schooling engaged in a host of practices that defined reading as a *woman's* enterprise. Like other teachers in post-Revolutionary America, Jane Barnham Marks rewarded excellence with tokens of achievement. Some instructors presented students with elaborately inscribed certificates. Others gave them autograph albums. Marks, a teacher at the South Carolina Female Collegiate Institute, chose Priscilla Wakefield's aptly titled *Mental Improvement* as a gift for one of her students, Harriet Hayne. Years after she had been given the book in 1821, Hayne, following Marks's precedent, presented the volume to her sister Sarah, who carefully inscribed

her name on the title page. Bessie Lacy reversed this pattern, giving the *Personal Recollections* of English author Charlotte Elizabeth Tonna to her most valued teacher at Greensboro's Edgeworth Seminary. Describing the gift as a "testimonial of gratitude" in a letter written in 1848, Lacy told her father why a book was appropriate and Julia St. John an equally appropriate recipient. At St. John's invitation, teacher and student had spent their evenings reading together. Lacy informed her father that St. John had been "highly gratified and surprised—said she would prize it as a gift from Bessie and also as completing the set of Charlotte Elizabeth's works." In Lacy's selection of Tonna's *Recollections* and in St. John's response, the attachment to reading was manifest, as was the identification with an exemplar of female learning who was widely read on both sides of the Atlantic.[24]

Six years after the school had been founded, Priscilla Mason, a student at one of the post-Revolutionary America's earliest academies, rose to the podium. The setting was Philadelphia's Young Ladies' Academy, the speaker was the class salutatorian, and the date was 1793. Mason's address seemed conventional, at least at the outset. Opening with a formulaic expression of gratitude to teachers and trustees, Mason proceeded with an equally formulaic declaration of self-effacement. She was "female," she was "young," she was "inexperienced," and more—on that day in May 1793 she was addressing a "promiscuous" assembly, as early nineteenth-century Americans labeled audiences composed of both men and women. What could she do but commence with an apology, as indeed she did before her radical departure from the typical address on female learning for any late eighteenth-century American, much less one who was female, young, and inexperienced. Claiming the public role that males reserved for themselves, the right to participate in the nation's legal and political life, Mason defined this opportunity not as a privilege, but as a basic human entitlement that had been denied women. "Our high and mighty Lords," as she described the party she held responsible, had "early seized the scepter and the sword; with these they gave laws to society; they denied women the advantage of a liberal education; [and] for[bade] them to exercise their talents on those great occasions, which would serve to improve them." Denunciations of the past were joined with declarations about a more auspicious present in which the promise of liberal learning might be fulfilled. "Happily," Mason told her listen-

ers, "the sources of knowledge are gradually opening to our sex." These altered circumstances had not yet erased the boundaries separating the private and public, and as she said pointedly, "the Church, the Bar, and the Senate are shut against us." Men still presented an obstacle to women's religious, legal, and political empowerment. But if Mason thought men were intractable, she was confident women could overcome their opposition and take for themselves the schooling that was their due. Speaking directly to her fellow students, Mason offered them a challenge enveloped in a promise: "Let us by suitable education, qualify ourselves for those high departments—they will open before us." Speaking at a moment when post-Revolutionary Americans were debating if and how women should be involved in public life, Priscilla Mason gestured to the future. She was prescient.[25]

NOTES

1. Judith Sargent Murray [Constantia], *The Gleaner*, 3 vols. (Boston: I. Thomas and E.T. Andrews, 1798), 3:188–89. Portions of this essay have been adapted from *Learning to Stand and Speak: Women, Education, and Public Life in America's Republic* (Chapel Hill: University of North Carolina Press, 2006).

2. Some scholars have addressed post-Revolutionary perspectives on women's intellectual potential and their claims for more advanced education. See Linda K. Kerber, *Women of the Republic: Intellect and Ideology in Revolutionary America* (Chapel Hill: University of North Carolina Press, 1980); and Mary Beth Norton, *Liberty's Daughters: The Revolutionary Experience of American Women, 1750–1800* (Boston: Little, Brown, 1980). On the significance of female academies and seminaries, see Kelley, *Learning to Stand and Speak*.

3. Sarah Pierce, "Address at the Close of School, October 29, 1818," in *Chronicles of a Pioneer School from 1792–1833, Being a History of Sarah Pierce and Her Litchfield School*, ed. Elizabeth C. Barney Buell, comp. Emily Noyes Vanderpoel (Cambridge, Mass., 1903), 177. Whether female or male, academies received little consideration until the appearance of Harriet Webster Marr, *The Old New England Academies Founded before 1826* (New York: Comet Press Books, 1959); Robert Middlekauff, *Ancients and Axioms: Secondary Education in Eighteenth-Century New England* (New Haven: Yale University Press, 1963); and Theodore R. Sizer, *The Age of the Academies* (New York: Teachers College Press, 1964). On selected female academies and seminaries, see Anne Firor Scott, "The Ever Widening Circle: The Diffusion of Feminist Values from the Troy Female Seminary, 1822–72," *History of Education Quarterly* 29 (1979): 3–25; Lynne Templeton Brickley, "Sarah Pierce's Litchfield Female Academy, 1792–1833" (Ed.D. diss., Harvard Graduate School of Education, 1985); Margaret A. Nash, "'A Salutary Rivalry': The Growth of Higher Education for Women in Oxford, Ohio,

1855–1867," in *The American College in the Nineteenth Century*, ed. Roger Geiger (Nashville: Vanderbilt University Press, 2000), 169–82.

4. The current scholarship on early schooling in colonial America, which addresses women's education only tangentially, includes Lawrence A. Cremin, *American Education: The Colonial Experience, 1607–1783* (New York: Harper & Row, 1970); Richard Gerry Durnin, "New England's Eighteenth-Century Incorporated Academies: Their Origin and Development to 1850" (Ed.D. diss., University of Pennsylvania, 1968); and Middlekauff, *Ancients and Axioms*. Published more than a half century ago and still the most informative sources are Thomas Woody, *A History of Women's Education in the United States*, 2 vols. (New York: Science Press, 1929); and Julia Cherry Spruill, *Women's Life and Work in the Southern Colonies* (Chapel Hill: University of North Carolina Press, 1938). On the literacies of reading and writing, see E. Jennifer Monaghan, "Literacy Instruction and Gender in Colonial New England," in *Reading in America: Literature and Social History*, ed. Cathy N. Davidson (Baltimore: Johns Hopkins University Press, 1989), 53–80; Monaghan, "Reading for the Enslaved, Writing for the Free: Reflections on Liberty and Literacy," *American Antiquarian Society, Proceedings* 108 (1998): esp. 311–15; Monaghan, *Learning to Read and Write in Colonial America* (Amherst: University of Massachusetts Press, 2005); Gloria Main, "An Inquiry into When and Why Women Learned to Write in Colonial New England," *Journal of Social History* 24 (1990–91): 579–89; Edward E. Gordon and Elaine H. Gordon, *Literacy in America: Historic Journey and Contemporary Solutions* (Westport, Conn.: Praeger, 2003), esp. 3–78.

5. Polly Warner's library, which has been preserved by the Portsmouth Historic House Association, is housed at the Warner House in Portsmouth, N.H. I am indebted to the staff at the Warner House for permission to do research in the collection. See also Richard L. Bushman, *The Refinement of America: Persons, Houses, Cities* (New York: Knopf, 1992), esp. 31–60; Pierre Bourdieu, "The Forms of Capital," in *Handbook of Theory and Research for the Sociology of Education*, ed. John Richardson (New York: Greenwood, 1986), 241–58.

6. William Darrell, *The Gentleman Instructed in the Conduct of a Virtuous and Happy Life. Written for the Instruction of a Young Nobleman. To Which Is Added, A Word to the Ladies*, 2 vols., 12th ed. (London: Printed for R. Ware, 1755), 1:172.

7. As David S. Shields has reminded us, the practice of polite letters was born not in eighteenth-century print, but in the conversations of coffeehouse and club, tea table and salon. See Shields, "Eighteenth-Century Literary Culture," in *The Colonial Book in the Atlantic World*, vol. 1 of A History of the Book in America, ed. Hugh Armory and David D. Hall (Cambridge: Cambridge University Press, 2000), 434–76; Shields, "British-American Belles Lettres," in *The Cambridge History of American Literature*, 2 vols., ed. Sacvan Bercovitch (Cambridge: Cambridge University Press, 1994), 1:310–41.

8. Gerda Lerner, *The Creation of Feminist Consciousness: From the Middle Ages to 1870* (New York: Oxford University Press, 1993), esp. 21–45, 192–219; *Boston*

Weekly Magazine, December 29, 1804, 37; "Outlines of a Plan of the Intelligent
and the Candid," *Boston Weekly Magazine*, August 4, 1798 (also printed in *Lady's
Magazine* [New York], March 1802, 165). See Linda Kerber, "The Republican
Mother: Women and the Enlightenment—An American Perspective," *American
Quarterly* 28 (1976): 187–205; Jan Lewis, "The Republican Wife: Virtue and
Seduction in the Early Republic," *William and Mary Quarterly*, 3rd series, 44
(1987): 689–721; Ruth H. Bloch, "American Feminine Ideals in Transition: The
Rise of the Moral Mother, 1785–1815," *Feminist Studies* 4, no. 2 (June 1978): esp.
101–13; Kerber, *Women of the Republic*, 269–288; Margaret A. Nash, "Rethinking
Republican Motherhood: Benjamin Rush and the Young Ladies' Academy of
Philadelphia," *Journal of the Early Republic* 17 (1997): 171–91. On the masculine
counterpart to republican motherhood, see Thomas A. Foster, ed., *New Men:
Manliness in Early America* (New York: New York University Press, 2011); Philip
J. Deloria, *Playing Indian* (New Haven: Yale University Press, 1998), esp. 1–70;
Carroll Smith-Rosenberg, "Surrogate Americans: Masculinity, Masquerade, and
the Formation of a National Identity," *Publications of the Modern Language
Association of America* 119 (2004): 1325–35. On white women's complicity in
practices of racial prejudice, see Pauline Schloesser, *The Fair Sex: White Women
and Racial Patriarchy in the Early American Republic* (New York: New York
University Press, 2002), esp. 1–11, 53–79.

9. "To Eliza Norris," undated verse epistle, Hannah Griffitts Manuscript Collection,
Library Company of Philadelphia. See Catherine La Courreye Blecki and Karin A.
Wulf, eds., *Milcah Martha Moore's Book: A Commonplace Book from
Revolutionary America* (University Park: Pennsylvania State University Press,
1997); Karin A. Wulf, *Not All Wives: Women of Colonial Philadelphia* (Ithaca, N.Y.:
Cornell University Press, 2000), esp. 53–84; Susan M. Stabile, *Memory's Daughters:
The Material Culture of Remembrance in Eighteenth-Century America* (Ithaca,
N.Y.: Cornell University Press, 2004), esp. 45–65.

10. Annis Boudinot Stockton to Julia Stockton Rush, March 22 [1790s], Rosenbach
Museum and Library, Philadelphia; Benjamin Rush, *Thoughts upon Female
Education* . . . (Boston, 1787), 5, 6, 19, 20. Rush's essay was also included in the
American Lady's Preceptor, a collection of essays, poetry, and historical sketches
published in Baltimore in 1810.

11. "The Valedictory Oration, Delivered by Miss Laskey," in *The Rise and Progress of
the Young-Ladies' Academy of Philadelphia* (Philadelphia, 1794), 100. In a shrewdly
argued essay on "obligation," Linda K. Kerber has highlighted distinctions in the
positions occupied by women and men in relation to the state; according to
Kerber, and other political theorists whom she cites, men are situated as free
agents, whereas women enter the social contract already encumbered by marriage
and by antecedent responsibilities to their husbands (Kerber, "Obligation," in *A
Companion to American Thought*, ed. Richard Wightman Fox and James T.
Kloppenberg [Cambridge, Mass.: Blackwell, 1995], 503–6). Rosemarie Zagarri has
shown that applying Enlightenment premises to women resulted in an emphasis

on duties and obligations rather than personal liberties and autonomy; see
Zagarri, "The Rights of Man and Woman in Post-Revolutionary America,"
William and Mary Quarterly, 3rd series, 55 (1998): 203–30.

12. David Hume, "Of Refinement in the Arts," in *Essays: Moral, Political, and
Literary*, ed. Eugene F. Miller (Indianapolis: Liberty Fund, 1987), 271; Henry
Home, Lord [Kames], *Six Sketches on the History of Man* . . . (Philadelphia, 1776),
220. See Ruth H. Bloch, "The Gendered Meanings of Virtue in Revolutionary
America," *Signs: Journal of Women in Culture and Society* 13 (1987): 37–58;
Rosemarie Zagarri, "Morals, Manners, and the Republican Mother," *American
Quarterly* 44 (1992): 192–215; Elizabeth Barnes, *States of Sympathy: Seduction and
Democracy in the American Novel* (New York: Columbia University Press, 1997),
esp. 1–18; Julia A. Stern, *The Plight of Feeling: Sympathy and Dissent in the Early
American Novel* (Chicago: University of Chicago Press, 1997), esp. 1–29; David
Waldstreicher, *In the Midst of Perpetual Fetes: The Making of American
Nationalism, 1776–1820* (Chapel Hill: University of North Carolina Press, 1997),
67–85; Mary Catherine Moran, "'The Commerce of the Sexes': Gender and the
Social Sphere in Scottish Enlightenment Accounts of Civil Society," in *Paradoxes
of Civil Society: New Perspectives on Modern German and British History*, ed.
Frank Trentmann (New York: Berghahn, 2000), 61–84; Fredrika J. Teute, "The
Uses of Writing in Margaret Bayard Smith's New Nation," in *The Cambridge
Companion to Nineteenth-Century American Women's Writing*, ed. Dale M. Bauer
and Philip Gould (Cambridge: Cambridge University Press, 2001), 203–20; Caleb
Crain, *American Sympathy: Men, Friendship, and Literature in the New Nation*
(New Haven: Yale University Press, 2001), 1–15; Sarah Knott, "Sensibility and
Selfhood in Revolutionary America" (lecture, University of Michigan, March
2004).

13. David S. Shields, *Civil Tongues and Polite Letters in British America* (Chapel Hill:
University of North Carolina Press, 1997); Shields, "British-American Belles
Lettres," 1:307–43; Lawrence E. Klein, "Gender, Conversation, and the Public
Sphere in Early Eighteenth-Century England," in *Textuality and Sexuality:
Reading Theories and Practices*, ed. Judith Still and Michael Worton (Manchester:
Manchester University Press, 1993), 100–115; Susan Stabile, "Salons and Power in
the Era of Revolution: From Literary Coteries to Epistolary Enlightenment," in
Benjamin Franklin and Women, ed. Larry E. Tise (University Park: Pennsylvania
State University Press, 2000), 129–48. For the post-Revolutionary decades, see
David S. Shields and Fredrika J. Teute, "The Republican Court and the
Historiography of a Woman's Domain in the Public Sphere" (paper, Society for
Historians of the Early American Republic, Boston, July 1994).

14. Schools and Academies Collection, American Antiquarian Society, Worcester,
Mass.; Elizabeth Sewall to Storrer Sewall, September 8, 1805, York Maine
Collection no. 228, Old York Historical Society, York, Maine; Brickley, "Sarah
Pierce's Litchfield Female Academy," esp. 192–309. An earlier version of the
argument presented here is in Mary Kelley, "Petitioning with the Left Hand:

Educating Women in Benjamin Franklin's America," in Tise, *Benjamin Franklin and Women*, 83–101.

15. Maria Campbell to Mary Humes, September 21, 1819, Campbell Family Papers, Rare Book, Manuscript, and Special Collections Library, Duke University, Durham, N.C. Wellesley College, which was chartered as a seminary in 1870, was renamed in 1873. Antioch College and the University of Iowa began to admit women in 1852 and 1856, respectively. We would do well to observe Anne Firor Scott's caution about defining the content and character of higher education in pre–Civil War America: "The quality or difficulty of a curriculum was not necessarily revealed by the label placed upon it, and a wide variety of institutions were engaged in providing some part of what would eventually come to be defined as a collegiate education" (Scott, "Ever Widening Circle," 3, 7, 22n10). Linda Eisenmann has made a similar point, noting that higher education was "a flexible nineteenth-century concept." Many in early nineteenth-century America used the term "seminary" as a designation for all institutions of higher education, including male colleges. See Eisenmann, "Reconsidering a Classic: Assessing the History of Women's Higher Education a Dozen Years after Barbara Solomon," *Harvard Educational Review* 47 (1997): 697.

16. Catalogue, Lafayette Female Academy, 1821; Broadside, First Female School, 1829; Circular, Mount Vernon School, Statement of the Course of Study and Instruction, 1830; Circular, Albany Female Academy, 1821; Knoxville Female Academy, 1831, Schools and Academies Collection (American Antiquarian Society, Worcester, Mass.); Petitions to the State Legislature, 1823, Mississippi State Archives, Jackson. The post-Revolutionary female and coeducational academies are the subject of Kim Tolley's "'A Triumph of Reason': Female Education in Academies in the Early Republic," in *Chartered Schools: Two Hundred Years of Independent Academies in the United States, 1727–1925*, ed. Nancy Beadie and Kim Tolley (London: Routledge Falmer, 2002), 64–86.

17. Scott, "Ever Widening Circle."

18. Catalogue, Brookfield, Massachusetts' Female Classical Seminary [1827]; Circular, Brooklyn Female Academy, 1851; Catalogue, Yorkville Female College, 1851; Annual Commencement, Pennsylvania Female College at Harrisburg, Pa., July 10, 1855, Schools and Academies Collection (American Antiquarian Society, Worcester, Mass.); Susanna Rowson, *A Present for Young Ladies: Containing Poems, Dialogues, Addresses, as Recited by the Pupils of Mrs. Rowson's Academy* (Boston: John West, 1811); Charles Edward Stowe, *Life of Harriet Beecher Stowe* (Boston: Houghton, Mifflin, 1889), 14–15.

19. Emily Dickinson to Abiah Root, January 17, 1838, in Thomas H. Johnson, ed., *The Letters of Emily Dickinson*, 3 vols. (Cambridge, Mass.: Harvard University Press, 1971), 1:60; Lucretia [?] to Eliza Adams, August 20, 1829, Manuscript Collections, Dartmouth College Special Collections, Hanover, N.H.; Mary [Beall] to [Robert Beall], November 20, 1849, Southern Historical Collection, University of North Carolina, Chapel Hill.

20. The evidence indicates that at least as many newspapers circulated in manuscript as in print, especially in the first few decades of the nineteenth century. The Hartford Female Seminary's "School Gazette," which is deposited at the Stowe-Day Foundation in Hartford, Conn., is one example.

21. William Wirt to Laura, Catherine, and Elizabeth G. Wirt, May 29, 1829, quoted in Anja Jabour, "'Grown Girls and Highly Cultivated': Female Education in an Antebellum Southern Family," *Journal of Southern History* 44 (February 1998): 61.

22. Marcus Cicero Stephens to Mary Ann Primrose, November 7, 1841, Marcus Cicero Stephens Letters, Southern Historical Collection, University of North Carolina, Chapel Hill. The label "bluestocking" was originally applied to Elizabeth Vesey, Elizabeth Montagu, and other members of circle, which began meeting regularly in London in the middle of the eighteenth century. Initially, bluestocking stood for a "philosophy" that spoke to women's need for the same intellectual stimulation in which learned men took pleasure. In a letter she wrote to one of the most illustrious members of the circle, Montagu addressed this matter directly. "Sensible and ingenious minds," she told Elizabeth Carter, "cannot subsist without a variety of rational entertainment." Montagu did not mark these "minds" as exclusively female, presuming instead that both women and men had similar needs. There was only one difference, as far as she was concerned—women had little opportunity for the intellectual stimulation that enlivened the minds of their male counterparts. Increasingly, as the circle became more established, the bluestocking took on the persona of a woman. They were the Hannah Mores, the Fanny Burneys, and the Hester Chapones, all members of a second generation who shared the aspirations of the founders of the circle. These were also the bluestockings that generations of teachers and students at America's academies and seminaries would recuperate as models for themselves. See Sylvia Harcstock Myer, *The Bluestocking Circle: Women, Friendship, and the Life of the Mind in Eighteenth-Century England* (Cambridge: Oxford University Press, 1990), esp. 7–12; Chauncey Brewster Tinker, *The Salon and English Letters: Chapters on the Interrelations of Literature and Society in the Age of Johnson* (New York: Macmillan, 1915), esp. 123–33; Nicole Pohl and Betty A. Schellenberg, eds., *Reconsidering the Bluestockings* (San Marino, Calif.: Huntington Library, 2003), esp. 1–19.

23. Sarah Sleeper, *Memoir of the Late Martha Hazeltine Smith* (Boston, 1848), 1; Diary of Sarah Porter, December 29, 1853; M. S. R., "Reading," in *Miss Porter's School: A History in Documents, 1847–1948*, 2 vols., ed. Louise Stevenson (Boston: Taylor & Francis, 1987), 1:43, 130–31. See also 40–43, 164, 166–68. The quotation from Isaac Bickerstaff that M. S. R. paraphrased is as follows: "Reading is to the mind what exercise is to the body, as by one, health is preserved, strengthened, by the other virtue which is the health of the mind is kept alive, strengthened and confirmed." See "The Lucubrations of Isaac Bickerstaff Esq.," *Tatler*, no. 147 (March 18, 1710).

24. Harriet Hayne's Mental Improvement is deposited in the South Carolina Female Collegiate Institute Collection, South Caroliniana Library, University of South Carolina, Columbia; Bessie Lacy to Drury Lacy, January 27, March 2, 1848, Drury Lacy Papers, Southern Historical Collection, University of North Carolina, Chapel Hill.

25. Priscilla Mason, "A Salutary Oration," in *The Rise and Progress of the Young-Ladies Academy of Philadelphia* (Philadelphia, 1794), 90, 92, 93.

AFTERWORD

Women in Early America

JENNIFER L. MORGAN

As the essays in this volume so fulsomely illustrate, we have eclipsed the recovery and recuperation that Carol Berkin rightly ascribes to the first wave of scholarship on women's history. The field's primary concern has moved from inserting women into a metahistory of the national project to understanding what new meaning is created by centering the lives of women—meaning that is located in the particular histories of women, but meaning that also exceeds those histories and offers us new ways in which to understand intersectional structures. It has become impossible to engage in the history of women without specifying both which women are the object of study as well as how their collective identities have been shaped by the structures of race, ethnicity, gender, class, and sexuality. This shift has resulted both from the cumulative impact of the increasing body of scholarship on women's lives and from the call—embedded in that scholarship—to widen the category of subjects who are the legitimate object of historical study. In other words, as scholars have mounted the argument that studies of the family and of women should occupy the same importance as those of economy and politics, they have produced work that legitimizes and demands critical engagement with intimacy, race, ethnicity, and environment even as it argues for a reconsideration of what, precisely, constitutes economies and polities. In this regard, the essays collected in this volume work on a number of different levels.

While traversing some very new ground, the essays also bring a new analytic frame to subjects that may, initially, feel familiar to the reader. As the field of women's history developed in relationship to second-wave feminist activism, areas of focus developed that continue to be important for historians of early America. For example, it is fitting that the

volume includes Dennis and Reis's essay on witchcraft. Traditionally at the heart of colonial American women's history, the study of witchcraft has long been at least one place where one could reasonably expect to find women's and girls' experience at the center. And yet here, as with so many of the volume's essays, we can see that the continued engagement with traditional subjects has yielded something new; we begin to understand that something fundamental has shifted. This is not only a story of a town gripped by hysteria that lashes out on vulnerable women and girls. Witchcraft tells us something about patriarchal power, but also about the racialized meanings of modernity and the primitive, about the history of Christianity, and about borderlands. Perhaps for some readers it always has opened up this vista of interpretive significance, but here the breadth of meaning is inescapable and reflects the new vistas opened up by scholarship that takes women and gender as its core analytic and interpretive frame.

While there are a range of essays exploring territory that we have come to associate with the field—witchcraft, elite women's religious and emotional lives, even the lives of female indentured servants—what they produce is actually a profound reconfiguration of the historical landscape. If there was a moment in time when once could blithely incorporate women's history as additive, it has fundamentally receded into our collective pasts. That it has done so was not inevitable. Scholars of race and gender occupied a space of deep-seated concern and reserve in the 1980s and 1990s, and were by no means sanguine that calls for intersectionality among feminist theorists of color would be taken up by women's historians. As a historian of enslaved women of African descent in the seventeenth- and eighteenth-century English Atlantic world, I had considerable concern that my place in women's history wasn't entirely legible. Instead, I found myself bandied about across the fields of women's history, African American history, and the history of the early Atlantic world—often in the unenviable position of being always singular. But the growth and influence of work like the articles collected here have made at least two things happen. It is rarely the case that a scholar of slavery proceeds without attending to gendered power and identity among the enslaved and slave owners, but of equal significance, it is rare that a study fails to engage the histories of race and racialized power and identity among white women. There are still inroads that need to be

made, particularly those that involve scrutinizing the gendered identities of early modern men, but there too we have seen significant change in the past three decades.

Reading through the collected essays one is struck, time and again, with the breadth of insights conveyed through the study of women's lives. Whether it is Doña Teresa's outrage at her confinement, or Catherine Byndloss's prerogative to enslave Betty and her daughters, the women we encounter in this volume are deeply embedded in the political economies in which they lived and their archival hauntings are crucial to tracing the complexities of those landscapes. It is this breadth that is this volume's most important contribution. For the essays collectively argue that the colonial landscape is always already a place in which women's presence was productive. Women produced crops and court cases, families and landscapes, military strengths and weaknesses, religious conflict and educational accord. To discount or delimit those lives is to fundamentally misunderstand the lived histories—political, cultural, social, and environmental—of the region.

These essays clearly suggest that women's history instantiates a structural realignment, for once you understand the impact (for example) of indigenous women's agrarian practices in the Ohio River Valley on the political and military histories in which they play such crucial roles, you cannot fail to recognize the impact of gendered silences in our archival practices or to ponder the myriad ways in which that archive must be revisited as we move forward. This newly configured archive is one in which Ona Judge's life takes center stage, and as her decisions unfold we come to understand something both about her and about George and Martha Washington. In this archive, we see that the constrictions on intimacy for indentured women in the seventeenth-century Chesapeake underpinned the rationality of nascent wage labor, and that the drive to extract meaning from these sources is one that we share with nineteenth-century women keen to press against the boundaries of the household. Ultimately all of these essays suggest that in the field of early American women's history we can observe the consequences of layered scholarship on subjects who have historically been omitted from the nation's archives. In unearthing their lives we are given glimpses into the range of women's lived experiences, but even further we are able to more completely approximate the complicated terrain of early America.

The field of women's history has certainly undergone a sea change. The foundational studies upon which these essays rest were ground-breaking but were also bound by the unexamined assumptions embedded in "woman's" universalist pretensions. Histories of particular women's lives—white, educated, heterosexual, and free—were cast as histories of Women's lives, and the field of women's history suffered accordingly. But the importance of their interventions isn't undone by their overly ambitious frame, and of course in the critiques of mainstream feminism that came in the wake of this scholarship came the seeds of its current integrity. Those critiques came in the form of critical race studies, queer studies, and the feminist elaboration of gender as an analytic. This volume offers us a slice of what is possible—a collection of women's history in which the category of "woman" is understood to be deeply embedded in a breadth of particularities. But it also offers us a glimpse of anther transformation. It is possible that this kind of work carries the seeds of the field's own destruction. In the face of an intervention that has led most of us to move from "women" to "gender" as the analytic frame of our work, the gathering of a series of historical essays under the rubric of women's history may strike some as old-fashioned. The fact that the particularities with which these essays are concerned include gender and sexuality is a key to their successful interventions, but it also carries with it a future vision of the field that may be unsettling to some. There is a contradiction in gathering a set of essays under the rubric of women in early America in which the essential argument is that one cannot write the social history of early America without women. By rendering "early America" unknowable in the absence of an engagement with gendered subjects, this kind of scholarship offers a transformative possibility that could result in an undoing of the field. One could envision a future in which the "women" in "early America" is redundant and impossibly old-fashioned. But questions remain, the archives are elusive, and the work of the history continues apace. Even as the essays in this volume use "women" as a fulcrum to unearth structures that concern both the lived experiences of women in the American past as well as the larger contours of political economy, race, gender, and environment, I feel confident that the analytical interventions of women's history will continue to make both political and historical sense for some time.

ABOUT THE CONTRIBUTORS

CAROL BERKIN is Presidential Professor of History at Baruch College, City University of New York. She is the author of numerous books, including *A Brilliant Solution: Inventing the American Constitution*; *Civil War Wives: The Lives and Times of Angelina Grimké, Varina Howell Davis, and Julia Dent Grant*; *First Generations: Women in Colonial America*; *Revolutionary Mothers: Women in the Struggle for American Independence*; and *Wondrous Beauty: The Extraordinary Life of Elizabeth Patterson Bonaparte*; and is editor of *Women of America: A History*; *Women's Voices, Women's Lives: Documents in Early American History*; and *Women, War, and Revolution*.

RUMA CHOPRA is Assistant Professor of History at San Jose State University. She is the author of *Unnatural Rebellion: Loyalists in New York City during the Revolution* and *Choosing Sides: Loyalists in Revolutionary America*.

MATTHEW DENNIS is Professor of History and Environmental Studies at the University of Oregon. He is the author of *Cultivating a Landscape of Peace: Iroquois-European Encounters in Seventeenth-Century America*; *Red, White, and Blue Letter Days: An American Calendar*; *Riot and Revelry in Early America*; and *Seneca Possessed: Indians, Witchcraft, and Power in the Early American Republic*.

ERICA ARMSTRONG DUNBAR is Associate Professor of History and Black American Studies at the University of Delaware. She is the author of *A Fragile Freedom: African American Women and Emancipation in the Antebellum City*.

THOMAS A. FOSTER is Professor of History at DePaul University. He is author of *Sex and the Founding Fathers: The American Quest for a*

Relatable Past and editor of *Long Before Stonewall: Histories of Same-Sex Sexuality in Early America* and *New Men: Manliness in Early America.*

RAMÓN A. GUTIÉRREZ is the Preston and Sterling Morton Distinguished Service Professor of American History and the College at the University of Chicago. He is the author of *When Jesus Came, the Corn Mothers Went Away: Marriage, Sexuality, and Power in New Mexico, 1500–1846* and editor of *Mexican Home Altars, Feasts and Celebrations in American Ethnic Communities,* and *Recovering the U.S. Hispanic Literary Heritage.*

JOY A. J. HOWARD is Assistant Professor of English at New Jersey City University. She is the author of "Jonathan Edwards's Metaphors of Sin in Indian Country," *Religion in the Age of Enlightenment* 2 (2010) and "Women of Faith and the Pen: Anna Maria van Schurman, Sor Juana Inés de la Cruz and Anne Bradstreet," *Journal of Prose Studies* 29, no. 3 (2007).

MARY C. KELLEY is Ruth Bordin Collegiate Professor of History, American Culture, and Women's Studies in the Department of History at the University of Michigan. She is the author, coauthor, and editor of eight books. Among her most recent works are *Learning to Stand and Speak: Women, Education, and Public Life in America's Republic* and *Private Woman, Public Stage: Literary Domesticity in Nineteenth-Century America.* She is also coeditor of *An Extensive Republic: Paint, Culture, and Society in the American Republic, 1790–1840.*

KAREN L. MARRERO is Assistant Professor of History at Wayne State University. She is the author of numerous essays, including "'She Is Capable of Doing a Good Deal of Mischief': A Miami Woman's Threat to Empire in the Eighteenth-Century Ohio Valley," *Journal of Colonialism and Colonial History* 6, no. 3 (2005); and "Finding the Space Between: The Means and Methods of Comparative History," *Canadian Review of American Studies/Revue canadienne d'études américaines* 33, no. 2 (2003).

JENNIFER L. MORGAN is Professor of History in the Departments of Social and Cultural Analysis and History at New York University. She is

the author of *Laboring Women: Reproduction and Gender in New World Slavery.*

ELIZABETH REIS is Professor of Women's and Gender Studies at the University of Oregon. She is the author of *Bodies in Doubt: An American History of Intersex* and *Damned Women: Sinners and Witches in Puritan New England* and is editor of *American Sexual Histories: Blackwell Readers in American Social and Cultural History; Dear Lizzie: Memoir of a Jewish Immigrant Woman;* and *Spellbound: Women and Witchcraft in America.*

SUSAN SLEEPER-SMITH is Professor of History at Michigan State University. She is the author of *Rethinking the Fur Trade: Cultures of Exchange in an Atlantic World; Contesting Knowledge: Museums and Indigenous Perspectives: Museums and Indigenous Perspectives;* and *Indian Women and French Men: Rethinking Cultural Encounter in the Western Great Lakes.*

KIM TODT is Assistant Professor of History at the University of Louisiana at Lafayette. She is the coauthor of "Capable Entrepreneurs: The Women Merchants and Traders of New Netherland," in *Women in Port: Gendering Communities, Economies, and Social Networks in Atlantic Port Cities, 1500–1800;* and author of "Trading between New Netherland and New England, 1624–1664," in *Early American Studies: An Interdisciplinary Journal.*

CHRISTINE WALKER is Assistant Professor of History at Texas Tech University. She is the author of "Anthony Bacon, 'Considerations on the Present State of the North American Colonies,' 1769," in *An Americana Sampler: Essays on Selections from the William L. Clements Library* (2011).

BETTY WOOD is Emeritus Reader in American History at the University of Cambridge. She is the author and editor of numerous books on women, gender, and slavery and the American South, including *Slavery in Colonial Georgia, 1730–1775; Women's Work, Men's Work: The Informal Slave Economies of Lowcountry Georgia,*

1750–1830; The Origins of American Slavery: The English Colonies, 1607–1700; Gender, Race and Rank in a Revolutionary Age: The Georgia Lowcountry, 1750–1820; and *Slavery in Colonial America, 1619–1775.* She is also coeditor, with Sylvia R. Frey, of *The Atlantic World: From Slavery to Emancipation.*

INDEX

Abbott, Elizabeth, 98
Abenaki, 120, 125
Abiquiu, New Mexico, 88
Adams, Abigail, 4
Adams, Eliza, 257, 258
Adams, John, 229
Addison, Joseph, 248
Aertsen, Leendert, 49
Africa, witches, witchcraft in West and
 Central, 77
Agreda, María de (María Fernández Coro-
 nel y Arana), 10
Aguilera, Melchor de, 13
Aguilera y Roche, Teresa de, 7–42; accus-
 ers, 13, 29; Ana (her slave), 21–22, 27, 28,
 39; aristocratic ancestry, 36; arrested,
 11, 12, 35; Avila, Enrique de, 20; Bernal,
 Catalina, 25; books owned by, 19; Ca-
 brera, José de, 23; Cárdenas, Juan de, 36;
 charged with heresy, 8; charged with Ju-
 daism, 8, 16, 19, 23, 28, 29; charged with
 lacking religious fervor, 22; charged
 with sorcery, 8, 27; charges against her,
 her rebuttal to, 18–23; charges dismissed
 by Holy Office of the Inquisition, 28–29;
 Christina (her slave), 12; Clara (her
 slave), 12, 17, 21, 22; Diego (her slave),
 12; enemies, 23; father, 13; Francisca
 (her slave), 22; Franciscan Order, 34;
 Galdiano, Bartolomé de, 7; Gamboa,
 Juan de, 27–28; husband (see López de
 Mendizábal, Bernardo de); imprison-
 ment by Holy Office of the Inquisition,
 7, 9–10, 11, 12–13, 28; Inés (her slave),

12; inquisitor, 23; interrogation by Holy
Office of the Inquisition, 14–15; Isabel
(her slave), 12; Isabelilla (her slave), 22;
Josefa (maid), 21–22; Juana (her slave),
21, 28; lineage, 14; Manso de Contreras,
Juan, 13, 23, 28–29, 32, 38; María (her
slave), 12, 21; marriage, 13–14, 35; Me-
dina Rico, Pedro (Dr. Medina), 11, 12–13,
14–15, 28; Mexico City, transported to,
12; Micaela (her slave), 12; mother, 13;
Noriega, Miguel de, 25–26; Peñalosa
Briceño y Berdugo, Diego Dionisio de,
20; personality, 10; property, 11–12, 24,
32; prosecutor, 16; published literature
on, 10–11; rant by, 23–28; residencias,
economics of, 30; Ruíz de Cepeda
Martínez y Portillo, Rodrigo (Dr. Ruíz),
16, 17–18; Sandoval, Josefa de, 26–27;
servants and slaves, her treatment of,
39; Zamora, Catalina de, 19
Alavés, Alonso de, 23
Albany Female Academy, 258–259
Alberro, Solange, 9, 36
Algonquian women, 82, 159, 181
Alison, Archibald, 254
Allen, Richard, 237–238
Ambrose, Abraham, Jr., 105
Anaya, Francisco de, 30
Ancient History (Rollin), 248
Anderson, John, 104
Antioch College, 267n15
Apaches, 30, 32, 33–34, 87
Arteaga, Pedro de, 26, 27
Ashley, Benjamin, 126, 134